ARTS OF CHINA

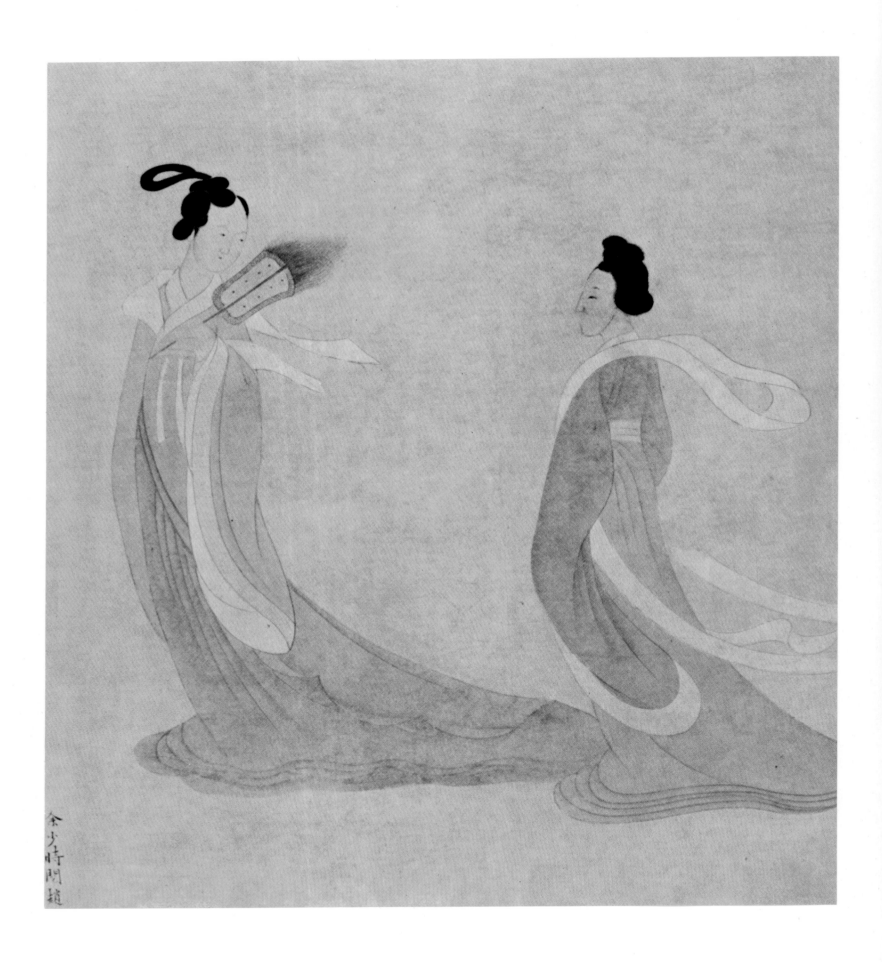

ARTS OF CHINA

Paintings in Chinese Museums

NEW COLLECTIONS

YOSHIHO YONEZAWA

MICHIAKI KAWAKITA

Translated by GEORGE C. HATCH

講談社

KODANSHA INTERNATIONAL LTD.

Tokyo, Japan & Palo Alto, Calif., U.S.A.

DISTRIBUTORS:

British Commonwealth (excluding Canada and the Far East)
WARD LOCK & COMPANY LTD.
London and Sydney

Continental Europe
BOXERBOOKS, INC.
Zurich

The Far East
JAPAN PUBLICATIONS TRADING COMPANY
C.P.O. Box 722, Tokyo

Published by KODANSHA INTERNATIONAL LTD., 2-12-21, Otowa, Bunkyo-ku, Tokyo, Japan and KODANSHA INTERNATIONAL/U.S.A., LTD., 577 College Avenue, Palo Alto, California 94306. Copyright in Japan, 1970, by KODANSHA INTERNATIONAL LTD. All rights reserved. Printed in Japan.

Library of Congress Catalog Card No. 68-17454
SBN 87011-128-0
JBC No. 3071-781543-2361

First edition, 1970

Contents

Acknowledgments

The publisher is grateful for the assistance of many people of the People's Republic of China in the preparation of this book. Cooperation rendered by the People's Republic has been instrumental in the realization of this volume and of Volumes I and II of *Arts of China*.

A great number of masterpieces of painting have been included in this volume, ranging from the Five Dynasties period to the present time. It is most significant that the magnificent paintings in the possession of museums of the People's Republic of China are being introduced here for the first time. Full gratitude is expressed to the following museums for their complete cooperation and support in photographing the paintings: The Palace Museum, Tientsin Museum, Liaoning Provincial Museum, Shanghai Museum, Nanking Museum, and the other museums whose treasures were so generously allowed to be reproduced here.

The publisher wishes to express its extreme indebtedness to the Chinese People's Association for Cultural Relations and Friendship with Foreign Countries, and the Japan-China Cultural Exchange Association, and to the officers of these institutions in China and Japan.

1970

Kodansha International

The Course of Chinese Painting

Yoshiho Yonezawa

I

IN THE PERIOD from late T'ang and the Five Dynasties to the end of Northern Sung (the tenth and eleventh centuries), Chinese painting was highlighted by newly conceived landscapes, flower-and-bird paintings, and religious painting inspired by the reconstruction of Buddhist and Taoist temples. Landscape painting achieved a remarkable development with such representative artists as Ching Hao, Kuan T'ung, Li Ch'eng, and Fan K'uan in north China, and Tung Yüan and Chü-jan of the southern Chiangnan region. Their style may be described as a kind of realism outstanding in Chinese landscape art, for they took as material the natural scenery of their own native areas. By this "realism" of style is meant the fact that artistic creation was based upon the intrinsic meaning—"the essential nature of all things," "the organizing principle of heaven and earth"—which they perceived in their observation of nature. This the artist grasped by immersing himself in nature and becoming one with heaven and earth. The "reality" of a landscape was thus attained by expressing its image as an ideal conception. Though here termed realistic, it was still a very different thing from modern realism, which stands upon the consciousness of a dichotomy between subject and object. Further, as these "realistic" artists rejected surface beauty and literal representation, it is clear that they took a critical view of the representational naturalism that was the leading tendency of T'ang painting. They were, moreover, not reticent to acknowledge that the unconventional ink wash landscapes that appeared in late T'ang, though differing from natural scenery itself, nonetheless "attained the universality of its organizing principle."[1] In short, this realistic style was nothing other than a form of impressionism, a kind of expression "from the depths of the breast." In it may be recognized the special character of the period.

The attitude of these painters in viewing landscapes from a direct frontal perspective was one of seriousness without the slightest display. They sought to penetrate the organizing principle and essential nature inherent in nature itself, to express in their painting a unity of inner reason and outer form, so that that their art tends to be overly rational and lacking in feeling. It should be noted, however, that the landscape paintings of this period, and in particular those of the representative artists mentioned above such as Ching Hao, Kuan T'ung, Li Ch'eng, Fan K'uan, Tung Yüan and Chü-jan, survive almost entirely in copies, without which the study of the landscape painting of the time could hardly be pursued. It is for this reason that several very rare copies are introduced in this volume.

The flower-and-bird painting of the Five Dynasties and Northern Sung period is represented by two distinct styles. The first, begun by Huang Ch'üan of Shu (Szechwan Province), was a decorative style characterized by clear outline and heavy coloring, and was referred to as the "wealth and honor" style. The second, founded by Hsü Hsi of Nan-T'ang (the Chiangnan region), was an elegant style distinguished by fine brushwork and blurred coloring, and was called the *yeh-yi* style, associating it with cultivated gentlemen in leisured retirement from office. The two were distinguished clearly just as the Northern and Southern schools of landscape painting, but as even good copies are not available, nothing concrete can be said. At any rate, the Huang Ch'üan style was based on the older representational tradition of T'ang, while the newer Hsü Hsi style was influenced by the ink wash technique and leaned toward a more impressionistic rendering of the spirit of flowers. There was

between them a significant difference of attitude. It was the Northern school of landscapes and the Huang Ch'üan style of flower-and-bird painting that received the support of Northern Sung painting academies.

In the period from the end of the Northern Sung court to the beginning of the Yüan dynasty, from the last half of the eleventh century to the last half of the thirteenth, the style of painting turned away from the realistic expression described above to a more conceptual formulation. The change was promoted at the end of Northern Sung by literati and aristocrats who sought an identity between calligraphy and painting, or between poetry and painting, a tide that soon swept over even the court academy. The most notable literati exponent of the relations between poetry, calligraphy, and painting was Su Shih (Tung-p'o), who held that the three together were an expression of the artist's character. In praising an ink bamboo screen by Wen T'ung, Su stated: "What virtue is not exhausted in poetry overflows into calligraphy, or changing its form, finds expression in painting; both are the overflow of poetic expression." With poetry at the center, the three were to be taken as a single form of expression. Within this formula is revealed the direction of literati painting, and it is of great historical significance. To the unification of painting and calligraphy, which had already been current in earlier times, the identification of painting with poetry was now added to form a new synthesis. As there were two forms of painting corresponding to each of these at the time, however, it is convenient to keep the two points of view separate for the moment.

The theory that painting and calligraphy are continuous modes of expression is at least as old as the gentry of the Six Dynasties period, who were masters of both arts. Concretely, it produced a style of outline drawing that emphasized the linear values of the brush. The technique was later taken up by the genius Wu Tao-tzu of T'ang, who created the most outstanding brushwork in Chinese art past or present. However, the unconventional ink wash, and especially the "spilled ink" painting that appeared in the Chekiang area in the later half of the T'ang dynasty, though also done in ink monochrome, has no connection in theory with the identification of painting and calligraphy. As it denied the elements of line and structural delineation common to the brushwork of both calligraphy and painting, it would be nonsense to intrude a discussion of that school here.

The ink wash painting supported by the Szechwan literati Wen T'ung and Su Shih was a new form centering around ink bamboo, and it did not necessarily deny the value of line. It seems to draw upon the "spilled ink" school insofar as it does not enclose objects within a formal outline, but still the function of ink was restricted within broad limits. The basic expressive property of ink is one of surface, while that of brush is line. These artists formed their bamboos by imposing line and structure on that surface, resulting in a compromise in which the ink is made subject to the brush. Thus through the mediation of the brush, ink wash painting was brought into line with the tradition of Chinese painting consistently stressing the value of line, and ink wash painting was for the first time able to assume a leading role in the theory identifying painting and calligraphy. The fact that Su Shih's statement of the unity of poetry, calligraphy, and painting was made in connection with the ink bamboos of Wen T'ung makes this clear. Ink bamboos were at once "something that matured in the depths of the breast," and the "offspring of the *samadhi* implied in cursive script,"[2] and were thus in this sense an expression of the artist's character and personality.

The literati painting group that formed around Su Shih at the end of Northern Sung intentionally opposed the court academy of professional painters, which had shown remarkable development. To do this, they had need of themes and styles that were suitable to literati as well as different from the professional painters, and further had to organize socially into a school of their own. The Tung-p'o group settled upon ink bamboos "nurtured within the breast" as their standard, and organized themselves on geographical and kin lines into the Shu (Szechwan) school. It is in this event that a group of literati painters first became a school, and it heralded the establishment of a genuine literati painting distinguished from the work of professionals on stylistic grounds; it was just this Tung-p'o group that became the model for later schools of literati painting.

Next, in the field of landscape painting, the school of "realism" in the Five Dynasties and Northern Sung period began to decline as its leadership passed from Li Ch'eng to Kuo Hsi. In its place began a movement to revive the style of the famous early eighth century T'ang painters such as Li Ssu-hsün and Li Chao-tao, and Wang Wei, whose work Su Tung-p'o praised as containing a "painting within a poem, and a poem within

a painting." Attention was also paid to the style of such Chiangnan painters as Tung Yüan and Hui-ch'ung. This change of style, unlike the ideological restorationism seen in Yüan and Ming painting, sought to transcend the old "realism" and create a new aesthetic realm by infusing poetry into painting. Wang Shen's "Misty River and Folded Peaks" scroll (Pls. 3, 32) is a representative work of this revival of eighth century T'ang painting.

The romantic emperor Hui-tsung at the end of the Northern Sung is well known as a patron of the arts, and was fond of producing a line of poetry as an examination theme for court painters, causing them to strive for poetic expression in their painting. Though the judgment of success in this respect must have been something of a problem, it was obviously an expression of the unity of painting and poetry theory. It was also in this period that artists began to place within their painting itself the simply sketched figure of a scholar of leisure enjoying the scenery, with whom the viewer of the painting could empathize in savoring the poetic atmosphere of the land-scape. This method was the forerunner of the formalized empathetic expression employed by the Southern Sung court painters Ma Yüan and Hsia Kuei, and was also the source of the "one-corner" composition of Ma, Hsia, and others, which brought into focus and emphasized only a single corner of the landscape.

The change that occurred in flower-and-bird painting at the end of Northern Sung was no less conspicuous than that in landscape painting. A new style was created by Ts'ui Pai and his disciple Wu Yüan-yü, which with "delicate brushwork and fresh, moist coloring," revolutionized techniques handed down from T'ang, the Five Dynasties, and Northern Sung. It drew probably on the previously overlooked manner of the Chiangnan painter Hsü Hsi. This new style was introduced into the court academy by Hui-tsung, who had once studied under Wu Yüan-yü, and it became a second court style in place of the Huang Ch'üan technique. After the political collapse of the Northern Sung court, it was continued in Southern Sung and gave rise to many famous works. This second court style, rather than pursuing ornamentation or realism, stressed an expression of the atmosphere and feeling that surrounded its subjects, and thus unquestionably elevated the quality of painting.

However, as the end of the Southern Sung period approached, the painting of the court academy underwent a qualitative deterioration, and ink wash painting flourished in its place. The period surrounding the end of Sung and the beginning of Yüan witnessed the golden age of ink wash painting, unmatched before or after. The ink painting of the Northern Sung period sponsored by literati had been limited to bamboo, plum branches, dead trees, rocks, and landscapes, but now its advocates became Ch'an (Zen) monks, who painted chiefly Tao-ist and Buddhist priests and other religious subjects and a variety of themes ranging from dragons and tigers, monkeys and cranes, reeds and geese to landscapes, flowers and vegetables. A comparison with the Northern Sung ink wash technique is not possible because no paintings in that style survive, but the works of Liang K'ai and Mu-ch'i of Southern Sung show not only a technical refinement, but achieve as well the expression of a higher realm in which inner and outer values, subjective and objective perspectives are perfectly fused. These works are the quintessence of the long tradition of Chinese painting that wove together natural and conceptual representation, and with this last glorious achievement, Sung painting draws to a close.

Ink wash paintings by Buddhist monks of the period survive now only in Japan, the result of a difference of taste in the two countries. There they were aesthetically valued very highly and treasured as masterpieces. In China, on the other hand, it has been the literati painting since Yüan times that has been most esteemed, while the ink painting of the monks has been scorned as "crude and out of tradition," and "unfit for pure enjoyment in one's study."[3] Thus the ink paintings of late Sung and early Yüan largely left China and came to rest in Japan. It would not be appropriate to include in a volume devoted to the tradition as it exists in Chinese collections a discussion of paintings that have not survived in China, but attention should be drawn to these ink paintings by monks in the following context. There are in Japan, in addition to the ink paintings, many Southern Sung works that anticipate the fourteenth and fifteenth centuries, and many Yüan and Ming paintings that belong to that tradition. It is no exaggeration to say that these collections surpass both in quantity and quality anything left in China. It is true that these Southern Sung paintings are artistically superior, and by nature much suited to the Japanese taste. It is no more than prejudice, however, to hold that these Southern Sung paintings contain all there is of value in Chinese art. The Chinese, on the other hand, display a similar bias in their tendency to

overvalue the work of literati painters devoted to the restoration of antiquity, and to reject the ink paintings of the Buddhist monks. There is need for an adjustment of views on both sides. It is particularly urgent that Japan should now attempt a reevaluation of Northern Sung art and the restorationist Yüan paintings based upon them, which have been largely unknown in this country.

The last stage of the medieval period of Chinese art is the Yüan dynasty in the fourteenth century. The Japanese, in their partiality for Southern Sung work, often look upon Yüan painting as an extension of the Southern Sung style, but this is to ignore the maincurrent of the time. The leading tendency among Yüan painters was in fact to deny the Southern Sung style and revive Northern Sung painting, a restorationism rooted in a desire to preserve the Chinese cultural tradition, which was looked upon lightly by the ruling Mongol dynasty. Painting founded on this ideology was chiefly supported by painters who held official positions in the Mongol court. They were led by Chao Meng-fu, a descendent of the Sung ruling house and a famous painter and calligrapher, who formed a literati painting school in the manner of the earlier Tung-p'o group. They regarded the Southern Sung academy style as feeble of brushwork and advocated instead the Five Dynasties-Northern Sung landscape styles of Li Ch'eng and Kuo Hsi, and the bird-and-flower painting of the Huang Ch'üan school. Within the Southern Sung academy they did recognize the landscape styles of Ma Yüan and Hsia Kuei, and in figure painting emphasized Wu Tao-tzu of T'ang and Li Kung-lin of the late Northern Sung period. All conformed in style to the traditional emphasis given line and brushstroke. Though they might welcome the ink bamboos of Wen T'ung and Su Tung-p'o, and the misty mountains of Mi Fu as genuine literati styles in Northern Sung, they yet rejected completely, irrespective of quality, the ink wash painting of the Buddhist monks of late Sung and early Yüan as "unfit for pure enjoyment in one's study." It may be supposed that these attitudes were rooted in a repressed and frustrated racial consciousness among the literati and that they fostered a restorationism that valued tradition more highly than art.

The restorationist painting that these artists did recognize as "fit for pure enjoyment in one's study" attempted to give an even bolder impression than Northern Sung painting itself. To achieve this they emphasized more strongly certain formal aspects of the Northern Sung style. They strengthened the elasticity and viscosity of line, thickened the tone of color and ink, and stressed contrast in composition as a means of augmenting the gravity and force of their art.

These techniques were certainly consistent with traditional Chinese concepts emphasizing lively and vigorous expression. But insofar as they tended to be merely formalistic efforts, without regard for the investigation of the organizing principle and essential nature inherent in natural phenomena as seen in Northern Sung paintings, or for the artist's own internal search for an expression of poetic feeling as exhibited by painters since the late Northern Sung, it was perhaps inevitable that this bold expression should become somewhat crude and empty of content. Such a tendency can indeed be recognized in the restorationist paintings of the Yüan period. They were often composites of stylistic elements borrowed piecemeal from older models, and such formalistic work as this, carried out in the name of "reverence for antiquity," was bound to neglect the creative effort required for genuine philosophical insight and poetic expression. Thus the creative genius of Chinese artists, which had surged forth in the T'ang and Sung periods, now became blunted as this traditionalist mentality grew. It is no wonder that the restorationist paintings of this period, which began and ended with the manipulation of formalistic techniques, were unable finally to throw open any new realms of aesthetic experience. Yüan painting, however, was not entirely confined to such a formalistic reverence for antiquity. The so-called Southern school of painting that arose in late Yüan is perhaps one exception. The Nan-tsung style followed the lead of Chao Meng-fu, and had at first a restorationist intent, but as it gained the support of literati outside officialdom, it began to follow a course of its own distinct from the officially based restorationism and sought to restore again a human element to painting.

II

The period from late Yüan to late Ch'ing may be called the premodern age in the history of Chinese painting,

and its art characterized by the following two features: positively, it was art that assigned priority to emotional inspiration, and passively, it stood in support of "spirit consonance," which inhered in the evocative properties of brush and ink themselves. Inspirationism was one aspect of the realism begun in late T'ang, but in contrast to the restraint imposed on that in a search for organizing principle and essential nature, this inspirationism was not thus inhibited, and its expression was more individualistic and sensual, responding with sensitivity to the impulsiveness of life. Beginning with the most outstanding of the Four Great Masters of Late Yüan, Huang Kung-wang, through the representative Ming literati painter Shen Chou, and the critic Ku Ning-yüan, all held that painting is something done only when "borne by inspiration," without which one's talent could not find expression.[4]

On the other hand, the theory that spirit consonance inheres in brush and ink is founded in the traditional idea of the identity of calligraphy and painting, and may have taken form by further absorbing the conventional notion that spirit consonance is inherent in mists. Such an argument is already seen in Ming art criticism, not to mention that of Ch'ing. This esteem for brush and ink meant of course an emphasis on the technical and formal aspects of painting, and was not necessarily in conflict with the high value placed on emotional inspiration. But the relative change of emphasis between inspiration and brush and ink, or put otherwise, between expressionism and formalism, did in fact greatly influence the course of Ming and Ch'ing painting. Furthermore, the ebb and flow of traditionalism in Ming and Ch'ing times, which had come on more strongly since the Yüan period, mixed with the conscious political reaction of the Ch'ing painters—who, as in Yüan, were under the rule of a foreign dynasty—gave to the painting of this period an even greater complexity.

The first stage of the premodern period begins with the late Yüan, in the last half of the fourteenth century, and ends with the first half of the Ming period in the fifteenth century. The character of the period was fundamentally transitional, for the revived Nan-tsung school was soon in the Ming period overturned by the power of the Pei-tsung school, which was suffused with a restorationist spirit.

Put simply, the northern Pei-tsung and southern Nan-tsung schools suggest two opposing styles of painting, but the terms came into use only in the late Ming period with the intention of esteeming the Southern and disparaging the Northern school. It was simply a matter of defining something called a Northern school in order to identify and enhance the Southern style.

The terms Pei-tsung and Nan-tsung have now nearly disappeared from use in China, though the abbreviated terms Nanga and Hokuga have been used in Japan since the Edo period and are still alive today. The scope of the terms Nanga and Nan-tsung Hua are different, however, in the two countries. The Chinese Nan-tsung style refers to a "soft" landscape done by literati painters, and it stands in contrast to the "hard" landscape style by professional painters. In Japan, however, the use of the terms neglected the fact that they were originally stylistic concepts limited to landscape painting, and flower and figure painting as well as landscapes done in the literati manner all fell within the Nanga style. The terms Southern and literati became synonymous, a peculiar Japanese usage that was unknown in China.[5]

The formation of a Southern landscape style appeared, as related above, in late Yüan, when the imitation of landscapes after the manner of Tung Yüan and Chü-jan, painters of the Chiangnan region in the Five Dynasties and Sung periods, became fashionable. The Tung-Chü style was thus the forerunner of Nan-tsung painting. The one who first introduced the Tung-Chü style into Yüan painting circles was of course Chao Meng-fu, but it was late Yüan painters outside the court academy who cut from it the fetters of restorationism, and evaluating the style anew through their own preoccupations with humanism and inspirationism, discovered a new path that led them into the premodern era. Thus was created the Southern landscape style that overwhelmed the painting circles of Ming and Ch'ing, and its founders were none other than Huang Kung-wang, Wu Chen, Ni Tsan, and Wang Meng, the Four Great Masters of Late Yüan. Each interpreted Tung and Chü in his own manner, and developed styles different from each other, so that they cannot be regarded as having formed a single school at the time. But as exponents of a Tung-Chü or Nan-tsung school, their painting gained wide support at the end of Yüan and beginning of Ming. As the autocratic structure of the Ming court became established, however, the Southern style was rejected and the power of the Northern school enhanced as it became

the center of the court painting academy. Within the Northern school, extensions from the Yüan period were many, but its mainstream became the Che school, a group of professional painters founded by Tai Chin. The Che style was founded on Ma Yüan and Hsia Kuei interpreted through Yüan restorationism; it was oriented toward formal values and later enhanced by the ink wash technique nurtured in the south coastal regions of Fuchien and Kuangtung. The school exaggerated the techniques of brush and ink in a show of great force, a method that suited the technical conception of spirit consonance and was perhaps in accord with the militant mood of the Ming court. However, it was perhaps inevitable that they should pass from a paucity of content to bluff, anxiety, and a coarseness of ink and brushwork, which produced in conclusion a nihilistic eccentricity and determined the demise of the school.

The second stage of the premodern period, corresponding to the latter half of the Ming dynasty in the sixteenth and first half of the seventeenth centuries, was the most flourishing period of Nan-tsung literati painting. At the end of the fifteenth century, when the Nan-tsung school was again on the rise and the Pei-tsung school showed signs of decline, the center of the painting forum was taken by the Yüan school, which took up the old academy style. Such famous painters as Ch'ou Ying and T'ang Yin came out of it. Ch'ou Ying was a professional, and T'ang Yin a literati painter, and as the school was identified with both of them, it showed a tension between literati and professional painters and was transitional in character. Thus as literati painting gained popularity, the Yüan school was absorbed within it, so that its line is unclear after Ch'ou and T'ang.

Those chiefly responsible for the revival of Nan-tsung painting were Shen Chou and his disciple Wen Cheng-ming, literati painters outside the court. The two were individualistic painters who differed in style and direction, but they had in common a high esteem for the Four Great Masters of Late Yüan and especially Huang Kung-wang, whose works they studied, and both further sought to express a rich emotional inspiration throughout their painting. Between imitating the traditional forms of the Yüan masters and expressing their own emotional inspiration lay a potential contradiction; they chose, however, a conservative stance in valuing tradition and inhibiting impulsive creativity. The weight of tradition might kill the frankness of inspirational expression, but as Shen and Wen showed, the goal of emphasizing traditional forms while maintaining the elegance of the painting could attract many adherents, and it became the direction of Nan-tsung literati painters. Around them, as with Su Shih in Sung and Chao Meng-fu in Yüan, formed a large school of literati painters based on geographical and kin ties. Their place of origin was Wu-chen (Su-chou), or more broadly, the old territory of Wu in Kiangsu Province, so that they were known as the Wu school as against the Che school, which upheld the Northern tradition. Thus with the Wu school at the center, painters in the Southern tradition appeared in large numbers from late Ming through Ch'ing times, and enjoyed unprecedented prosperity.

In Japan the Wu school is not so familiar as the Che school, and the term Nan-tsung is used in its place. In China, on the contrary, the name is still very much alive among art historians. Both the Wu and Che groups are identified by geographical affinities—Che in Chekiang Province and Wu in Kiangsu Province—but the significant point of difference between them is of course that the Che school was composed of professional artists, and the Wu school of literati painters. Thus the term Wu school refers to a group of literati painters in the Wu region, and is not a stylistically limited concept. Various kinds of flower painting such as "the four gentlemen," or bamboo, chrysanthemum, orchid, and plum, were all included within literati painting, a point of difference from Nan-tsung painting. The school lost its distinction from Nan-tsung painting, however, when in emphasizing exclusively its nature as a group of literati painters, it began to claim for its own tradition literati painters from mid-T'ang whom it favored, and to call them men of Wu whether certain or not. One may properly speak of Nan-tsung painting from at least the four Yüan masters, but in the case of the Wu school its actual formation came only after the revival of Nan-tsung painting by Shen Chou and Wen Cheng-ming. Since it was formed on the necessity of an opposition to the Che school, it is historically meaningless to seek its origins earlier than Shen Chou and Wen Cheng-ming.

Painting of the late Ming period gives the appearance of having been dominated by literati painting of the Southern school. Even the Che school, in the style of its late master Lan Ying, felt its influence. As the Nan-tsung style spread and its painters grew more numerous, varying branches developed throughout the Chiangnan

region. These did not stand apart theoretically, and were rather offspring of the Wu school formed on geographical and kin lines. They were, however, related to the tendency of the Wu school at this time toward more individualistic expression, a process that began in late Ming and grew strikingly in early Ch'ing. It was in opposition to this that Tung Ch'i-ch'ang, the most prominent leader of late Ming literati painting, called up anew the old slogan "Esteem the South and disparage the North," testifying to an orthodoxy of the Southern school and putting in motion a movement to preserve it. Here the unresolved tension within Nan-tsung painting since its revival—inspiration or form, tradition or creativity—became a compelling problem. Its resolution was deferred until the Ch'ing dynasty, but a matter related to it that cannot be ignored is the existence in Ming times of flower painting taken as literati art. The Nan-tsung landscape painting that took in the style of the Four Great Masters of late Yüan was of course haunted by traditionalist conventions, but in the case of flower painting such restrictions were few. The flower paintings of Shen Chou, for example, were far more free and lively than his landscapes, and the large-scale flower paintings by his successor, Ch'en Ch'un, raised the genre to a level comparable to literati achievements in landscape and ink wash plum and bamboo. In addition, the unconventional floral art of the famous late Ming literati Hsü Wei, which gave precedence to emotional inspiration over form and to creativity over tradition, exerted also a great influence on the art of the Ch'ing period.

The progress of Chinese painting toward a "premodern" identity was from late Yüan exceptionally slow. It is not until the third stage of the premodern period, or the first half of the Ch'ing dynasty in the latter half of the seventeenth and early eighteenth centuries, that premodern elements began to appear. Ch'ing painting, to those who equate value with antiquity, may appear the inferior product of a degenerate age. On aesthetic grounds, however, it is not necessarily inferior even in comparison with the art of the Sung period, properly considered the golden age of Chinese painting. Of course Sung and Ch'ing painting had each its own character. In the case of Sung painting, which sought to identify inner spirit with outer form, the style evolved through changing emphasis on those elements. In Ch'ing painting, contrasts in style were produced by support for one or another of the antagonistic propositions left unresolved from Ming—tradition or creativity, form or inspiration.

The Four Wangs (Wang Shih-min, Wang Chien, Wang Hui, and Wang Yüan-ch'i) were influential literati painters in early Ch'ing who succeeded to the leadership of the school that had formed around Tung Ch'i-ch'ang. It was they who undertook the literal preservation of traditional forms within the Nan-tsung literati school, and though this posture may have served to perpetuate tradition, it also undeniably assisted in the formalization of the style and gave impetus to mannerism. Second-rate painters in this line were numerically the most powerful; adhering too rigidly to the already skeletal forms of the Southern school, they declined at the end of Ch'ing, though a residue survives even today. As related above, the rigid formalism of the Four Wangs was an attitude taken in opposition to the permissive pluralism that began to flower in late Ming, and its persistence testifies plainly to the strength of traditionalism.

The pluralism that stimulated a conservative reaction in this period is a phenomenon worth special attention in the history of Chinese painting. Being highly individualistic, it cannot be characterized by one or two examples, but a unanimous choice from among the hundred flowers that bloomed here, both highly individualistic and artistically superior, would be Tao-chi (Shih-t'ao) and Chu Ta (Pa-ta Shan-jen). Both were anti-establishment survivors of the previous dynasty, and their painting was an expression of that rebelliousness. Tao-chi specialized in landscapes, and Chu Ta in flower painting; Tao-chi worked in the tradition of the Southern school, and Chu Ta in ink wash and the outline style. Though differing in theme and form, common to both of them was a disdain for the authority of tradition, and a freedom and uniqueness of expression. Their unconventional style was the natural expression of their personalities, revealing at the same time a lofty spirit that transcended the mundane world, and of great significance as a recovery of the original intent of literati painting.

With regard to the controversies over form and inspiration, tradition and creativity, the Four Wangs took the model position of giving preeminence to the values of form and tradition, while Tao-chi and Chu Ta single-mindedly pursued inspiration and creativity. The more the positions of the two groups became defined, the less room there was for compromise between them. In contrast to the Four Wangs, who gathered around them many adherents on geographical and kin lines, Tao-chi and Chu Ta remained isolated figures. In terms of numbers

the new school was no match for the old, but the antagonism between the two grew sharper with the passage of time.

The last half of the Ch'ing dynasty in the eighteenth and nineteenth centuries was a period in which flower painting gained prominence among literati in the place of the Nan-tsung landscape style. Adherents of Nan-tsung painting were of course still numerous, but the progress of flower painting was so impressive that, parti-cularly in light of later developments, it must be accorded the leading role of the period. The flower painting of the previous period was represented by the famous Yün Shou-p'ing in the literalist style, and the expressionism of Hsü Wei and Chu Ta. In this period the expressionist tradition was dominant, represented by the so-called Eight Eccentrics of Yang-chou. Yang-chou was at the time a commercial city dealing in salt and rice, and also a cultural center with a free atmosphere. There gathered many roaming artists and men of letters to engage actively in aesthetic pastimes.

The Eight Eccentrics are usually named as Chin Nung, Cheng Hsieh, Li Shan, Huang Shen, Lo P'in, Li Fang-ying, Wang Shih-shen, and Kao Hsiang, but the list is not fixed, for sometimes Kao Feng-han and Min Chen are added. The Eight gathered from different parts of the country, and though there were relation-ships of teacher, disciple, and friend among them, on the whole each was a school unto himself, and their styles were varied and diverse. In this respect they differed from the Nan-tsung painters with their proliferation of schools, and more resembled Tao-chi and Chu Ta of the previous period. They were all men who took up the brush in middle age, and riding on inspiration worked their favorite themes of flower, plum, and bamboo, even figure paintings of Buddhist and Taoist monks, in a manner that transcended judgments of skill or awk-wardness. Their work bespeaks the passionate and easily moved feelings that they possessed, feelings that gave to their art an elegant and lively tone, but at the same time an eccentric distortion. Their eccentricity lies, of course, in the unconventional and deformed expression engendered by their passionate feeling, but it must also have to do with the fragile and elusive beauty of their work, which is inseparable from its deformity. It is thus an eccentricity that is similar yet different from the vacuous "mad heterodoxy" of the earlier Che school.

The Yang-chou painters were active through an entire century, but with reforms in the salt administration, commerce in Yang-chou declined, and left without patrons they dispersed across the country. After the T'ai-p'ing Rebellion (1851–64), the Yang-chou tradition found support in the urban population of great cities such as Shanghai, and has become a representative style within the so-called national painting through the work of the contemporary painter Ch'i Pai-shih.

Chapter Notes

1. See the material concerning the attitude toward painting of Fan K'uan and Chü-jan in Liu Tao-ch'un's (劉道醇) 聖朝名画評 (*Appraisal of Famous Paintings in the Sage Court*), and Ching Hao's (荊浩) 筆法記 (*A Record of Brush Tech-nique*).

2. See Huang T'ing-chien's (黄山谷) critique 豫章黃先生文集 of Su Shih's (東坡) "Thicket of Decayed Trees."

3. See T'ang Hou's (湯垕) 畫鑑, an appraisal of the painting of Mu-ch'i (牧谿), and Hsia Wen-yen's (夏文彦) 圖繪寶鑑, an appraisal of the painting of Hsueh-ch'uang (雪窓; P'u Ming) and Tzu-t'ing (子庭; Tsu Po).

4. See Huang Kung-wang's colophon on the scroll "Hermitage on Fu-ch'un Mountain"; Shen Chou's (沈周) 夜坐記 (*Notes on "Sitting in the Night"*), gathered in 夜坐図題語 (*Colophons on the Painting "Sitting in the Night"*); and the chapter 論興致 ("On Inspiration") in the 画引 (*Prefaces to Paintings*) by Ku Ning-yüan (顧凝遠).

5. As related even by the Chinese art historian Yü Chien-ko (兪劍華) in his 中国繪画史 (*History of Chinese Painting*), "The term Nanga is a Japanese abbreviation of the Chinese Nan-tsung school of painting."

BIBLIOGRAPHY

陳衡恪「中国絵画史」　民国11

滕固「中国美術史」　民国14

鄭昶「中国美術史」　中華書局　民国18

鄭昶「中国画学全史」　中華書局　民国18

兪剣華「中国絵画史　上・下」　商務印書館　民国26

潘天寿「中国絵画史」　商務印書館　民国26

滕固「唐宋絵画史」　神州国光社　民国22

童書業「唐宋絵画談叢」　中国古典藝術社　1958

余紹宋「書画書録解題」　北平図書館　民国21

福開森 (Ferguson)「歴代著録画目」　中国文代研究所　民国23

孫韜公「中国画家人名辞典」　神州国光社　民国23

王季銓・孔達 (Contag) 編「明清画家印鑑」　商務印書館　民国29

朱鋳禹編「唐宋画家人名辞典」　中国古典藝術出版社　1958

郭味蕖編「宋元明清書画家年表」　人民美術出版社　1958

虞夏編「歴代中国画学著述録目」　中国古典藝術出版社　1958

商承祚・黄華編「中国歴代書画篆刻家字号索引」　人民美術出版社　1960

徐邦達編「歴代流伝書画作品編年表」　上海人民美術出版社　1963

傅抱石「中国的絵画」　中国古典藝術出版社　1958

劉凌滄編「歴代人物画」　中国古典藝術出版社　1958

兪剣華編「中国壁画」　中国古典藝術出版社　1958

泰嶺雲編「中国壁画藝術」　人民美術出版社　1960

宗典編「柯九思史料」　上海人民美術出版社　1963

黄湧泉編著「陳洪綬年譜」　人民美術出版社　1960

鄭拙盧「石濤研究」　人民美術出版社　1961

顧麟文編「揚州八家史料」　上海人民美術出版社　1963

「神州国光集　18巻」　神州国光社

「故宮名画集　45巻」　北京故宮博物院　民国25

「参加倫敦中国美術展覧会図録」　商務印書館　民国29

「画苑掇英」　上海市文物保管委員会　1955

「唐五代宋元名迹」　古典文学出版社　1957

「南京博物院蔵古画選集」　1957

「中国近百年絵画展覧選集」　文物出版社　1959

「上海博物館蔵画」　上海人民美術出版社　1959

「天津市藝術博物館蔵画集」　文物出版社　1959

「唐宋元明清名画選」　上海人民美術出版社　1960

「遼寧省博物館蔵画集」　文物出版社　1962

「蘇州博物館蔵画集」　文物出版社　1963

「傅山書画選」　人民美術出版社　1962

「担当書画集」　文物出版社　1963

「梅瞿山画集」　上海人民美術出版社　1960

「新羅山人画集」　上海人民美術出版社　1962

「揚州八家画集」　文物出版社　1959

「悲鴻墨画選集」　人民美術出版社　1954

「永楽宮壁画選集」　文物出版社　1959

「永楽宮」　人民美術出版社　1964

「北京北海寺明代壁画」　中国古典藝術出版社

Painting in Modern China

Michiaki Kawakita

I

IN HIS *The Development of Chinese Painting in the Last Hundred Years*, Cheng Chen-to stated:

"The invasion of China by the Western imperialists after 1840 exerted a harmful influence upon our country politically, economically, and culturally. From that period there was created in China a peculiar form of social organization, semi-feudal and semi-colonial. The feudal ruling class and the imperialist invaders soon joined forces, and in concert subjected the Chinese people to a terrible oppression and exploitation. Western things invaded China with a violent force, and the number of persons interested in traditional Chinese painting diminished greatly, such that most people have tended to ignore the achievements of Chinese painting in the last hundred years. But it is not true that there is nothing of value in modern Chinese painting, and to assert so is nothing more than the stubborn prejudice of capitalist scholars given to esteeming the past and belittling the present. Chinese painting of the last hundred years is not inferior to that of former ages; it has, in addition, its own modern process of development and creativity and has produced many great artists."

As related above, the situation in the late Ch'ing period did indeed degenerate into a hopeless situation after the Opium War (1840–42), as the invasion of European power became increasingly conspicuous and finally linked with the autocratic forces within the country. The famous T'ai-p'ing Rebellion (1851–64) was a typical reaction against this situation. The fact that it began under the leadership of peasants in the rural areas of Kuang-tung Province showed the existence of a real, deep-rooted power surging within China in addition to the forces of imperialism and autocracy. The manner in which this real power revealed itself in the realm of art at the end of the Ch'ing dynasty shall be our objective in tracing here the course of modern Chinese art. This creative force was not produced by the traditionalist school emphasizing form and technique in obedience to autocracy, nor did it proceed from second-rate colonial artists under the sway of the imperialist invaders.

Looking at it from this point of view, the first phase of modern Chinese art must be sought in such painters as Chao Chih-ch'ien, and Jen Hsiung or Jen Yi. These artists, rejecting the wave of restorationist traditionalism on the rise since the seventeenth century and absorbing the vigorous, convention-breaking spirit of the Eight Eccentrics of Yang-chou, exhibited this real power within China in an unstable period. Stated in the language of today, there was in this group a vigorous desire to break through the bonds of feudalism and imperialism. Among them Chao Chih-ch'ien (1829–84) had the greatest reputation, and may be said to have been the pivotal figure in Chinese art in the transitional mid-nineteenth century.

Formerly, the important areas of artistic activity in China had been the cities of Canton, Su-chou, Shanghai, Nanking, Wu-hsi, and Peking, but after the Opium War, as Shanghai became the chief commercial port in China, artists from every province began to gather there. Receiving the influence of Jen Hsiung (1820–56), who was equally as renowned as Chao Chih-ch'ien, and his younger brother Jen Hsün (1835–93), Jen Yü (the son of Jen Hsiung) and Jen Yi (1840–96, known as Jen Po-nien) became the center of the Shanghai painting forum. Particularly from the Kuang-hsü reign period to the first years of the Republic, it is said that Shanghai painters were almost all under the influence of Jen Yi.

Chao Chih-ch'ien infused a powerful vitality and sensuousness into an easy fluency of style. Historically, he

continued the fresh approach of such painters as Hua Yen and Li Shan, while at the same time receiving the influence of the earlier Ming painters Ch'en Ch'un and Hsü Wei. He had an especially stirring sense of color, and achieved an individuality of style within a harmony of firm and yielding elements. Jen Hsiung, in contrast, reveals nuances somehow suggestive of the Western painting tradition, and appears in places to draw upon the manner of Ch'en Hung-yüan from his own native district. Jen Hsün, who was particularly skilled at flower-and-bird painting, and Jen Yü, whose landscapes exhibited a tone of loneliness and solitude, both showed individual characteristics within a single artistic family. Jen Yi, who was most skilled at figure painting, showed a superior hand as well in his richly individualistic animal and bird paintings. These reflect a touch of foreign influence, which he combined with the powerful brushwork of the Chao Chih-ch'ien style. It is of interest that Wu Ch'ang-shih, who was to become the leading painter of the next generation, had at first studied flower painting under Jen Yi.

The Buddhist monk Hsü-ku (1824–96), who died in the same year as Jen Yi, belongs rather to the same age as Chao Chih-ch'ien. He had attained the rank of general at the Ch'ing court, but soon deserted the dynasty to join the T'ai-p'ing Rebellion. Later he became a monk and settled in Shanghai, where he was said to have assisted revolutionary activities in secret. This rebellious character made itself felt in his vivid painting style. Especially in his goldfish and squirrel paintings, he exhibited a skillful drawing technique, impressive in its sharp and lively brushwork.

Besides those mentioned above, late Ch'ing artists include Hu Hsi-kuei, Hu Kung-shou, and Chang Hsiung, while Chu Ch'eng, Su Liu-p'eng, and Su Jen-shan were leading painters in Canton. At any rate, the greatest artist of the late Ch'ing–early Republican period was undoubtedly Wu Ch'ang-shih.

II

Wu Chün-ch'ing (1844–1927) was styled Ch'ang-shih, and was a native of An-chi in Chekiang Province. He was also well known in Japan. A district magistrate in late Ch'ing times, he was famous for his seal style of calligraphy and seal engraving. After the age of fifty he became known for his painting as well. He studied Li Shan, Chang Ssu-ning, Shih-t'ao and Pa-ta Shan-jen, and attained a particularly unique and bold style in his paintings of flowering plants. These were a further extension of the style of Chao Chih-ch'ien. Free and novel in composition, his paintings possess the same resilient strength that reverberates through his engraved calligraphy, and achieve an especially striking tone. His themes are commonly seen peonies, grapes, wisteria, gourds, hibiscuses, lilies, and chrysanthemums, which in both color and brushwork overflow with a fresh vitality. Once he had taken up his brush, he wielded it with the speed of an arrow to create decisively drawn forms that exude an unbridled spirit of rebellion. Wu Ch'ang-shih soon came to dominate the artistic circles of Shanghai, and when his disciples became teachers in the Shanghai Professional School of Art, his influence spread all over the country. The style had its genesis in Chao Chih-ch'ien, whose manner received in Wu Ch'ang-shih a much modernized expression, which exerted a broad influence on later painting. Among those later artists are Wang Yi-t'ing, who is well known in Japan, and the recently active Ch'i Pai-shih, who was perhaps the most fundamentally influenced of all.

Artists of the same generation as Wu Ch'ang-shih include Sha Fu, P'u Hua, Ku Yü, Ch'ien Hui-an, Ch'eng Chang, Wu Ch'ing-yün, Ni T'ien, Lin Shu, who was also a translator of Western literature, and Wu Yu, an unusual, Western-influenced newspaper artist. None of these, however, could compare with Wu Ch'ang-shih in their influence upon the painting of the early Republican period. Among these later artists, the most active were Kao Lun, the leading painter of the Ling-nan school of the next generation, Ch'en Heng-k'o, Hsiao Sun, and Yao Hua of Peking, Ku Lin-shih of Su-chou, Ma Chiung and Wang Fo of Shanghai, and Ch'en Shu-jen of Canton.

Among these, Kao Lun (1879–1951) had studied in Japan at the end of Ch'ing, and even produced works for the "White Horse Society" (Hakubakai) and the "Pacific Painting Society" (Taiheiyō Gakai) in Japan. Joining Sun Yat-sen's T'ung Meng Hui, he later worked in the revolutionary movement in Canton. After

the revolution in 1911, he again took up painting in Japan, studied in America and Europe as well, and attempted an interesting synthesis of Chinese and Japanese painting. His paintings of local scenes in the Ling-nan area had a special flavor. Particularly his emphasis on color and ink wash were unusual in China, where the importance of line was so much stressed, and had a great influence on later generations. The brothers Kao Lun and Kao Ch'i-feng (styled Chien-seng) were two important artists to transmit this influence.

Ch'en Heng-k'o of Peking (1876–1922) also studied Western art and attempted a synthesis of Eastern and Western styles, achieving an effect pleasing in its purity. Ch'en Pan-ting (1876—), active in recent years with soft-toned flowering plants and landscapes in the Jen Yi style, is perhaps another representative artist of the Peking school. Apart from these the names of Hsiao Chün-hsien and Chin Ch'eng are well known. Chang Ta-ch'ien of Shanghai and P'u Ju of Peking, called together "Chang of the South and P'u of the North," are also noteworthy. However, as powerful artists of the late Republican and People's Republic of China period, the names of Ch'i Huan, Huang Pin-hung, and Hsü Pei-hung must be introduced.

III

Ch'i Huan, styled Wei-ch'ing, is known generally under the alias Ch'i Pai-shih, and has a great many lovers here in Japan as well. His pseudonym was taken from the name of his native village Pai-shih-ts'un, in Hsiang-p'iao-nan-hsiang, Hunan Province, where he lived and worked as a carpenter until the age of forty, designing furniture and painting portraits. Later he traveled widely throughout China, and when banditry became rife in Hunan, moved to Peking at the age of fifty. According to a story of the time, a friend once recommended Ch'i Pai-shih to President Ts'ao K'un for a small office, but Ch'i Pai-shih declined to serve, sending in reply a painting of iris and crab that carried a satirical poem shaming those who would ride with the tide as does the crab. It is perhaps natural that such paintings should be permeated with the soul and spirit of traditional Chinese literati. Because he started out as a carpenter, there lies basically beneath his style an unadorned reality and warm love of life, and a strong sense of humor and irony. His brush was swift and his forms sure; within his bold compositions and clean, simple drawing, there abounds a lively and beautifully sensuous spirit. This fresh charm is the most outstanding in modern Chinese painting, and as a further powerful development of the Chao Chih-ch'ien-Wu Ch'ang-shih style, it should be regarded as a fine example of the mainstream of Chinese painting. Because he was widely respected as a painter genuinely from among the people, he became after the Liberation a delegate to the First People's Political Consultative Conference, a member of the National People's Congress, and chairman of the Artists' Association of China. In Ch'i Pai-shih the connection of modern Chinese art with the nineteenth century is clearly revealed.

Huang Pin-hung (1863–1954), named Chih and styled Pin-hung, was a native of Yi District in Anhui Province. Showing his special characteristics best in landscape paintings, he was unfettered by the contemporary Hui school from which he came, and instead brought new life to the T'ang-Sung tradition. His convoluted, aerial view landscapes were frequently spread out in a clear, fresh atmosphere to give an effect of vast breadth and distance, and are distinguished by a singularly melodic composition. Huang Pin-hung was also compiler of the monumental anthology *Mei shu ts'ung shu*, and as a professor in the Hangchou Professional School of Art, devoted himself until death to art education.

Hsü Pei-hung (1895–1953) was a native of Yi-hsing, Kiangsu Province, and painted in a somewhat different style from the traditionally oriented Ch'i Pai-shih and Huang Pin-hung. Like Liu Hai-su, a former head of the Shanghai Professional School of Art, Hsü Pei-hung had studied painting in France. After returning to China he worked for a long time as a professor in Nanking, and held in Western painting circles in China a position somewhat analogous to that of Lu Hsün in literature. In Chungking during the war, he engaged in morale-raising painting for the people, and after the Liberation, became head of the Central Art Academy in Peking, and chairman of the Artists' Association of China. His work was a mixture of Chinese and Western painting, and as can be seen in his horse paintings, showed an unusual new freshness of style. Though his is perhaps but one passing style in a transitional period of Chinese art history, it will be most interesting to see what new directions may be opened through his influence.

With these three painters as a foundation, contemporary Chinese art is seeking a new style of socialist realism with creative attitudes corresponding to the doctrine of socialist construction in the new China. It is by no means simple to find a real solution to this new task while retaining the deep-rooted traditional legacy of Chinese painting. The senior leaders in continuing the work of these three masters have been Hu P'ei-heng, P'an T'ien-shou, and Ch'ien Sung-yen, followed by such strong contemporary artists as Fu Pao-shih, Li K'o-jan, Yeh Ch'ien-yü, Wu Tso-jen, and Kuan Shan-yüeh. Among these latter, the work of Li K'o-jan perhaps merits special attention. Real achievement from these new directions, however, is still in the future. What kind of transformations Oriental art will undergo in the present turbulent century is a matter of urgent concern to us in Japan. The changing course of the glorious tradition of Chinese painting in a socialist world is by no means irrelevant to us, and to judge the nature of its slow development lightly and superficially would only be productive of error.

THE PLATES

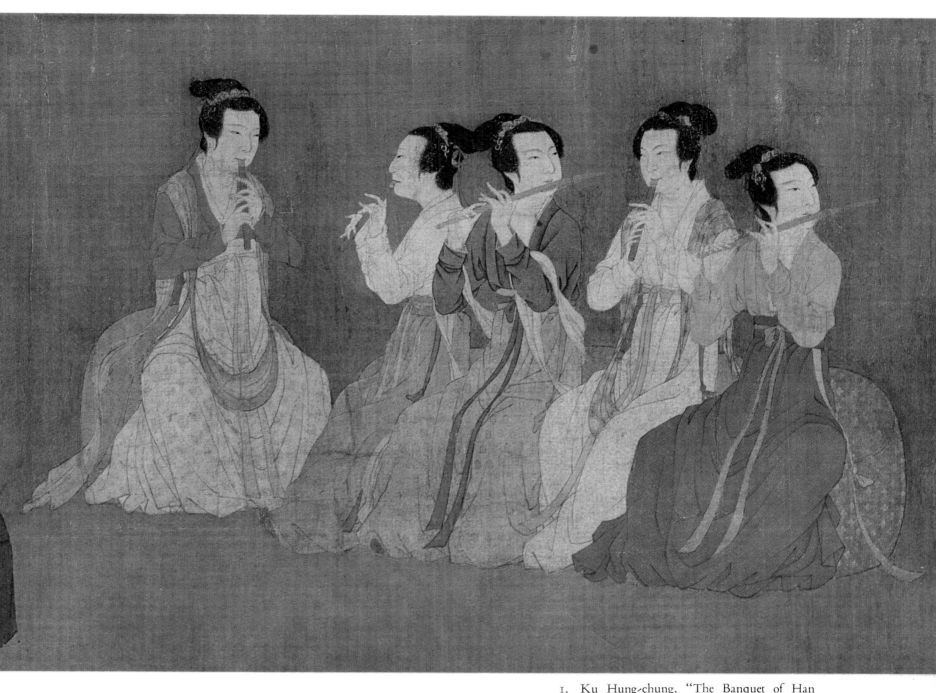

1. Ku Hung-chung. "The Banquet of Han Hsi-tsai" (detail). Five dynasties. The Palace Museum.

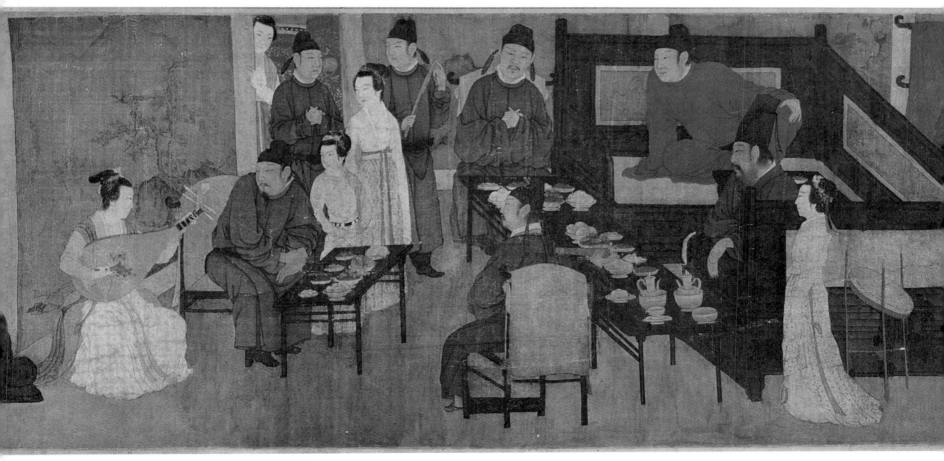

2. Ku Hung-chung. "The Banquet of Han Hsi-tsai" (detail). Five dynasties. The Palace Museum.

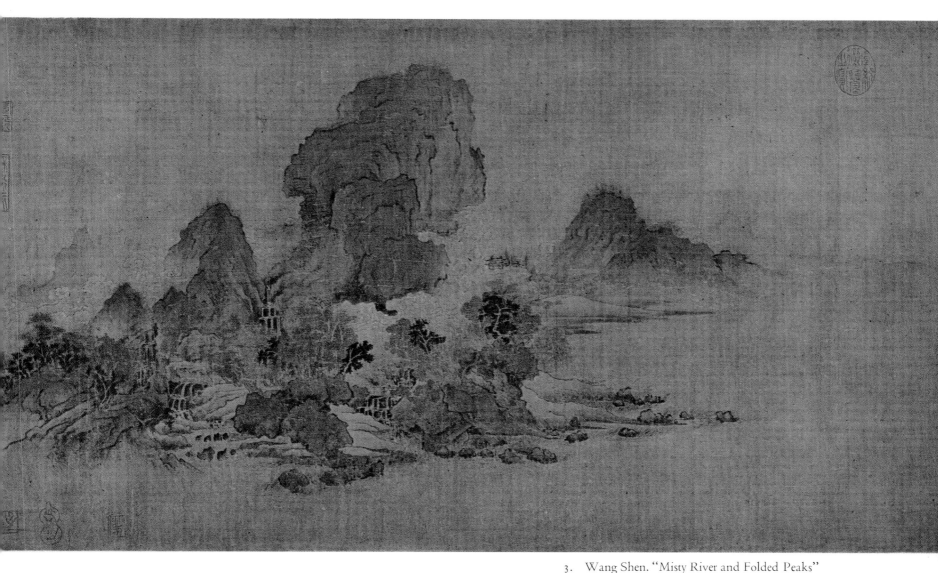

3. Wang Shen. "Misty River and Folded Peaks" (detail). Northern Sung. Shanghai Museum.

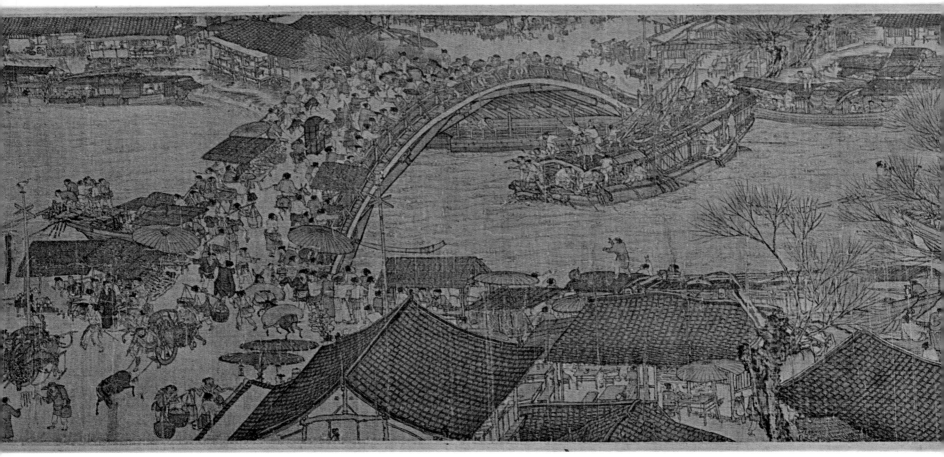

4. Chang Tse-tuan. "Ascending the River at the *Ch'ing-ming* Season" (detail). Northern Sung. The Palace Museum.

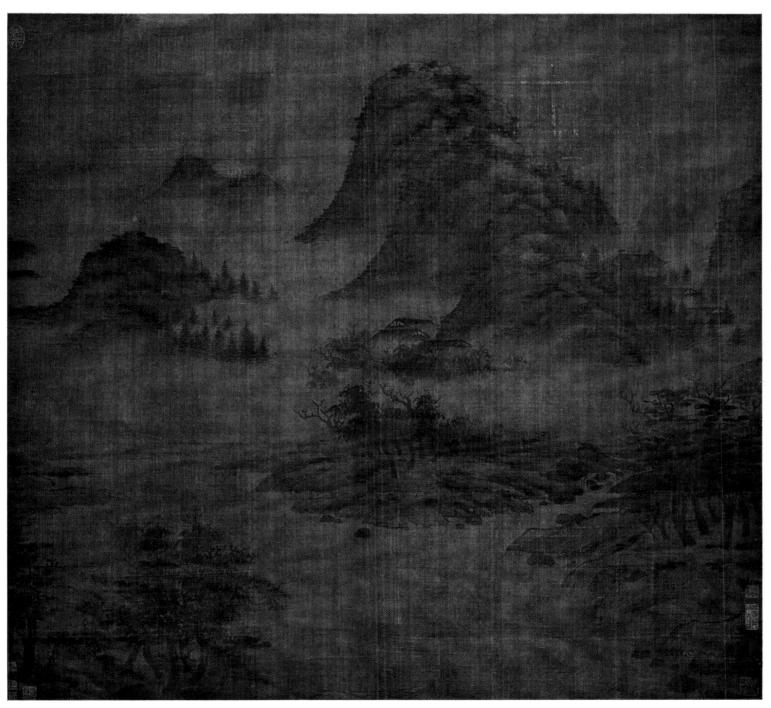

5. Kao K'o-kung. "Spring Mountains on the Verge of Rain." Yüan dynasty. Shanghai Museum.

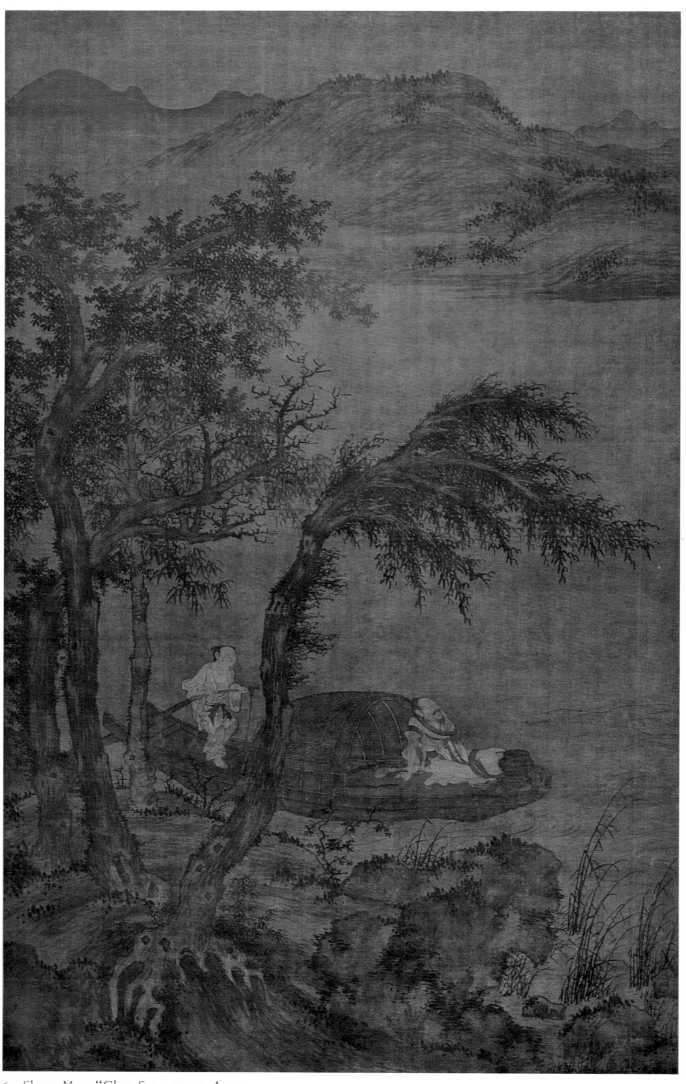

6. Sheng Mao. "Clear Song on an Autumn
Boat." Yüan dynasty. Shanghai Museum.

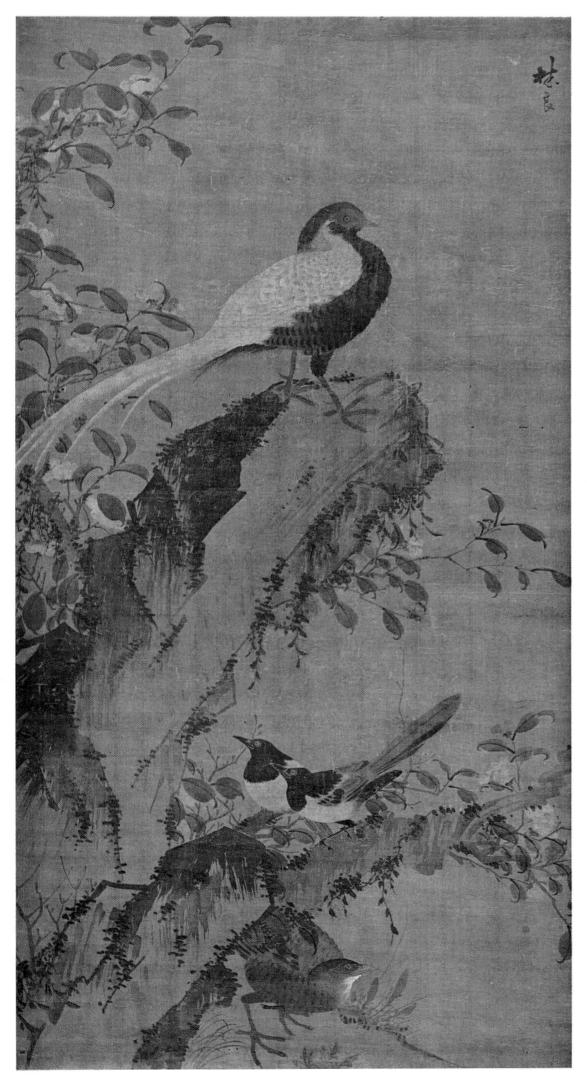

9. Lin Liang. "Wild Camelia and White Birds." Ming dynasty. Shanghai Museum.

33

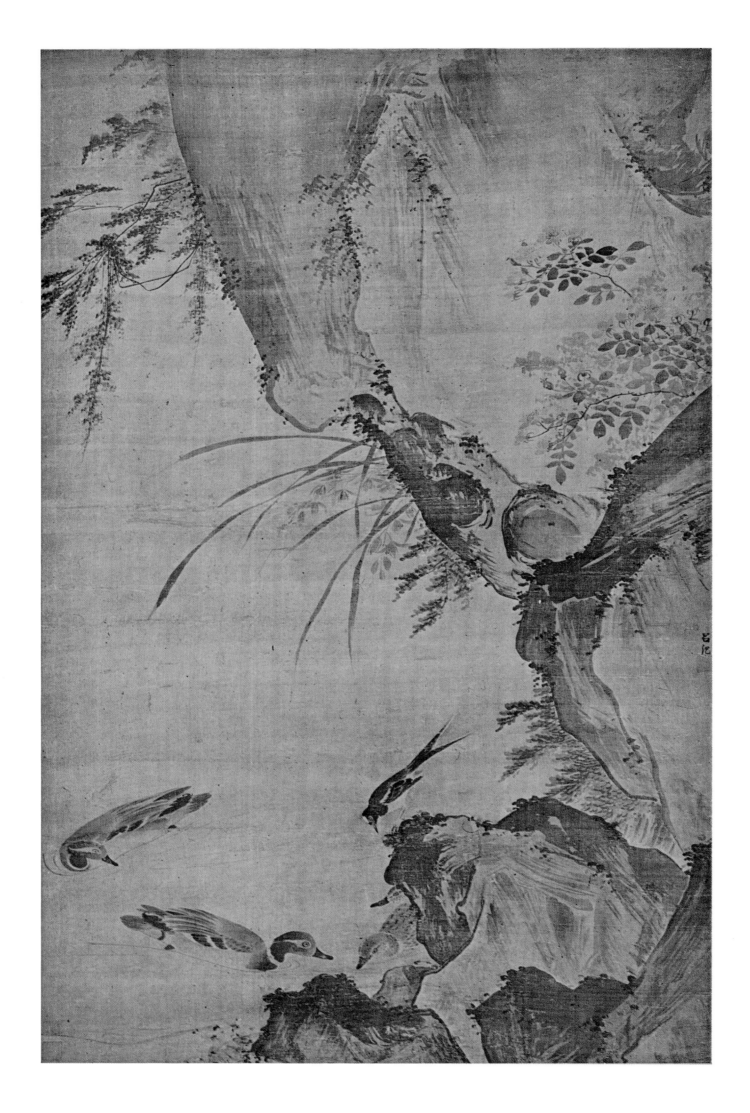

34

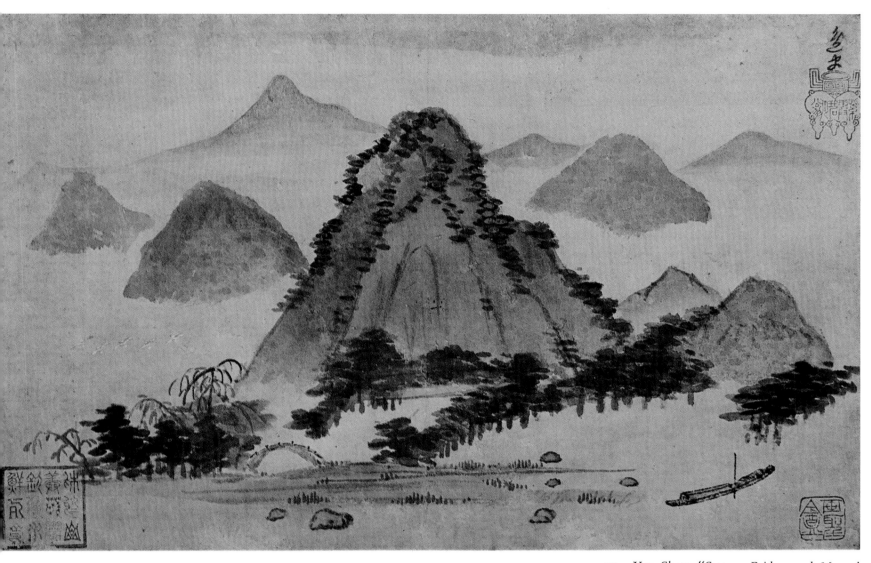

11. Yao Shou. "Stream, Bridge, and Moored Boat." Ming dynasty. Shanghai Museum.

◁ 10. Lü Chi. "Swimming Ducks." Ming dynasty. Shanghai Museum.

12. Hsü. Tuan-pen. "Stream and Autumn Colors." Ming dynasty. Shanghai Museum.

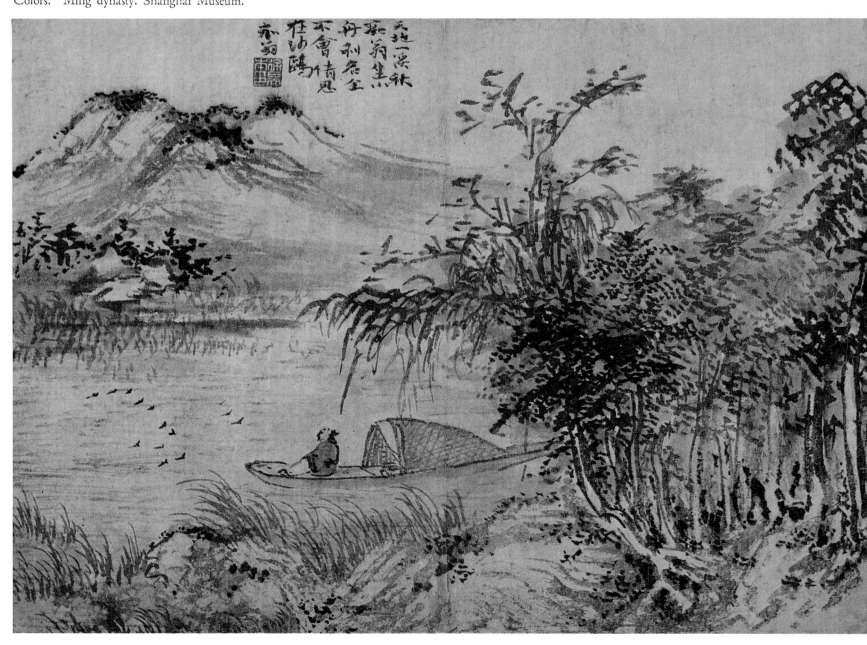

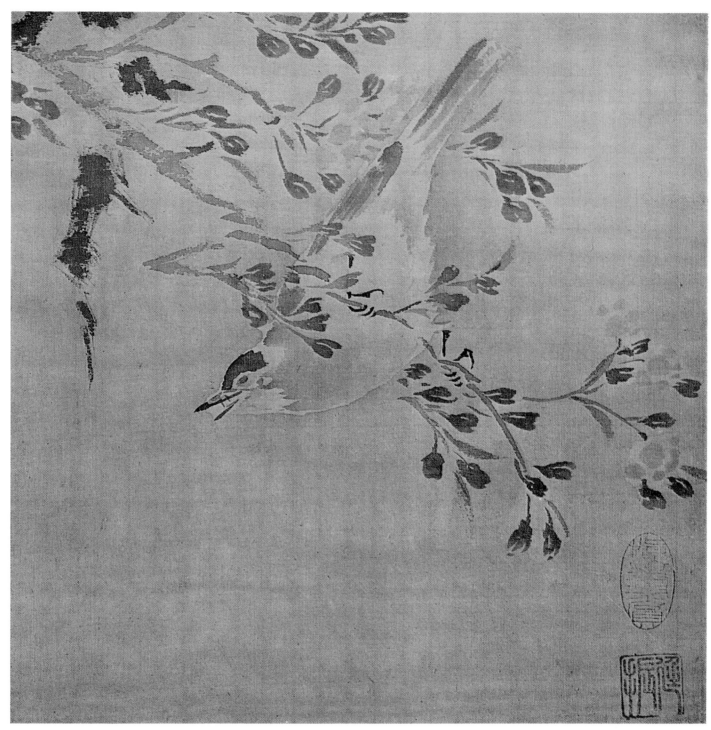

13. Sun Lung. "Flowers, Birds, Grass, and Insects" (album page). Shanghai Museum.

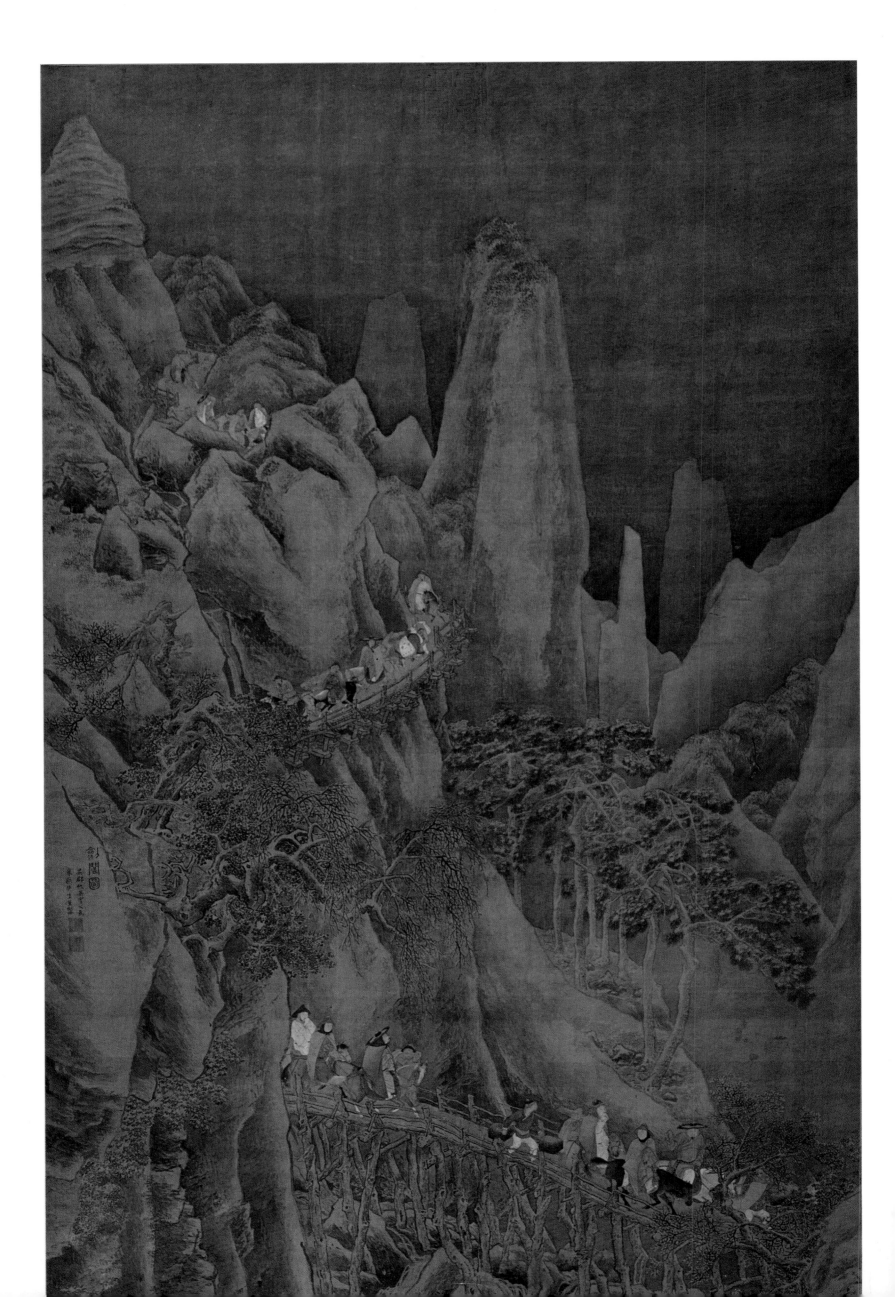

14. Ch'ou Ying. "The Plank Road over Chien Mountain." Ming dynasty. Shanghai Museum.

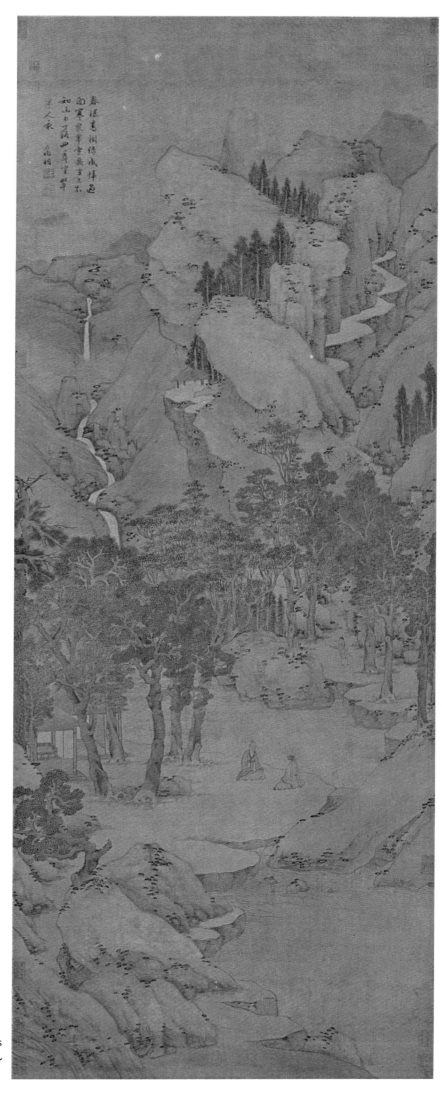

15. Wen Cheng-ming. "Tall Trees in Late Spring." Ming dynasty. Shanghai Museum.

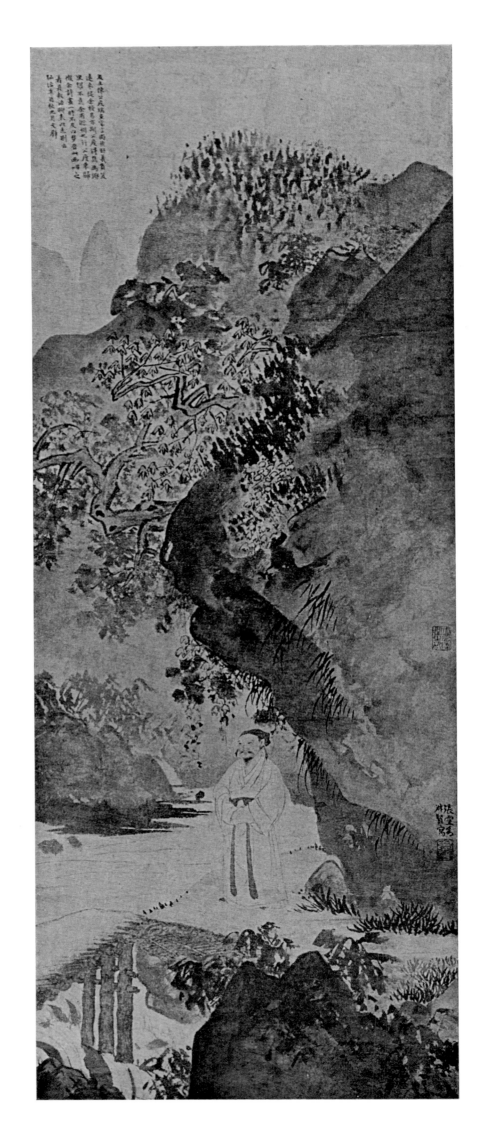

16. Chang Ling. "A Noble Scholar in Autumn Mountains." Ming dynasty. The Palace Museum.

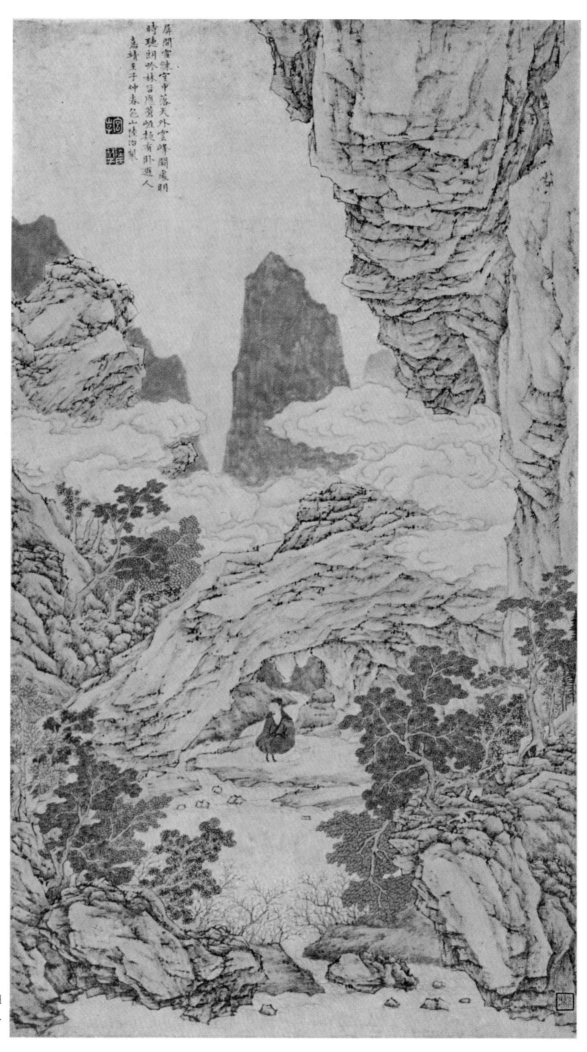

屏間翠練空中落天外雲峰闊處明
時聽朗吟林岫蒼收靜者有卧遊人
嘉靖壬子仲春色山陸治製

17. Lu Chih. "Cloudy Peaks and Forested Valleys." Ming dynasty. Shanghai Museum.

18. Hsiao Yün-ts'ung. "Sparse Trees on Cloud Terrace" (detail). Ming dynasty. Nanking Museum.

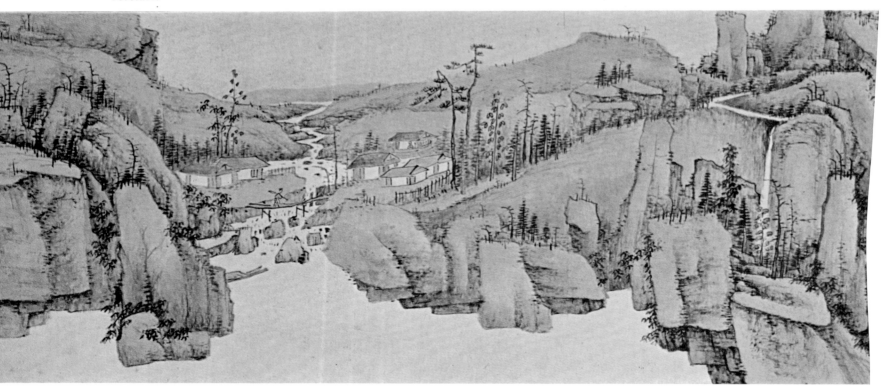

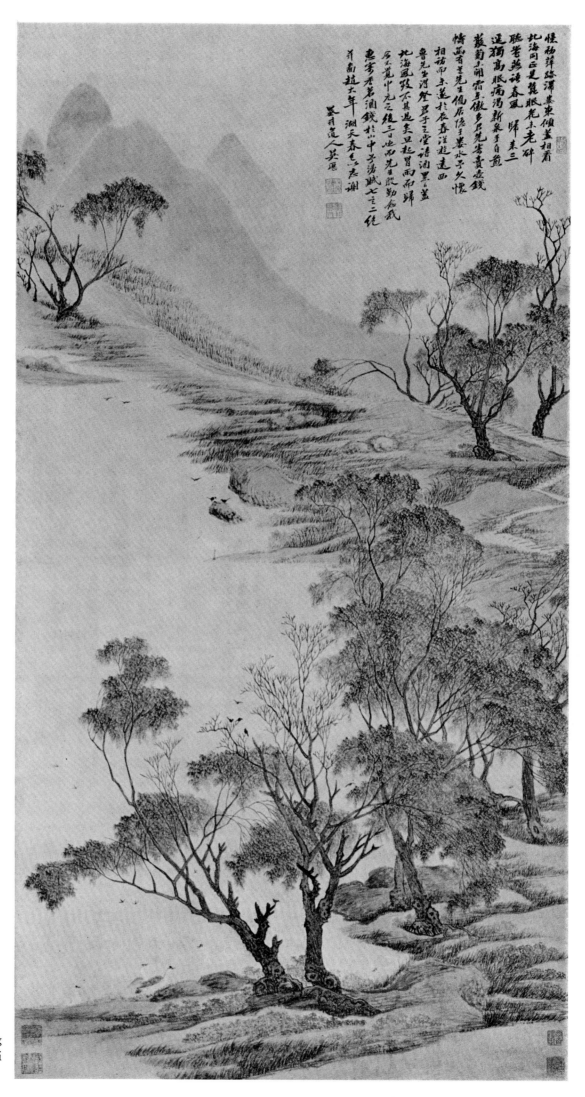

21. Wu Li. "Lake, Sky, and Spring Colors." Ch'ing dynasty. Shanghai Museum.

22. Yün Shou-p'ing. "Fallen Flowers
and Swimming Fish." Ch'ing dynasty.
Shanghai Museum.

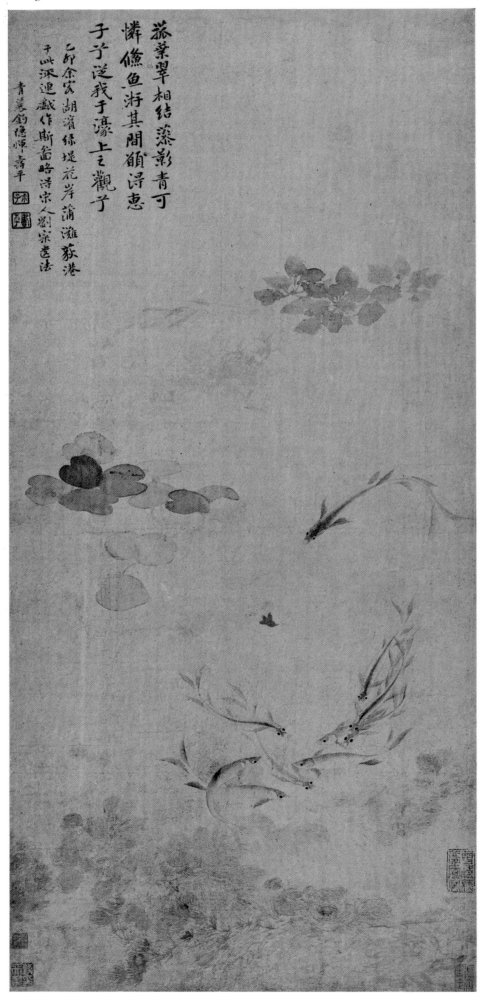

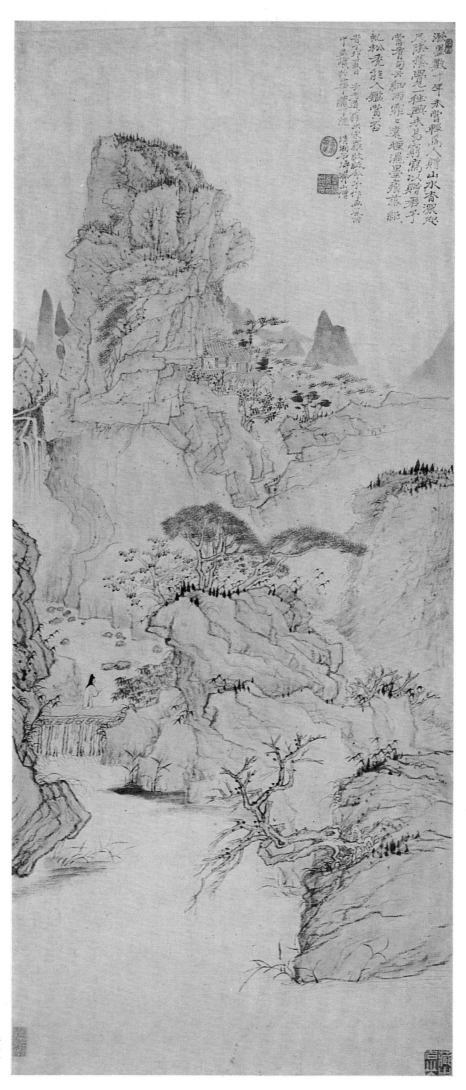

23. Shih-t'ao. "Dragon Pines in Light Rain." Ch'ing dynasty. Shanghai Museum.

24. Chin Nung. "A Butterfly Orchid."
Ch'ing dynasty. Liaoning Provincial
Museum.

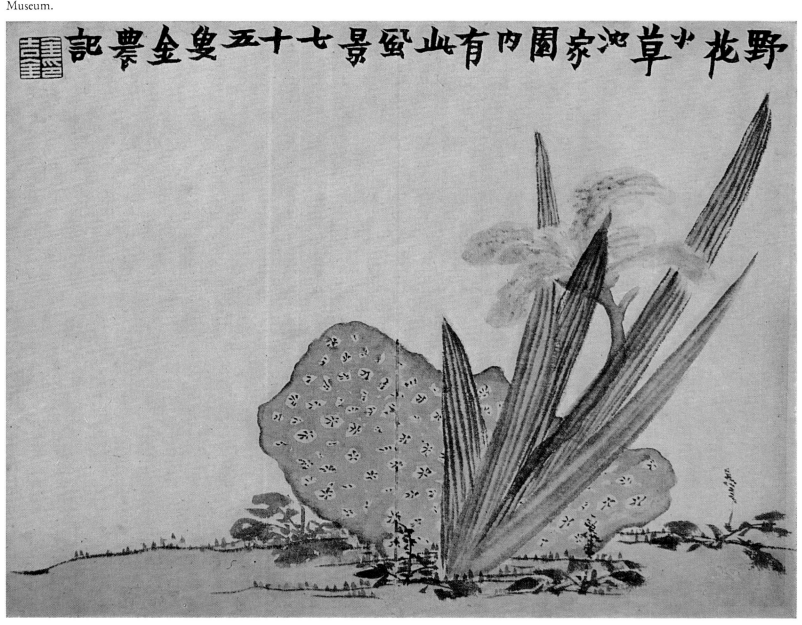

野花小草池家内園有山蚕景七十五雙金農記

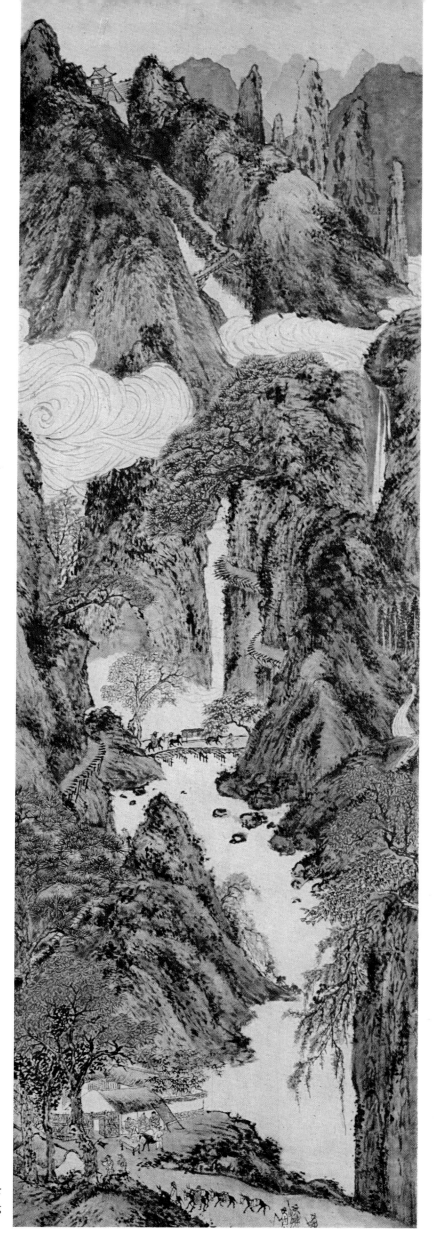

25. Lo P'ing. "Plank Road over Chien Mountain" (detail). Ch'ing dynasty. The Palace Museum.

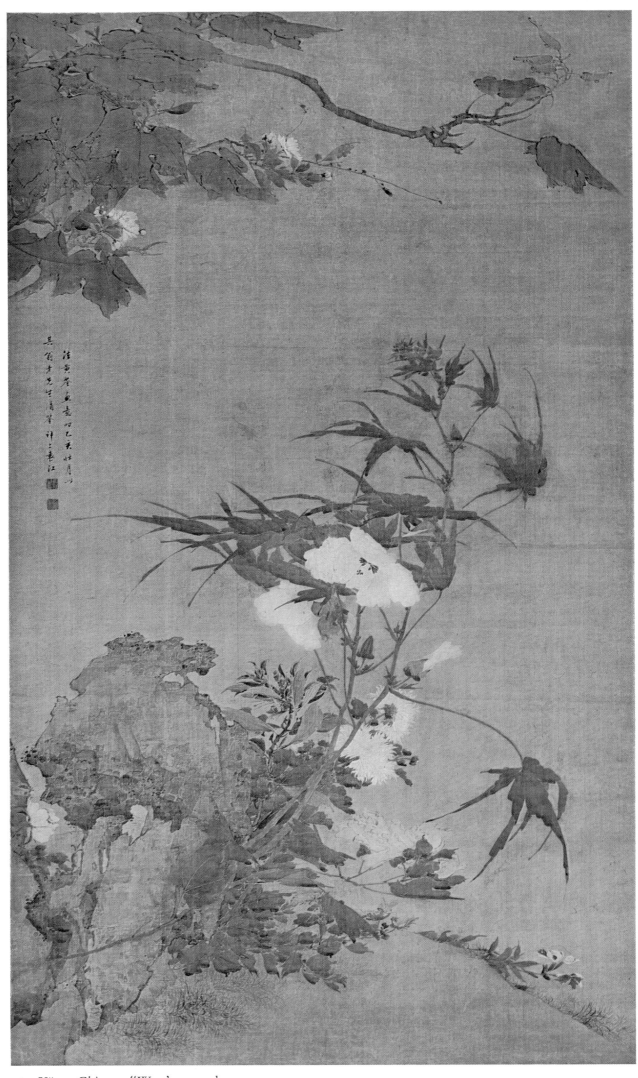

26. Yüan Chiang. "Wu-t'ung and
Hibiscus." Ch'ing dynasty. Fine Arts
Research Institute, Central Art Acade-
my, Peking.

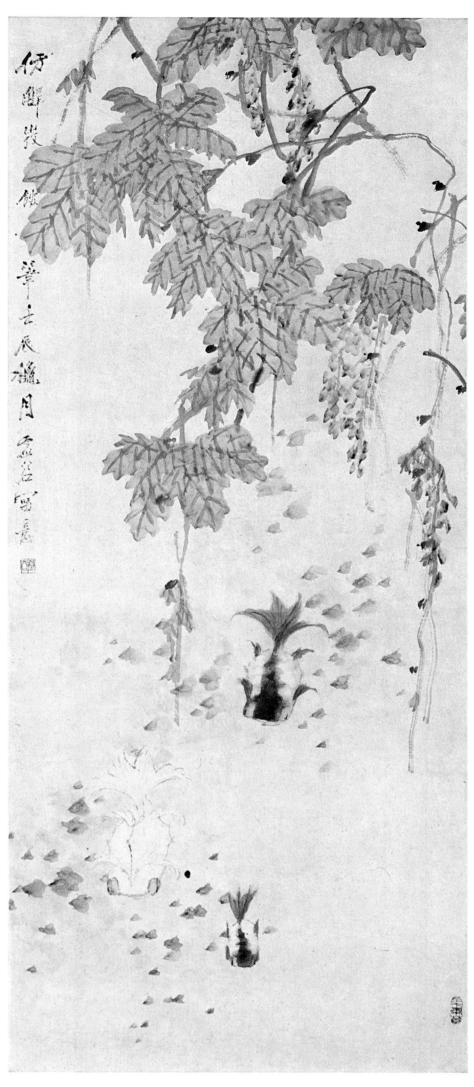

27. Hsü-ku. "Wisteria and Gold-fish." Modern. The Palace Museum.

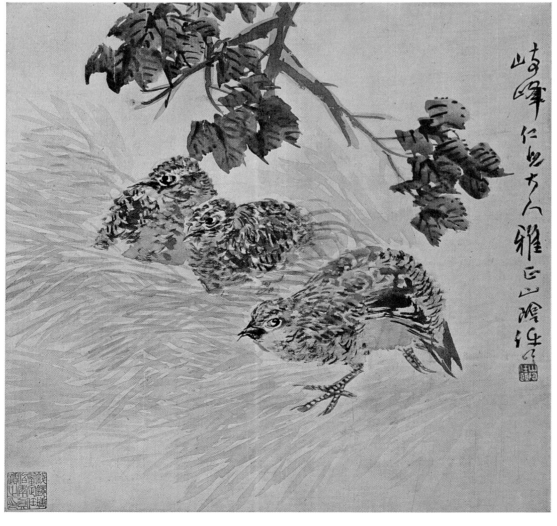

28. Jen Yi. "Maple Leaves and Quail."
Modern.

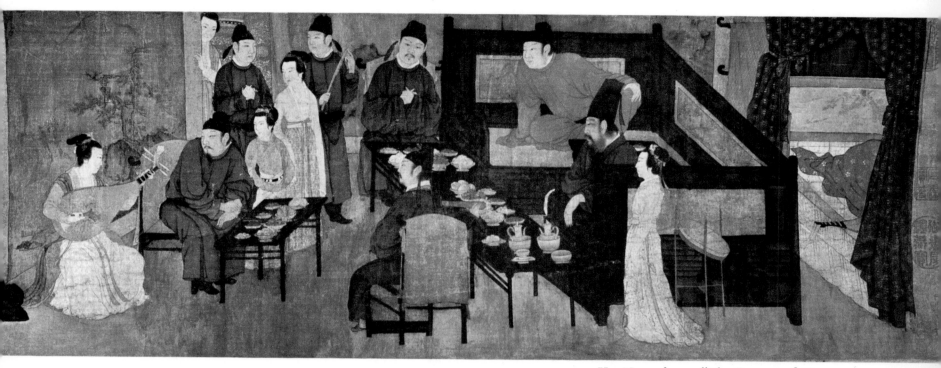

29. Ku Hung-chung. "The Banquet of Han Hsi-tsai" (detail). Five Dynasties. The Palace Museum.

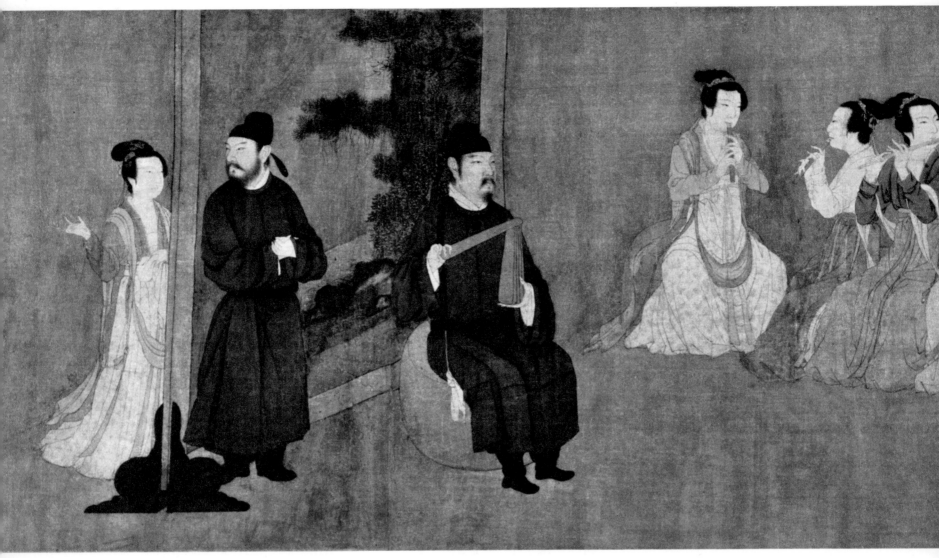

30. Ku Hung-chung. "The Banquet of Han Hsi-tsai" (detail). Five Dynasties. The Palace Museum.

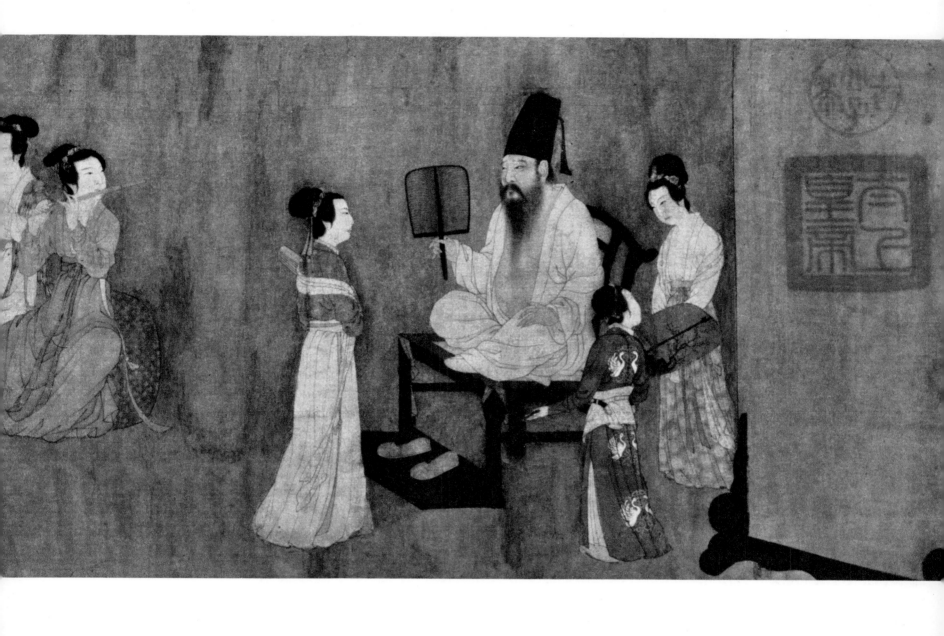

31. Tung Yüan. "Awaiting the Ferry at the ▷
Mount Hsia-ching Pass." Five Dynasties. Liaon-
ing Provincial Museum.

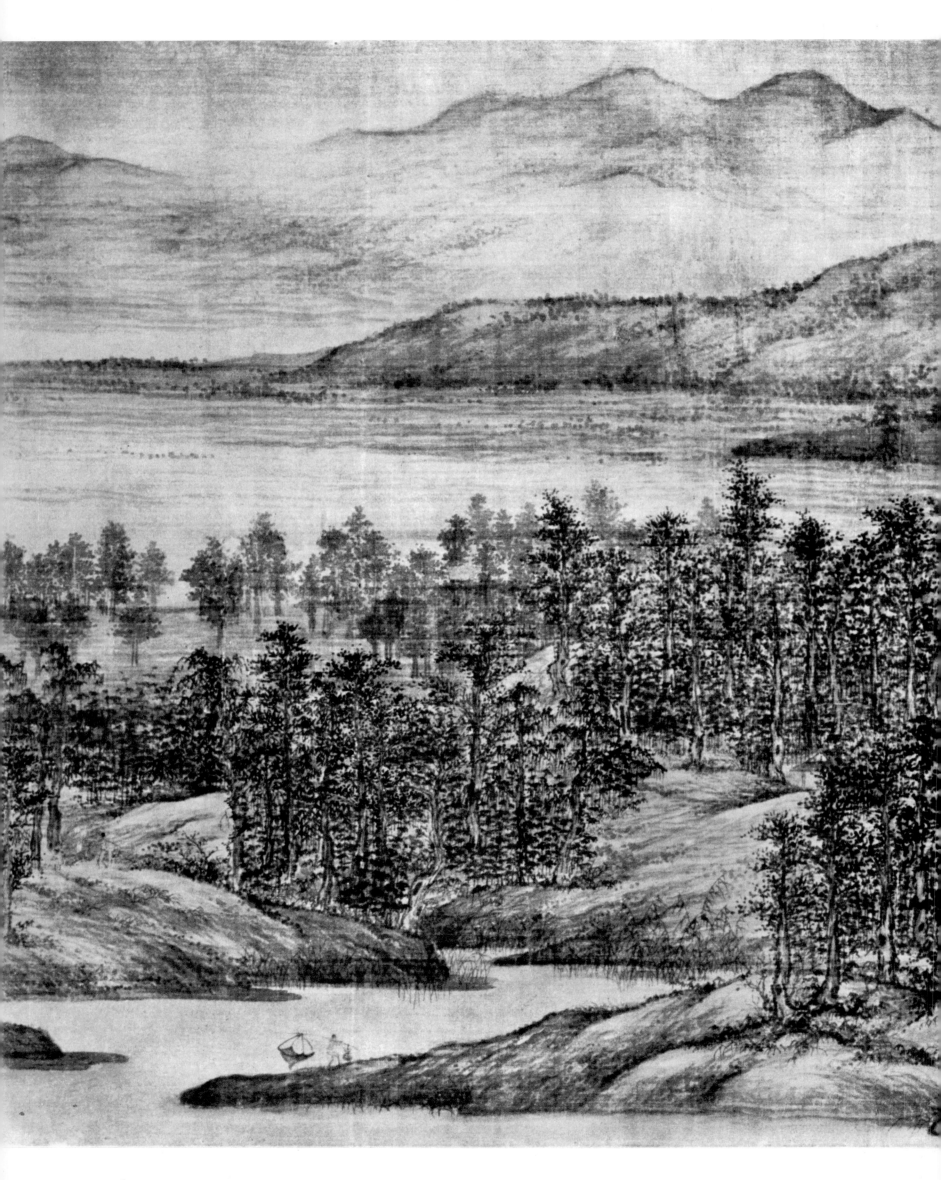

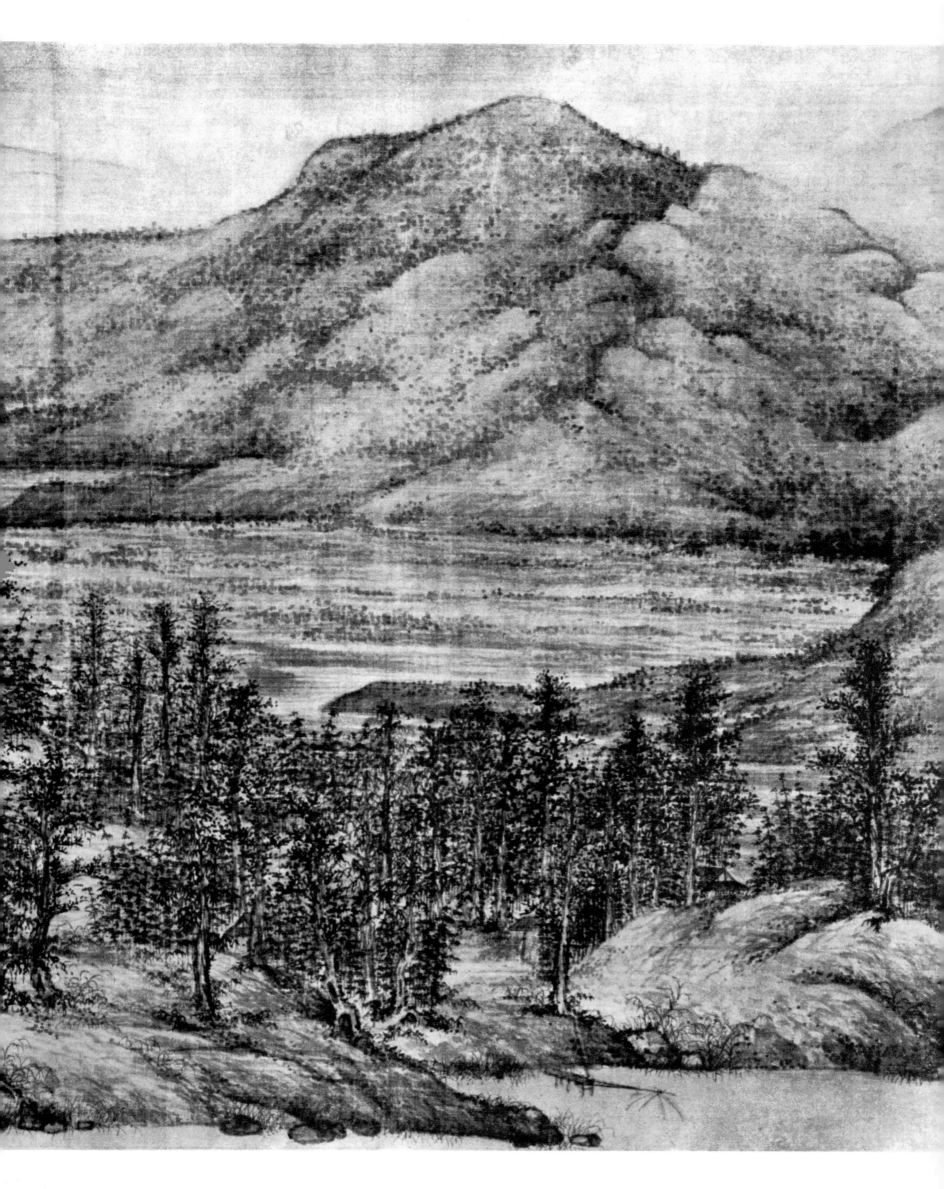

32. Wang Shen. "Misty River and Folded Peaks" (detail). Northern Sung. Shanghai Museum.

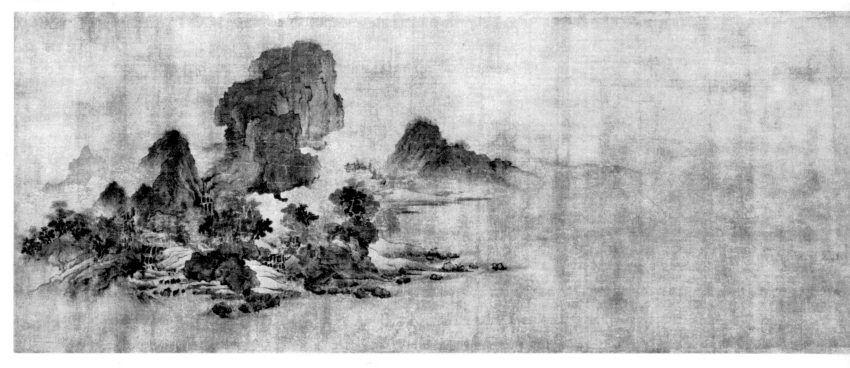

33. Chü-jan. "Wind in the Pines of a Myriad Valleys." Northern Sung. Shanghai Museum.

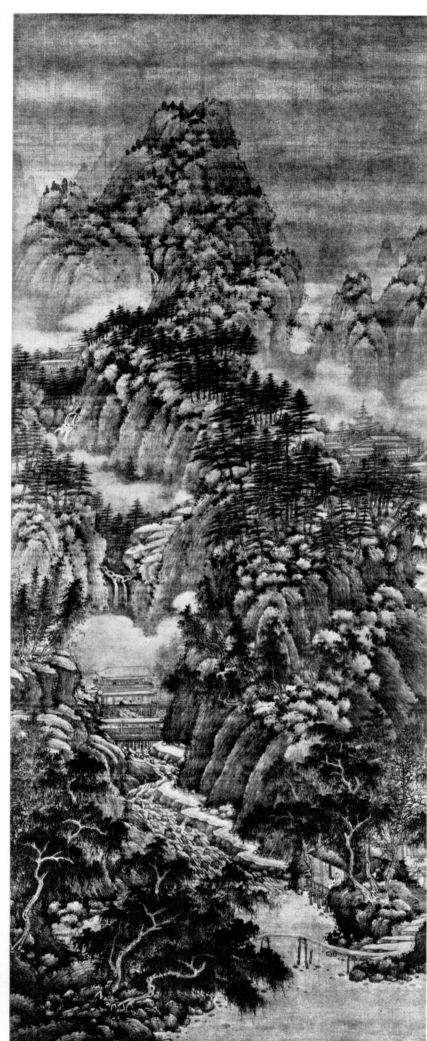

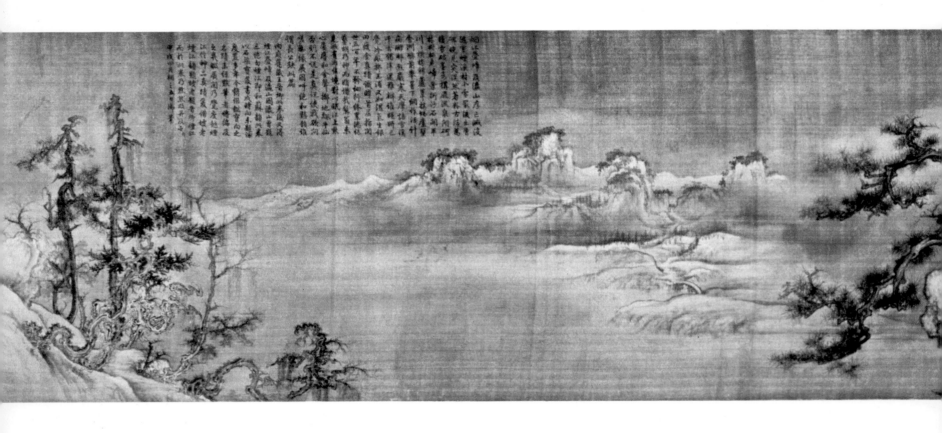

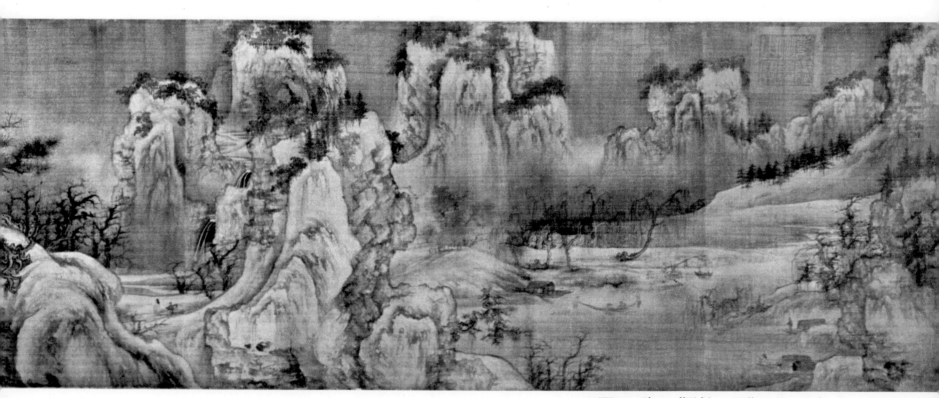

34. Wang Shen. "Fishing Village in Light Snow." Northern Sung. The Palace Museum.

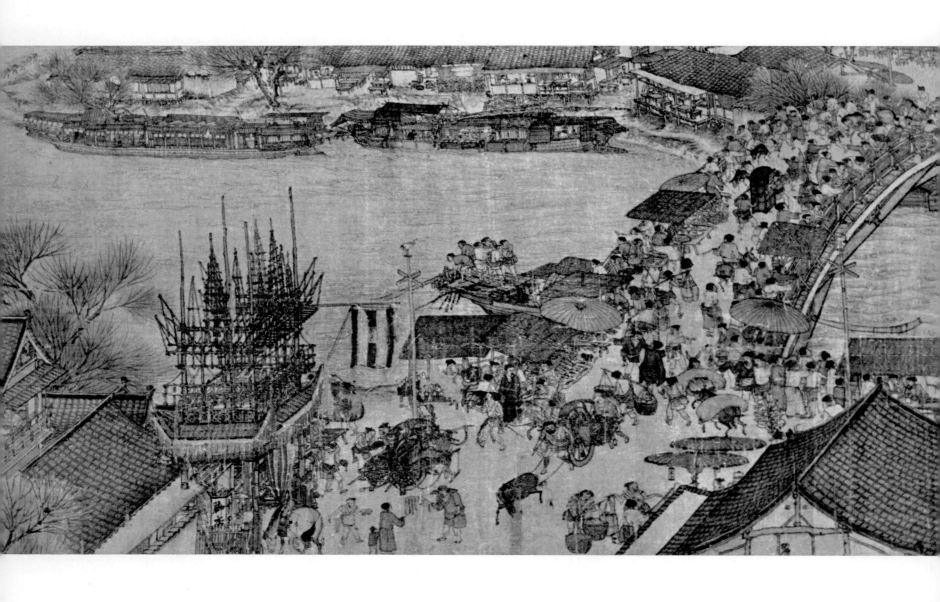

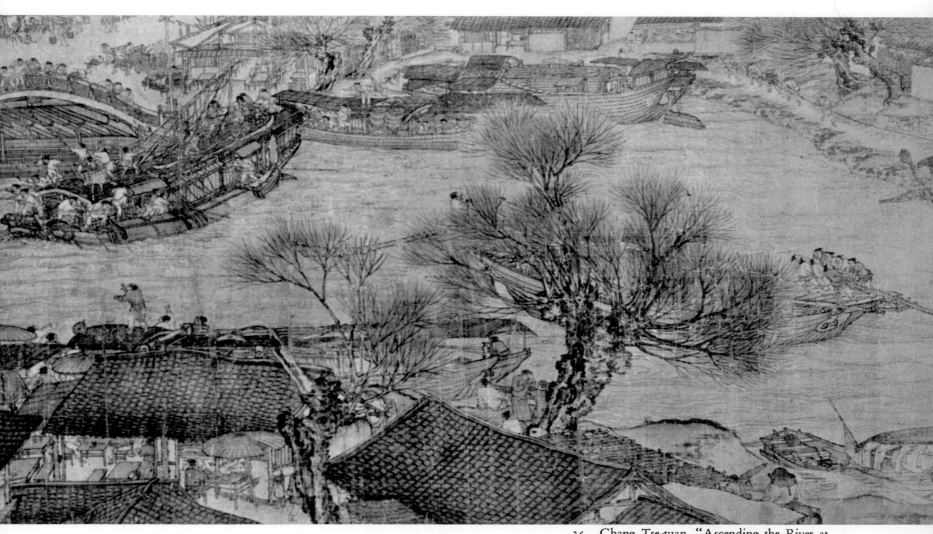

35. Chang Tse-tuan. "Ascending the River at the *Ch'ing-ming* Season" (detail). The Palace Museum.

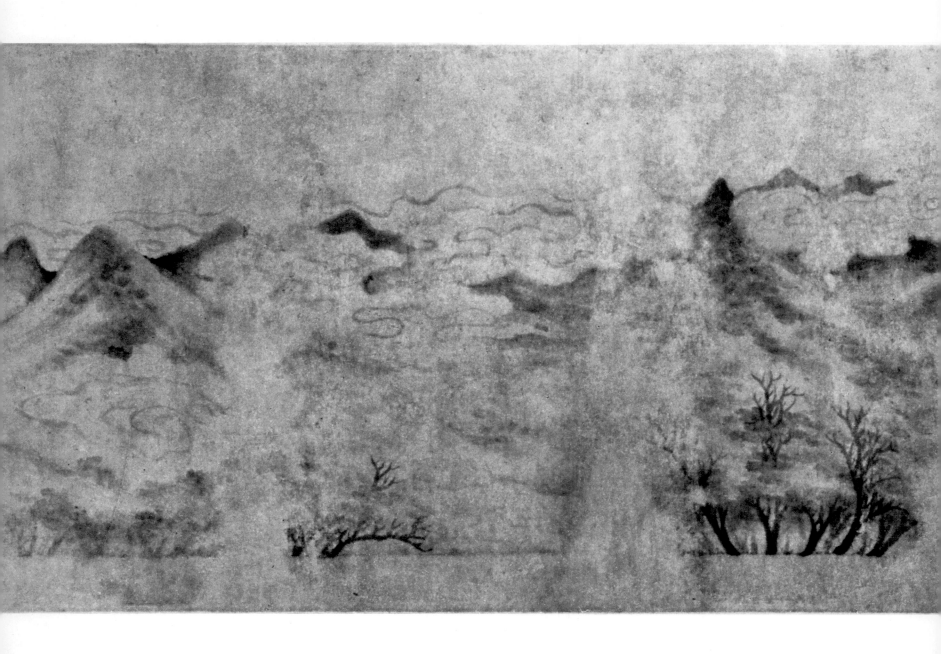

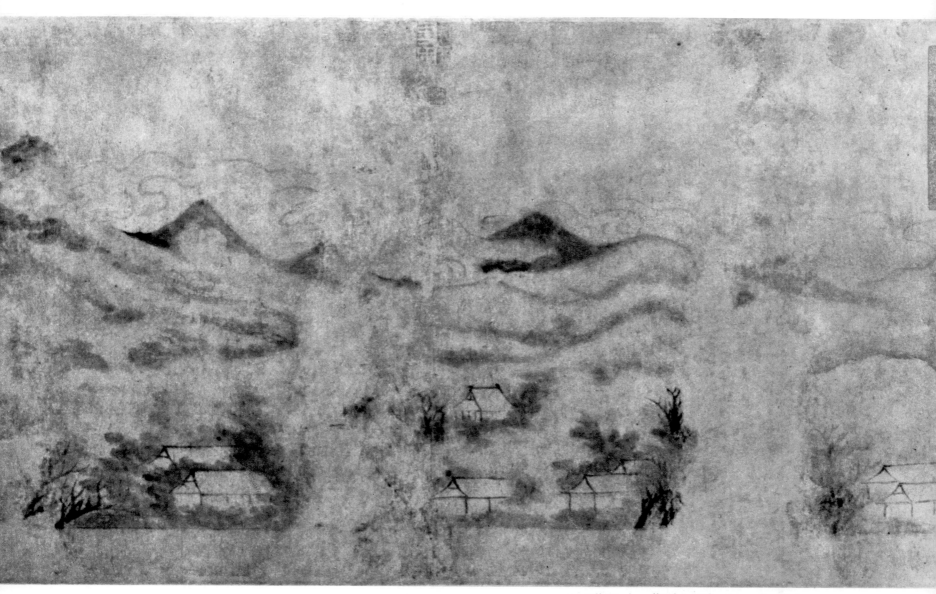

36. Mi Yu-jen. "White Clouds on the Hsiao-hsiang River." Southern Sung. Shanghai Museum.

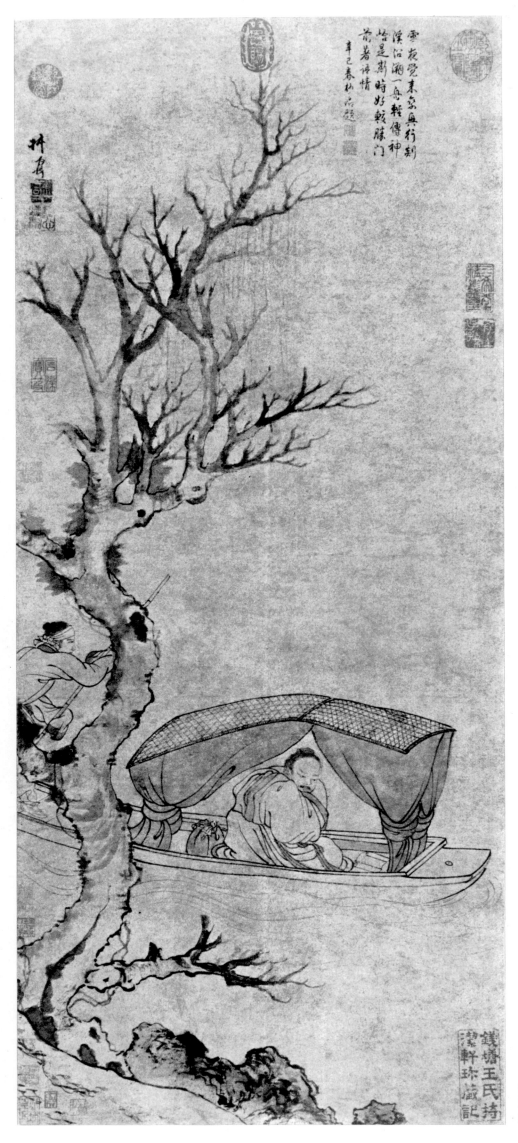

雪夜覺來寒擁衾行
溪沿湘一舟輕傳神
盡是剌時好較勝門
前著詩情
年已春秋□鏡

37. Chang Wo. "Visiting Tai on a
Snowy Evening." Yüan dynasty. Shang-
hai Museum.

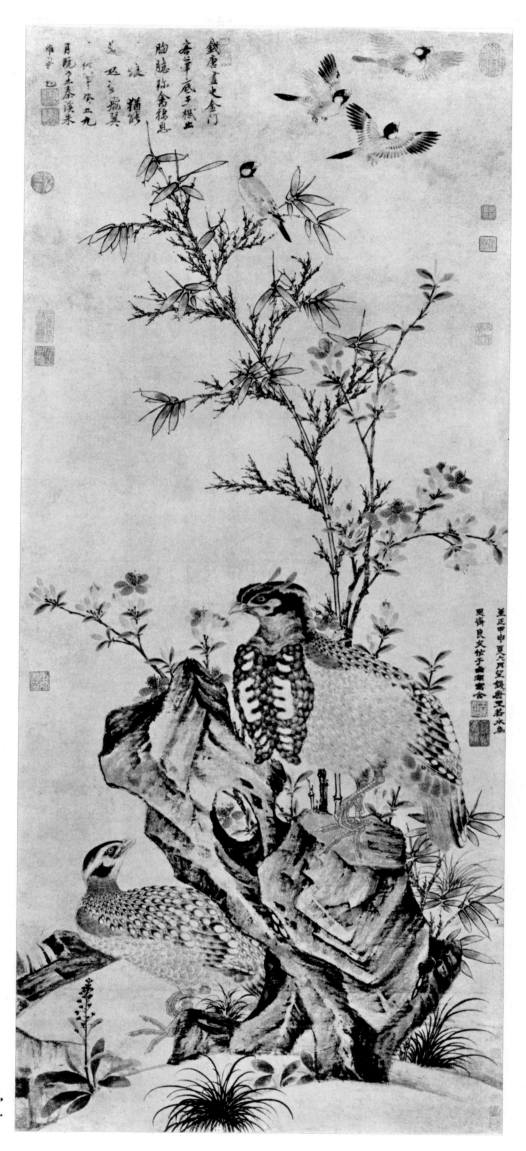

38. Wang Yüan. "Bamboo, Rocks, and a Flock of Birds." Yüan dynasty. Shanghai Museum.

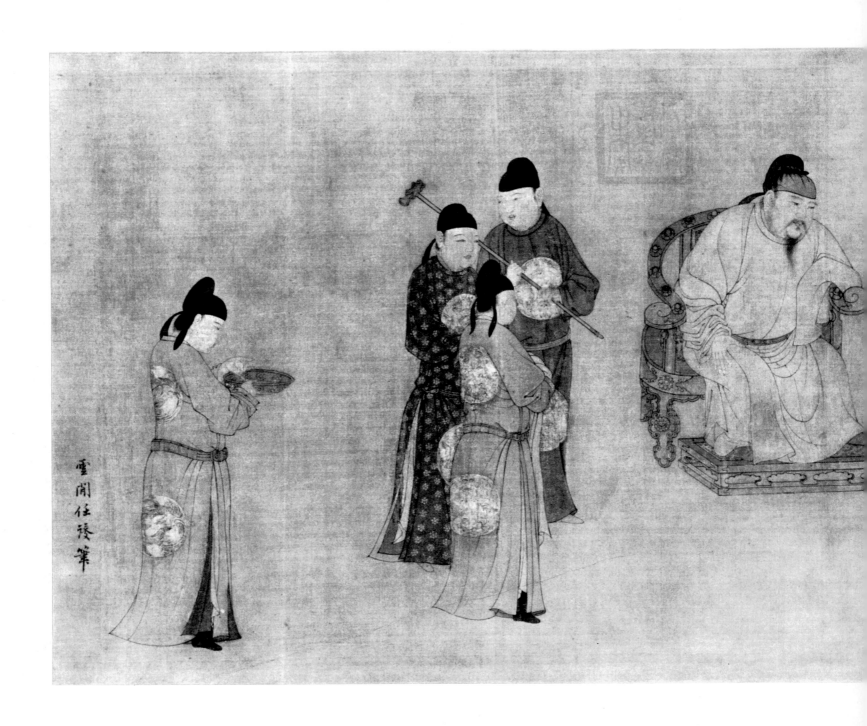

巾絛山色髻鬌春
差中有此人道
術壽來許世間
知里糸魚俊朝
寧謂盛儀堂如
髯痩神释逸板
出驢馳言不露
可惜雅引仙葉
逗霓素鶴破那
能醫
甲申夏六月上
浣尚題

39. Jen Jen-fa. "Chang Kuo in Audience with the Ming-huang Emperor." Yüan dynasty. The Palace Museum.

69

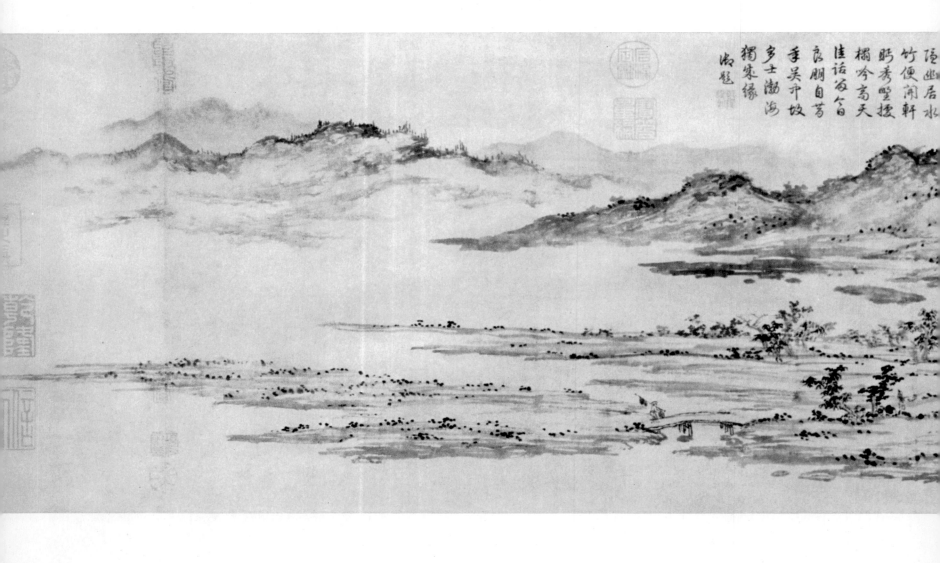

40. Chu Te-jun. "Country Villa" (detail).
Yüan dynasty.

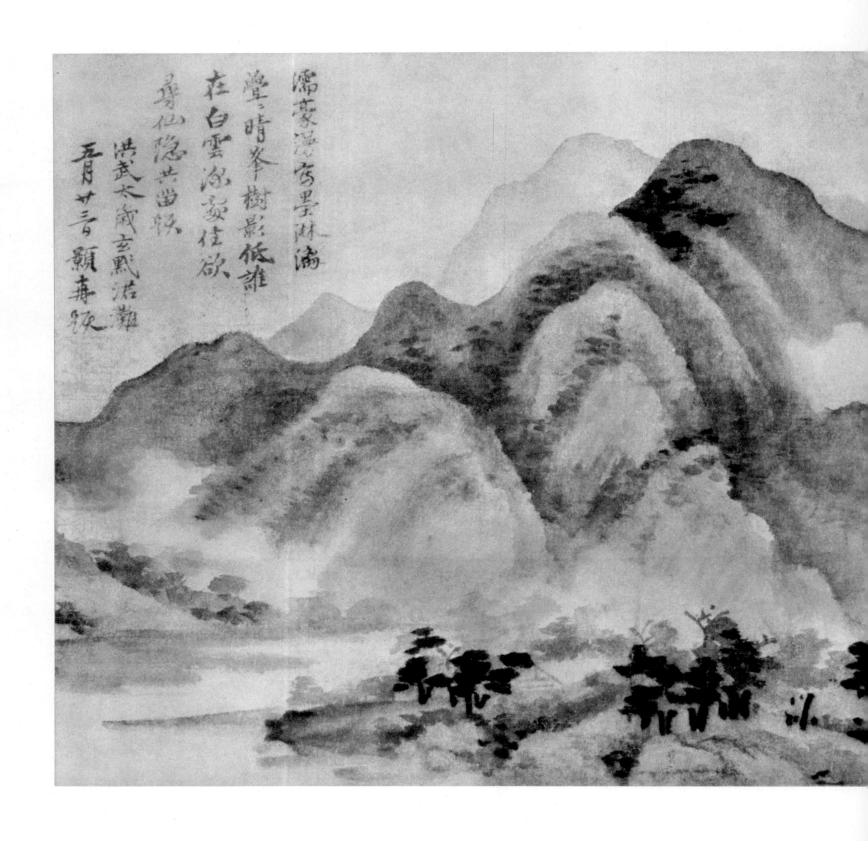

濡蒙潑窗墨淋漓
巒晴峯樹影低誰
在白雲深處佳欲
尋仙隱共留題
洪武太歲玄默涒灘
吾月廿三日顯壽跋

72

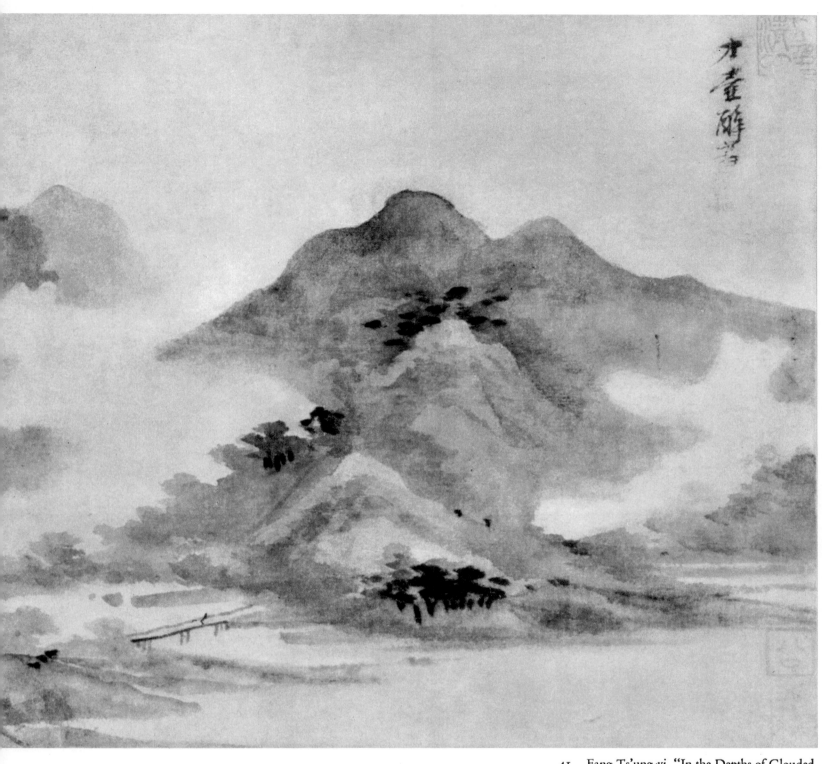

41. Fang Ts'ung-yi. "In the Depths of Clouded Mountains." Yüan dynasty. Shanghai Museum.

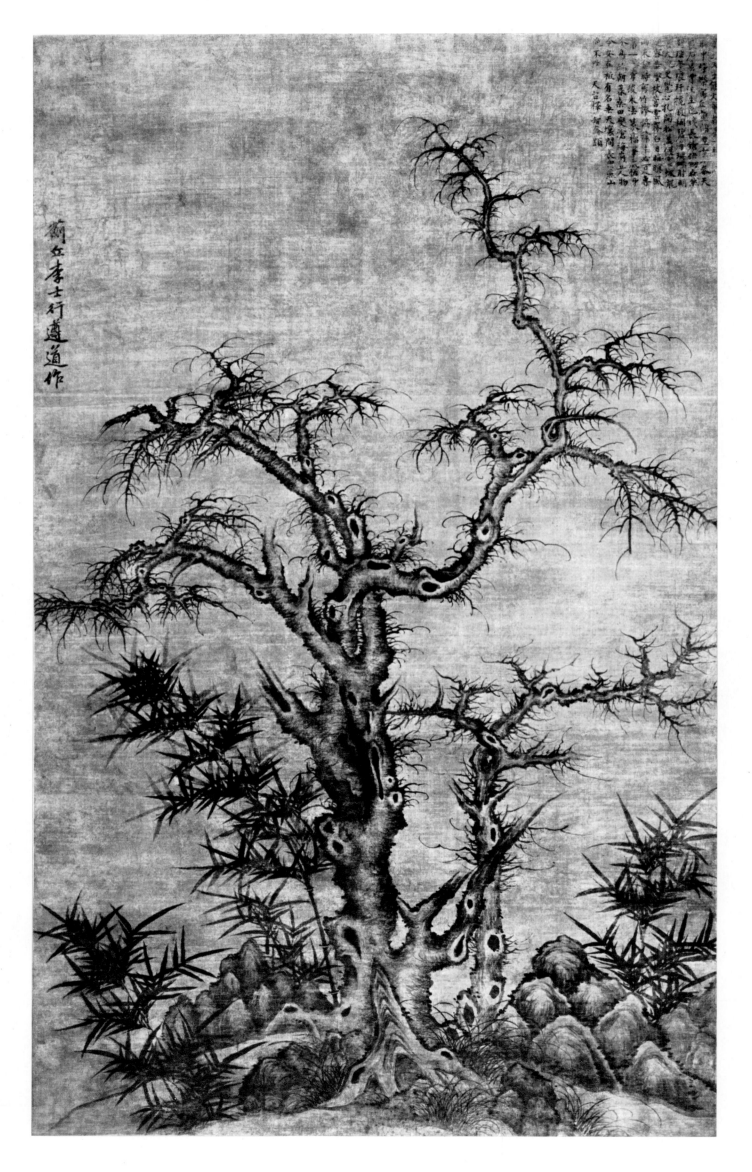

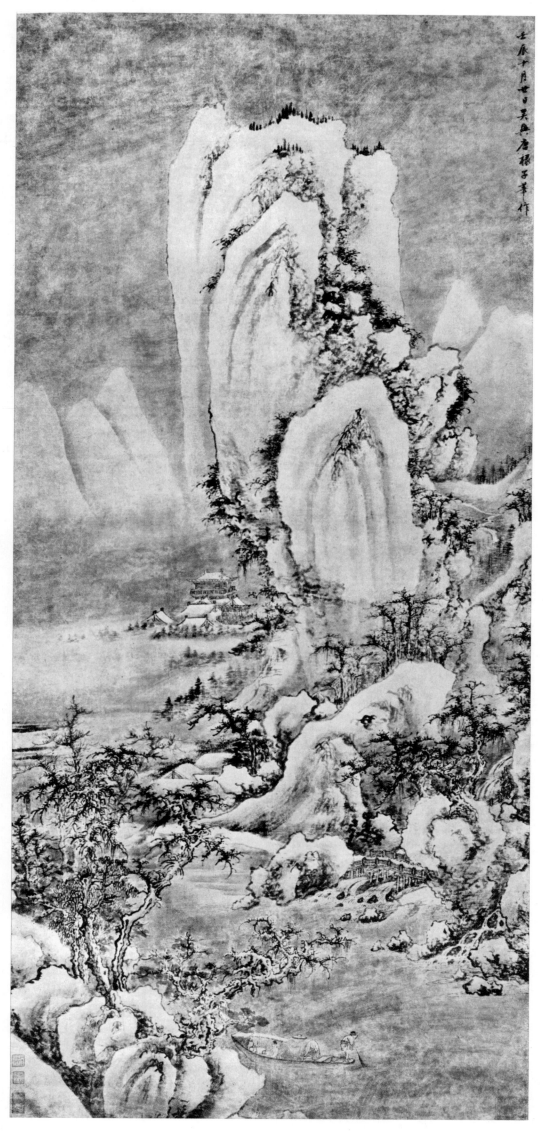

42. Li Shih-hsing. "A Grove of Dead Trees." Yüan dynasty. Shanghai Museum.

43. T'ang Ti. "Fishing in a Snowy Cove." Yüan dynasty.

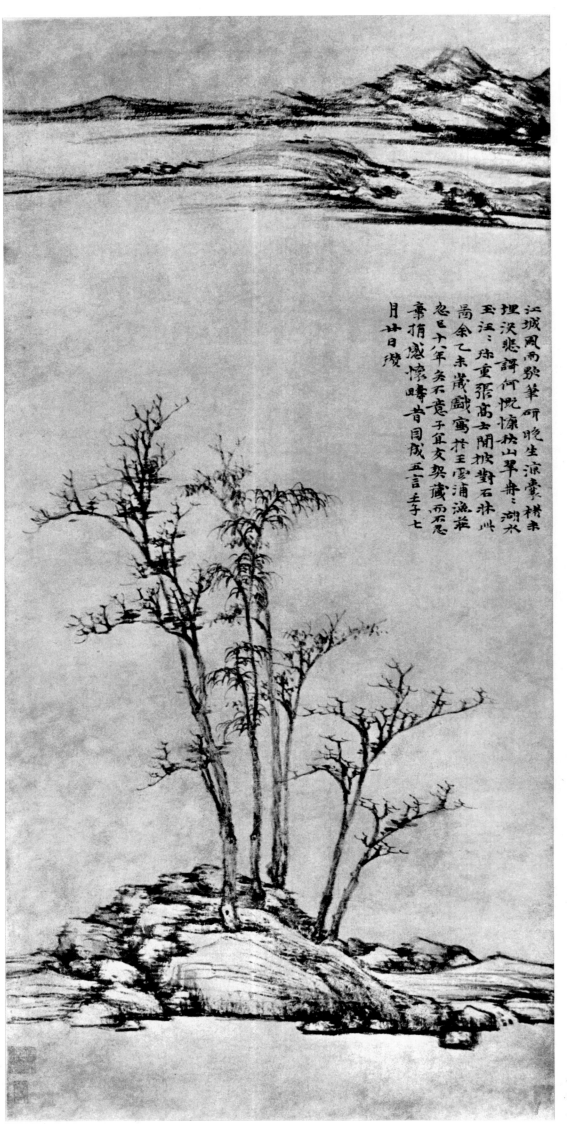

江城風雨歇筆研晚生涼囊楮未
理決悲謌何慨悵枞山翠舟之湖水
玉汪之珠重張高士開披對石林州
嵩余乙未歳戲寓柱王雲浦漁莊
忽巳十八年矣不意子宜友契藏而石忘
章揖感憬曙昔因賦五言壬子七
月廿日瓚

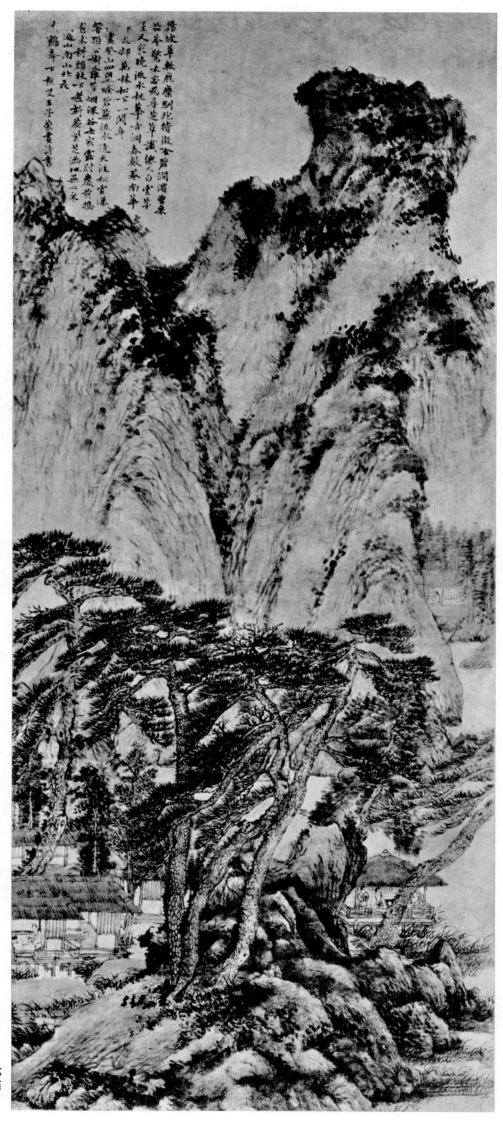

45. Wang Meng. "Reading in Spring Mountains." Yüan dynasty. Shanghai Museum.

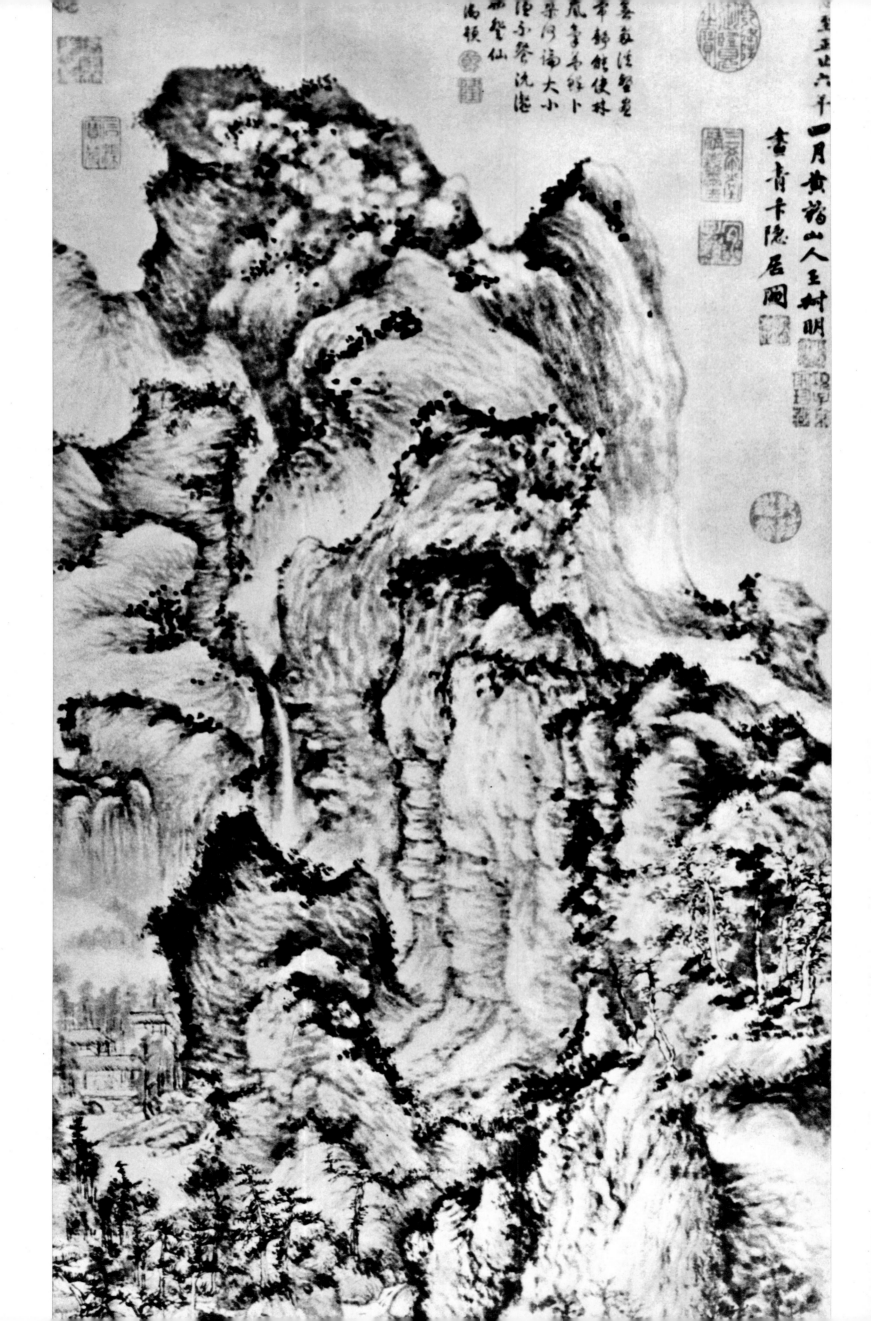

46. Wang Meng. "Hermitage at Pien-shan" (detail). Yüan dynasty. Shanghai Museum.

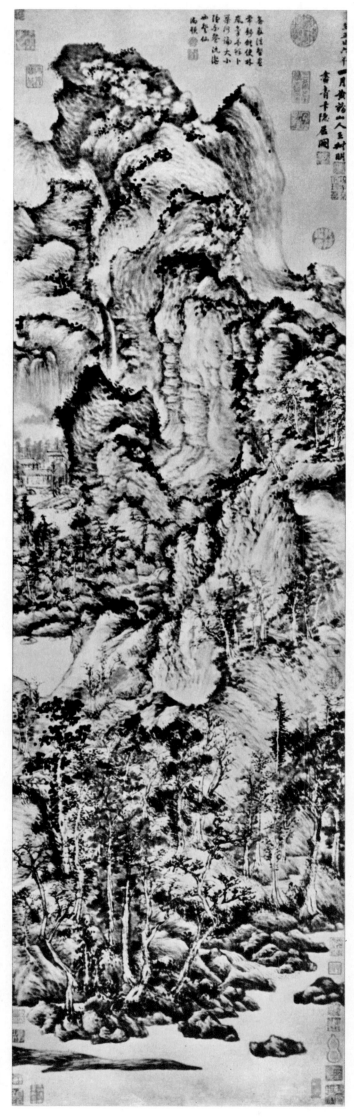

47. Wang Meng. "Hermitage at Pien-shan." Yüan dynasty. Shanghai Museum.

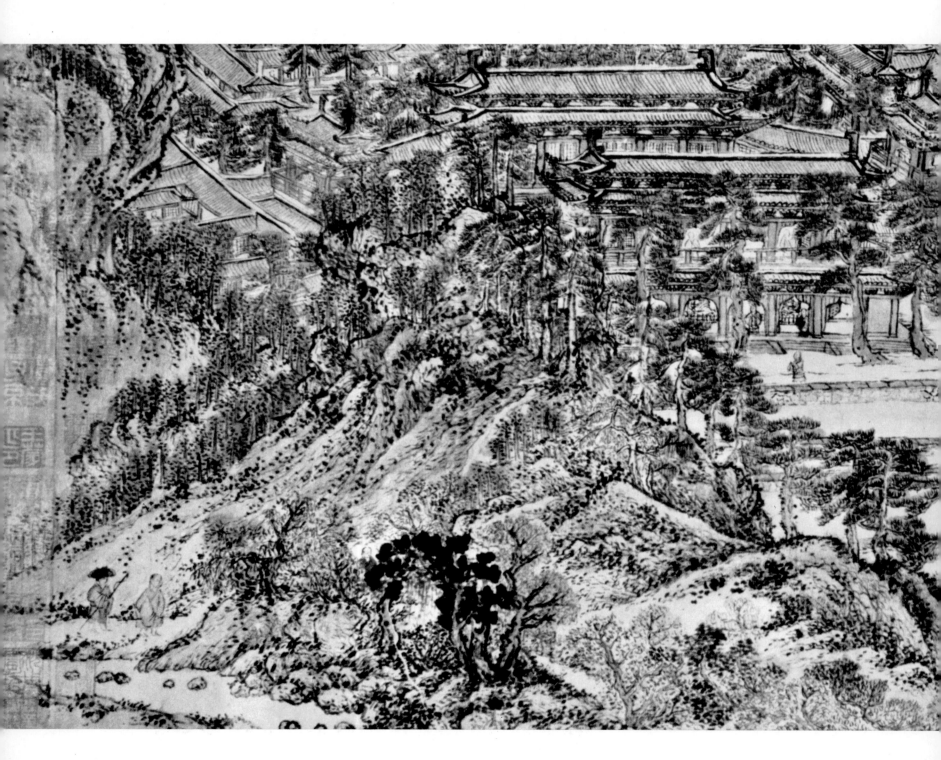

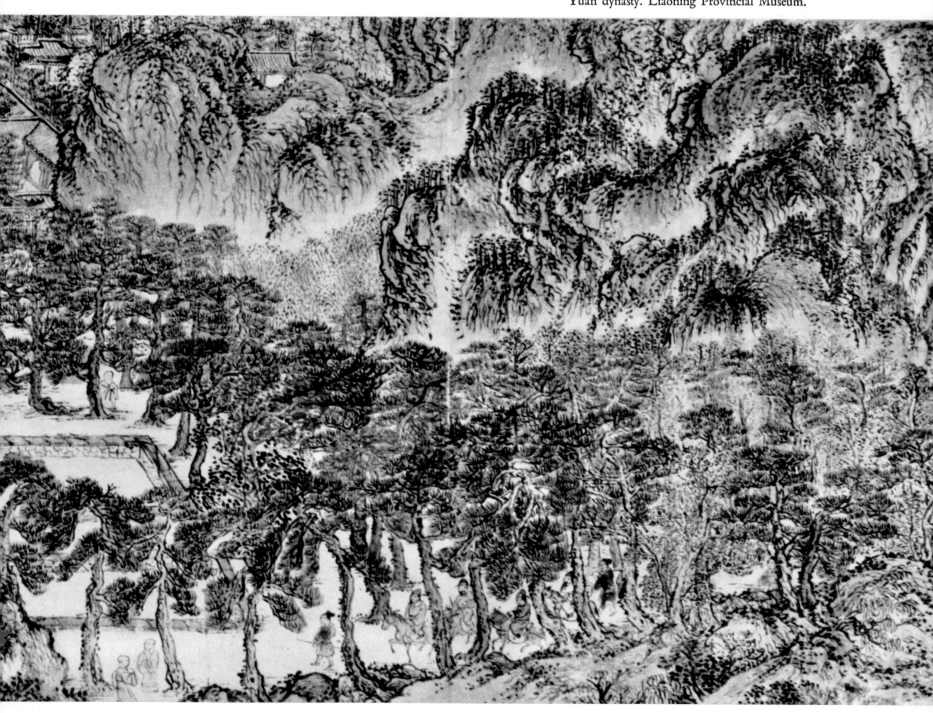

48. Wang Meng. "Mount T'ai-pai" (detail).
Yüan dynasty. Liaoning Provincial Museum.

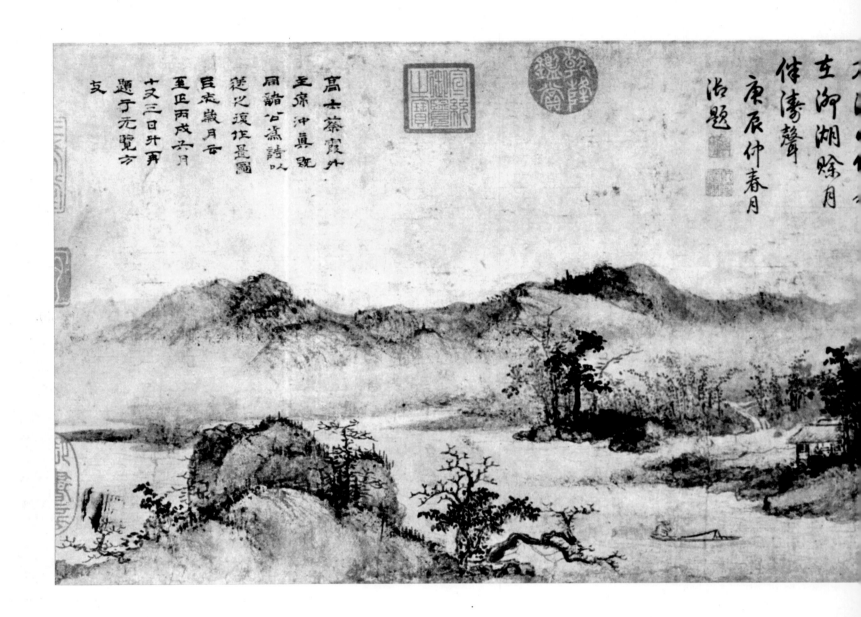

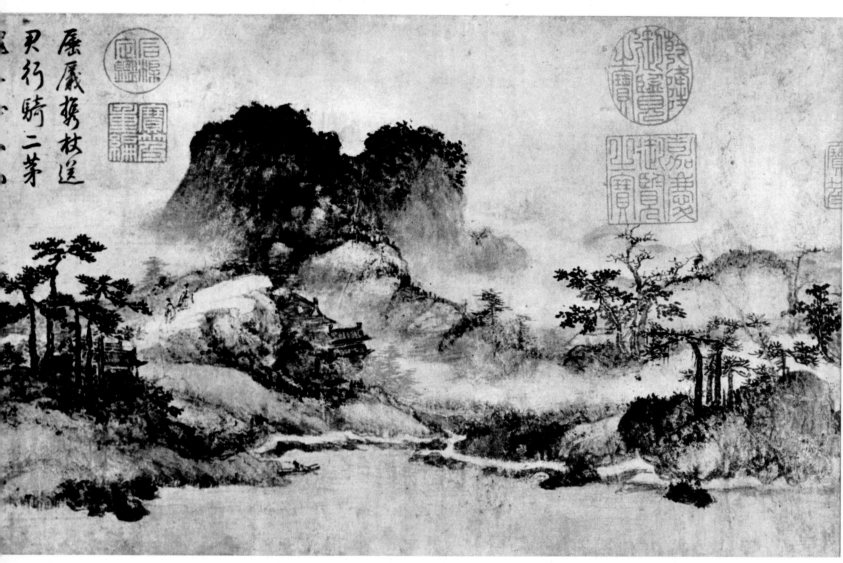

49. Li Sheng. "A Landscape Scroll." Yüan dynasty. Shanghai Museum.

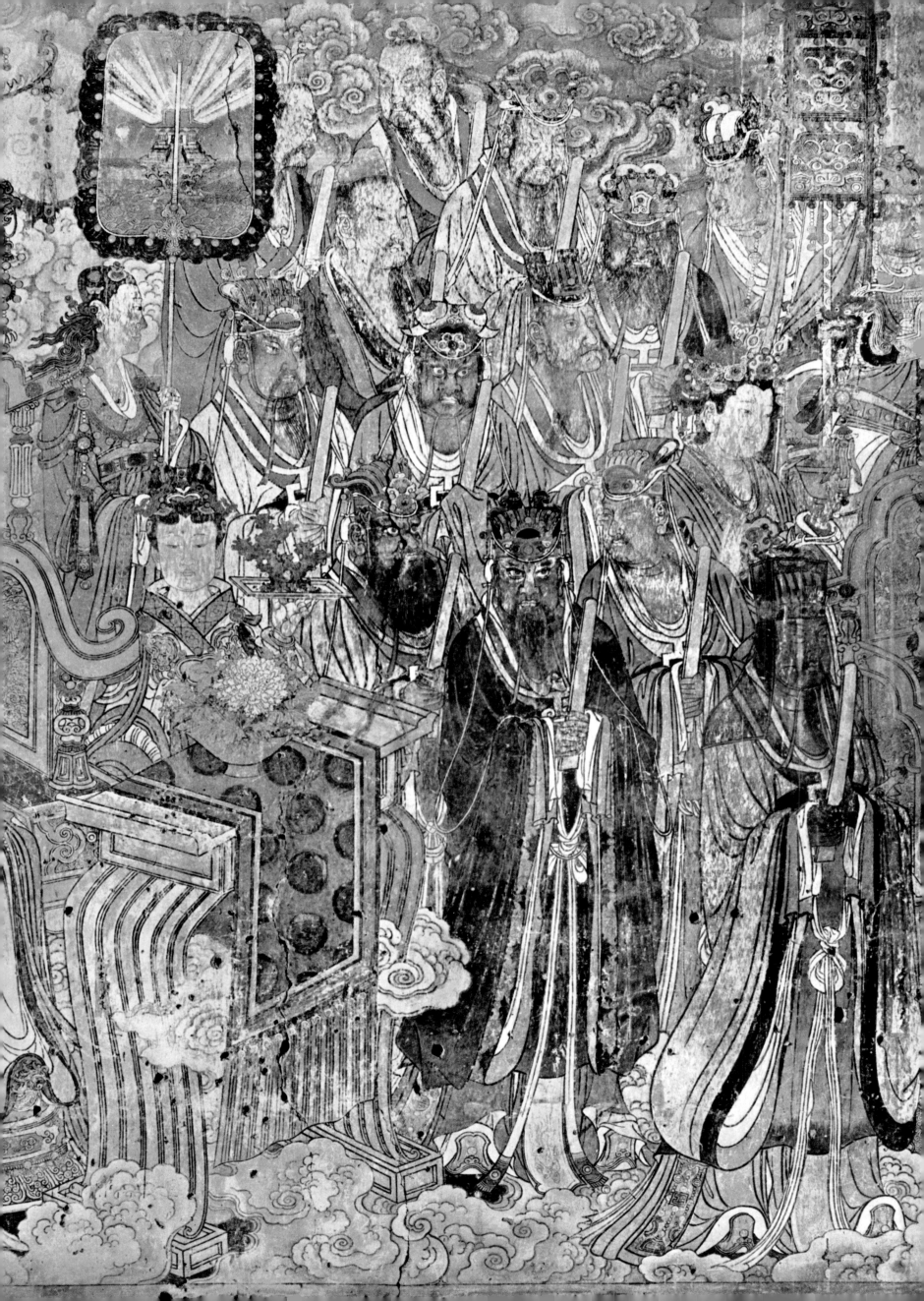

50. Mural in the San-ch'ing Hall of the Yung-lo Palace. "A Group of Divines" (detail). Yüan dynasty.

51. Mural in the Ch'un-yang Hall of the Yung-lo Palace. "Chung Li-ch'üan and Lü Tung-pin" (detail). Yüan dynasty.

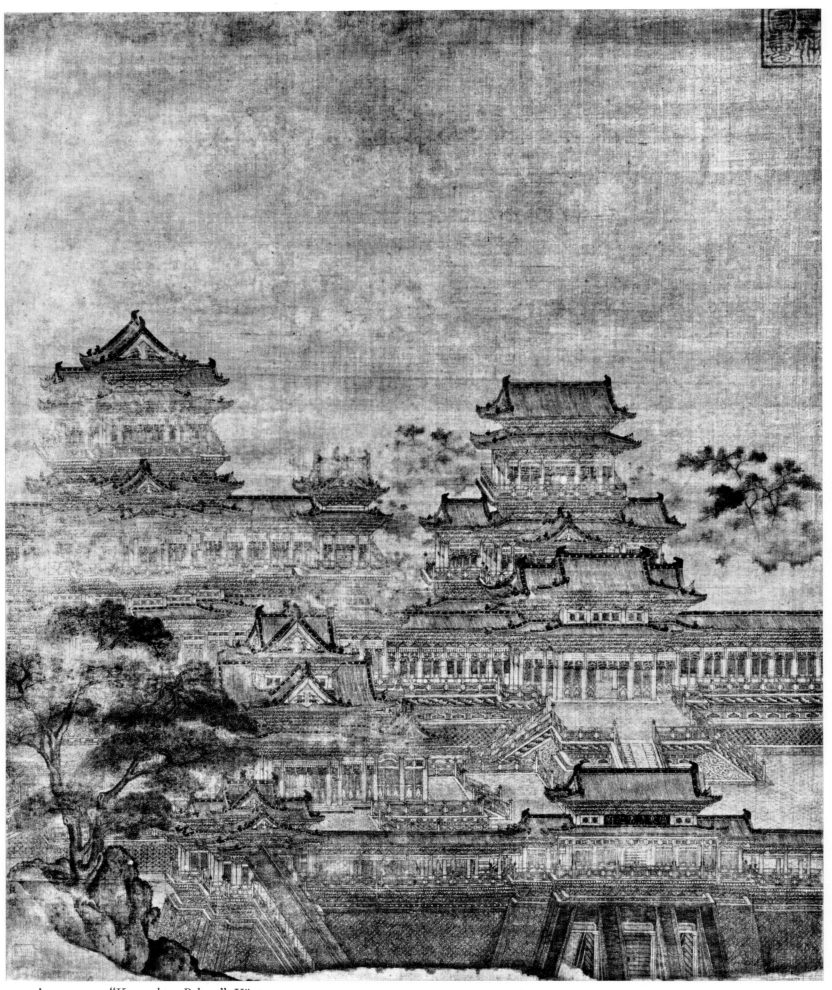

52. Anonymous. "Kuang-han Palace." Yüan
dynasty. Shanghai Museum.

53. Chao Yüan. "Grass Pavilion at ▷
Ho-hsi." Ming dynasty. Shanghai
Museum.

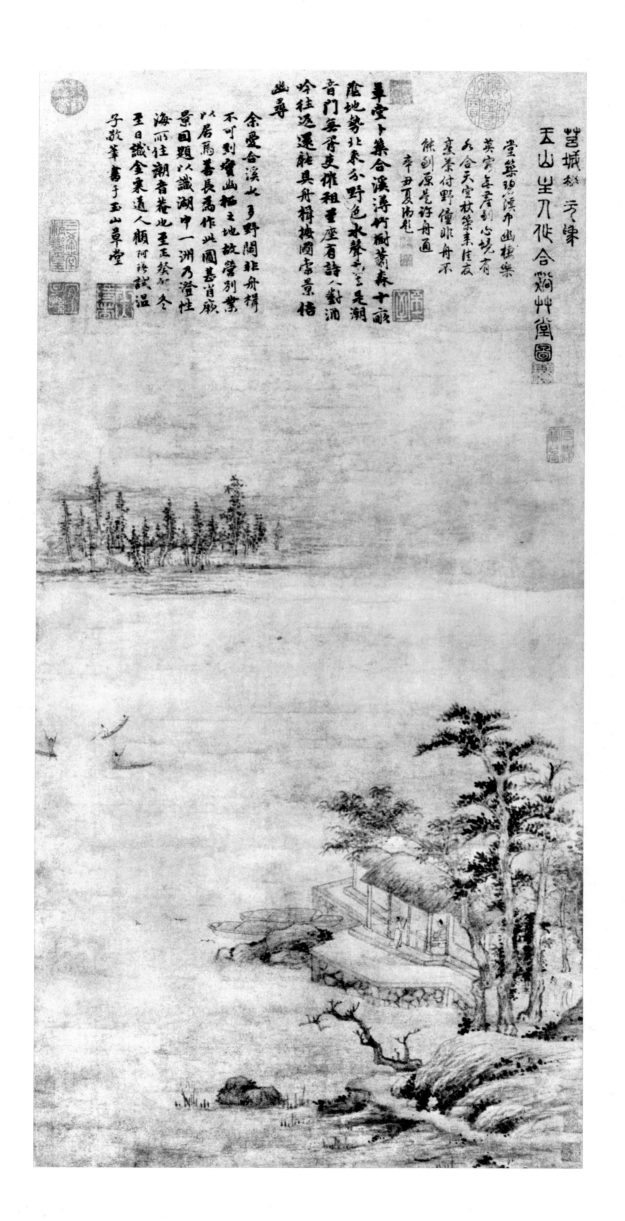

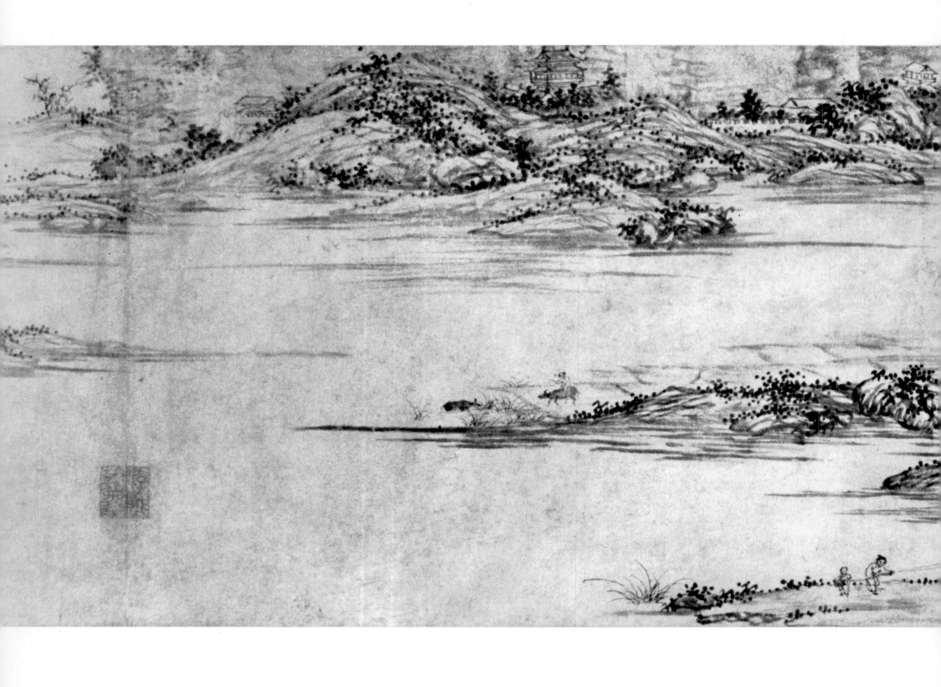

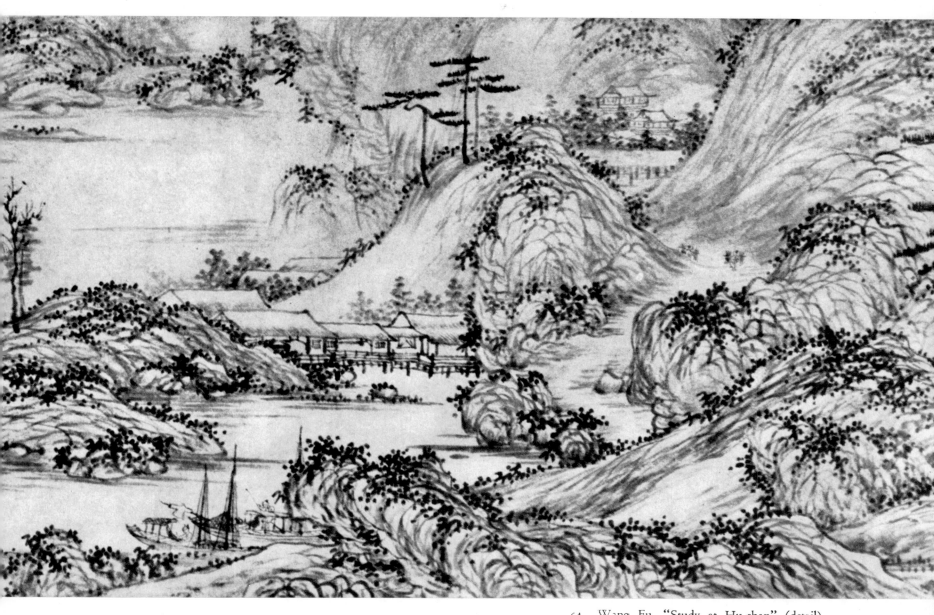

54. Wang Fu. "Study at Hu-shan" (detail).
Ming dynasty. Liaoning Provincial Museum.

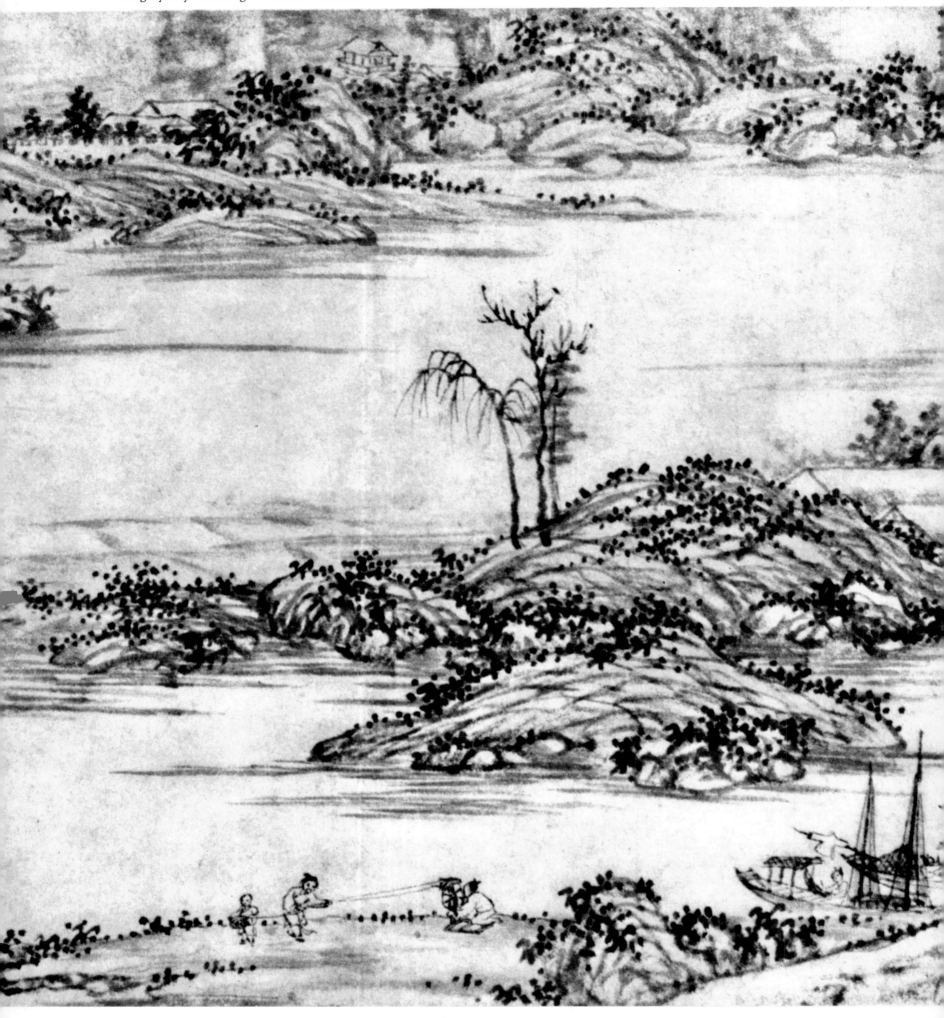

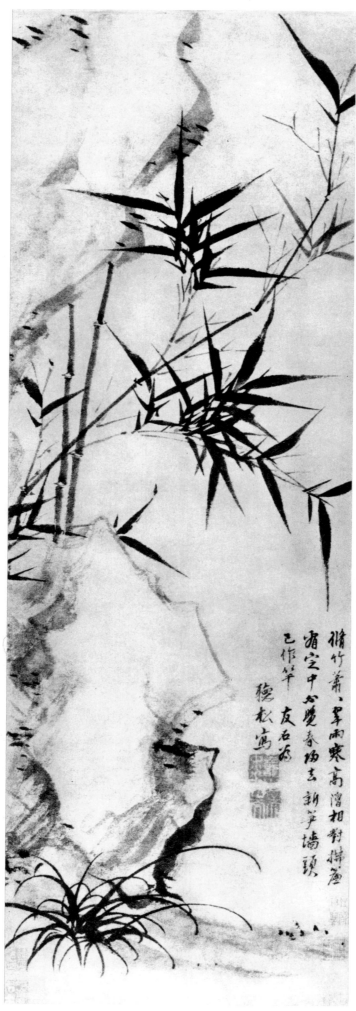

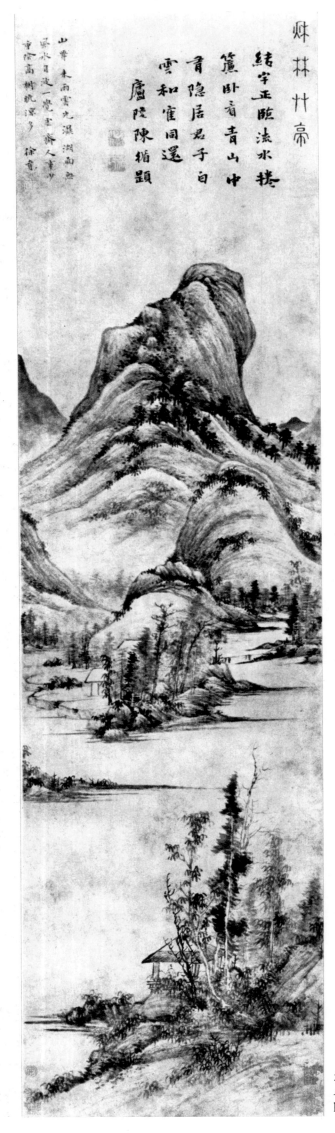

麻林竹帝

結宇正臨流水楼
簾卧看青山中
青隱居君子白
雲和崔同選
廬陵陳楯題

山帶　未雨雲光濕湖雨無
暴水日沈一覺畫春人事少
重陰高樹帆深多　徐賁

57. Hsü Pi. "Grass Pavilion in an Autumn Forest." Ming dynasty. Shanghai Museum.

58. Wang Mien. "Ink Plums." Ming dynasty. Shanghai Museum.

64. Chang Lu. "Figures" (detail).
Ming dynasty. Tientsin Museum.

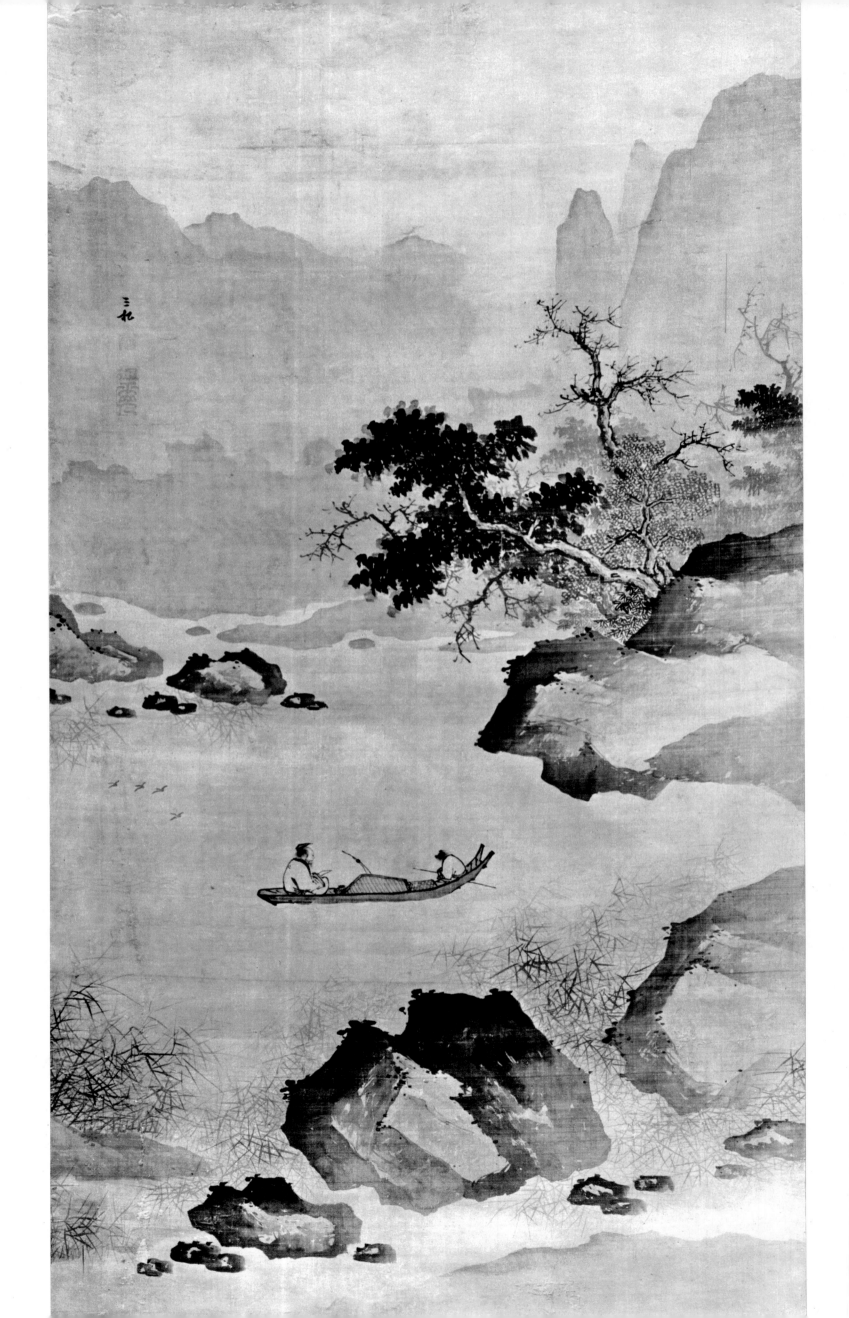

66. Chou Wen-ching. "Winter Crows on an Old Tree." Ming dynasty. Shanghai Museum.

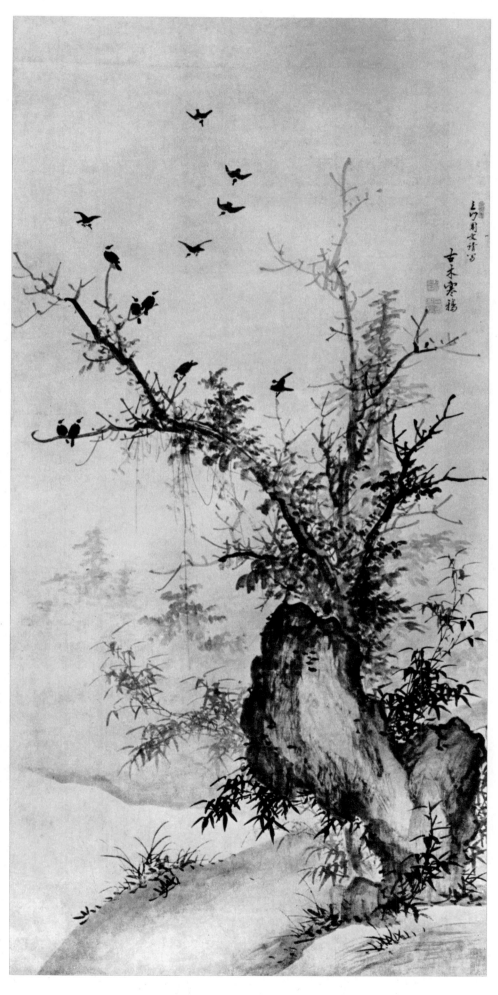

◁65. Chiang Sung. "A Drifting Boat by a Reedy Bank." Ming dynasty. Tientsin Museum.

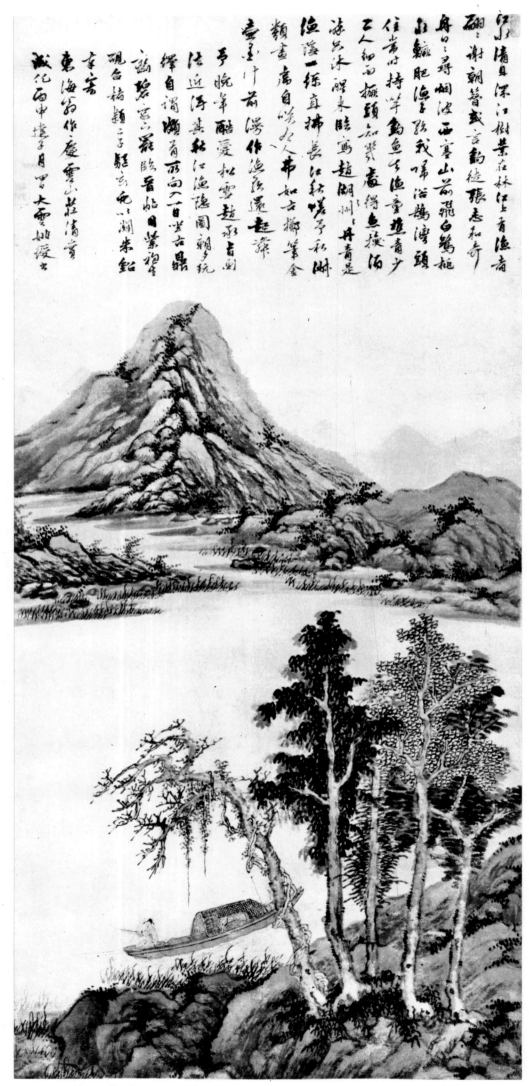

紅蓼備具深江樹葉在林江上青漁者
磯磯謝朝暮武言鉤德張志和奇
舟日之時烟波西塞山前飛白鷺柁
小艣肥漁歌我唱沿梅灣頭
佳嵩時持竿釣魚竿漁童填青少
工人細兩撥頭知緊青得魚操伯
涼兀沫醒來暗畫趙湖州丹青是
漁隱一綠直拂長江紅嗟亭利湖
類畫高自笑如人帚如古搬篙金
壹壺十荷澇作漁隱遠趁深
弓晚年酷愛松雪趙水岩岡
倪近浮其私江漁隱圖朝夕玩
繹自謂瀨有而向一日紫古鼎
鶴碧宓以羅臨晉帖日縈縈
硯色椅類三子疑玄兔小瀨朱鉛
客客
東海翁作慶雲山莊清賞
戌化丙申臈李月曽大雲姚綬書

67. Yao Shou. "Fishing in Solitude
on an Autumn River." Ming dynasty.
Shanghai Museum.

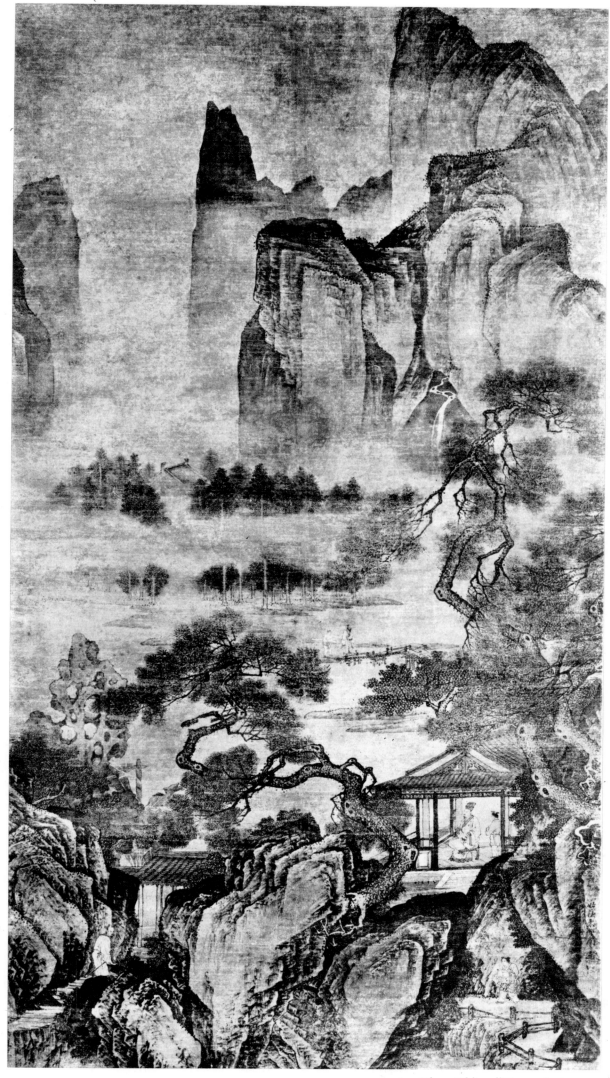

68. Chou Ch'en. "Guests Arrive at a Mountain Study." Ming dynasty. Shanghai Museum.

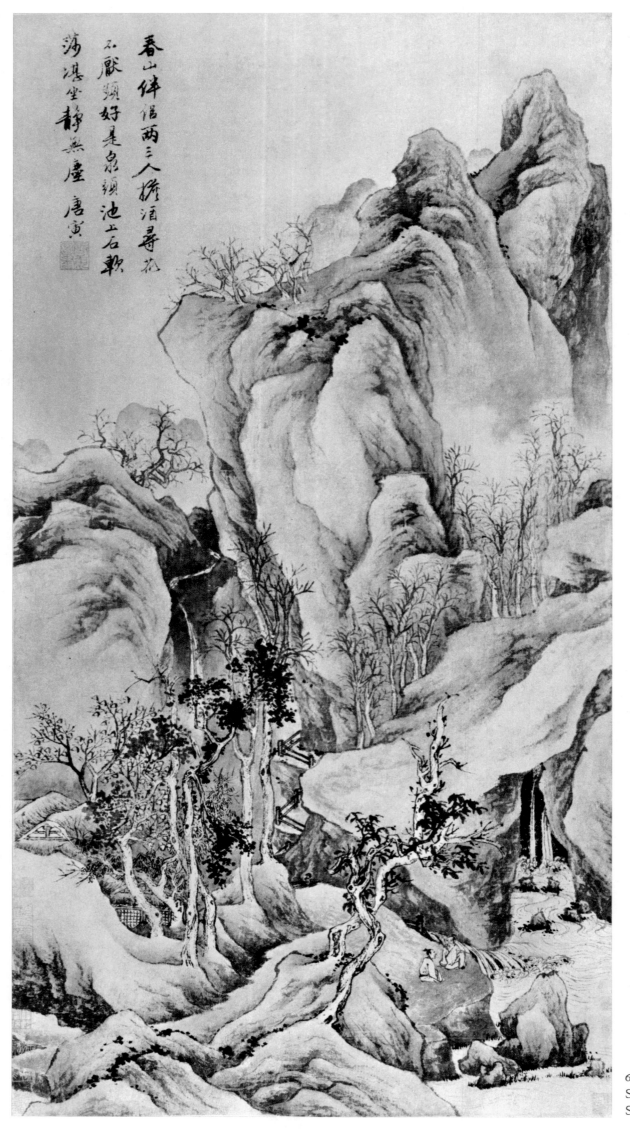

春山伴侶兩三人擠酒尋花
石厭翛好是泉頭池上石敽
蕩湛坐靜無塵 唐寅

69. T'ang Yin. "Companions in
Spring Mountains." Ming dynasty.
Shanghai Museum.

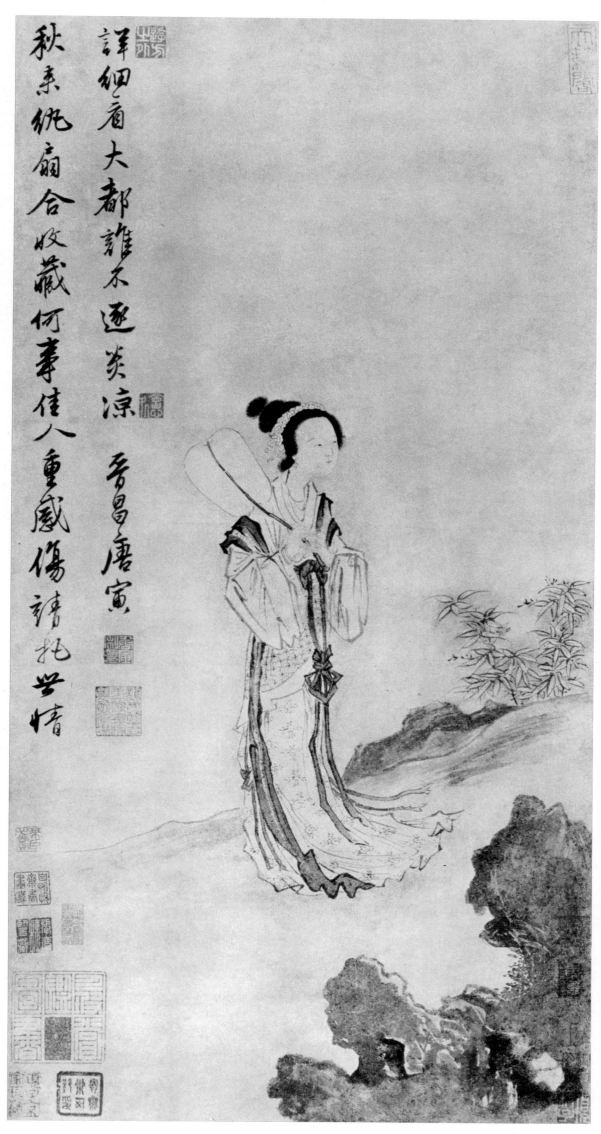

秋來紈扇合收藏何事佳人重感傷請托無情詳細看大都誰不逐炎涼晉昌唐寅

70. T'ang Yin. "Silk Fan in the Autumn Wind." Ming dynasty. Shanghai Museum.

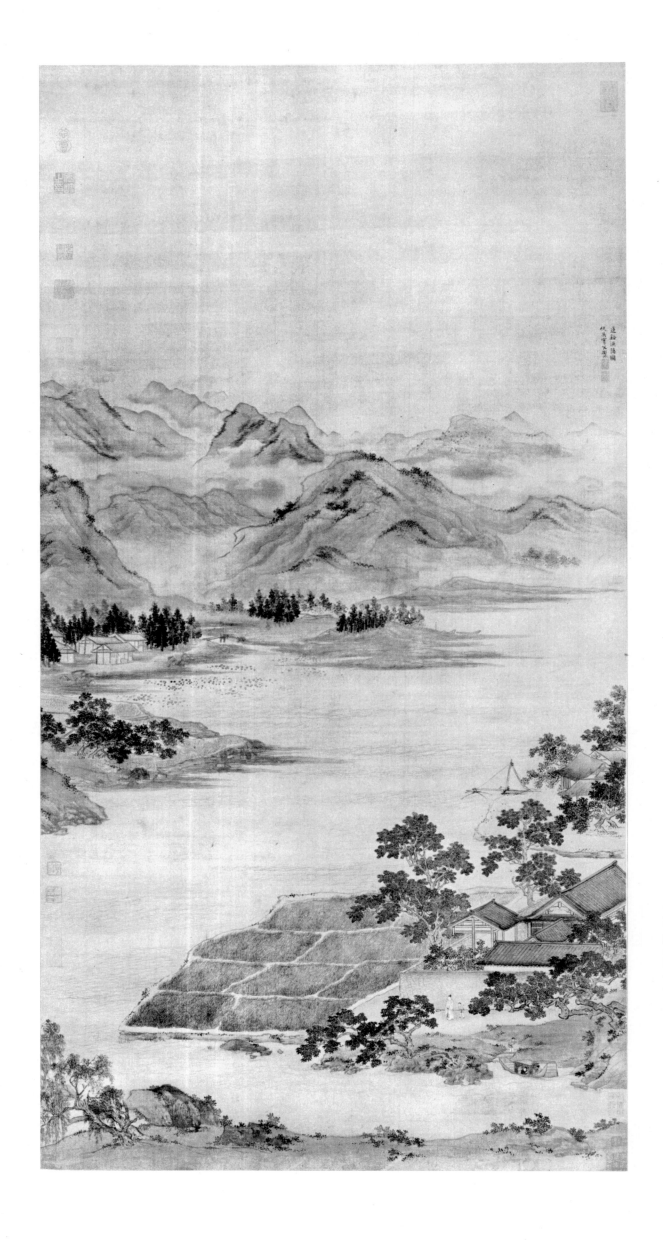

71. Ch'ou Ying. "Recluse Fishing at
Lien-hsi." Ming dynasty. The Palace
Museum.

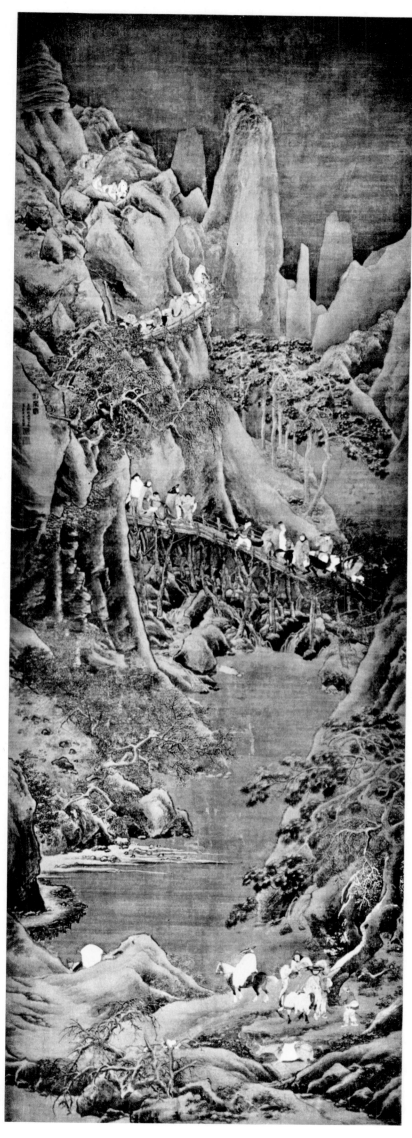

72. Ch'ou Ying. "The Plank Road
over Chien Mountain." Ming dynasty.
Shanghai Museum.

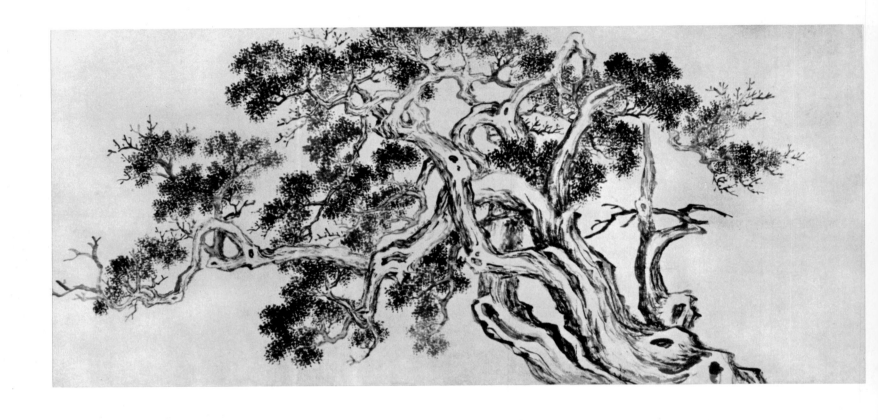

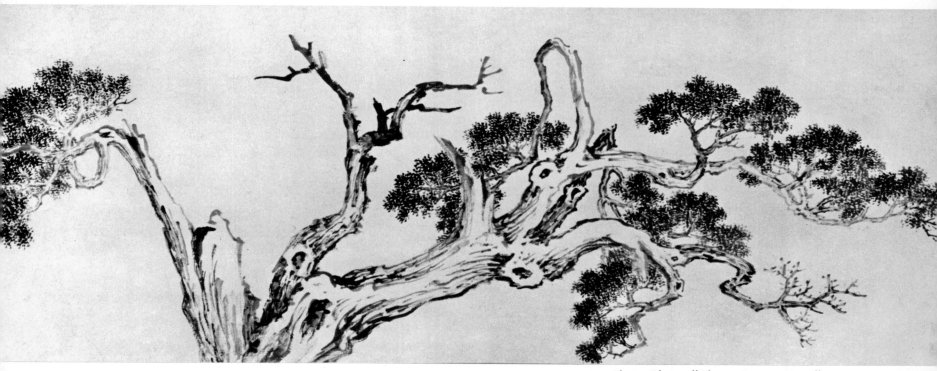

73, 74. Shen Chou. "Three Cypress Trees" (details). Ming dynasty. Nanking Museum.

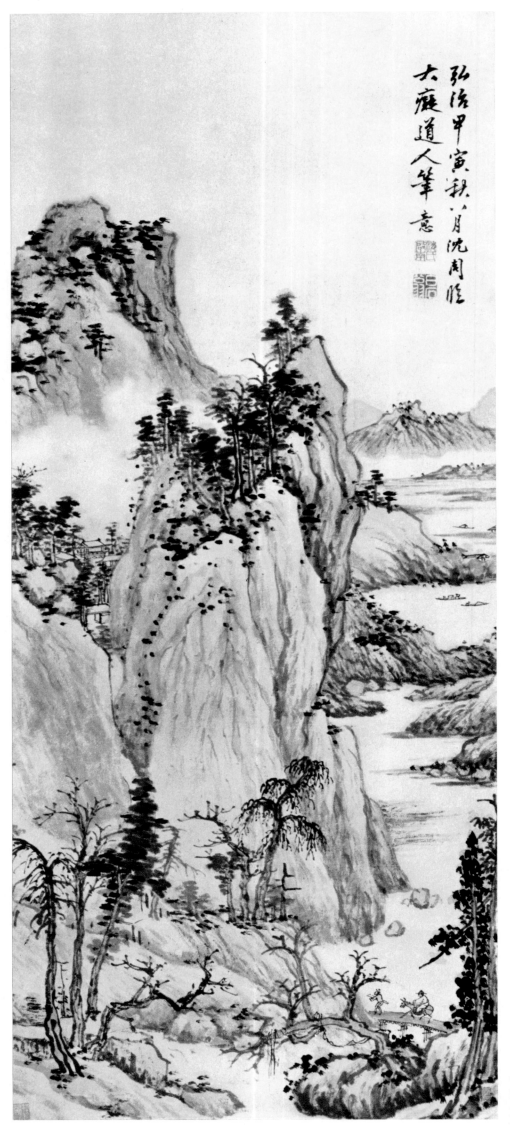

弘治甲寅秋八月沈周臨
大癡道人筆意

75. Shen Chou. "After a Landscape by Ta-ch'ih." Ming dynasty. Shanghai Museum.

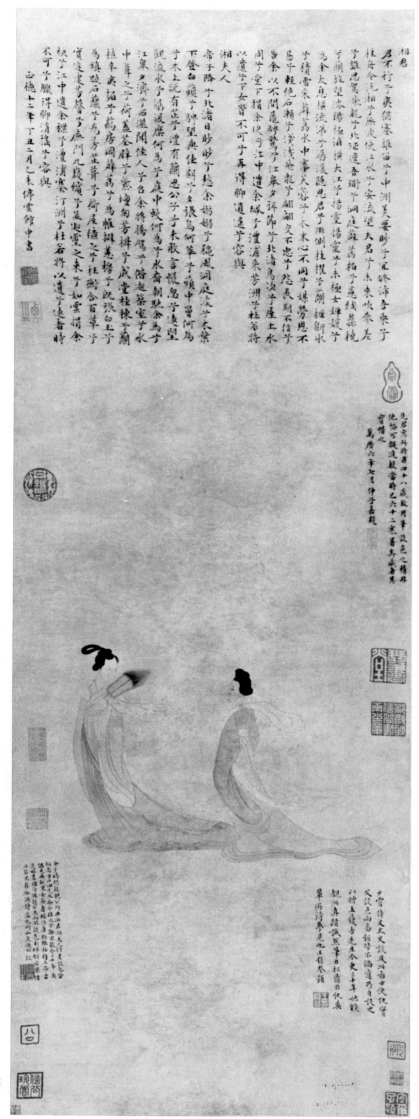

相君

君不行兮夷猶褰誰留兮中洲美要眇兮宜修沛吾乘兮桂舟令沅湘兮無波使江水兮安流望夫君兮未來吹參差兮誰思駕飛龍兮北征邅吾道兮洞庭薜荔柏兮蕙綢蓀橈兮蘭旌望涔陽兮極浦橫大江兮揚靈揚靈兮未極女嬋媛兮為余太息橫流涕兮潺湲隱思君兮陫惻桂櫂兮蘭枻斲冰兮積雪采薜荔兮水中搴芙蓉兮木末心不同兮媒勞恩不甚兮輕絕石瀨兮淺淺飛龍兮翩翩交不忠兮怨長期不信兮告余以不閒鼂騁騖兮江皋夕弭節兮北渚鳥次兮屋上水周兮堂下捐余玦兮江中遺余佩兮澧浦采芳洲兮杜若將以遺兮下女時不可兮再得聊逍遙兮容與

湘夫人

帝子降兮北渚目眇眇兮愁予嫋嫋兮秋風洞庭波兮木葉下登白薠兮騁望與佳期兮夕張鳥何萃兮蘋中罾何為兮木上沅有茝兮澧有蘭思公子兮未敢言荒忽兮遠望觀流水兮潺湲麋何食兮庭中蛟何為兮水裔朝馳余馬兮江皋夕濟兮西澨聞佳人兮召余將騰駕兮偕逝築室兮水中葺之兮荷蓋蓀壁兮紫壇播芳椒兮成堂桂棟兮蘭橑辛夷楣兮藥房罔薜荔兮為帷擗蕙櫋兮既張白玉兮為鎮疏石蘭兮為芳芷葺兮荷屋繚之兮杜衡合百草兮實庭建芳馨兮廡門九嶷繽兮並迎靈之來兮如雲捐余袂兮江中遺余褋兮澧浦搴汀洲兮杜若將以遺兮遠者時不可兮驟得聊逍遙兮容與

正德十二年丁丑二月乙未停雲館中書

先君宗伯時第四十八歲故用辛酉元之精抹
他尚可讓逸敷當時乙亥著夫豐者見
萬曆六年七月伊孚盟題

少嘗得文太史諸及此畫古使況守
夊伏惡而易領臂不滿孺方月該之
此幀五覺古光本今史三十年徃於
胡興真蹟恨無筆力松翁士恨奉題
蕐雨清影案息此士徙奉題

今我愧道猶公所

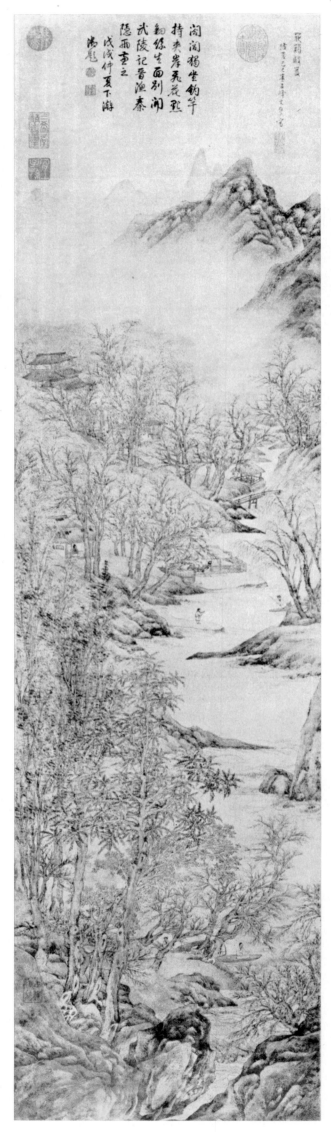

閟閟楊堂釣午
持來崖先荒眈
翻綠生面別闖
武陵記晉漁泰
隱而畫之
戊戌竹夏下游
湖氍

77. Wen Po-jen. "Fishing in Seclusion
by a Flowery Stream." Ming dynasty.
Shanghai Museum.

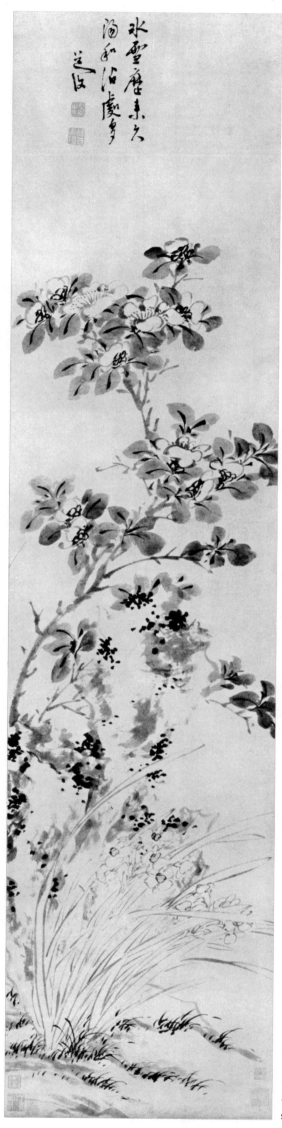

78. Ch'en Ch'un. "Camelia and Narcissus." Ming dynasty. Shanghai Museum.

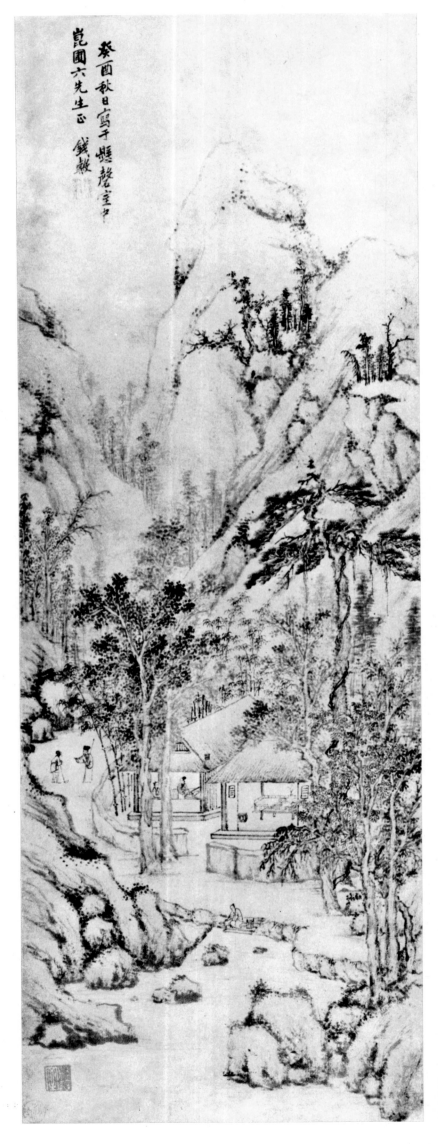

79. Ch'ien Ku. "Ladling Water by a
Mountain Home." Ming dynasty.
Shanghai Museum.

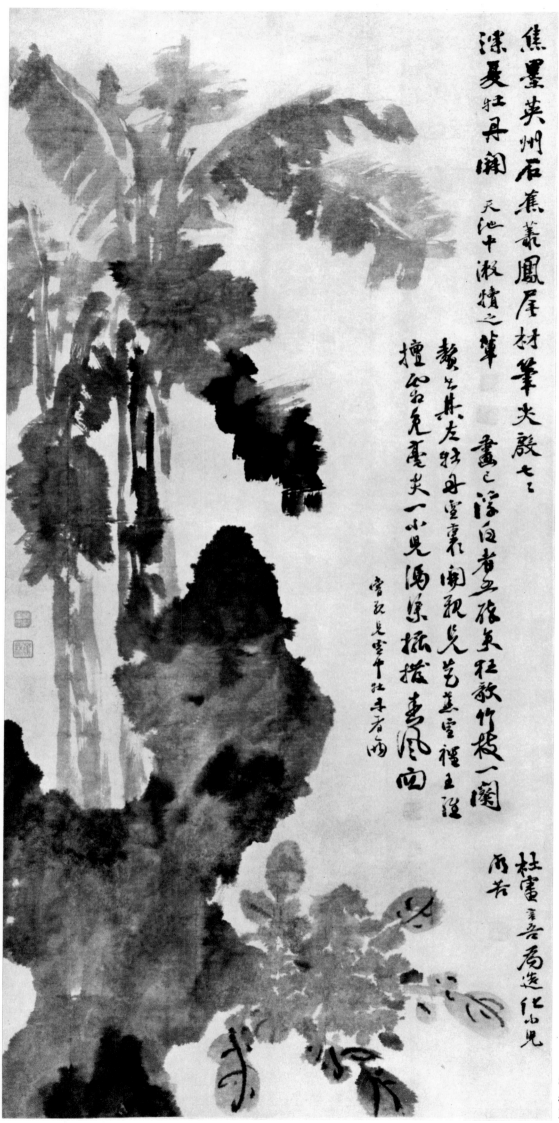

焦墨英州石蕉叢鳳尾材筆夾嶔七之
深夏牡丹開
天池中潄犢之筆
畫之浮白者五發氣狂教竹枝一閣
檀谷免毫夾一小兒漏染撥撥青風濁雨
贅名蘇老牡丹雲裏閣覷先筆蓋雲褞玉艶
雲數足雲中壯丹右滴
桂畫言喜屬選化小兒
阿若

80. Hsü Wei. "Peony, Banana Palm, and Rock." Ming dynasty. Shanghai Museum.

81–84. Hsü Wei. "Miscellaneous Flowers"
(details). Ming dynasty. Nanking Museum.

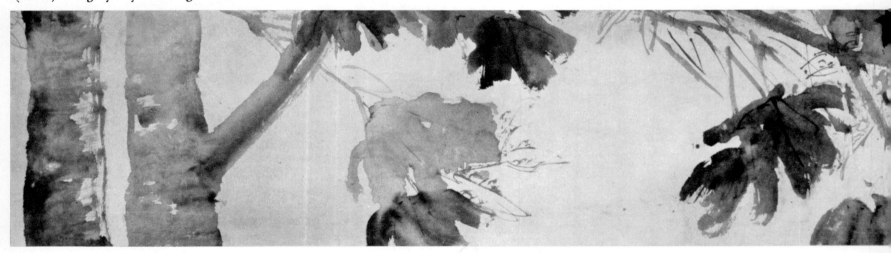

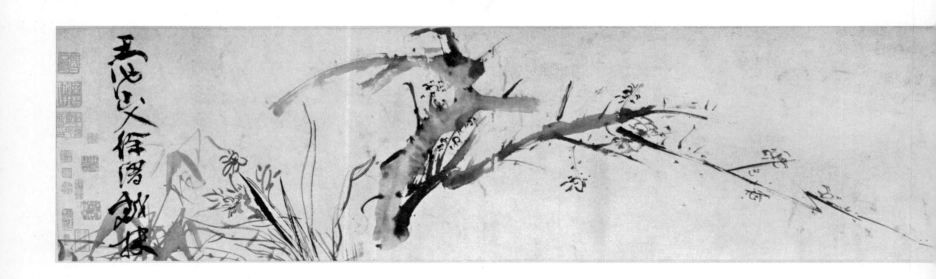

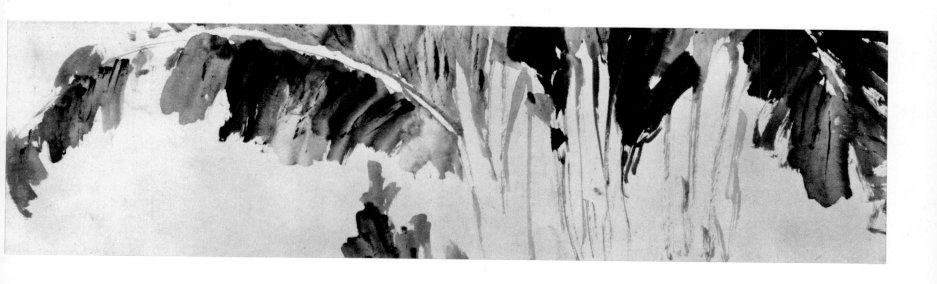

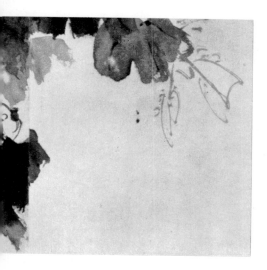

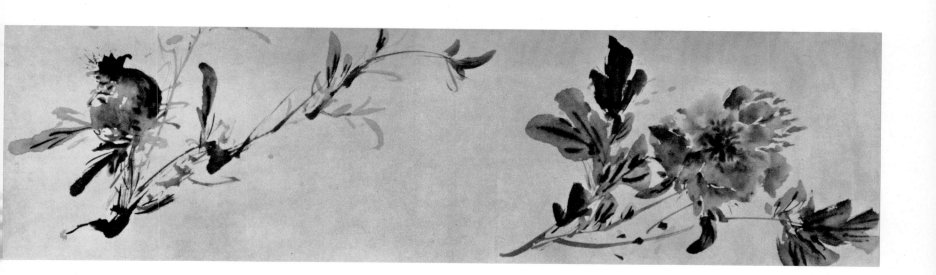

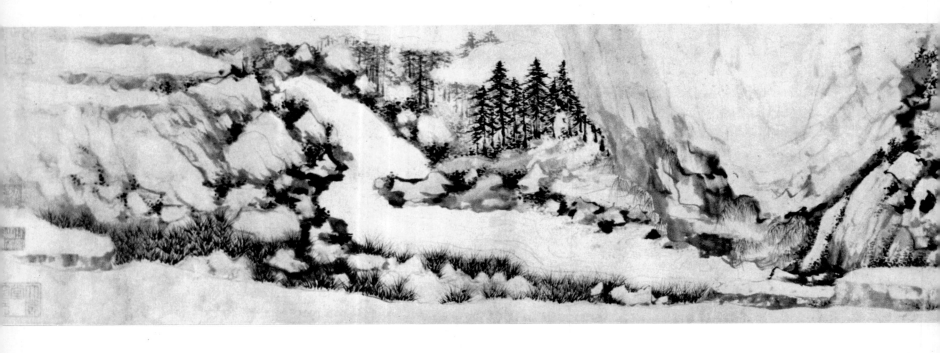

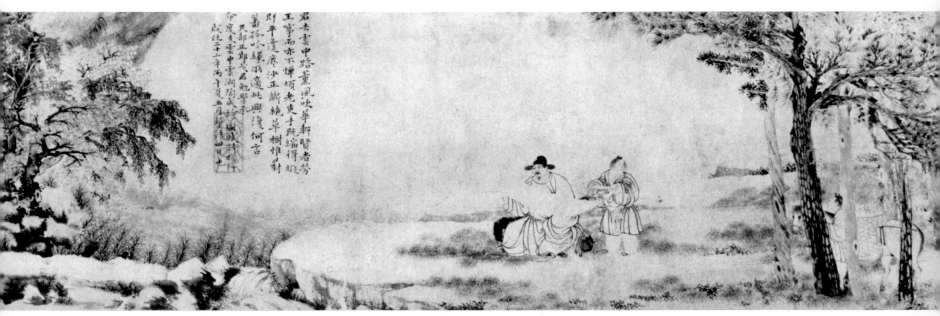

85. T'ao Ch'eng. "Leave-taking for Yün-
chung." Ming dynasty. The Palace Museum.

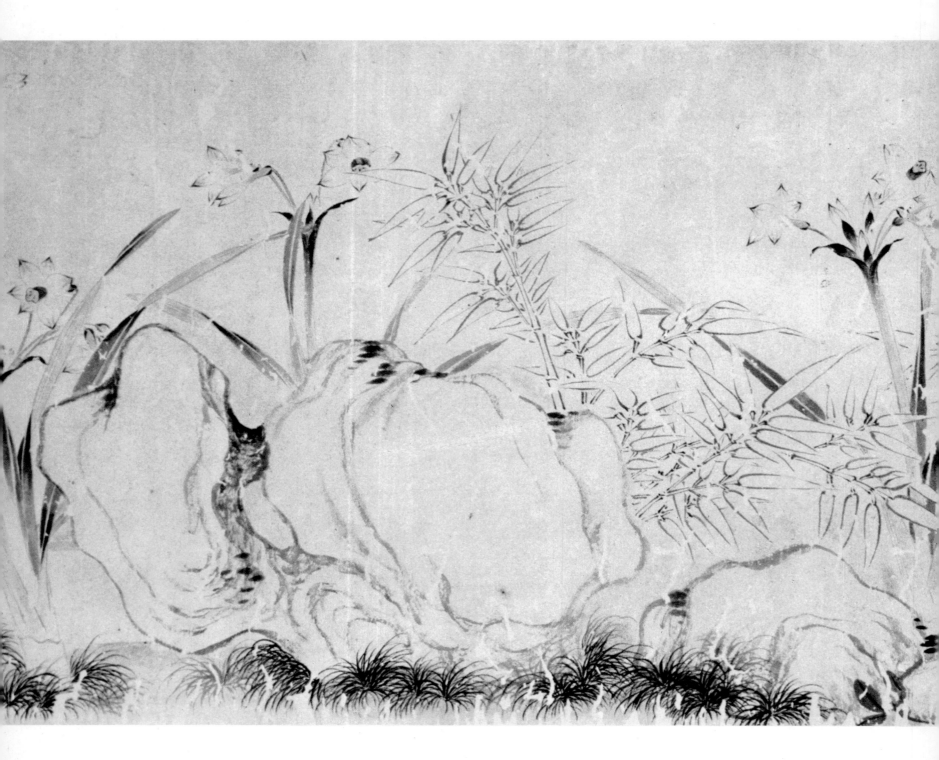

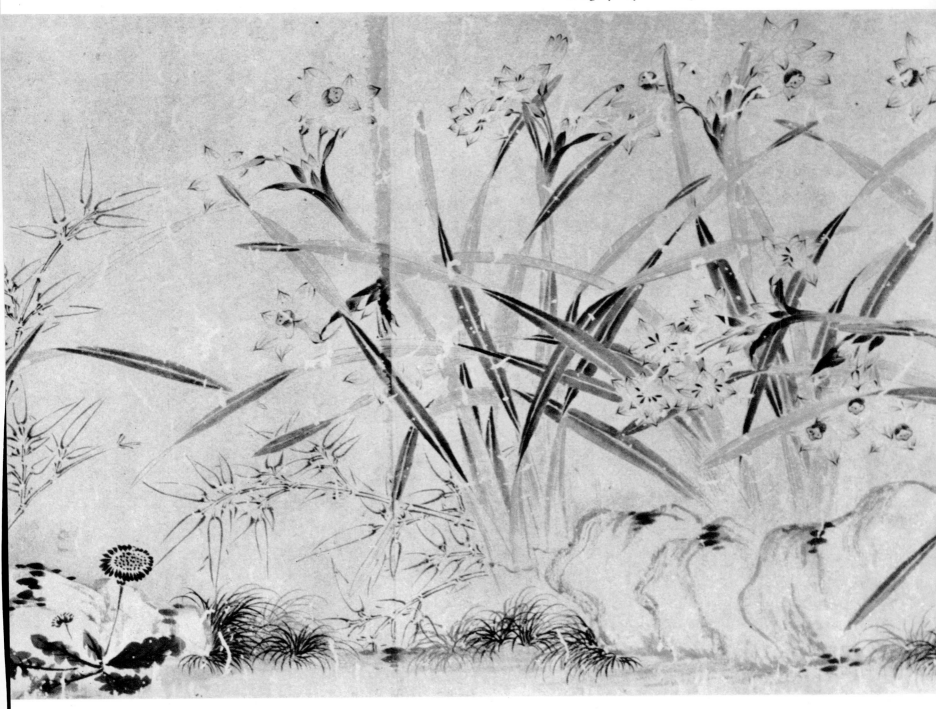

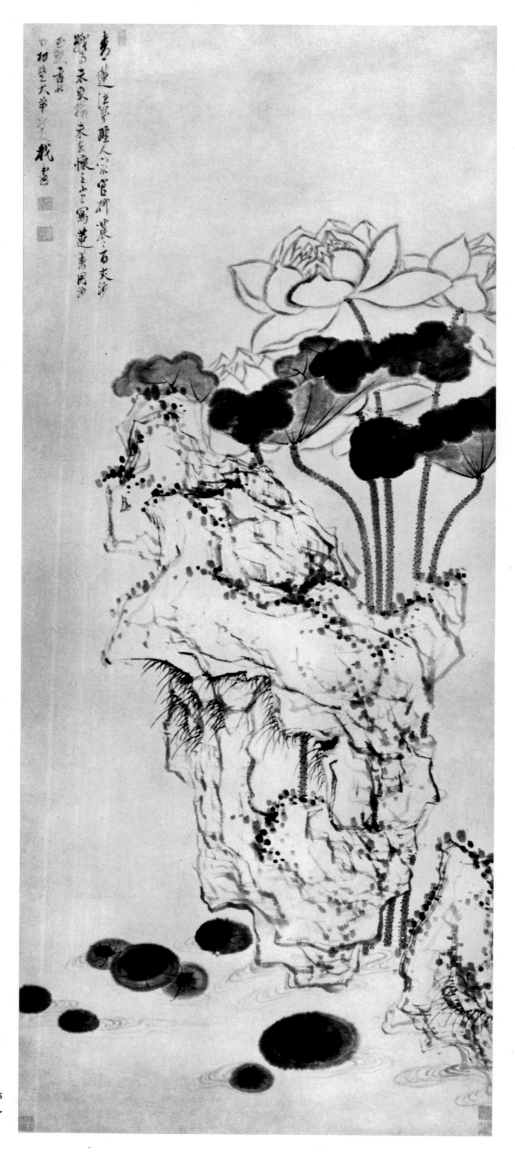

87. Ch'en Hung-shou. "Lotus and Rock." Ming dynasty. Shang-hai Museum.

122

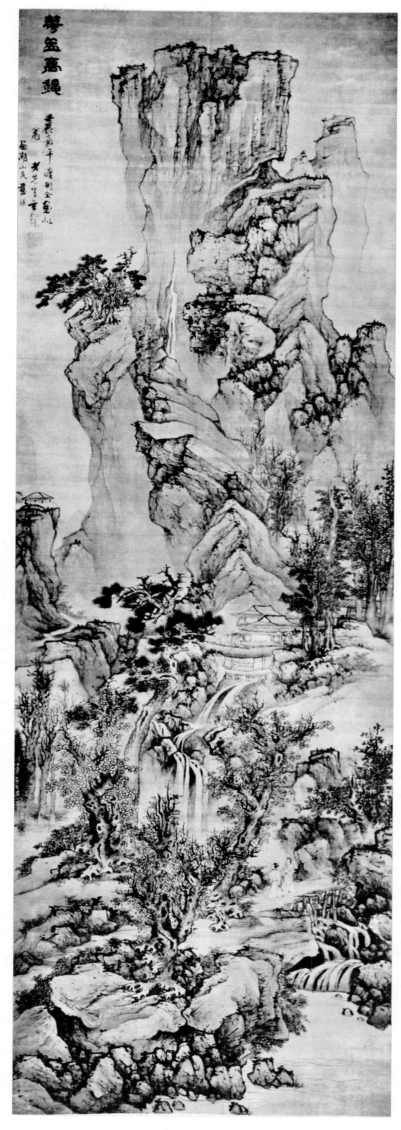

90. Lan Ying. "Mount Hua at the Height of Autumn." Ming dynasty. Shanghai Museum.

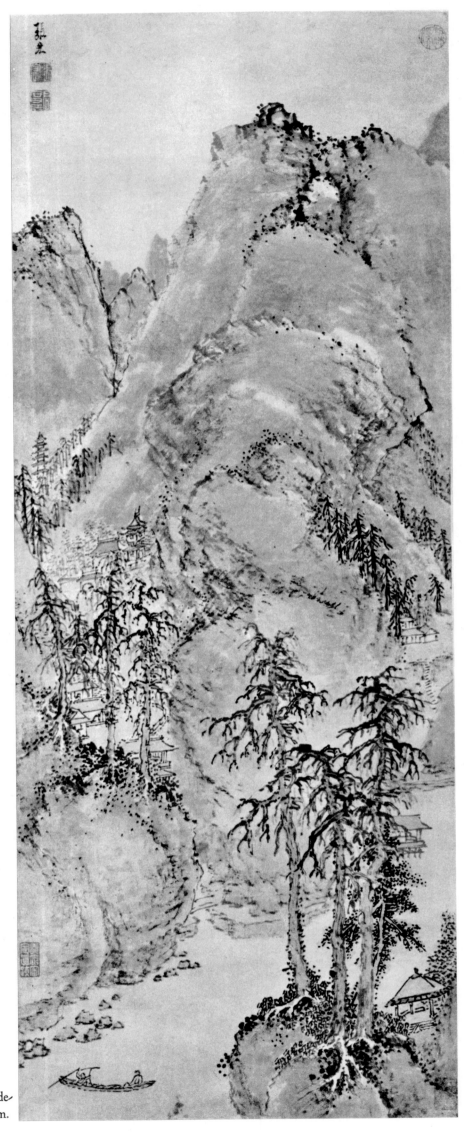

91. Chang Hung. "Landscape" (detail). Ming dynasty. Tientsin Museum.

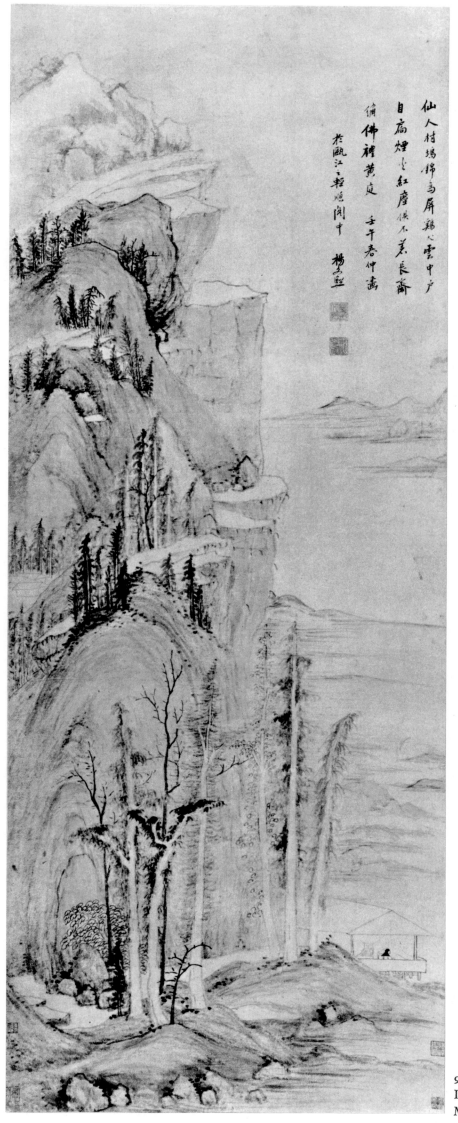

仙人村媽綿為屏雞心雲中戶
自扃煙光紅塵候不羨長齋
備佛禮黃庭 壬午春仲畫
於頤江一輕順閣中 楊文聰

92. Yang Wen-ts'ung. "Village of the
Immortals." Ming dynasty. The Palace
Museum.

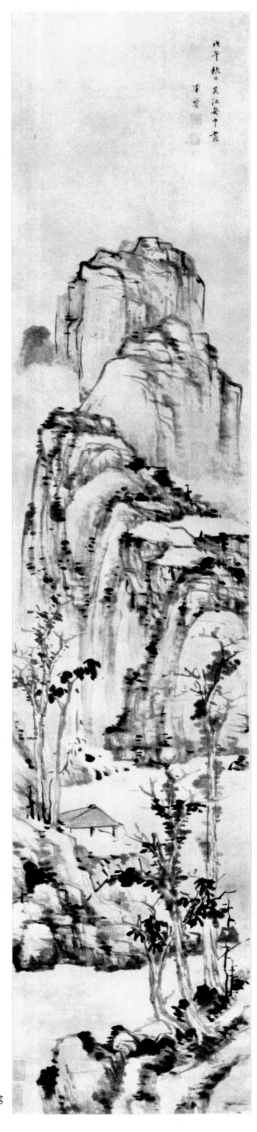

93. Li Liu-fang. "Landscape." Ming
dynasty. Tientsin Museum.

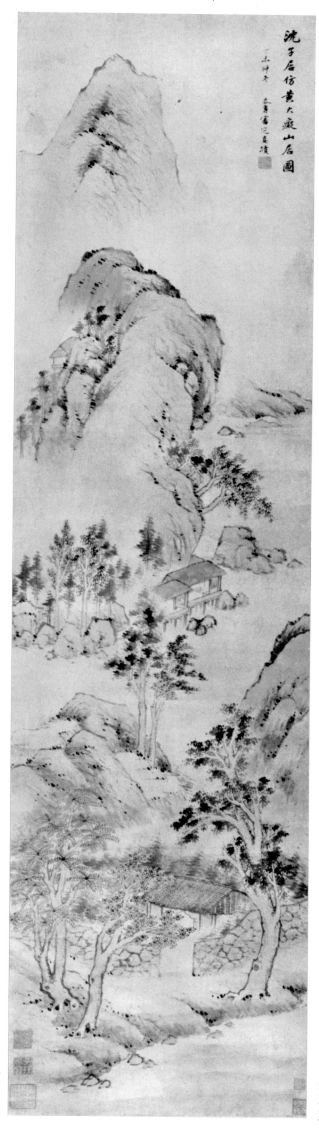

沈子居仿黃大癡山居圖

94. Shen Shih-ch'ung. "Mountain Residence." Ming dynasty. Tientsin Museum.

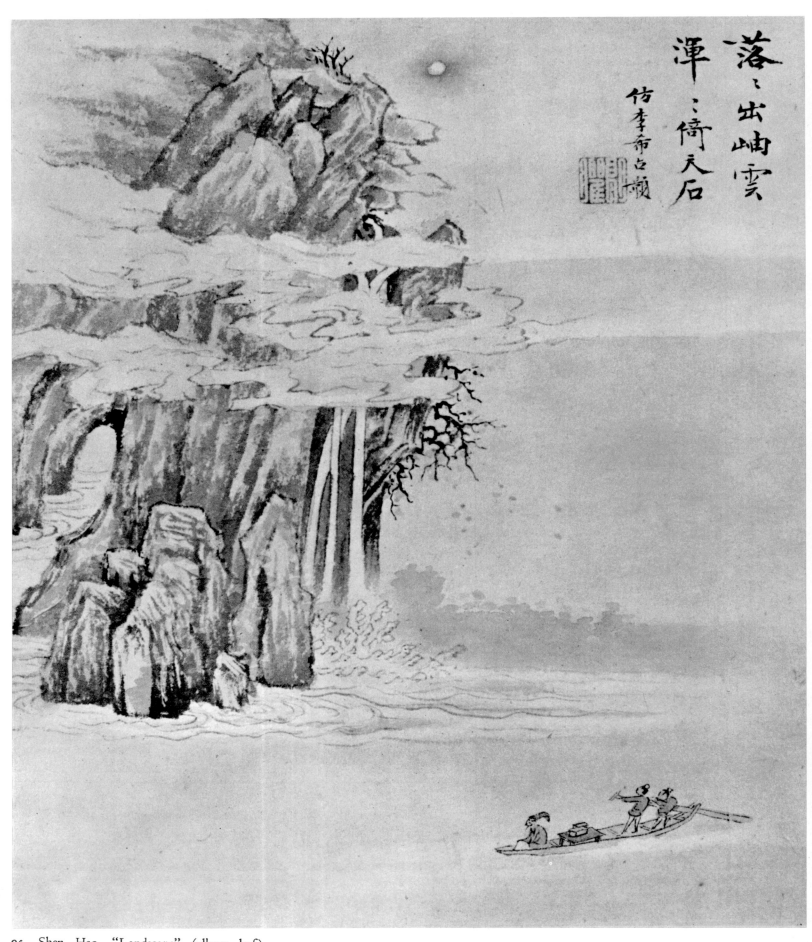

落落出岫雲
渾渾倚天石
仿李希古舊幀

95. Shen Hao. "Landscape" (album leaf).
Ming dynasty. Tientsin Museum.

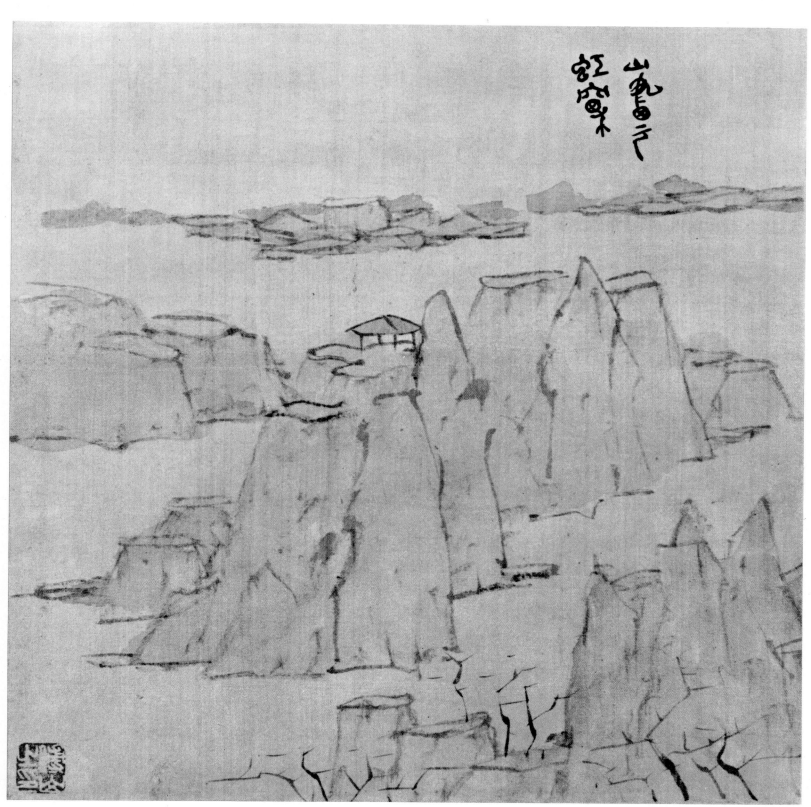

96. Fu Shan. "Landscape" (album leaf).
Ch'ing dynasty. Tientsin Museum.

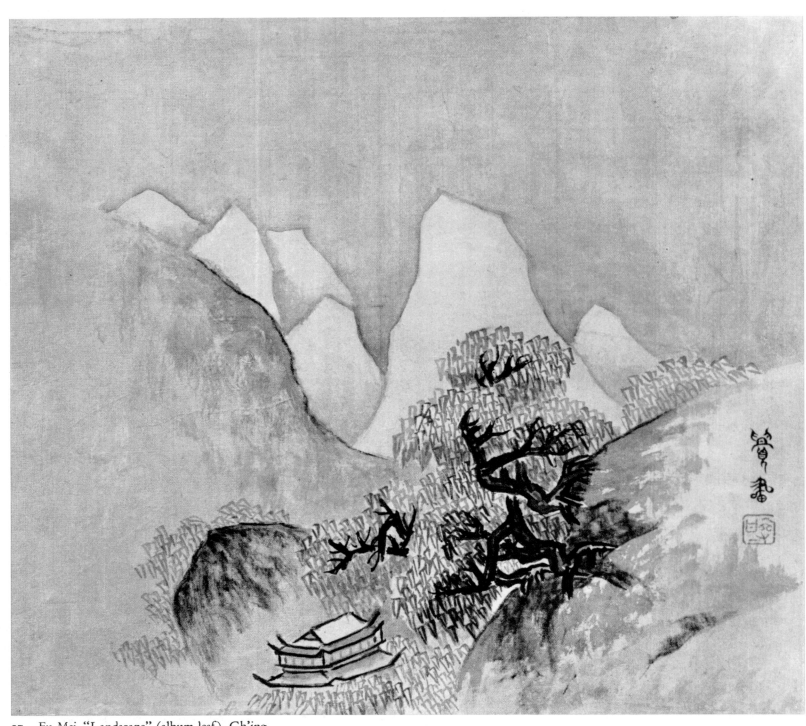

97. Fu Mei. "Landscape" (album leaf). Ch'ing
dynasty. Tientsin Museum.

98. Kung Hsien. "Leaves in Red ▷
and Yellow." Ch'ing dynasty. Shanghai
Museum.

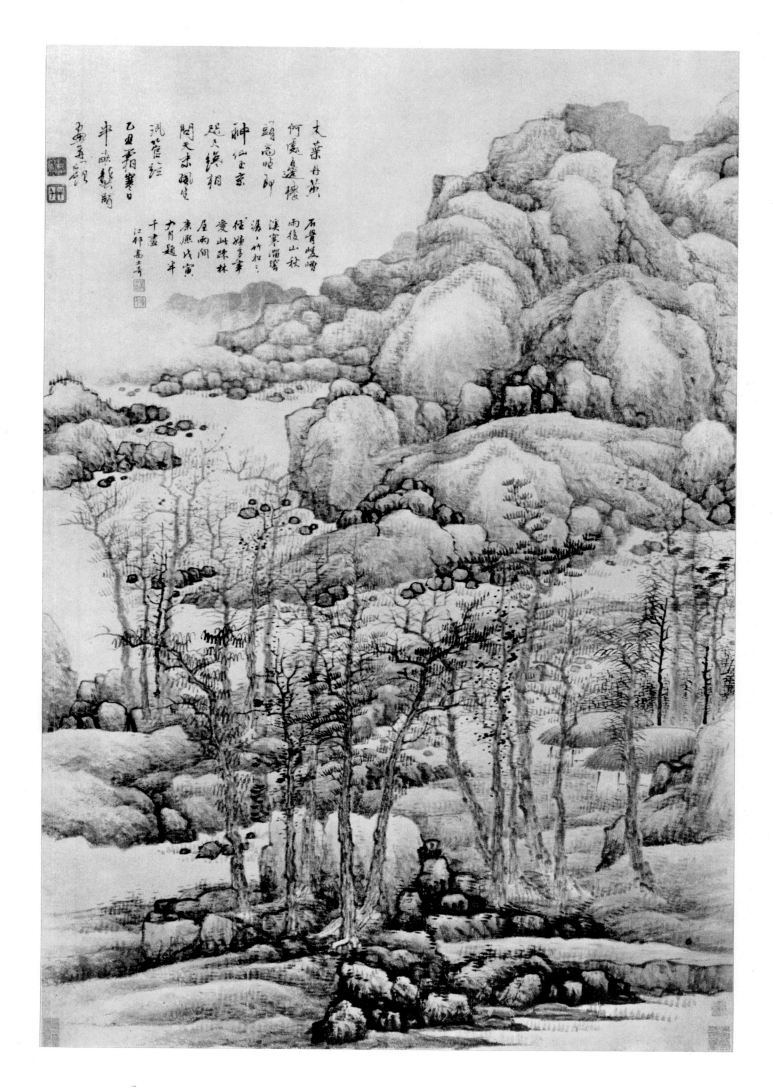

133

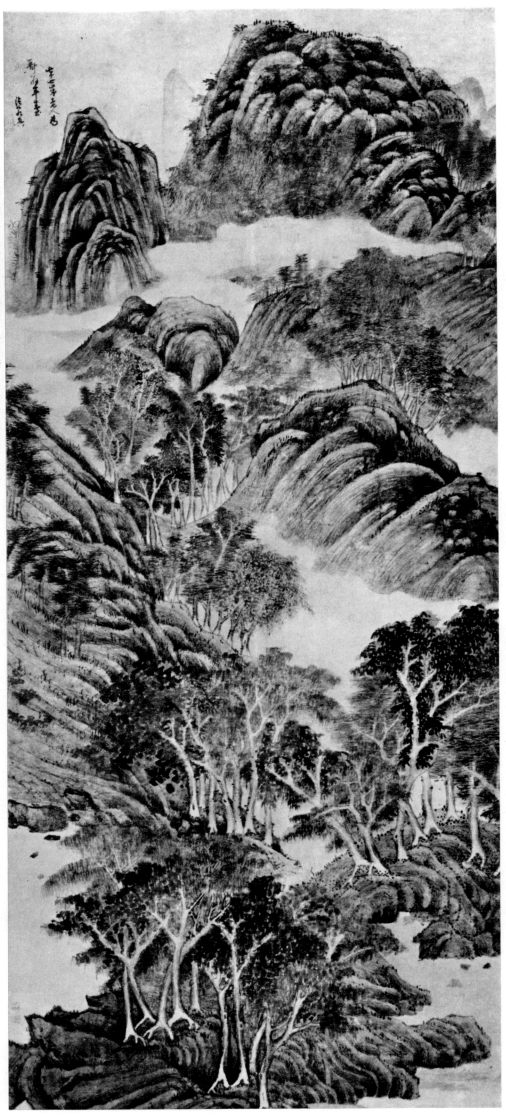

99. Fa Jo-chen. "Landscape." Ch'ing dynasty. Liaoning Provincial Museum.

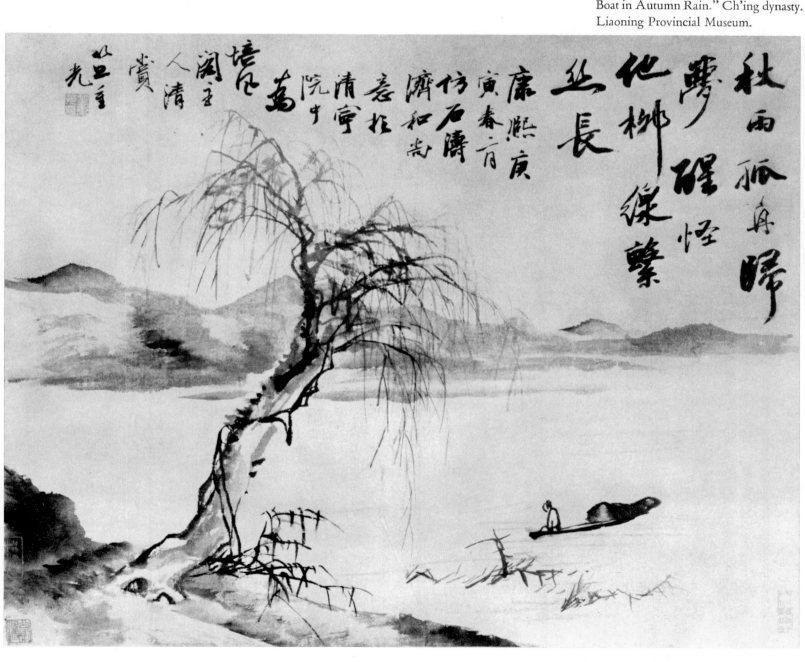

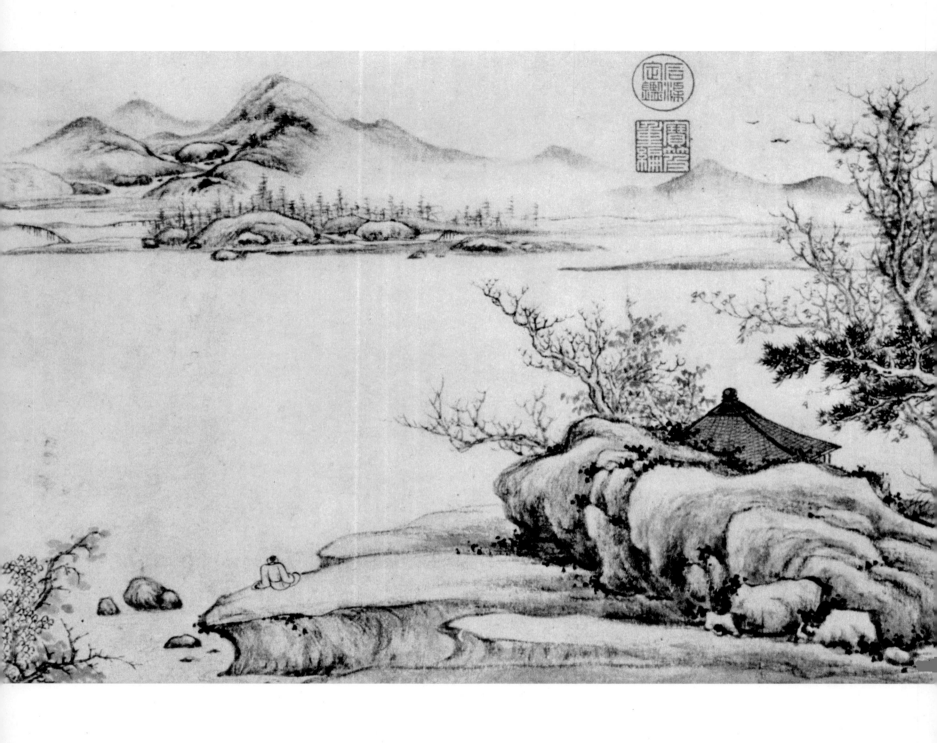

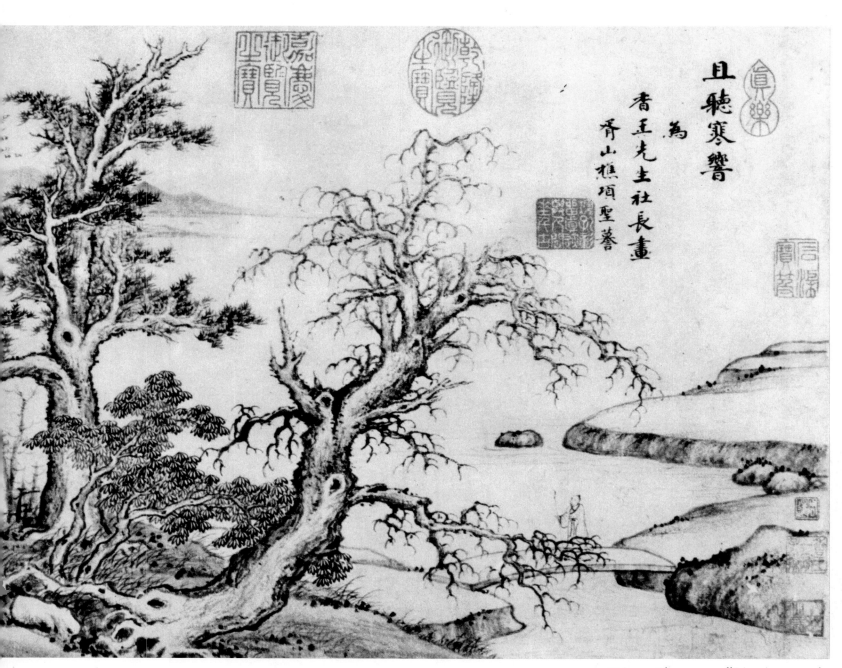

且聽寒響

為

者 王 先 生 社 長 畫

胥 山 樵 項 聖 謨

101. Hsiang Sheng-mo. "Listening to the Sounds of Winter" (detail). Ch'ing dynasty. Tientsin Museum.

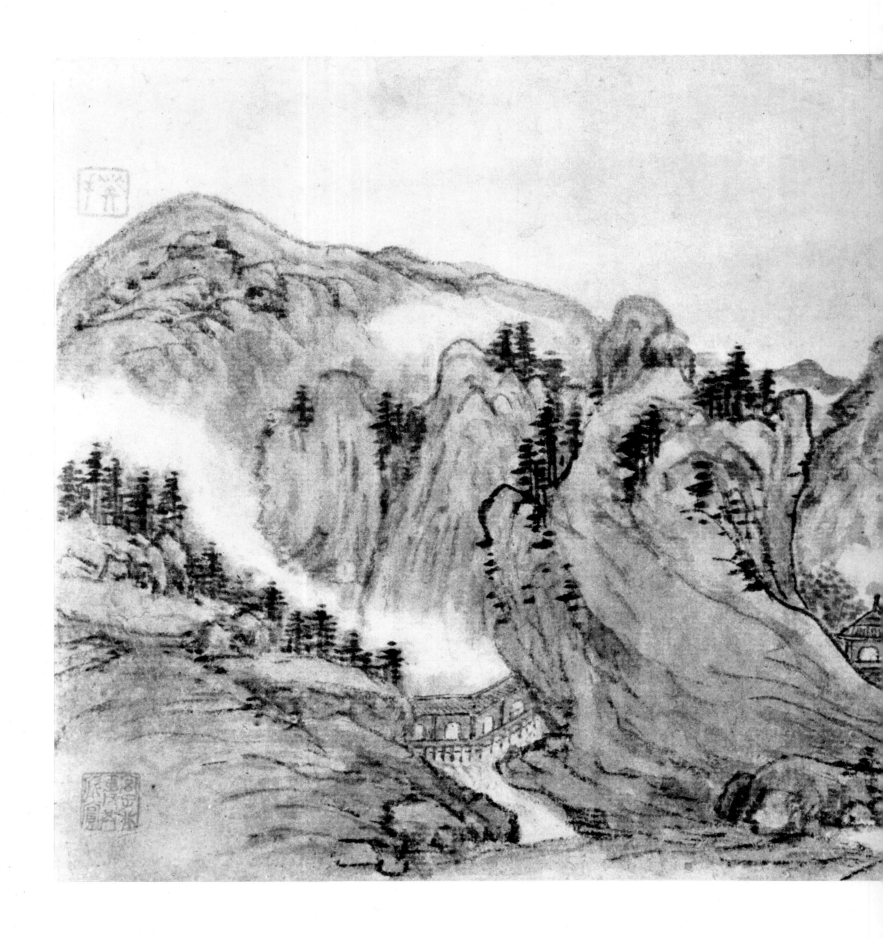

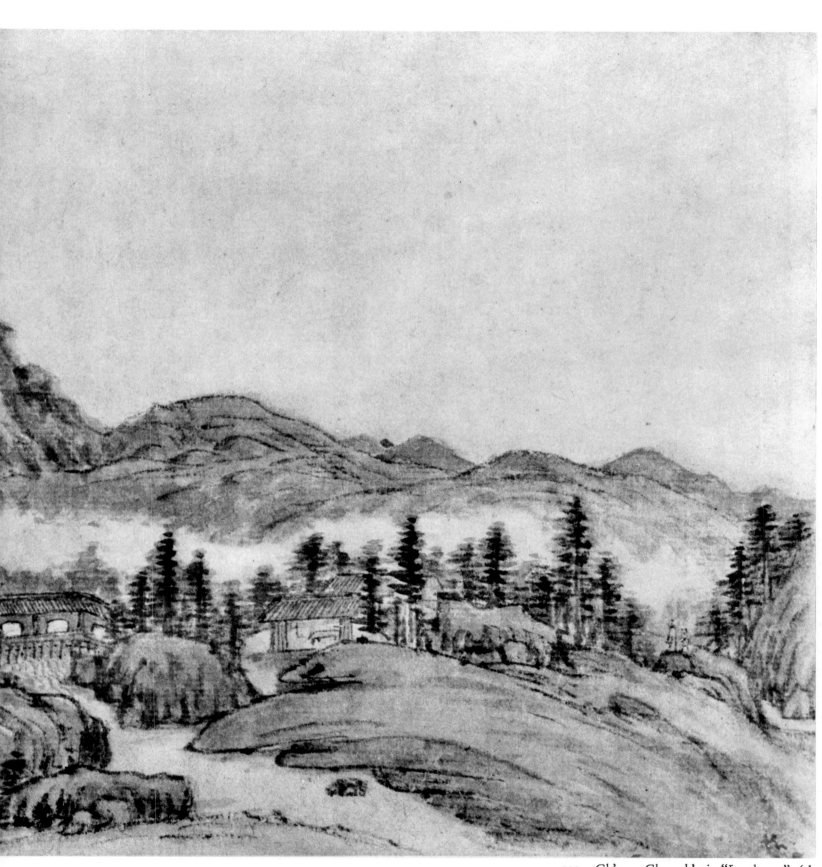

102. Ch'eng Cheng-k'uei. "Landscape" (album leaf). Ch'ing dynasty. Nanking Museum.

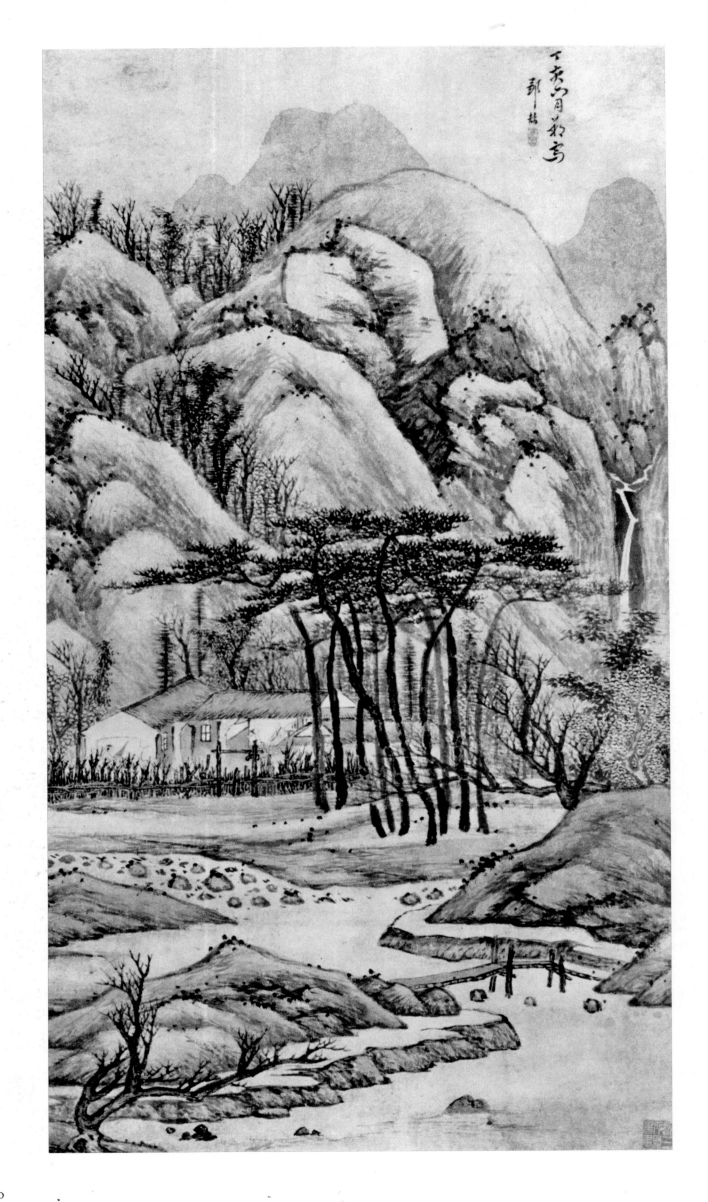

103. Tsou Che. "Monks Conversing in a Pine Forest." Ch'ing dynasty. Shanghai Museum.

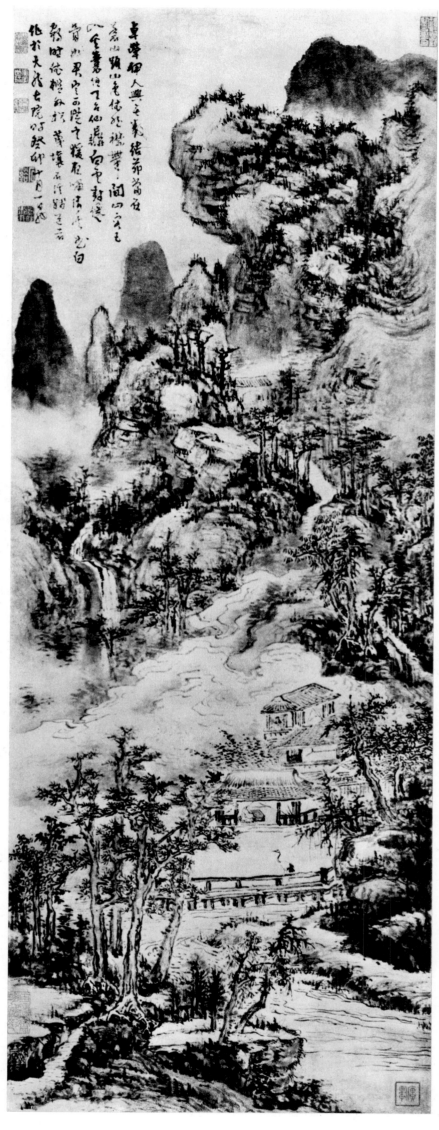

104. K'un Ts'an. "Thatched Hut in Green Mountains." Ch'ing dynasty. Shanghai Museum.

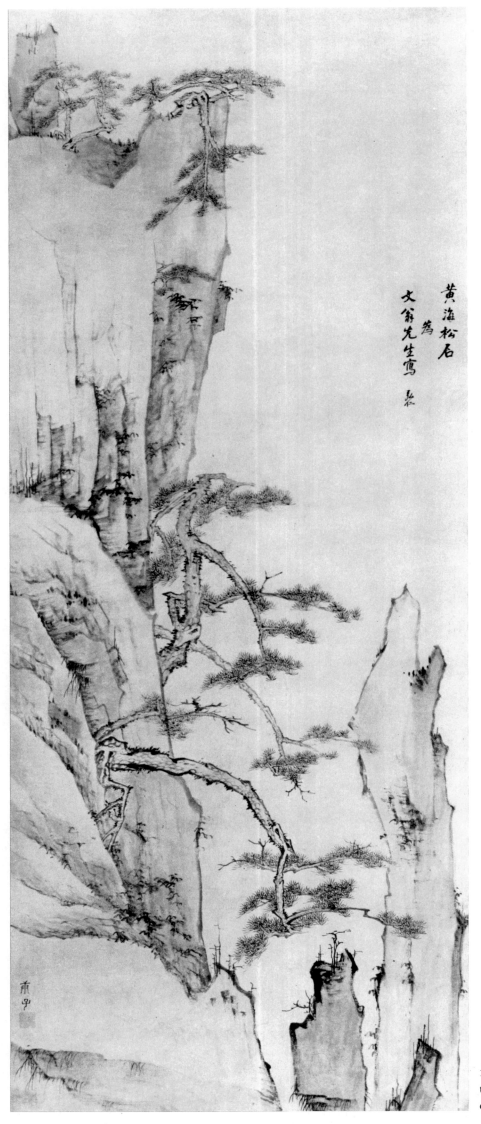

黄海松石

文翁先生寫
為

105. Hung-jen. "Pines and Rocks in
the Clouds of Huang-shan." Ch'ing
dynasty. Shanghai Museum.

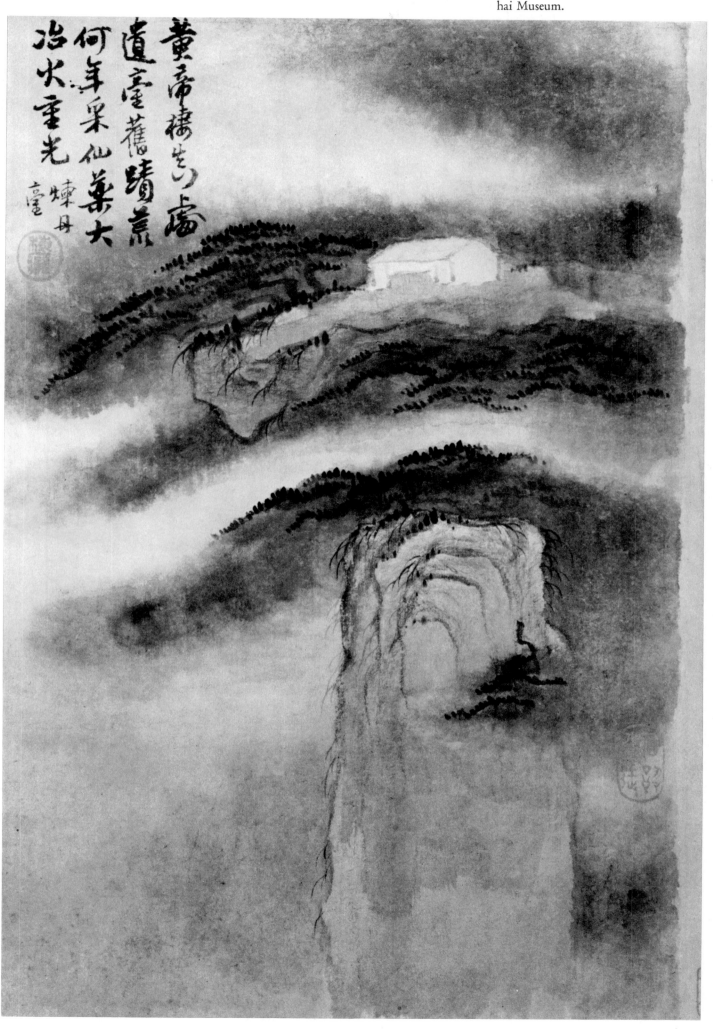

黄帝樓生山上

遺臺舊蹟荒

何年采仙藥

冶火童光

臺

煉母

107. Chu Ta. "Lotus" (album leaf). Ch'ing dynasty. Shanghai Museum.

居敬堂對
瓶花擬畫童
蓬

108. Chu Ta. "Landscape" (album leaf).
Ch'ing dynasty. Shanghai Museum.

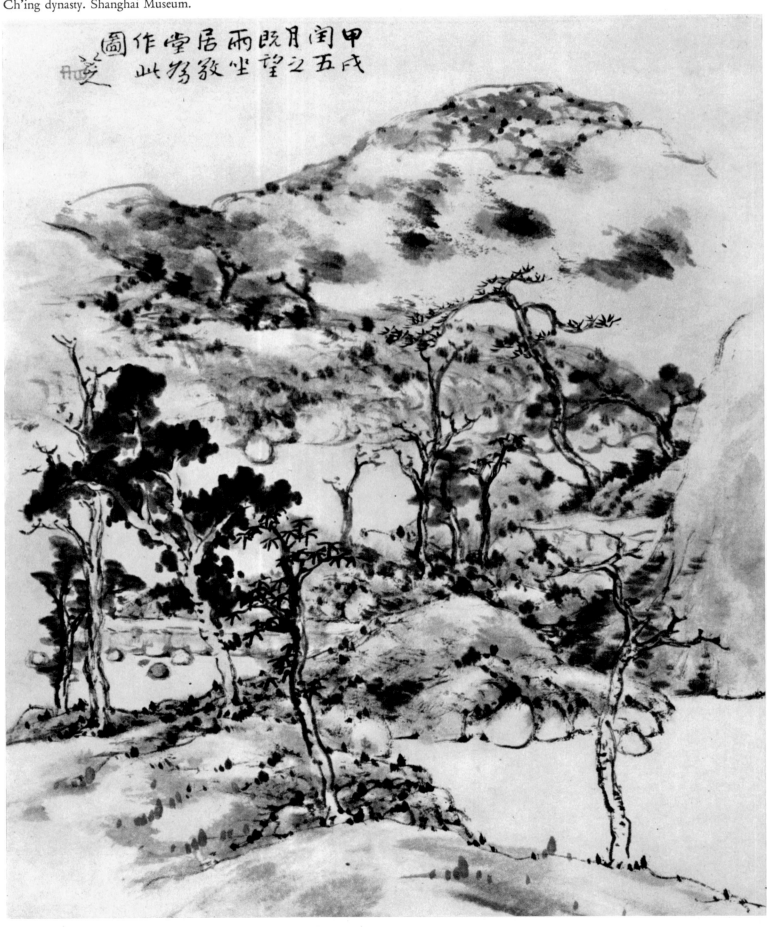

110. Kao Ch'i-p'ei. "Noble Scholar" (album leaf). Ch'ing dynasty. Shanghai Museum.

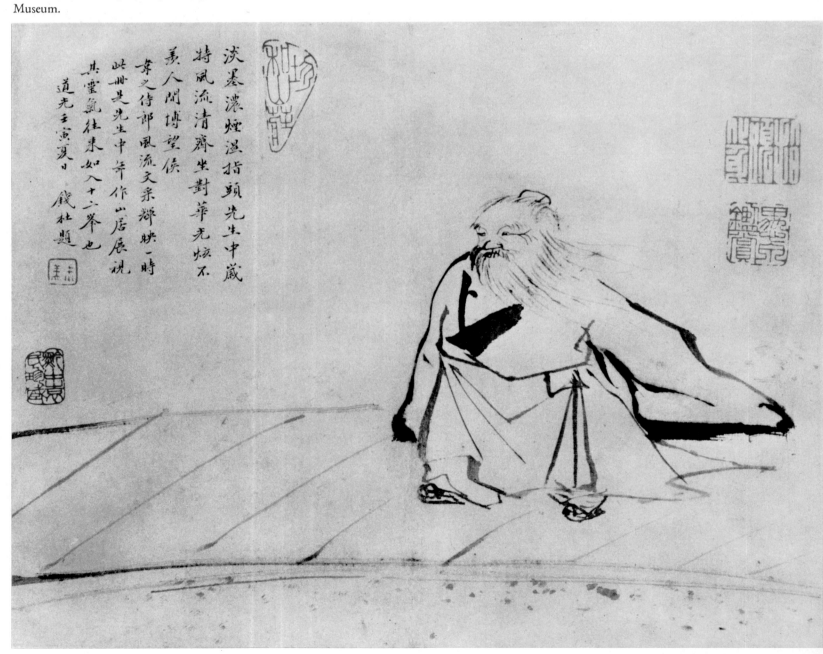

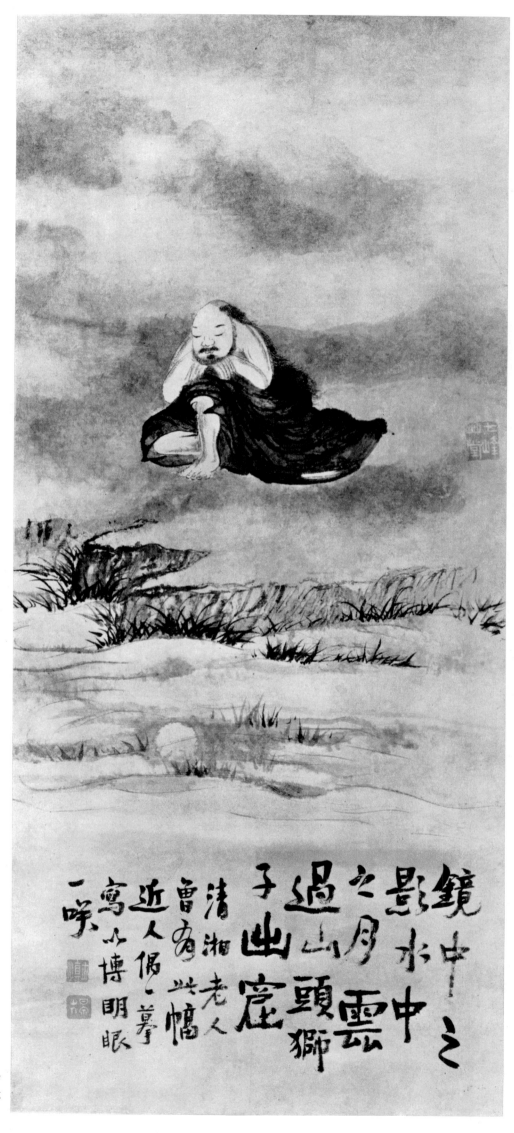

鏡中之影水中雲過山頭獅子峰窟

清湘老人曹曾為興此幅近人偶舉寫山博明眼一哂

111. Wang Shih-Shen. "After the Figure Painting of Tao-ch'i." Ch'ing dynasty. Kuangtung Museum.

112. Huang Shen. "Flowers." Ch'ing dynasty.
Nanking Museum.

113. Kao Hsiang. "Landscape" (album leaf).
Ch'ing dynasty. Shanghai Museum.

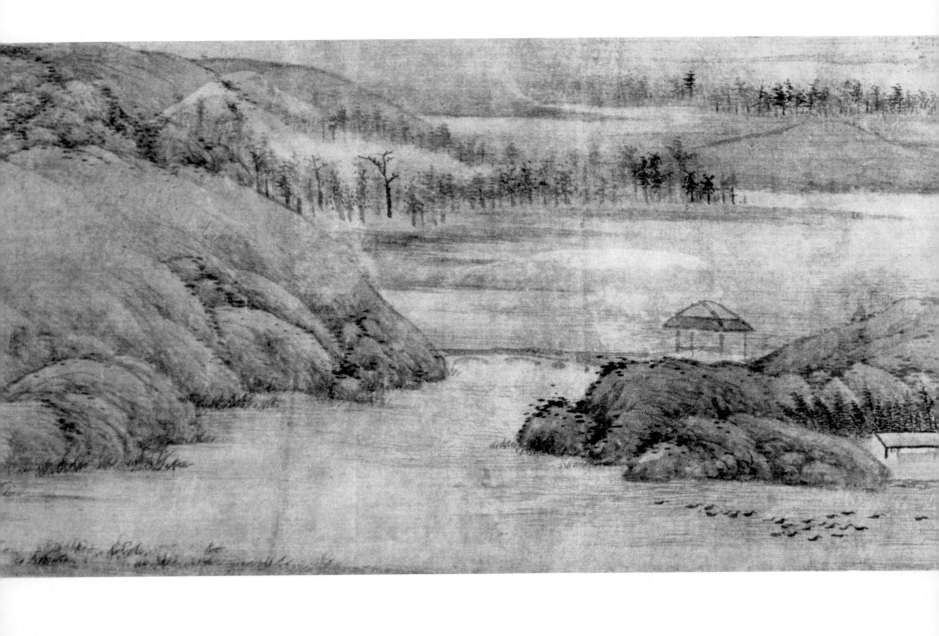

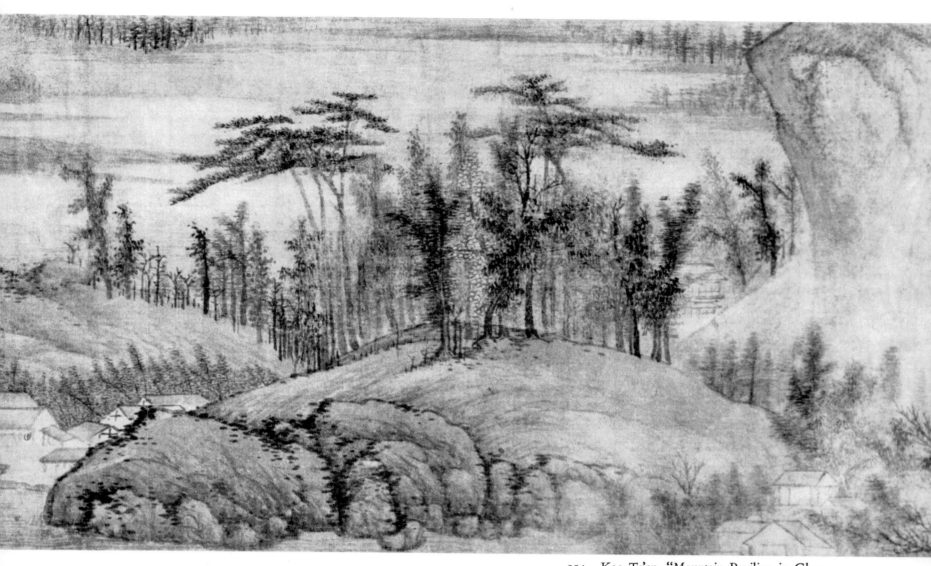

114. Kao Ts'en. "Mountain Pavilion in Clear Autumn" (detail). Ch'ing dynasty. Liaoning Provincial Museum.

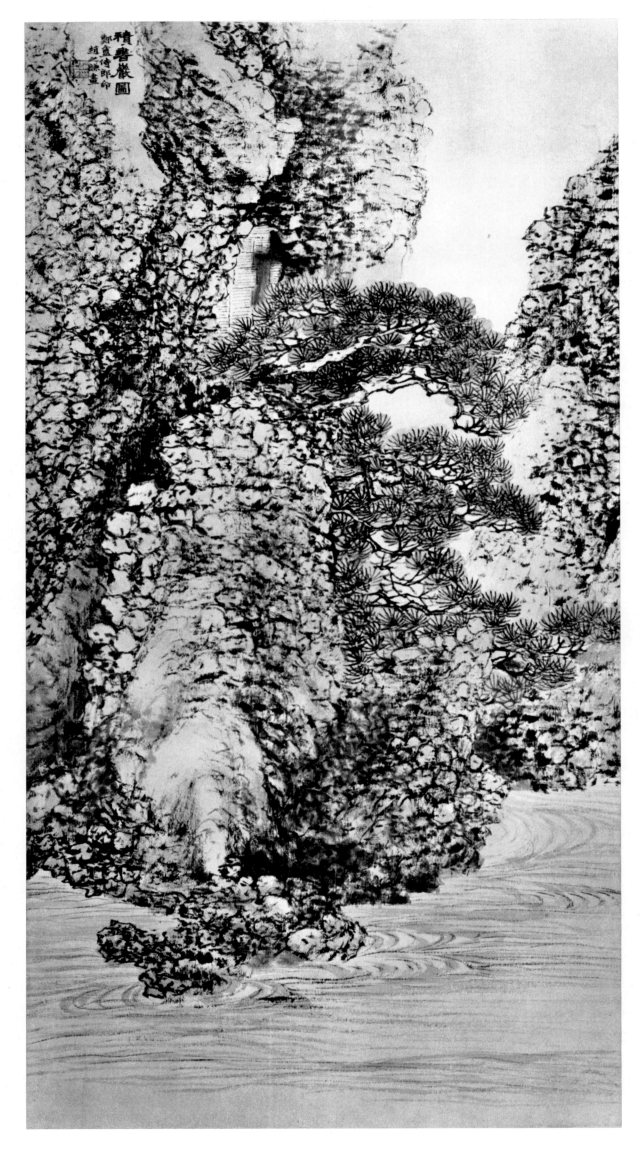

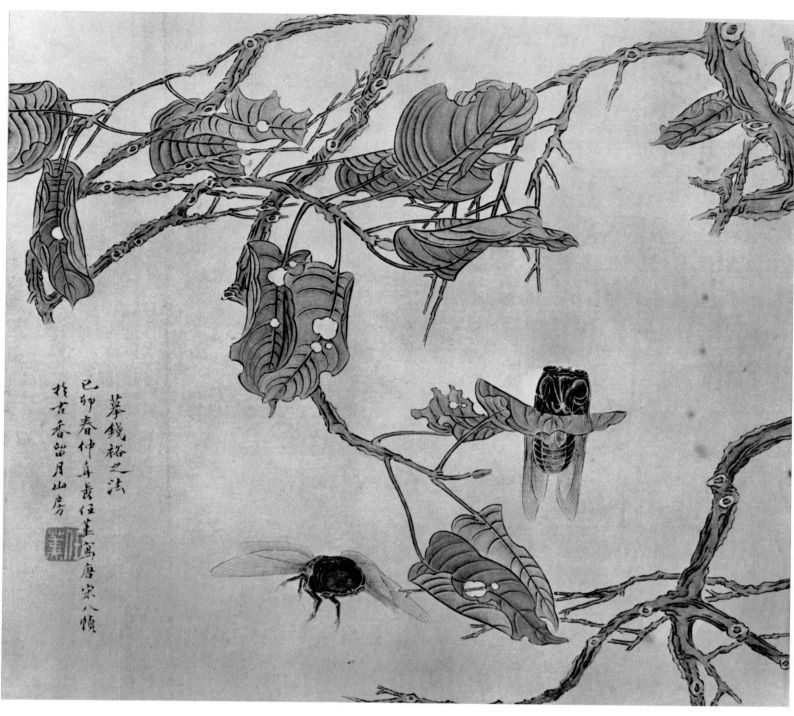

葦錢裕之法
巳卯春仲牟岳任薰寫唐宋八頃
於吉香留月山房

116. Jen Hsün. "Red Leaves and Autumn Cicadas." Modern.

◁115. Chao Chih-ch'ien. "The Chi-shu Cliffs." Ch'ing dynasty. Shanghai Museum

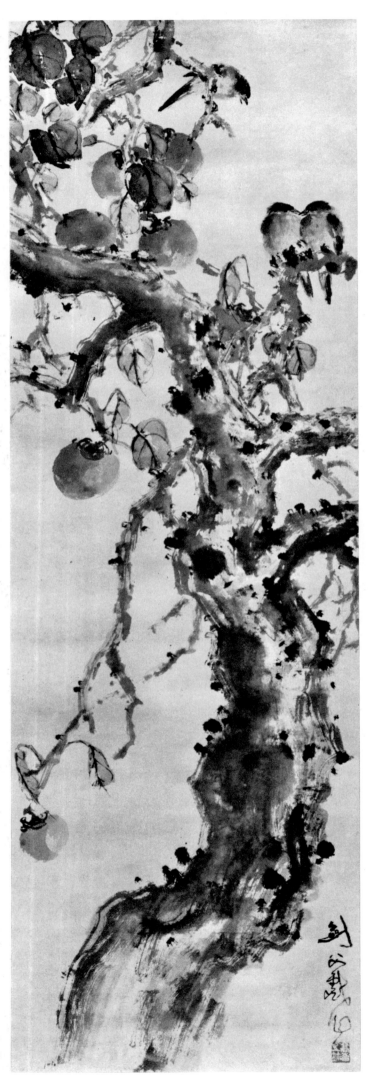

117. Kao Lun. "Starlings and Persimmon." Modern. Association of Chinese Artists.

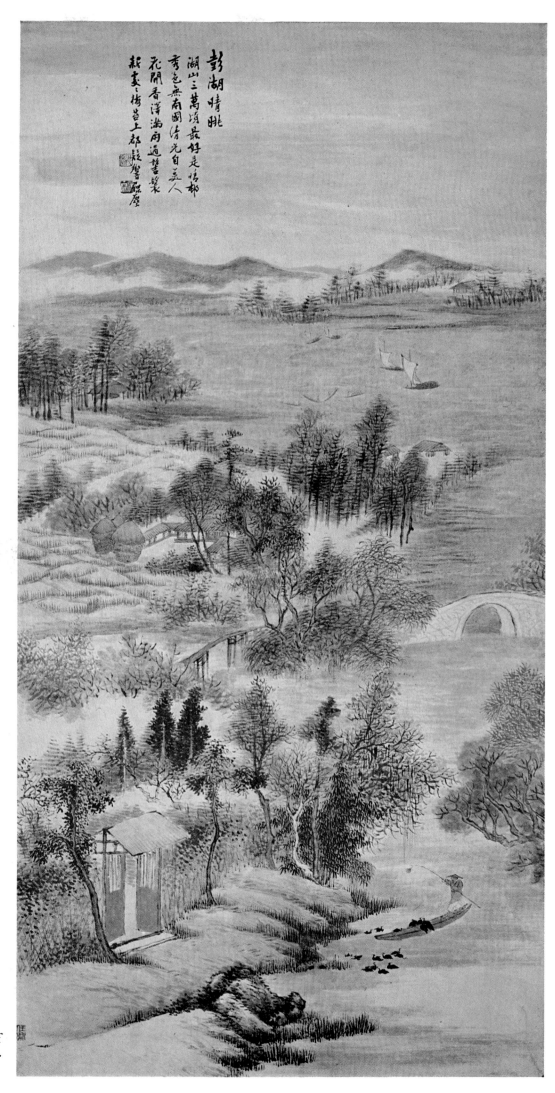

彭湖晴眺

湖山三萬頃最好是情都
奇色無兩國清先自美人
花開香浮渺渺府通善業
新麦上楊岩上郡鼓馨磁塵

118. Jen Yü. "A Clear View of
P'eng-hu." Modern. Kiangsu Provin-
cial Museum.

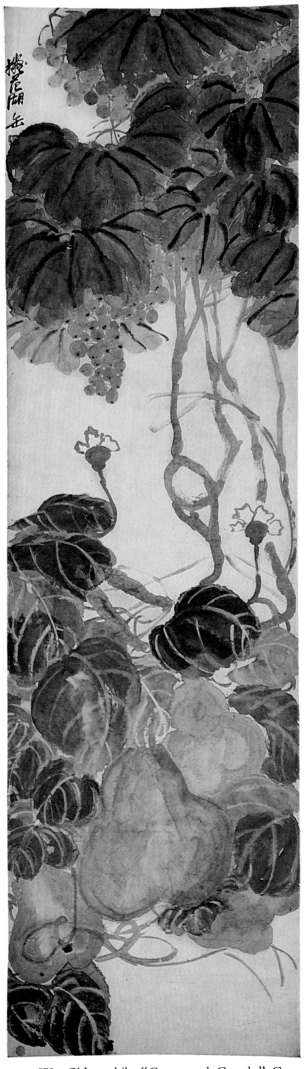

119. Wu Ch'ang-shih. "Grapes and Gourds." Con-
temporary. The Palace Museum.

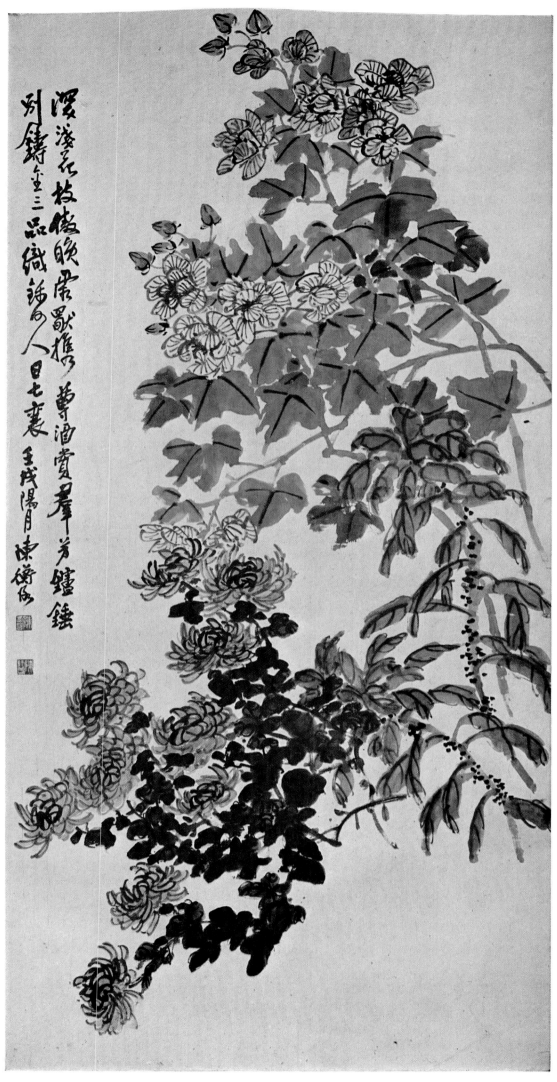

120. Ch'en Heng-k'o. "Autumn Flowers." Modern.
The Palace Museum.

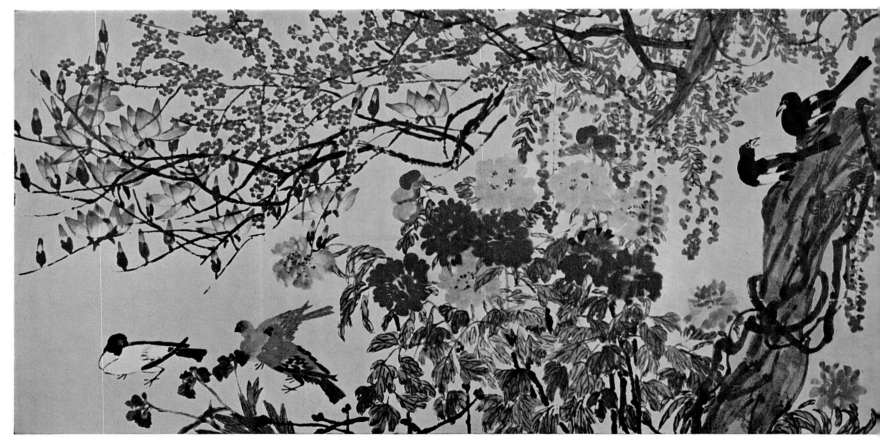

121. Ch'i Pai-shih. "Flowers and Doves." Contemporary.

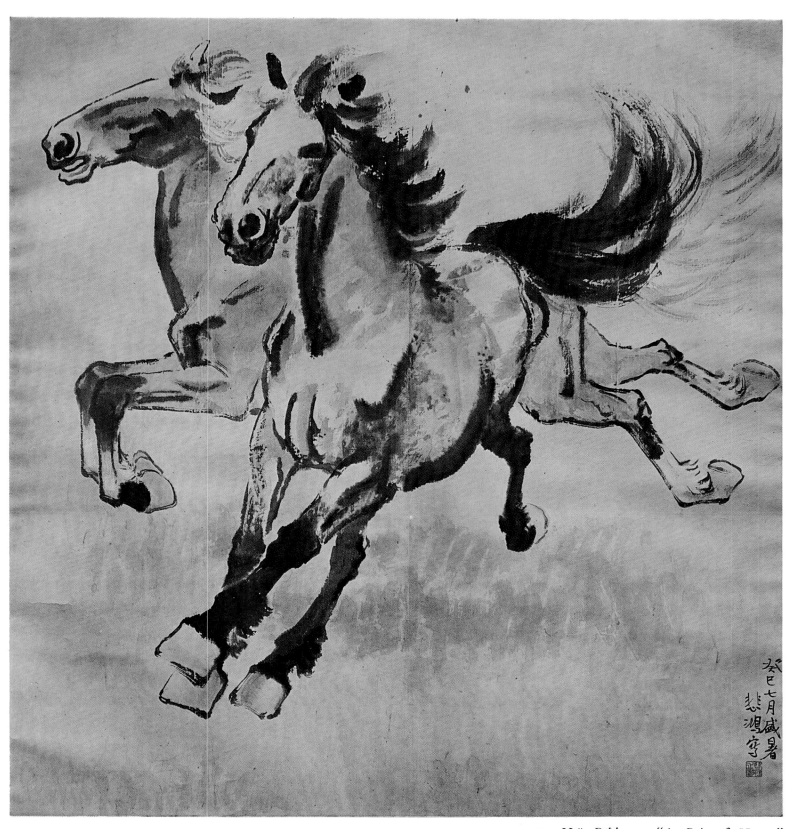

122. Hsü Pei-hung. "A Pair of Horses."
Contemporary.

123. Fu Pao-shih. "Chung-shan Tomb." Contemporary.

124. Li K'o-jan. "Green Rocks and Silken Falls." Contemporary.

. Chiang Chao-ho. "Village Girl Reading Chairman Mao." Contemporary. 126. Wu Tso-jen. "A Portrait of the Artist Ch'i Pai-shih." Contemporary.

127. Yeh Ch'ien-yü. "The Great Alliance of Races in China." Contemporary.

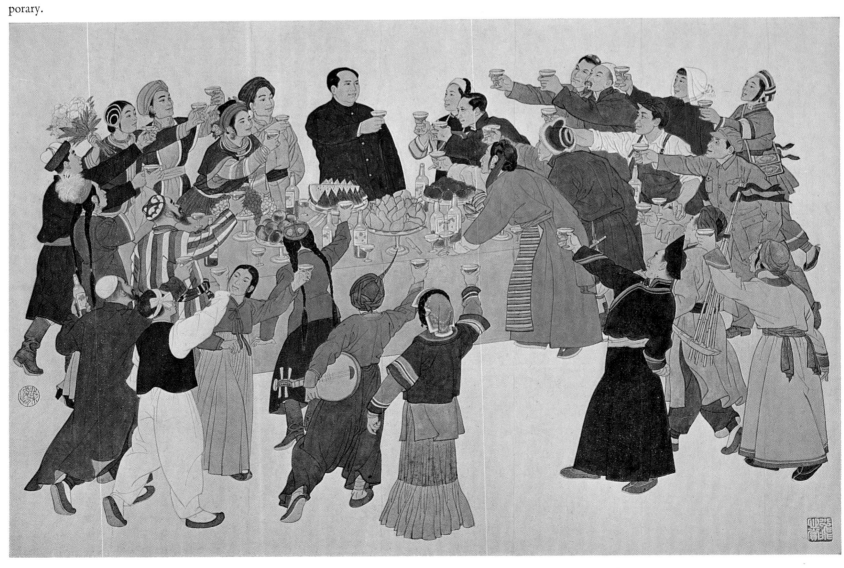

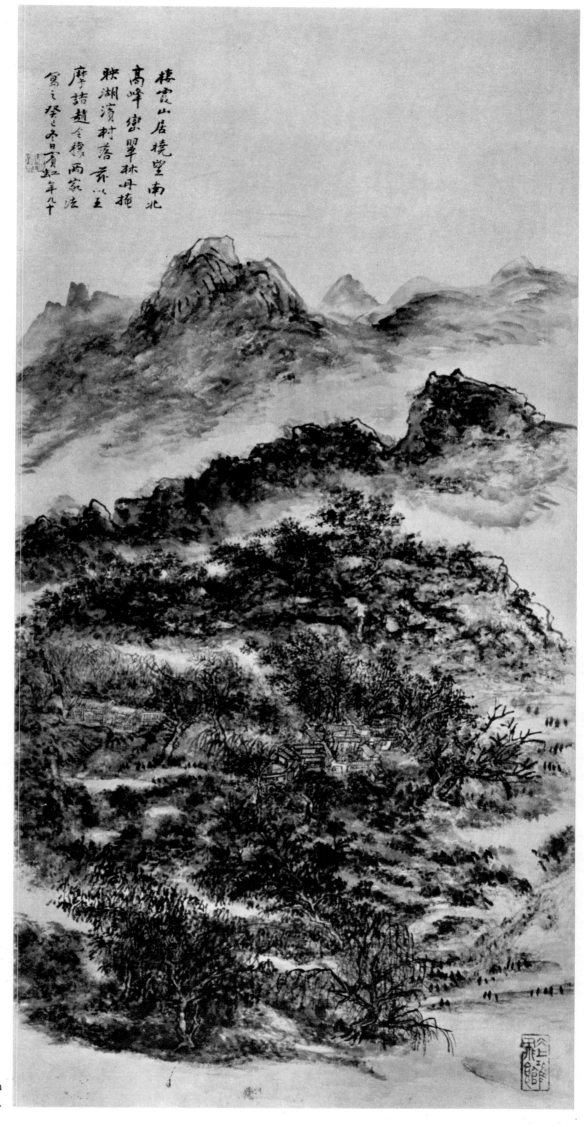

楼霞山居晓望南北
高峰翠翠林丹掩
映湖滨村落荒以王
摩诘赵令穰两家法
写之癸巳中日黄虹年八十

128. Huang Pin-hung. "Mountain
Residence at Ch'i-hsia." Contemporary.

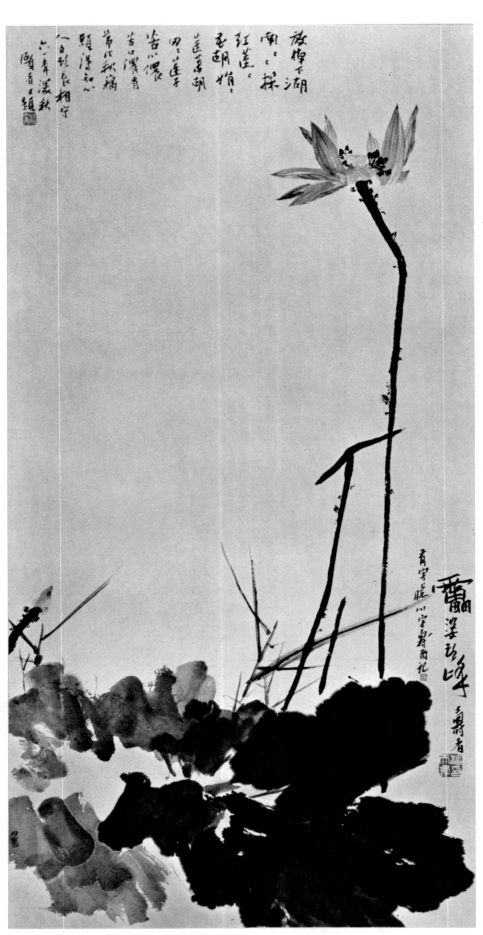

129. P'an T'ien-shou. "Red Lotus."
Contemporary.

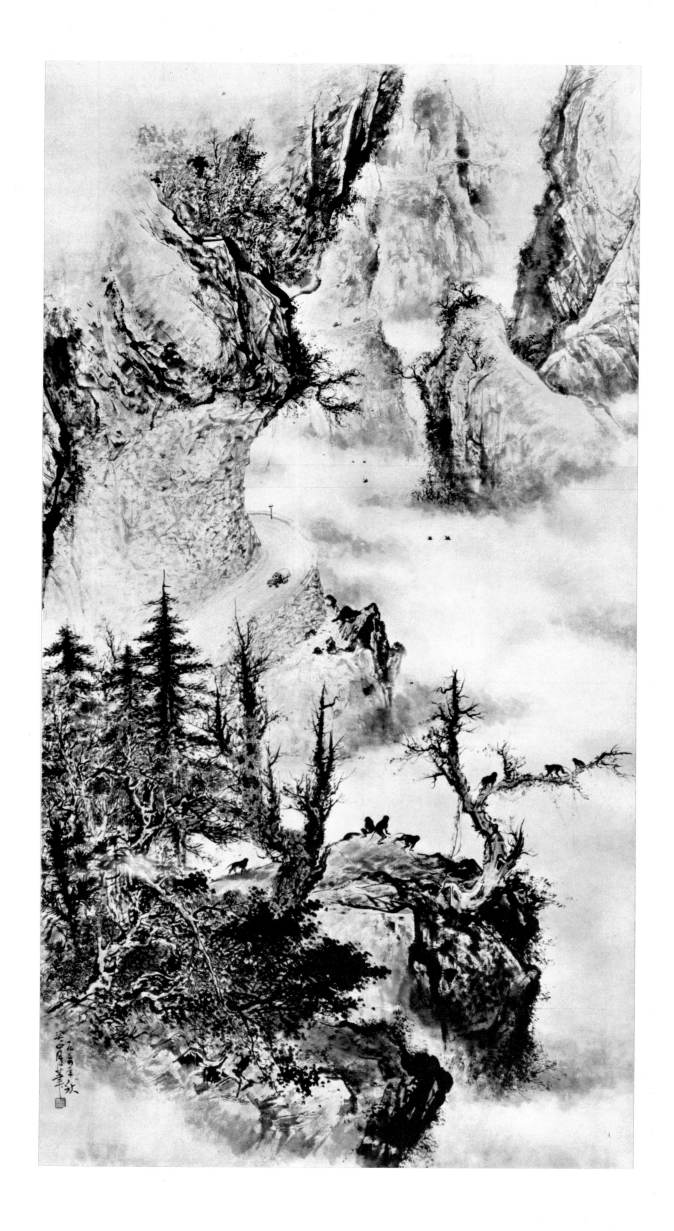

131. Hu P'ei-heng. "Shao-shan, the Place where
Chairman Mao Studied as a Youth." Contemporary.

武宗旭日

132. Hu P'ei-heng, Ch'in Chung-wen, Kuan Sung-
fang, Wu Ching-ting, Chou Yüan-liang, Chou Huai-
min, Kuo Ch'uan-chang, Yin Po-heng, Liu Li-shang,
and Yen Ti. "Sunrise at Tai-tsung." Contemporary.

太湖上
无锡鸿工营匠景象
景匠辉映后日见壮
崇美随兴漫写其间
一九六○年钱松嵒

170

134. Li Ping-hung. The "Revolutionary Uprising at Nan-ch'ang." Contemporary.

135. Wang Te-wei. "Heroic Sisters." Contemporary.

◁133. Ch'ien Sung-yen. "On Lake Fu-jung." Contemporary.

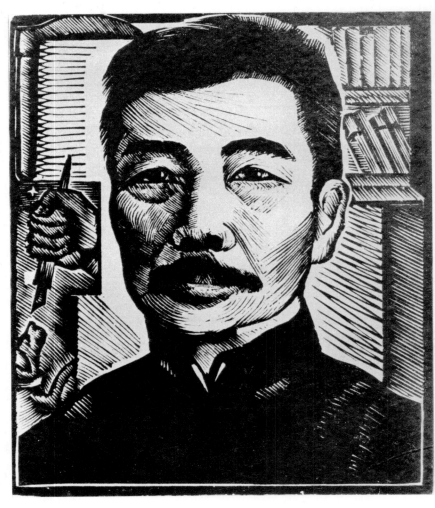

136. Li Ch'ün. "A Portrait of Lu Hsün." Modern.

137. Ch'en Yen-ch'iao. "Resistance." Modern.

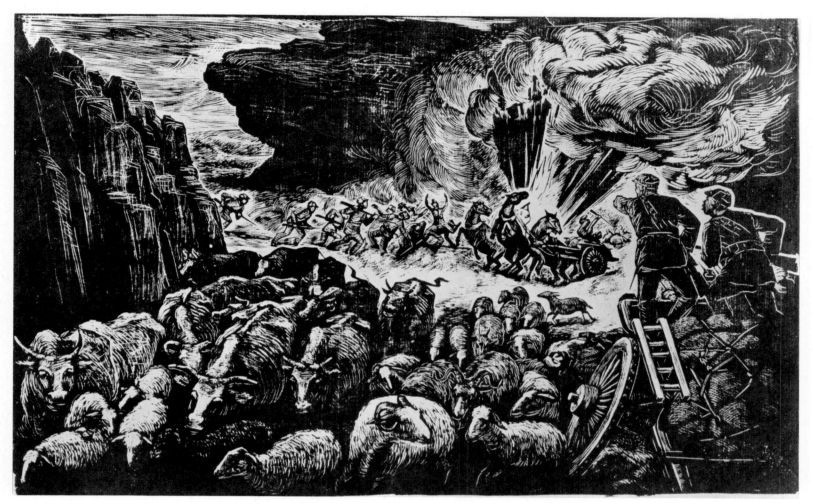

138. Wo Cha. "Seize Back our Cattle and Sheep!" Modern.

139. Yen Han. "Ambush." Modern.

173

140. Shih Lu. "Overthrow Feudal-
ism!" Contemporary.

141. Ku Yüan. "The Struggle to
Lower Rents." Modern.

142. Li Hua. "Arise!" from the
"Angry Tide" series. Contemporary.

143. Chang Yang-hsi. "Carrying Food
to the Fields." Contemporary.

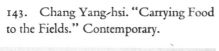

144. Hsiao Lin. "At the Construction Site of T'ien-an-men." Contemporary.

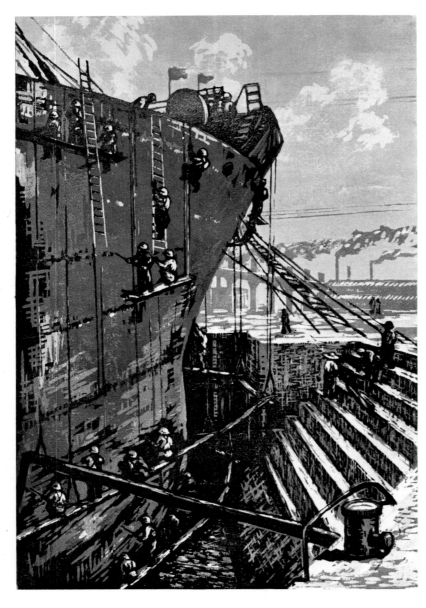

145. Shen Jou-chien. "In the Midst of Another Great Leap Forward." Contemporary.

146, 147. Paper Cutouts (actual size). Contemporary. Nanking.

148, 149. Paper Cutouts (actual size). Contemporary. Shanghai.

150, 151. Paper Cutouts (actual size). Contemporary. Fuchien.

152. Paper Cutout (actual size). Contemporary. Kiangsu.

153. Paper Cutout (actual size). Contemporary. Chekiang.

NOTES TO THE PLATES

Notes to the Plates

Jacket picture. *Li Shan. "Spring Scene at Ch'eng-nan." Ch'ing dynasty. Color on paper. 193.0 × 105.6 cm. Shanghai Museum.*

Li Shan, who lived from the end of the seventeenth century until after 1755, was styled Tsung-yang, and took the aliases Fu-t'ang and Ao-tao-jen. He was a native of Hsing-hua in Kiangsu Province.

In 1711 (K'ang-hsi 50), he became a holder of the *hsiao-lien* degree in the provincial examination. Having offended his superiors, he finally resigned the magistracy of T'eng District in Shangtung Province, and retired to his native place to pass a life of leisure. His friend Cheng Pan-ch'iao said of his style of living, "In twenty years of sensual dissipation, his colors raced across three thousand miles." Cheng also said that he had studied under Chiang Yen-hsi and Kao Ch'i-p'ei, while others relate that he took as his master Lin Liang of the Ming period. His style, however, was individualistic and unconventional. Li Shan eschewed traditional techniques, and without regard to skill or awkwardness, wielded his brush in a manner dictated by the surge of his own feelings. He was thus numbered among the Eight Eccentrics of Yang-chou.

This painting is known by its colophon as a late work of 1754 (Ch'ien-lung 19). Within the contrast and harmony of imposing crags and delicate peonies and wisteria, Li Shan's beautiful, limitless emotion surges forth. The eccentricity of his inherently impulsive brush is here suppressed, and his imperious spirit is sublimated in the grandness of the painting. It may be considered a representative work.

Frontispiece, 76. *Wen Cheng-ming. "Lady Hsiang and Madame Hsiang." Ming dynasty. Color on paper. Full size: 100.8 × 35.6 cm. The Palace Museum.*

Wen Cheng-ming (1470–1559) was a native of Wu District in Kiangsu Province. His given name was Pi, and his style was Cheng-ming, by which he was commonly known. His aliases were Heng-shan and T'ing-yün-sheng. A disciple of Shen Chou, he was praised as a master of poetry, calligraphy, and painting. With his teacher Shen Chou he was a founder of the renaissance of literati painting, and was revered as the leader of the Wu school. He followed in the line of the Four Great Masters of the late Yüan period, but being influenced by Chao Meng-fu and T'ang Yin (who succeeded to the tradition of the imperial painting academy), and further taking an interest in Li T'ang and other Northern Sung painters, he was master of figure, flower-and-bird, and orchid and bamboo painting,

as well as the landscapes that were the special accomplishment of the Wu school.

The Lady Hsiang and Madame Hsiang of this painting, as can be surmised from the painter's own inscription, are the daughters of the Emperor Yao, called O-huang and Nü-ying, who became empress and consort to Emperor Shun. When Emperor Shun died in the meadows of Ts'ang-wu (Ning-yüan District in Hunan Province), the sisters jumped into the Hsiang River (which runs into Tung-t'ing Lake in Hunan) and became river spirits. Thus the Empress O-huang was named Lady Hsiang and the consort Nü-ying was called Madame Hsiang. This painting is a work of 1517, when Wen Cheng-ming was forty-eight. According to the painter's remarks in the lower left-hand corner, it was done in reminiscence of a painting of Lady and Madame Hsiang by Chao Meng-fu that he had seen when young. Its coloring is said to be after the manner of Ch'ien Shun-chü of the Yüan dynasty. But according to the lower right-hand inscription of Wang Chih-teng, who saw the painting thirty years later, Wen Cheng-ming first had Ch'ou Ying do the coloring, but was unsatisfied and did it himself in a manner far beyond the ability of Ch'ou Ying. Further, the upper right-hand colophon of Wen Chia (second son of Wen Cheng-ming), who saw the painting sixty-two years later, says that the delicacy of its brushwork and coloring are unmatched by any other copies, suggesting thus that in his time imitations had already been done. Though the design of this work may be based upon an older painting, it is an excellent example of figure painting that exhibits in its brushwork and coloring Wen Cheng-ming's unique character of proper elegance.

1, 2, 29, 30. *Ku Hung-chung. "The Banquet of Han Hsi-tsai" (details). Five Dynasties. Color on silk. Full size: 28.7 × 335.5 cm. The Palace Museum.*

Han Hsi-tsai (902–70), styled Shu-yen, was from a noted family in Pei-hai, Shantung Province. Unrestrained and carefree, servile in no respect, endowed with a brilliant and versatile talent, he was hailed as "the crown of contemporary romantics." During the T'ung-kuang reign period (age 20–23), after taking his *chin-shih* degree, he became a freelancer who threaded his way skillfully through political intrigue and slander, and participated at will in court councils. In his old age he squandered his fortune amid the wine cups, and indulged night and day in bacchanalian orgy in which he matched up his guests, priest and layman alike, with the hundreds of concubines that he kept. This nonsense even the irresolute latter emperor Li Yü could

finally no longer bear, and in the interest of urging Han to a measure of self-discipline and dignity, he ordered Ku Hung-chung, at the time a painter-in-attendance at the imperial painting academy, to portray "the nightless city of pleasure."

The connection of Ku Hung-chung with "The Banquet of Han Hsi-tsai" begins with this story; but it is related that at this time Ku Ta-chung and Chou Wen-chü were also ordered to do the same work, and the catalogues contain several references to paintings of a similar theme.

In particular, there have been attempts to ascribe the painting to the well-known Chou Wen-chü. A copy of Tu Chin's "The Banquet of Hsi-tsai" (fifteenth century) done by Kanō Yasunobu of Seisen in the fourteenth year of the Bunka era (preserved in the Tokyo National Museum), except for an increase of background objects and differences in coloring, is entirely the same as that in the Palace Museum with respect to the arrangement, posture, and action of the figures. Nonetheless, Tu Chin's colophon clearly states, "I copied the work of Chou Wen-chü." Further, a banquet painting attributed to Wang Chen-p'eng (first half of the fourteenth century) has precisely the same design as this copy. These facts suggest that the attribution of this unsigned scroll to Ku Hung-chung may not be adhered to with certainty.

The scroll is divided into five sections, in each of which Han Hsi-tsai appears wearing a "thunder turban," a fashion of his own creation. The first section (here published) is a banquet scene in which Han listened to a *p'i-p'a* played by the sister of Li Chia-ming, vice-commissioner for entertainment quarters. The second section shows five men, two women, and one monk. Han, standing, beats a drum, while his favorite courtesan, Wang Wu-shan, dances the *lu-yao*. It was this portion that later became an established painting theme, and was also imitated by Ch'ou Ying and T'ang Yin. The next section, with one man and seven women, shows Han seated on a bed washing his hands in a basin. The fourth section (here published) is a scene of flute playing. The *ti, kuan,* and *p'ai-pan* (used by men) were popular musical instruments of the time. The last section, consisting of three men and three women, depicts a man seated on a chair holding the hand of a loosely attired woman, while Han, standing behind the man, directs something. According to the *Ta kuan lu,* this scene is called "the secret play of the illicit guests." As the scroll is unrolled, the most shocking scene is presented at the last—an arrangement probably designed to delight the eye of the viewer. In the case of the Palace Museum piece, however, it may be supposed that in line with the puritanism of Sung paintings, postures were somewhat rectified.

The colophons of Pan Wei-chih and Wei To, etc., at beginning and end, and the seals of connoisseurs and appraisers leave no doubt that this scroll is the one recorded in the *Shih-ch'ü pao-chi.* The line, coloring, style, and the painting-within-a-painting design of the screens on the scroll; the fact the colophonists are all of the Yüan period or later; the fact that the interest in a world of pleasure is firmly restrained by the characteristically prudish spirit of Sung, such that none of the figures lose their decorum; and the alert, clever faces of these courtesans with broad, eminent foreheads, all leave no doubt that this scroll is a late Northern Sung work.

Allowing for duplication of entries in the painting catalogues, it is yet known that there were in circulation three or four versions of the so-called "Banquet Paintings from the Brush of Ku." It is fairly certain, however, at least on the authority of recorded descriptions of the paintings, that all were later imitations. Hence it seems probable that the work contained in the Palace Museum is the oldest and best of the "Banquet of Han Hsi-tsai" scrolls, and the only one among several lost banquet paintings to have survived the ravages of history. In any case, the "A-1" classification given this scoll by the appraisers of the Ch'ing court does indeed appropriately speak the praise and fondness accorded to this famous painting.

3, 32. *Wang Shen. "Misty River and Folded Peaks" (detail). Northern Sung. Color on silk. Full size: 45.3 × 165.5 cm. Shanghai Museum.*

Wang Shen (latter half of the eleventh century), styled Chin-ch'ing, was the descendent of Wang Ch'üan-pin, a minister of merit in the founding of the Sung empire. The family was originally from T'ai-yüan in Shanhsi Province, but had for several generations resided in the Sung capital of K'ai-feng in Honan Province. He was married to Princess Ta-ch'ang of Wei (1051–80), the second daughter of the Emperor Ying-tsung and the younger sister of the Emperor Shen-tsung, but due to his political stand with the conservative party, he was expelled from the capital after the death of the princess. During the Yüan-yu reign period of the Emperor Che-tsung (1086–93), he was reinstated in the central government. He built within his residence a "Hall of Painting Treasures," where he gathered outstanding paintings and calligraphy. He was an intimate friend of such famous literati as Su Shih, Huang T'ing-chien, Mi Fu, and Li Kung-lin, and was fond of a life of elegance.

Wang Shen's style of painting was learned from that of Li Ch'eng, and he often did ink wash landscapes in the "level distance" perspective. He was, however, also accomplished in the glittering "gold and jade" style of landscape, which employed the technique of Li Ssu-hsün of T'ang. In addition to these, he also did the bamboo in ink so popular at the time, taking Wen T'ung as his master.

Wang Shen's painting of "The Misty River and Folded Peaks" and the poem that Su Shih wrote in praise of it are famous events, and the work is included in the *Hsüan-ho hua-p'u,* a catalogue of the end of Northern Sung. From Ming times, several paintings of the same title were in circulation, some of them carrying Su Shih's poem as well, but the relation of the present painting to the "Misty River and Folded Peaks" originally recorded in the *Hsüan-ho hua-p'u* is not clear. Further, the grand perspective that characterized the composition of the earlier T'ang style and the outline of mountain contours that marks the drawing of Yen Wen-kuei are quite different from the style of the "Fishing Village in Light Snow" (Pl. 34), which is also attributed to Wang Shen. The scene of the painting is not necessarily consistent with the description given in Su Shih's poem, and it carries no seal. As these facts reveal, the identity of the painter and colophonist is not without its problems. Nevertheless, a careful scrutiny of the painting itself leaves no room for doubt that it is a work of no later than the end of the Northern Sung period. As an example of the revival of T'ang painting that found support among the literati nobility at the end of Northern Sung, it is an important and priceless legacy. The attribution of the painting to Wang Shen is probably due to the title "from the brush of Wang Shen" at the head, written in the "slender gold" style of calligraphy reminiscent of the Emperor Hui-tsung.

4, 35. Chang Tse-tuan. "Ascending the River at the Ch'ing-ming Season" (detail). Northern Sung. Color on silk. Full size: 24.8 × 528.0 cm. The Palace Museum.

Chang Tse-tuan (first half of the twelfth century) was styled Cheng-tao and was a native of Tung-wu in Shantung Province. As a young man he went to the capital Pien-ching to study, and began the study of painting there. He was accomplished at architectural painting, and developed his own school through his fondness for painting buildings, bridges, boats, and carriages.

There are several extant works bearing the title "Ascending the River at the Ch'ing-ming Season, by Chang Tse-tuan," but all are copies or forgeries of a later age with the exception of the one introduced here, which is thought to be the original work on which the others were based. The present scroll came into the possession of persons in the Chin state after the collapse of Northern Sung, and after several changes of ownership during Yüan and Ming times, it finally came into the imperial palace in the Ch'ing dynasty. The scroll is now missing the latter portion depicting the interior of the city, making it impossible to see any inscription that Chang might have written at the end. Nevertheless, the realistic expression of the scene in the painting possesses a verisimilitude that could hardly be expected of a copy, and the work may be judged without doubt to be Chang Tse-tuan's original.

At the time of ch'ing-ming (from the vernal equinox to the fifteenth day of spring), cityfolk go out to the suburbs to visit the graves of their ancestors, which become as bustling as a marketplace. At the approach of evening, everyone returns again to the city. This was an annual spring event in the Northern Sung period. The present scroll depicts an afternoon of the ch'ing-ming holiday. At the head of the scroll is portrayed the outskirts of Pien-ching, the crowds already thinning, with a row of willow trees just begun to bloom. The scene moves gradually along the Pien River toward a prosperous town. The painting breaks off at the city wall, but judging from copies, it must have continued on to the Chin-ming Pond. In the portion published here the rainbow bridge that spans the Pien River occupies the center. The bridge, dispensing with supporting pillars for the convenience of boats passing through, the roadway beneath the bridge for the use of the boat haulers, and the warped rafters of the roofs seen in the foreground, all have a realism that only an original could possess.

This realism is closely related to the development in Sung of genre and architectural painting (a kind of mechanical drawing that depicts houses, boats, and carriages). In architectural painting, the name of Kuo Chung-shu of the early Northern Sung period is well known, but Yen Wen-kuei, who lived about a century before Chang Tse-tuan, cannot be ignored. Besides landscapes, Yen Wen-kuei also often painted ships and barges, and his "The Festival of the Seventh Evening," depicting the festivities on the night of July 7 when girls offer paper and thread in prayer for skill at sewing, is a work of great reputation. Both the "Festival of the Seventh Evening" and "Ascending the River at the Ch'ing-ming Season" are new themes produced by the flourishing of urban society in Northern Sung, and the strong expressive power seen in the painting may be said to be a reflection of the energy possessed by that urban society.

It is not clear on whom Chang Tse-tuan modeled his style. But judging from the spare use of ink in the "parched brush" technique employed on the trees and embankments, and the use of "level distance" perspective in the composition at the beginning of the scroll, he seems to have adhered to the Li Ch'eng school, and is an extraordinary master of architectural, genre, and figure painting.

5. Kao K'o-kung. "Spring Mountains on the Verge of Rain." Yüan dynasty. Light color on silk. 100.5 × 107.0 cm. Shanghai Museum.

Kao K'o-kung (1248–1310) was styled Yen-ching, and took the alias Fang-shan. His ancestors were Uighurs from Central Asia who had lived in Peking for many generations. He served the Yüan court and rose to the presidency of the Board of Punishments. Kao was adept at both landscape painting and ink bamboo. He studied first the landscape style of Mi Fu and Mi Yu-jen, then later the work of Li Ch'eng and Tung Yüan. Wang T'ing-yün of the Chin state was his model for ink bamboo.

There were a variety of landscape styles current in the Yüan dynasty, many based on the revival of earlier forms. From among these Kao K'o-kung based his own work fundamentally on the Mi style, and adopted elements from Tung Yüan, who was later made the foundation of the southern Nan-tsung tradition. He was thus with Chao Meng-fu a pioneer in Yüan literati painting, and along with the Four Great Masters is regarded as a representative painter of the Yüan period.

This painting is a landscape scene viewed from a somewhat high perspective. The effect of depth and breadth are achieved by interspersing cloudy mists between expanded ink surfaces. The soaring central mountain is in the Tung Yüan style, while the moss spotted on the mountains, the trees, and the mists are all in the Mi Fu manner. The technical foundation of Kao's painting is clearly exhibited here. His fine brushwork and elaborate finishing perhaps seem formalistic and lacking inspiration in comparison with the later Four Great Masters, but they opened new realms of elegance and tranquillity. Kao K'o-kung's works are few in proportion to his fame. This painting is thus an important piece through which the use of the Mi Fu and Tung Yüan landscape styles in the Yüan period can be known.

6. Sheng Mao. "Clear Song on an Autumn Boat." Yüan dynasty. Color on silk. 167.5 × 102.4 cm. Shanghai Museum.

Sheng Mao, styled Tzu-chao, was a native of Chia-hsing in Chekiang Province. He lived next door to Wu Chen, one of the Four Great Masters of Yüan, and was even said to have been the most popular of the two. Sheng Mao was probably the younger. It has been estimated that he was born in the middle of the Chih-yüan reign period (1264–94) and died late in the Chih-cheng reign period (1341–67). Skilled at landscape, human figure, and flower-and-bird painting, he was said to be "rich in a very refined beauty, but occasionally too artful." He first studied painting under Ch'en Lin, an artist within the academy tradition who was influenced by the restorationism of Chao Meng-fu. He did landscapes in the academy style, some modeled on Hsia Kuei, but under the influence of Chao Meng-fu seems to have further taken note of the Chiangnan landscape tradition of the Sung masters Tung Yüan and Chü-jan. The work presented here is a landscape and figure painting in which the distant mountain across the water as well as the foreground trees and banks and the figures in the boat are brought into a large close-up perspective. Its style should be

described as that of Tung Yüan seasoned with a touch of Chao Meng-fu. Although somewhat rigid, the painting shows typical Yüan features in its formalistic technique and bland, descriptive flavor. The work is essentially done under the influence of Chao Meng-fu, and is not unreasonably attributed to Sheng Mao.

7. *Chao Yung. "Orchid and Bamboo." Yüan dynasty. Color on silk. 74.6 × 46.4 cm. Shanghai Museum.*

From behind a rock drawn with pale ink and dry brush, young bamboo and rose branches raise their heads, their weight caught by the casually placed rock on the bank at the left. Between them, orchids done in "boneless" colored wash bloom and spread their leaves. Though the coloring is bright, the impression is yet one of loneliness.

The painter, Chao Yung, was a native of Kuei-an in Chekiang Province. He was styled Chung-mu, and attained the rank of painter in attendance at the Court of Assembled Worthies. The son of Chao Meng-fu and his wife Kuan Tao-sheng (herself a well-known painter of ink bamboo), he was born in 1289 (Chih-yüan 26) and the date of his death is unknown. He was a skillful painter of human figures and horses, and also of bamboo and rocks, all of which seem to have been within the family tradition.

Paintings of the "four gentlemen," or orchid, bamboo, plum, and chrysanthemum, were favored by literati as a projection of their own personality. The origin of orchid painting is not clear, but the family of Chao Meng-fu, and the literati and monks who surrounded them, were all noted orchid painters. Most surviving orchid paintings, however, are done in ink wash only, and colored orchids such as these are rare. In this painting the effect is achieved through the interplay of colors, rather than the linear beauty usually seen in the ink wash type.

8. *Pien Wen-chin. "Spring Birds and Flowers." Ming dynasty. Color on silk. 155.0 × 99.0 cm. Shanghai Museum.*

Pien Wen-chin was by one account styled Ching-chao, and by another named Ching-chao and styled Wen-chin. Some say that he was a native of Sha District in Fuchien Province, others that he was from Lung-hsi in Shanhsi Province. The dates of his birth and death are not clear. In the Yung-lo reign period (1403–25) in early Ming he was summoned to the capital at Nanking and appointed a painter-in-attendance in the Wu-ying Palace. He painted chiefly flowers and birds, and together with Chiang Tzu-ch'eng and Chao Lien, specialists respectively in figure and tiger painting, was praised as one of "the three wonders of the court."

This style of flower-and-bird painting, in which outlined objects are filled in with splotches of heavy color, was begun by Huang Ch'üan of the Five Dynasties period and carries his name. It was revived in the Yüan period and practiced through Ming times.

This painting is an example of the Huang style in early Ming. The flowers, trees, bamboos, and rocks are done in outlines of varying width; the colors are heavily applied, but remain fresh and without oppressive feeling. Compared with the Huang-style flower-and-bird painting of Lü Chi, famed for his Hung-chih Painting Academy, Pien Wen-chin's work shows a higher quality and a more traditional composition and brushwork, due to the absence as yet of any influence from the Che school. The classical manner of this work was not only the individual style of Pien Wen-chin, but also a restriction generally imposed on the period. The upper left-hand corner bears the signature "Painted by Pien Ching-chao of Lung-hsi, painter-in-attendance in the Wu-ying Palace." It is a representative piece among the few surviving works of this painter.

9. *Lin Liang. "Wild Camelia and White Birds." Ming dynasty. Color on silk. 152.3 × 77.2 cm. Shanghai Museum.*

Lin Liang, styled Yi-shan, was a native of Kuangtung Province. He was recommended for appointment as a court painter in the Hung-chih reign period (1488–1505). A specialist in flower-and-bird painting, he did both colored works of great ingenuity and ink wash paintings with features of a vigorous cursive script. His style, particularly in the ink wash paintings, was based on a local variant of the traditional ink wash "flowers and feathers" type current in the late Southern Sung and early Yüan periods. In contrast to the flower-and-bird painter Lü Chi, however, who entered the painting academy at the same time and was judged "finally unable to transcend the court style," Lin Liang's work was held to possess "vigor and originality well worth noting."

This painting, using bright color on part of the camelias and birds, gives a different effect from the ink wash paintings in which Lin was particularly skilled. The method of coloring is not in the Huang Ch'üan manner, but is the same "boneless" technique employed in ink painting. If this work is one of his "skillfully refined flower-and-bird paintings" referred to in painting histories, then his use of color and ink wash would seem to be no different at all. The large rocks, contoured in the axe-cut manner, impart an imposing feeling to the painting, and are done under the influence of the Che school. The composition, placing a white male pheasant high on a rock in the upper part of the picture, is a new design with Ming flower-and-bird painting, which aims at a more imposing and grand expression. There are quite a few of Lin Liang's paintings in Japan, but no colored work has yet been found.

10. *Lü Chi. "Swimming Ducks." Ming dynasty. Color on silk. 153.4 × 98.3 cm. Shanghai Museum.*

Lü Chi, active in the late fifteenth and sixteenth centuries, was a native of Yin District in Chekiang Province. He was styled T'ing-chen, and used the aliases Lo-yü ("happy fool") and Lo-yü ("happy fisherman"). At first he followed Pien Wen-chin and studied the Huang Ch'üan style of flower-and-bird painting, but his style is said to have changed after taking an opportunity to copy the famous T'ang and Sung paintings in the collection of the powerful Yüan Chung-ch'e. In the Hung-chih reign period he was summoned to the court academy and appointed "Director of the Brocade Guard." Lü Chi was best known for his flower-and-bird painting, but was also skilled at landscape and figure painting. Among his flower-and-bird paintings are both heavily and lightly colored works. His "Flowers and Birds of the Four Seasons," owned by the Tokyo National Museum, is an example of his heavily colored style. This painting of the "Swimming Ducks" is of the lightly colored variety, and resembles the coloring of Lin Liang (Pl. 9). It bears the signature of Lü Chi, and a seal reading, "the seal of Lü T'ing-chen of Ssu-ming." This writer was somewhat surprised to see only lightly colored paintings by Lü Chi when he visited China.

11. *Yao Shou. "Stream, Bridge, and Moored Boat (album leaf).* *Ming dynasty. Color on paper. 31.2 × 48.5 cm. Shanghai Museum.*

Yao Shou (1423–95) was a native of Chia-shan in Chekiang Province, and was styled Kung-shou, with the aliases Ku-an and Yün-tung Yi-shih. He was the son of Yao Fu, a collector of calligraphy, painting, and epigraphy. He gained his *chih-shih* degree in the T'ien-shun reign period, and became an inspector in the censorate. In the Ch'eng-hua reign period he was appointed prefect of Yung-ming-fu in Yünnan Province, but he later returned to his native place in retirement and took the name Tan-ch'iu Hsien-sheng. Skilled in poetry, painting, and calligraphy, his best work was in painting in bamboo and rock, and land-scape. A literati painter contemporary with Shen Chou, Yao, too, looked to the style of Wu Chen of Yüan, though he later turned toward Chao Meng-fu and Wang Meng.

This painting is one leaf from an album. The main tone is set by ink wash, on which fresh, vivid colors are applied. It is a Mi Fu type landscape in which a touch of Kao K'o-kung is added to a Wu Chen base. The effect is close to the style of Shen Chou, but carries a mood of greater clarity and lightheartedness. The upper right-hand corner carries the signature "Yi-shih" and a seal reading "old man of the purple clouds and jade moon." At the lower left is Yao Shou's square seal, which reads "resting in moun-tains whose beauty sustains, fishing in waters whose fresh-ness revives." The painting is undated, but is probably a work of the Hung-chih reign period (1488–1505).

12. *Hsü Tuan-pen. "Stream and Autumn Colors." Ming* *dynasty. Color on paper. 30.0 × 40.0 cm. Shanghai Museum.*

Hsü Tuan-pen, a native of Chin-ling (Nanking) in Kiang-su Province, was born in 1438 and was last recorded living in 1517. He later changed his name from Tuan-pen to Shih-chung; he was styled T'ing-chih, and took the aliases Ch'ih-hsien ("foolish immortal") and Ch'ih-ch'ih Tao-jen ("the silly foolish man of the *tao*"). Hsü was well-versed in poetry and prose composition, and a skillful painter of landscape, flower and plant, rock and bamboo, and figure painting. In painting landscapes, trees, and rocks, he cast off old techniques and used his brush as he pleased. This painting is a small piece from an album, but in it can be seen a magnanimity of style that followed the free and unrestrained manner of late Yüan. He was said to have been a close friend of Shen Chou, but there is no trace of the relationship in his painting. His works are rare in Japan.

13. *Sun Lung. "Flowers, Birds, Grass, and Insects" (album* *leaf). Ming dynasty. Color on silk. 22.7 × 21.5 cm. Shanghai* *Museum.*

Three different persons may possibly be identified as Sun Lung.

The first Sun Lung (written with the character for "emi-nent"; 孫 龍) was styled T'ing-chen, and took the alias Tu-ch'ih. He was a native of Wu-chin (Ch'ang-chou or P'i-ling) in Kiangsu, and was the grandson of Sun Hsing-tsu, a minister of merit in the founding of the Ming empire. He was skilled at painting feathers, grass, and insects in the "boneless" style. Judging from his relationship with Yao Shou, he must have lived during the T'ien-shun, Ch'eng-hua, and Hung-chih reign periods.

The second person was Sun Ts'ung-chi, a native of Jui-an in Chekiang. During the Yung-lo reign period (1403–

24) his fame in plum painting was said to equal that of Hsia Chung-chao in ink bamboo. Since the same piece of information is given about Sun Lung (the "eminent") in the works of the early Ming literati Yang Shih-chi (1365–1444), it seems possible that Ts'ung-chi was the style name of Sun Lung (the "eminent").

The third Sun Lung (written with the character for "dragon"; 孫 龍) was a contemporary of Lin Liang, who entered the painting academy during the Hung-chih reign period (1488–1505) and specialized in bird and feather painting.

Since the painting presented here carries the seal "T'ing-chen," the artist must be Sun Lung (the "eminent"). However, the other paintings in the same album all carry a seal reading "Sun Lung t'u-shu" (painting by Sun Lung [the "dragon"]), instead of the T'ing-chen seal. Since all the leaves in the album seem to be painted by the same person, Sun Lung (the "eminent") and Sun Lung (the "dragon") must be the same person. This album car-ries poems by Yao Shou; and so does a similar album held by the Palace Museum in Taiwan, which is entitled "An Album of Paintings from Life by Sun Lung (the 'dra-gon')." In this latter volume appear seals which read "Paintings by Sun Lung (the 'dragon')," "Descendent of the Founding Statesman the Marquis of Chung-mien," and "Bequeathed Works of K'ung-t'ung." If it is true that Sun Lung (the "dragon") was the descendent of the founding statesman the Marquis Chung-Mien (which was the honorary title of Sun Hsing-tsu), then this Taiwan album is further evidence that Sun Lung (the "eminent") and Sun Lung (the "dragon") are the same person. Further, since both volumes carry poems by Yao Shou, the artist there named Sun Lung (the "dragon") must be contemporary with the Sun Lung (the "dragon") who was a contemporary of Lin Liang, and quite possibly the same man. In any case the names Sun Lung (the "eminent") and Sun Lung (the "dragon") are not only of the same pronounciation, but almost certainly belonged to the same person.

This painting is an album leaf depicting grass and insects, flowers and birds in the boneless style. The bird perched on the cherry-apple branch is done with splotches of color in a clean light touch. The composition is in the academy style. Apart from this work, other paintings in the album deal mostly with plant and insect themes. These show the influ-ence of the famous Ch'ang-chou plant and insect style, which was a local form different from the Ming academy tradition. Judging from this style, Sun Lung (the "emi-nent"), who was from Chang-chou and an expert in bird and feather painting, may indeed be the Sun Lung (the "dragon") who is the painter of this work.

This painting provides a basis for understanding the local Ch'ang-chou style, which extended to Yün Shou-p'ing, a famous flower-and-bird artist from Ch'ang-chou in the early Ch'ing period.

14, 72. *Ch'ou Ying. "The Plank Road over Chien Moun-* *tain" (detail). Ming dynasty. Color on silk. Full size: 295.4* *× 101.9 cm. Shanghai Museum.*

Ch'ou Ying was styled Shih-fu and took the alias Shih-chou. He was born in T'ai-ts'ang in Kiangsu Province, and later moved to Wu District (Su-chou). The dates of his birth and death are not known, but he was active in the first half of the sixteenth century during the Cheng-te and Chia-ching reign periods. It is said that he was originally a lacquer

craftsman by trade and occasionally painted houses as well, a status rather far removed from that of the literati painters who held sway at the time. He later turned to professional painting, studying under Chou Ch'en and receiving indirectly the influence of Chou Ch'en's master Ch'en Hsien. His training was typical of most professional painters, who began by copying ancient paintings, paying special attention to outline and the application of color, a procedure that many of Ch'ou Ying's paintings plainly show.

Ch'ou Ying, Chou Ch'en, and T'ang Yin were known as "the three Masters of the Court School." The many Ch'ou Ying paintings that survive today are mostly either the work of common professional painters to which the seal of Ch'ou Ying has been fixed, or later copies falsely attributed to him. It is extremely difficult to sort out his original works from among these.

This painting, entitled "The Plank Road over Chien Mountain," depicts the flight of the T'ang Emperor Hsüan-tsung across the plank roads of Szechwan. Just as described in Li Po's poem Shu-tao nan ("The Hard Journey to Shu"), the precipitous mountain trails are spanned by many perilous bridges.

The story of the Ming-huang emperor's flight from the rebellion of An Lu-shan into Szechwan has been a favorite theme of Chinese painters, for it can combine a compelling tale with an awesome natural scene. The existence of numerous works of a similar composition attributed to Li Ssu-hsün or Li Chao-tao shows the same painting to have been copied again and again. In this painting, however, the copyist Ch'ou Ying appears to have worked from an original of a different tradition from that of Li Ssu-hsün and Li Chao-tao. The detailed drawing of the figures in the painting, the beautiful color tone, and of course the depiction of the natural scene centering upon the wooden roads, and the skilled handling of space make this a superb piece in which to examine the technique of Ch'ou Ying. This painting was done for Tu Ch'iung (1396–1474), and is supposed to have been one of Ch'ou Ying's comparatively early works. There exists another painting that bears a striking resemblance to this one, but whether it was copied from Ch'ou Ying's work, or both come from the same original, is not clear.

15. *Wen Cheng-ming. "Tall Trees in Late Spring." Ming dynasty. Color on silk. 170.1 × 65.7 cm. Shanghai Museum.*

Wen Cheng-ming (see note to Frontispiece) was a disciple of Shen Chou and a painter in the Nan-tsung tradition. He was especially fond of Chao Meng-fu of Yüan, as is shown by his style of calligraphy, and was further influenced by his contemporary, T'ang Yin. He was said to be as artless and unaffected in attitude as ancient painters, though his art was more elaborate. The painting presented here is rather more elegant than elaborate. It is undated, but judging from the meticulous style in which not a dot or a stroke is neglected, it is probably a work of Wen's middle age. Some resemblance to Chao Meng-fu and T'ang Yin may be recognized, but the work is closest to the style of Shen Chou and its elegance is most characteristic of Wen Cheng-ming.

16. *Chang Ling. "A Noble Scholar in Autumn Mountains." Ming dynasty. Light color on paper. 82.7 × 32.0 cm. The Palace Museum.*

Chang Ling (ca. 1470–1520), styled Meng-chin, was a native of Wu-chün (Su-chou). The family had been poor for many generations, and far removed from elegant surroundings. Chang Ling was the first scholar to appear in the family. He lived close by T'ang Yin, and the two became congenial drinking companions. Many anecdotes have been handed down about them. It is also claimed elsewhere that Chang Ling had first studied under Chu Yün-ming, who was an intimate friend of T'ang Yin. Chang resembled T'ang Yin in character, and matched him as well in poetic ability. Like T'ang and many other literati painters, Chang, too, was unsuccessful in the examinations, and remained outside officialdom. Associating with adventurers, he lived a carefree life much in the manner of the "mad scholars" of old.

Though little of Chang's work survives, its style is varied and difficult to define. His stylistic affinities are unclear, though he seems to have been influenced by both the court academy and the Nan-tsung painters of the Wu school.

This painting was done for a person styled Shu-hsien (possibly Yüan K'ung-chang). It was much praised by the artist's contemporaries and shows him at his best. Depicting a man attired in the ceremonial dress of antiquity, it shows the T'ang Yin manner in the drawing of the central figure and trees and in the use of ink, and further employs the composition and brushwork of the Che school. The painting bears a colophon by Wen Cheng-ming dated 1501 (Hung-chih 14), who presented it to a departing friend in place of one of his own works. It is an interesting piece that gives concrete evidence of the relationship between Chang Ling and Wen Cheng-ming discussed by Ch'ing art critics.

17. *Lu Chih. "Cloudy Peaks and Forested Valleys." Ming dynasty. Color on paper. 86.0 × 46.4 cm. Shanghai Museum.*

Lu Chih (1496–1576), a native of Wu-chün in Kiangsu Province, was styled Shu-p'ing and took the alias Pao-shan-tzu. He was renowned for qualities of frugality, righteousness, filial piety, and friendship. After failing the provincial examination he turned his back on the times, and building a hermitage on Chih-hsing Mountain in Wu District, Kiangsu, he ended his life as a scholar recluse.

Lu Chih's painting followed the Four Great Masters of late Yüan, particularly Wang Meng, and he associated himself with the Wen Cheng-ming and Chu Yün-ming group. Though Wang Shih-chen held him nearly equal to Wen Cheng-ming, Lu was never able to surpass his master. Later he turned from landscape to flower-and-bird, bamboo and rock painting, and with Ch'en Ch'un established a new style.

This painting was done in 1552 (Chia-ching 31), when the artist was sixty-seven. It depicts a noble scholar cleansing his mind by the sound of a running stream, in a forested valley reminiscent of the artist's own mountain estate, which was described by Wang Shih-chen as "enclosed about by clouded peaks, between which flowing waters run, and beyond where one sat," and was planted full with chrysanthemums and rare flowers and plants. The influence of Wen Cheng-ming is evident in the shading technique and drawing of the trees. The almost excessive concern with detail and the neatness of the coloring, which were the mark of Lu Chih as a literalistic flower-and-bird painter, are fully exhibited as well in the realism of this landscape.

18. *Hsiao Yün-ts'ung. "Sparse Trees on Cloud Terrace"*

(detail). Ming dynasty. Color on paper. 26.5 × 233.8 cm. Nanking Museum.

Hsiao Yün-ts'ung (1596–1673) was a native of Wu-hu in Anhui Province. He was styled Ch'ih-mu, took the alias Wu-men Tao-jen, and in his late years went by the name Chung-shan Tao-jen. In late Ming he became an alternate candidate in the local examinations, but after the establishment of the Ch'ing dynasty he refused to take office, and ended his days in retirement. He once wrote on one of his paintings, "I am a man of the open fields, and have nothing to offer the imperial court. I but labor over these scrolls, and store them away waiting for someone who will understand me." Here Hsiao's remorse as a painter in retirement can be seen.

Hsiao Yün-ts'ung retained his creative powers to the end of his life. Lan Ying said of his landscapes that "he created his own style, which was neither Sung nor Yüan," and Chang Keng that "he held to no particular tradition, but established his own school." Huang Yüeh, however, held that "there was to the contrary something of the Northern Sung manner in his painting." Each of these critics has perhaps caught one aspect of his work. Hsiao Yün-ts'ung was known as the founder of the Ku-shu school, which cannot be regarded as simply a branch of the Wu school. Even apart from his strongly individualistic manner, the fact that his regional base in Tang-t'u (Ku-shu), Anhui, was quite far removed from Su-chou, Kiangsu, where the Wu school was centered, gave to the style of his school a markedly local character.

This "Sparse Trees on Cloud Terrace" scroll possesses a slightly more severe effect than his natural warm and graceful manner. Its block structure is in imitation of the Ni Tsan style of landscapes, which he and Hung-jen (styled Chien-chiang) from his own native district were fond of painting.

19. *Lan Ying. "Mount Hua at the Height of Autumn" (detail). Ming dynasty. Color on silk. 311.2 × 102.4 cm. Shanghai Museum.*

Lan Ying, a native of Ch'ien-t'ang in Chekiang Province, was born in 1585 and last recorded alive in 1664. He was styled T'ien-shu, and used several aliases: Tieh-sou, Hsi-hu Shan-min, Hsi-hu Wai-shih, Meng Tao-jen, Tung-kuo Lao-nung, Tung-yüan Tieh-sou, and Wan-lü Ah-chu-che. He excelled at landscape painting, but as the last leader of the Che school has not always been highly evaluated by the literati, who esteemed instead the southern Nan-tsung tradition. The style of Lan Ying, however, was a fusion of Che school forms with Nan-tsung techniques. Though his paintings may not be of the highest quality, they show originality in a superior decorative effect, and possess elements linking them with the Yüan (袁) school of later times. Many of Lan Ying's works have survived in Japan, and their influence on premodern Japanese painting cannot be ignored. The Mt. Hua (Hua-yüeh) in the title of this painting is probably Hua-shan in Shenshi Province, one of the famous five "sacred" mountains of China. The scroll is dated 1652 (Chia-p'ing, jen-ch'en cycle), marking it a work of the artist's sixty-eighth year. It shows somewhat the stylistic influence of Kuan T'ung, and borrows structural elements from Northern Sung landscape painting. As was the common practice of the time, the artist has created his own aesthetic realm under the pretext of reproducing the works of antiquity. Notable in this scroll, which should be

called a reproduction of the Northern Sung style, is the decorative effect of the "spread fiber" shading technique, the distribution of the spotted moss, the surface handling of the mountain volumes, and the harmonious blending of ink and color, all characteristic of the Lan Ying style.

The commemorative inscription on the scroll has been effaced, but beneath the signature "Lan Ying, the Mountain Man of Western Lake," seals reading "the Seal of Lan Ying" (in white) and "T'ien-shu" (in red) are stamped.

20. *Wang Shih-min. "Conception of a Tu Fu Poem." Ming dynasty. Color on paper. 39.0 × 25.6 cm. The Palace Museum.*

Wang Shih-min (1592–1680) was a native of T'ai-ts'ang in Kiangsu Province. He was styled Sun-chih and took the aliases Yen-k'o and Hsi-lu Lao-jen. He served the Ming court at the beginning of the Ch'ung-chen reign period, and rose in rank to become Lesser Lord of the Court of Imperial Sacrifices, whence he became known as Wang Feng-ch'ang ("server of the T'ai-ch'ang court"). Wang excelled at poetry, painting, and calligraphy. Taking Tung Ch'i-ch'ang as his teacher, he continued the orthodox tradition of Nan-tsung landscape painting, and mastered the essence of Huang Kung-wang. After the collapse of the Ming dynasty, he devoted himself with Wang Chien to the instruction of the younger Wang Hui, Wu Li, and Wang Yüan-ch'i, to form the so-called school of the "Four Wangs, Wu, and Yün," the latter being Yün Shou-p'ing, a friend of Wang Hui.

This painting is from an album entitled "Tu Fu Poems Conceived as Paintings" (杜甫詩画册). At the top of the painting is a stanza from a seven-word regulated poem entitled "The Official Halls of Hsiang-chi Temple in Fu-ch'eng District [Szechwan]" that reads, "Green cliffs filled with wind, a solitary delicate cloud; red maples turned against the sun, a myriad trees in luxuriant foliage." This painting is an attempt to capture the idea of that poem. Wang Shih-min's work is generally of elegant quality, but his paintings tend to be rather fixed and rigid in form, and lacking in inspiration. Although this is a small work, it is of interest for the candidness of its expression.

21. *Wu Li. "Lake, Sky, and Spring Colors." Ch'ing dynasty. Color on paper. 123.8 × 62.6 cm. Shanghai Museum.*

Wu Li (1632–1718) was a native of Ch'ang-shu in Kiangsu Province. He was styled Yü-shan, and went by the alias Mo-ching Tao-jen. One of the "Four Wangs, Wu, and Yün" group, he was a leader of the orthodox Nan-tsung school. First, with his friend Wang Hui (styled Shih-ku), he had studied under the direction of Wang Shih-min, and mastered the technique of Huang Kung-wang. In 1682, at the age of fifty-one, he became a Christian, after which he was said to have broken relations with Wang Hui. His use of Western techniques of depth perspective also probably began from this period.

This painting is in imitation of one by Chao Ta-nien, the aristocratic painter of Northern Sung. While conveying the effect of the earlier work, the style is yet Wu Li's own. To the traditional aerial view he has added a touch of Western perspective, achieving a refreshing, elegant effect. The painting may be recommended as one of Wu Li's best works.

22. *Yün Shou-p'ing. "Fallen Flowers and Swimming Fish."*

Ch'ing dynasty. Color on paper. 65.5 × 30.1 cm. Shanghai Museum.

Yün Nan-t'ien (1633–90) was a native of Wu-chin (Ch'ang-chou) in Kiangsu Province. He was first given the name Ko and styled Shou-p'ing; later he took Shou-p'ing as his common name and styled himself Cheng-shu. Nan-t'ien was his alias, others being Pai-yün Wai-shih, Tung-yüan Ts'ao-yi, and Yün-hsi Wai-shih. He excelled at landscapes and flower-and-bird painting, and particularly in the latter employed a "boneless" coloring technique in the manner of Hsü Ch'ung-ssu of Northern Sung. His landscapes were based upon the style of the late Yüan paint-ers Huang Kung-wang and Ni Tsan. It is said that he con-ceded his landscapes no match for those of Wang Hui, and devoted himself to flower-and-bird painting; but in fact he had a better hand than Wang Hui even in landscape paint-ing. His preoccupation with flower-and-bird painting was probably the result of his having come from Ch'ang-chou, the home of plant and insect painting. Yün painted quite literally from the forms of life, seeking an expression of mood and sentiment. His style opened new vistas in floral painting and he was esteemed as founder of the Ch'ing literalist school. This painting is an especially outstanding example of the "water plant and fish" type, which Yün often at-tempted. According to the artist's colophon at the top, it is a work of 1675, when the artist was forty-two. He further claimed there that he had "achieved the manner of Liu Ts'ai of Sung," who was active during the reign of the Emperor Shen-tsung in Northern Sung. Liu Ts'ai was well known for his skill in capturing the essence of live fish swimming about, rather than merely copying dead fish taken from the water. There are many famous works on the "water plant and fish" theme, which had become an established form in the Sung period, and this painting is a masterpiece in no way inferior to the Sung product.

23. *Shih-t'ao. "Dragon Pines in Light Rain." Ch'ing dynasty. Color on paper. 102.6 × 41.3 cm. Shanghai Museum.*

Shih-t'ao was born in 1640 and last recorded alive in 1714. He was given the Buddhist "dharma names" of Tao-chi and Yüan-chi, and took the aliases K'u-kua Ho-shang, Ta-ti-tzu, and Ch'ing-hsiang Lao-jen. A descendent of the Ming imperial house and son of the Chu Heng-chia, prince of Ching-chiang (Kianghsi Province), he became a monk while still a youth at the collapse of the dynasty. Shih-t'ao had great pride in his noble birth and deep grief for the fall of his country. He studied Buddhism under the masters Tao-min and Pen-yüeh, who ingratiated themselves with the Manchus and served the Ch'ing court; and he himself was several times among those welcoming the K'ang-hsi emperor on his imperial journeys. Torn thus between two loyalties, his deep consciousness of himself as a "refugee" from a fallen dynasty must have brought him frustrations indeed. After moving to Yang-chou at about forty, his life, reputa-tion, and relations with high Manchu officials became stabil-ized, and apart from recurrent illnesses, he passed a peaceful old age. Among his writings there is a famous "Comments on Painting" (画語錄) in one volume, which is highly re-garded as a theory of art stressing individualistic values in artistic creation. To the painting circles of the late Ming, so bound by established conventions and forms, Shih-t'ao's fresh, free style, together with that of Pa-ta Shan-jen, afforded an inexhaustible light.

The painting presented here was done in 1687 (K'ang-

hsi 26) when the artist was forty-seven or forty-eight years old. The "Dragon Pines" of the title refers to the twisted shapes of the trees. The Tzu-lao Tao-weng to whom this painting was presented remains unknown, but as the artist had for the previous year been traveling about and working in Buddhist temples, it is perhaps the same Mei-ch'ien Tao-weng to whom he often presented his works during this time.

Shih-t'ao's painting style, like his calligraphy, is rich in variation. In this painting, however, ink tones are decidedly subdued and the feeling moderated in a prudent rendition of a practiced theme. The power and profound depiction of nature seen in the later album, "Eight Scenic Wonders of Huang-shan," is not seen in this early work, but this still is an excellent example of his early period that shows the Nan-tsung side of his style.

24. *Chin Nung. "A Butterfly Orchid." Ch'ing dynasty. Color on paper. 25.0 × 32.0 cm. Liaoning Provincial Museum.*

Chin Nung (1687–1763) was a native of K'ang District in Chekiang Province. He was styled Shou-men, and took the alias Tung-hsin and a number of other names descrip-tive of his interests and experience, such as Chi-liu Shan-min, Hsi-yeh Chü-shih, Hsin ch'u chia an chou fan seng, and Pai erh yen t'ien chai. Chin Nung associated first with literati around the Hang-chou region, then at about thirty visited Yang-chou and subsequently toured all of China. His paintings were strange, and so was his charac-ter. Criticized as uncompromising and eccentric, he headed the list of the Eight Eccentrics of Yang-chou. At the age of fifty he unsuccessfully attempted the *po-hsüeh hung-ju* examination for special talent, and thereafter threw himself into painting and calligraphy, excelling at plums, bamboo, flower and fruits, human figures, and landscapes. The Eight Eccentrics were strongly amateurish, and the scope of their painting themes was narrow. Chin Nung, however, was more versatile in this respect. He was said to have modeled his plums on those of Pai Yü-ch'an, his bamboo on that of Wen T'ung, and his horses on those of Ts'ao Pa and Han Kan. But he was not formally constrained by them, and in all cases set forth clearly his own creative vision.

This painting is a work of the artist's seventy-fifth year. There is no attempt to draw rocks as rocks or orchids as orchids, nor does the expression have any relation to tradi-tional methods. The orchid and rock further possess a strong vitality and vivid symbolism. The seal on the paint-ing, 吉金吉, is a pseudonym the artist began to use after developing a deep interest in epigraphy. The "butterfly or-chid," also called the "butterfly flower," has the generic name of *Iridaceae*, and is a perennial herb that grows in wet places.

25. *Lo P'ing. "Plank Road over Chien Mountain" (detail). Ch'ing dynasty. Color on paper. 100.5 × 27.2 cm. The Palace Museum.*

Lo P'ing (1733–99) was styled Tun-fu and used various aliases such as Liang-feng, Hua-chih-ssu Seng, Chin-niu Shan-jen, etc. He was originally from Hsi District in Anhui Province, but took up residence in Yang-chou, where he became Chin Nung's leading disciple, and was counted one of the Eight Eccentrics of Yang-chou. In religious paintings he was the equal of Ch'en Hung-shou and Ts'ui Tzu-chung. His ghost paintings are particularly famous.

According to the artist's colophon, this painting was done in 1794 at the age of sixty-two. In that year Chang Tao-wo, who was traveling to Szechwan, entrusted the painting of a work on this theme to Lo P'ing. Poems for Chang Tao-wo by friends on departure are written on the mounting paper around the edge of the painting. All of these were done in 1794, but a colophon by Wang-fang Kang beside the artist's own was written in 1806, seven years after Lo P'ing's death. The characters 劍閣 in the title of the painting refer to the plank road by which one passes over the two strategic mountains of Ta-chien and Hsiao-chien on the way from Ch'ang-an to Szechwan. For another view of this plank road, see Plates 14 and 72 by Ch'ou Ying.

It is apparent from this painting that Lo P'ing had studied well the fundamentals of the Nan-tsung school. In landscape painting, perhaps because of so many traditional limitations, even the works of the Eight Eccentrics are unexpectedly common and unremarkable in unusual elements. Even Pa-ta Shan-jen shows this same tendency in his landscape painting.

26. *Yüan Chiang. "Wu-t'ung and Hibiscus." Ch'ing dynasty. Color on silk. 166.0 × 94.5 cm. Fine Arts Research Institute, Central Art Academy, Peking.*

Yüan Chiang, who lived in the first half of the eighteenth century, was a native of Chiang-tu District in Kiangsu Province. He was styled Wen-t'ao, and became a court painter during the Yung-cheng reign period (1723–35). He excelled at landscapes, and was considered first in the Ch'ing dynasty in the architecture-landscape type. The so-called Yüan school was a continuation of his style. In the painting forum of the eighteenth century period, which saw the flourishing of a formalized Nan-tsung style, the positive attitude of the Yüan school painters in search of realism and decorative effect is noteworthy. These have been constant features of court painting in China. Yüan Chiang and his school were close students of Sung painting, and took from it their sense of superior representation and noble ornamentation. In landscape painting they modeled themselves on the style of Li Ch'eng and Kuo Hsi of Northern Sung, with occasional reference to the adherents of that school in Yüan and Ming times. In their fusion of architectural and landscape types, however, the effect is one of cold, intellectual beauty, much different from the domineering spirit of Yüan and Ming works, which links them with Sung painting.

Floral paintings by Yüan Chiang are rare but very well done, showing the artist to have an expert hand in this field too. In the artist's colophon this work is dated 1755 (Ch'ien-lung 20) and said to be modeled on the style of Huang Ch'üan of Shu (Szechwan) of the Five Dynasties period. It differs from the new floral style of Yün Shou-p'ing and Tsou Yi-kuei, showing the same cold beauty and clean incisiveness as the paintings of landscape and pavilions mentioned above.

27. *Hsü-ku. "Wisteria and Goldfish." Modern. Color on paper. 117.4 × 49.3 cm. The Palace Museum.*

The Buddhist monk Hsü-ku (1824–96) was originally named Chu Hsü-pai, and was a native of Hsin-an in Anhui Province. After rising to the rank of general under the Ch'ing dynasty, he abandoned government service to become a monk. He settled in Shanghai, where he went into hiding and gave assistance to the revolutionary movement.

This revolutionary atmosphere permeated his painting, which possesses a feeling of sharp exhilaration.

Hsü-ku was particulary adept at flower and animal painting, in which he skillfully captured the characteristic features of squirrels and goldfish and achieved a lively representation with passionate brushwork. These features are fully visible in this painting, in which the scene, through an abbreviated expression, is brushed out in an extremely vivid manner. The interesting shapes and subtle coloring of the wisteria vines, and the shape and coloring of the goldfish, are extremely effective. In addition, the artless evocation of the water surface with a few touches of the brush impart to the painting a pleasant sense of movement.

28. *Jen Yi. "Maple Leaves and Quail." Modern. Color on silk. 33.5 × 33.8 cm.*

Jen Yi (1840–96) was a native of Shan-yin in Chekiang Province, and was styled Po-nien. Though he also painted landscapes, his specialty was figure painting and flowers-and-birds. Particularly in his flower-and-bird paintings he is considered to have established a new style that sought the internal relations between flower and bird. A long resident of Shanghai, his reputation was high in the Yangtze area, and he exerted a great influence on painting circles of the Republican period.

His early paintings are in the Sung and Yüan style, and employ heavy coloring. Later, enlightened by Pa-ta Shan-jen and further influenced by Western painting, he showed new aspects with the concurrent use of the "boneless" ink wash style. He did not directly draw upon the school of the Eight Eccentrics of Yang-chou, but being in Shanghai and aroused to resistance against the semi-colonial air there, a strong individuality is expressed in his works, which brings them perhaps naturally close to the Yang-chou school.

This painting is a lively and sharp depiction of maple leaves and quail, which gives a feeling of movement in its tightly compressed style. The subdued coloring and sharp brushwork express the feelings of the painter.

31. *Tung Yüan. "Awaiting the Ferry at the Mount Hsia-ching Pass." Five Dynasties. Color on silk. 50.0 × 300.0 cm. Liaoning Provincial Museum.*

Tung Yüan was styled Shu-ta, and was a painter in the Southern T'ang state (937–75) during the Five Dynasties period. Not much is known about his life. His native place is said to have been Chung-ling, or sometimes simply Chiangnan, "south of the river." His official titles are given as Hou-yüan fu-shih ("Assistant Commissioner of Rear Park") and Pei-yüan-shih ("Commissioner of North Park"). It is recorded in Kuo Jo-hsü's *Experiences in Painting* (圖画見聞誌) that at a snow-gazing party given on New Year's Eve of 947 by Li T'ing-hsün and Hsü K'uang, Tung Yüan, along with Kao Chung-ku, Chou Wen-chü, Chu Ch'eng, and Hsü Ch'ung-ssu, collaborated on a painting entitled "Enjoying the Snow," in which Tung Yüan had been responsible for the winter trees. By this entry we may gather that Tung Yüan is a representative landscape artist of the Southern T'ang state.

Tung Yüan's painting was described by Shen K'uo as "especially skilled in distant scenes in the autumn mist; he painted the real mountains of Chiangnan with no attempt at novelty, but did not draw steep, craggy mountains." And again, "The style of Tung Yüan and Chü-jan was entirely suited to distant views. Their brushwork was rather

free: seen close-up, things in the painting do not appear as they should, but viewed from farther away, the scene is clear, melancholy, and thoughtful, as if one were gazing upon another world." We cannot vary the distance from which we examine this plate, but at the least Shen K'uo's first comment is very appropriate.

Kuo Jo-hsü says of Tung Yüan's landscapes, "His ink wash was like that of Wang Wei, and his coloring like that of Li Ssu-hsün," suggesting thus the existence of two kinds of Tung Yüan paintings. The Sung catalogue *Hsüan-ho hua-p'u* says, "At the time colored landscapes were not many, and artists who could imitate Li Ssu-hsün were very few. Tung Yüan became especially famous at the time on this account." T'ang Hou of Yüan also acknowledged the existence of colored paintings with little contour shading, and of ink wash paintings in which the "tangled fiber" shading technique was used on mountain rocks to give a three-dimensional feeling, but was not used on rounded rocks, thin forests, or distant trees. However, these colored paintings may not all be regarded as in the Li Ssu-hsün style. Neither this scroll nor the famous "Hsiao-hsiang" scroll, though colored, follow Li Ssu-hsün. In this scroll the techniques used on the rocks and trees remain entirely within the ink wash method.

The scroll presented here seems to have once been in the collection of the Emperor Wen-tsung of the Yüan dynasty, and was appraised by K'o Chiu-ssu. A work of the same name is listed in the *Hsüan-ho hua-p'u*, and it was possibly this entry on which K'o Chiu-ssu' based his opinion. But the present scroll bears no trace of having been in the Hsüan-ho collection, and its transmission before Yüan times is not known. In the Ming dynasty it came into the possession of Chu Keng (a president of the Board of Rites and Grand Scholar of the East Library) during the Wan-li reign period; Tung Ch'i-ch'ang encountered it there and judged it genuine. After the change of dynasty it came into the Ch'ing imperial collection. Such is the history of the scroll, but in the *Shih-ch'ü pao-chi* it was given a second-rate ranking, indicating that Ch'ing appraisers did not consider it authentic. Though their opinion may be the correct one, the scroll yet remains evidence of a conception of the Tung Yüan style formed since the Yüan period, and it should be valued as a masterpiece in the transmission of that style, along with the "Winter Trees and River Isles" painting and the "Hsiao-hsiang" scroll.

33. *Chü-jan. "Wind in the Pines of a Myriad Valleys." Northern Sung. Light color on silk. 77.5 × 200.7 cm. Shanghai Museum.*

Chü-jan (tenth century) was a native of Chung-ling in Kianghsi Province, and a monk of the K'ai-yüan temple at Chiang-ning (Nanking). He excelled at landscape painting in the Tung Yüan style, and in later ages was ranked beside Tung Yüan as a founder of the Nan-tsung tradition of literati painting.

Tung Yüan proceeded from "jagged peaks and sheer cliff" themes to a realm of "trees and rocks dark and wet; mountains rounded, deep and clear." And Chü-jan, too, went from "imposing crags" to "blandness" in his later years. Both were further said to paint "misty scenes with graceful line and rich ink, all suitable to distant views." Reference is made to these common features in the critical literature, but in the surviving works themselves Chü-jan's predominant "imposing crags" are much in contrast

to Tung Yüan's usual blandness. This "Wind in the Pines of a Myriad Valleys" painting is attributed to Chü-jan, and shows fully the characteristics ascribed to him in literary sources. Further, the folded mountain peaks and rounded rocks scattered widely between forest and foothills were regarded as the typical Chü-jan manner in later times, as is proved beyond doubt in the "Landscape" painting by Fa Jo-chen published in this volume (Pl. 99). This painting is probably a piece of copy work done during the Yüan resurgence of the Tung-Chü style, but it is, as stated above, a painting of great historical importance.

34. *Wang Shen. "Fishing Village in Light Snow." Northern Sung. Light color on silk. 44.5 × 219.0 cm. The Palace Museum.*

The life of Wang Shen, who lived in the latter half of the twelfth century, is discussed in the note to Plate 3, "Misty River and Folded Peaks."

This painting shows the characteristic features of Wang Shen's style, which was based on that of Li Ch'eng. The "level distance" perspective employed at the left particularly resembles Li Ch'eng. The artist's own originality is best seen in the depiction of the river mouth at the right. On the river bank stands a row of willow trees, while fishing boats drift about the river mouth. This picture recalls the "small scene" format with which Wang Shen was so skillful. This was continued by Chao Ta-nien in the next generation and became a genre in its own right.

In the light of these features, the painting is probably correctly ascribed to Wang Shen. After passing through the hands of many collectors in the Ming period, the painting came finally into the Ch'ing imperial treasury. The colophon in the upper left is from the brush of the Ch'ien-lung emperor.

36. *Mi Yu-jen. "White Clouds on the Hsiao-hsiang River." Southern Sung. Ink on paper. 28.7 × 295.5 cm. Shanghai Museum.*

Mi Yu-jen (1086–1165) was styled Yüan-hui, and was known by the alias Lai-cho Lao-jen in his later years. He was the son of Mi Fu (1051–1107), and carried on well the family tradition. Together they were referred to as "Big Mi" and "Little Mi." Mi Fu was designated a "Doctor of Painting and Calligraphy" while in the service of the Emperor Hui-tsung, and was a genius noted for eccentric behavior. His son Mi Yu-jen, however, spent several decades as an unfortunate local official, and only after the age of sixty was he able to gradually return to the capital. This divergence of fortune between father and son not only influenced their personalities, but their painting styles as well. Suppressing the irregularities of his father's style, which included such eccentricities as the use of straw brushes and grass roots as painting tools, Mi Yu-jen did only landscapes, and these were mostly horizontal scrolls laying out extended mountain views immersed in bright, welling mists. This broad view of the Hsiao-hsiang river region was perhaps best suited to his artistic ideas.

This scroll is mentioned six times in catalogues such as the *Ta kuan lu*. In measurement it is close to the entries in the *Shih-ch'ü pao-chi* and the *Wang-shih shan-hu-wang*; but in the light of Mi Yu-jen's own colophon, it resembles rather the entries in the *Ch'ing-ho shu-hua-fang* and the *Shih-ku-t'ang shu-hua hui-k'ao*. But the colophon on the Shanghai copy

contains information inconsistent with any of the above records, so that is is still undecided to which record the Shanghai copy presented here corresponds.

Further, there is doubt that the scroll has come down perfectly intact, because in the *Shih-ch'ü pao-chi* it is pointed out that the last line of the third colophon by the Ch'ien-lung emperor is placed by the head of the scroll. The thirty-two postscripts by twenty writers that follow the artist's colophon are an unorderly conglomeration made up from three groups originally written on other Mi Yu-jen paintings. This fact was not noticed even by Wang Tsung-ch'ang and Shen Chou, whose postscripts appear at the end of the scroll.

The rolled-up scroll appears to have been water soaked at some point, so that damaged places appear about every twenty centimeters. Both sky and ground were damaged, so that in addition to the loss of river isles and fishing boats, the high-welling clouds and rootless trees characteristic of Mi Yu-jen's style are unfortunately not visible. When compared to the scroll entitled "Elation at Cloudy Mountains" in the Palace Museum in Taiwan, which is a later copy than the Shanghai piece, the loss of these features is very apparent.

The entire scroll has been heavily patched and retouched, and the spotting of the moss is somewhat formalized. A tendency toward uniformity is most obvious in the outline of the cloudy mists and the arranging of the villages in a single direction. However, the painting still retains the touch of a spontaneously inspired brush, when compared to the later formalized "Mi style landscapes" with their mechanically repeated moss spots, and the mood that flows through the entire scroll is most charming. This is an especially fine piece among surviving Mi Yu-jen copies, and was probably done not later than the Yüan period.

37. Chang Wo. "Visiting Tai on a Snowy Evening." *Yüan dynasty. Ink on paper. 91.8 × 39.6 cm. Shanghai Museum.*

Chang Wo (fourteenth century) was styled Shu-hou, and used the alias Chen-chi-sheng. He was a native of Hang-chou in Chekiang Province. He gained office through the classical explication examination, but the official world left him unsatisfied, and he immersed himself in poetry and painting. Among his writings is a collection entitled "The Papers of Chen-chi-sheng." Chang excelled at figure painting, and studied in particular Li Kung-lin, whose *pai-miao* outline technique he apparently mastered. In 1348 (Chih-cheng 8) the great patron of literati artists Ku Chung-ying did honor to thirty-seven outstanding scholars, whom he gathered in his Jade Mountain Grass Hall. It was an event that rivaled the "Purification Ceremony at Orchid Pavilion" thrown by Wang Hsi-chih, and the "Miscellaneous Gathering at West Garden" held late in Northern Sung times. Chang Wo was one of the group, and is said to have preserved the event in a scroll entitled "An Elegant Gathering with Yü-shan." He thus became, with Ni Tsan and K'o Chiu-ssu, a full member of the late Yüan literati painting forum that formed around Ku Chung-ying.

This painting depicts Wang Hui-chih (styled Tzu-yu), who on a clear, moonlit night after a snowfall, abruptly boarded a small boat to visit Tai K'uei (styled An-tao). The story goes that he got as far as Tai K'uei's door, when suddenly he turned around and went back. When asked the reason he replied, "I went that far on an impulse, but

then the desire left me and I had no reason to visit Tai An-tao after all." The figure of Wang Hui-chih sitting in the boat and the folds of the clothing on the boatman handling the oar are different from the drawing in Li Kung-lin's scroll, "The Nine Songs" (held by the Boston Museum of Art), which Chang is said to have imitated. The rapidity of the brushwork and the strength of the lines with their variable "thick and thin" quality are already beyond the *pai-miao* outline method of Li Kung-lin and have become Chang Wo's own. Together with the characteristic features of the Li Ch'eng–Kuo Hsi school of literati painters in the Yüan period, as shown in the expression of the trees and the shading of the rocks, these features impart to the work a bold carelessness generally characteristic of late Yüan literati painters, and especially those from the Chekiang region.

A colophon by the Ch'ien-lung emperor and five imperial seals appear on the painting, but it is not recorded in the *Shih-ch'ü pao-chi*, the catalogue of the Ch'ing imperial collection.

38. Wang Yüan. "Bamboo, Rocks, and a Flock of Birds." *Yüan dynasty. Ink on paper. 137.7 × 59.5 cm. Shanghai Museum.*

Wang Yüan was a native of K'ang District in Chekiang Province. The dates of his birth and death are not known, but he was active during the Chih-cheng reign period (1341–67). He was styled Jo-shui, and took the alias Tan-hsüan. A friend and student of Chao Meng-fu, he excelled at figure, landscape, and flower-and-bird painting. In landscape he took Kuo Hsi as his model, in flower-and-bird painting followed Huang Ch'üan, and imitated T'ang dynasty figure painting. His ink wash bamboo and rock paintings were particularly valued at the time. In this painting, flowers and birds of the Huang Ch'üan style are placed among ink bamboo and rocks. It has been retouched in later times, yet transmits the characteristic features of Yüan painting faithfully. At the right of the painting appears the inscription "The fifteenth day of the sixth month in summer of the *chia-shen* year of the Chih-cheng reign period," which dates the painting in 1344. There have long been in Japan flower-and-bird paintings attributed to Wang Yüan, but no genuine works have yet been discovered. This painting is a noteworthy document in Chinese art history.

39. Jen Jen-fa. "Chang Kuo in Audience with the Ming-huang Emperor." *Yüan dynasty. Color on silk. 41.5 × 107.3 cm. The Palace Museum.*

Jen Jen-fa (1254–1327) was styled Tzu-ming and used the alias Yüeh-shan. He was a man of storied wealth from Ch'ing-p'u District in Kiangsu Province. Well versed in water utilization, he made a substantial contribution as a water control official. Skilled at both calligraphy and painting, he was particularly noted for his house paintings.

This painting depicts Chang Kuo, a Taoist priest from T'iao-shan in Hopei Province, performing some mysterious Taoist art before the throne of the Emperor Hsüan-tsung of T'ang. He was said to have been several hundred years old, and to have ignored the summons of the emperors T'ai-tsung and Kao-tsung. Once he feigned death before the Empress Wu Tse-t'ien, and when she had been convinced it was true, came to life again. Upon hearing of Hsüan-tsung's interest in seeking the *tao*, Chang Kuo gradually made his way to Ch'ang-an. The emperor's delight and faith in Chang's Taoist arts were such that he

even wished to give a princess in marriage to him. It is related that he rode thousands of miles a day on a white mule, and when resting would fold the mule up like paper and place it in a box. One day he gave one of his followers a dipper of wine, and when still more was forced upon him, the youth turned suddenly into a wine keg. The attendant at the left edge of the painting is offering his cup, probably with reference to this story. The three men standing by the yellow-robed emperor are ornately colored in vermillion, blue, and green, while the red spotting of Chang Kuo's shoes, the horse's saddle, and the attendant's belt give a fresh, vivid effect. But the restful, unhurried elegance of the painting is due not so much to the movement and expression of the figures as to the smooth, lovely line, which he must have taken from the orthodox tradition of Li Lung-mien. At the end of the scroll there are colophons by K'ang Li-k'uei of Yüan and Wei Su of Ming. This work is not only one fine example among many surviving paintings attributed to Jen Jen-fa, but is also a rare masterpiece of Yüan dynasty genre painting.

40. *Chu Te-jun. "Country Villa" (detail). Yüan dynasty. Light color on paper. 28.3 × 118.7 cm.*

Chu Te-jun (1294–1365) was styled Tse-min. His native place is variously given as P'ing-chiang in Hunan, or either Wu-tu or K'un-shan in Kiangsu Province. Wu-tu is perhaps most appropriate, as it is so given in the tomb inscription written by Chou Po-chü. Because the family was originally from Sui-yang, he was referred to in the literature of his time as "the Sui-yang painting master." Chu took office under the Yüan court, and rose to the position of Cheng-tung Director of Confucian studies. He resigned and then took office again in 1352 (Chih-cheng 12) as magistrate of Ch'ang-hsing. Serving there only a short time, he again retired and shortly thereafter died. Chu Te-jun was a man of grave integrity, and when paintings were requested from him, he would refuse on the pretext of a sore wrist. The scarcity of his work is attributed to this.

It was on the recommendation of Chao Meng-fu that Chu Te-jun had been appointed to the office of historical compilation, and Chu showed his influence as well in painting. Chu may have studied the Li-Kuo landscape style directly from Chao Meng-fu.

This painting depicts the Hsiu-yeh Pavilion, a country house and study built in Yü-hang, Chekiang, by the artist's friend Chou Ching-an. Chu Te-jun also wrote a commemorative inscription for it in which he wished Chou a successful future.

The composition of the scroll is in the so-called level-distance landscape form, and lays out the scene described in the colophon. At the right is an arrangement of rather largely drawn pine trees, a manner often employed by Chu Te-jun, and visible occasionally in the paintings of Chao Meng-fu. A rather thick "tangled fiber" shading is used on the mountain peaks and slopes. The drawing is rapid and free, and has a strong southern (Nan-tsung) character in comparison with the artist's usual structural shading technique based on the Li-Kuo style.

This painting is a work of 1364 (Chih-cheng 24), the year before Chu Te-jun's death, and is an important example of the artist's latest style. The scroll carries seals of appraisal by Hsiang Yüan-pien, An Ch'i, and Kao Shih-ch'i, showing a notable transmission since late Ming, and bears several seals of the Ch'ien-lung emperor, indicating its existence in the Inner Treasury of the Ch'ing dynasty.

41. *Fang Ts'ung-yi. "In the Depths of Clouded Mountains." Yüan dynasty. Ink on paper. 25.0 × 57.4 cm. Shanghai Museum.*

Fang Ts'ung-yi was styled Wu-yü, with the aliases Fang-hu, Chin-men Yü-k'o, and Pu-mang Tao-jen. A native of Kuei-hsi in Kianghsi Province, he became a Taoist priest at Shang-ch'ing-kung, a Taoist temple at Lung-hu Mountain in that area. The dates of his birth and death are not known, but he appears to have been alive during the Hung-wu reign period (1368–99) in early Ming, and to have lived over ninety years. The colophon at the left of the painting carries the phrase 洪武玄戩沮灘, indicating the year 1392 (Hung-wu 25). The colophon is not Fang Ts'ung-yi's own. Said to have studied both Mi Fu and Kao K'o-kung, Fang excelled at landscapes, of which he did two kinds: one with free, careless brushwork, the other much in the Mi style. This painting belongs to the latter sort in its broad-perspective composition, the wide spreading of wet ink, and the drawing of the clouds and mists. Fang Ts'ung-yi's clouds and mists, however, overflow with a spirit unmatched by the formalistic painters in the Mi style that developed from Ming times.

42. *Li Shih-hsing. "A Grove of Dead Trees." Yüan dynasty. Ink on paper. 169.6 × 100.4 cm. Shanghai Museum.*

Li Shih-hsing (1282–1328), styled Tsun-tao, was a native of Chi-ch'iu in Hopei Province, and was the son of Li K'an, well known for his paintings of ink bamboo. His talent in painting and calligraphy was acknowledged by the Emperor Jen-tsung; he was made an official of the fifth grade in the Imperial Secretariat, and later became the prefect of Huang-yen in Chekiang. Though he also did landscapes, Li Shih-hsing was better known for his ink bamboos, and excelled particularly at dead tree, bamboo and rock paintings, which may be classified as the "sparse thickets and old trees" type. Though his paintings were seldom recorded in the painting catalogues and few survive today, they became favorite themes in the poetry of the literati of his day. This painting is probably based on a theme of the Li Ch'eng school, "winter forest in the level distance," in which the more distant landscape is neglected in favor of emphasizing the dead trees in the center foreground, and making it thus chiefly a tree and rock painting. Judging by the clawlike forms of the old trees and bamboo, the artist appears to have based his technique on the Northern Sung Li Ch'eng-Kuo Hsi style, which flourished anew in the Yüan period. The painting bears the signature "done by Li Shih-hsing Tsun-tao of Chi-ch'iu." At the upper right is a seven-word poem, but nothing is known about its author, a T'ien-t'ai monk named Chih-yüan.

43. *T'ang Ti. "Fishing in a Snowy Cove." Yüan dynasty. Light color on paper. 148.3 × 68.2 cm.*

T'ang Ti, styled Tzu-hua, was from Wu-hsing in Chekiang Province. He began as a teacher in Ch'en-chou, Hunan, served as inspector and auditor in the Ch'ing-t'ien district of Chekiang, and finally became magistrate of Hsiu-ning District in Anhui. As he obtained his offices by selective promotion, his learning and ability were widely recognized, and he seems as well to have made a notable contribution to the political affairs of his time.

A literati painter, T'ang Ti excelled at landscapes and was considered the finest of the Chiangnan painters who worked in the Kuo Hsi style. His study of Kuo Hsi reveals

itself generally in the manner of his composition, and more specifically in the expression of space and the technique of filling in a scene with claw-shaped winter trees. The fine detail technique of his brushwork shows the influence of Chao Meng-fu, and he retained at the same time that bold freedom characteristic of Yüan painting circles.

The movement to restore Northern Sung painting, which was promoted by Chao Meng-fu, tended to emphasize the two opposing styles of Tung Yüan and Chü-jan on the one hand, and Li Ch'eng and Kuo Hsi on the other. As later painters eclectically adopted elements from both, rather complex stylistic forms resulted. It is for this reason that T'ang Ti is said variously to have studied Kuo Hsi and also to have taken Chao Meng-fu and Tung Yüan as his masters.

This painting is a work of 1352 (Chih-cheng 12). It is the finest of the surviving works of T'ang Ti and is very characteristic of his style. The central mountain is largely drawn and conveys a feeling of weight. The scene laid out below seems to be after Kuo Hsi in its attempt to arrange a distant view, but it is not well handled, and tends to destroy the feeling and perspective of the scene in the foreground. The rocks, slopes, and peaks are outlined in sharply contrasting "thick and thin" lines, and the contour shading is rough and harsh, which well illustrates the technique of the Li-Kuo school of landscape in the latter half of the Yüan period.

44. *Ni Tsan. "Autumn Sky in a Fishing Village." Yüan dynasty. Ink on paper. 96.0 × 47.0 cm. Shanghai Museum.*

Ni Tsan (1301-74) was a native of Wu-hsi in Kiangsu Province. He was styled Yüan-chen and had many aliases, the most familiar of which was Yün-lin. A man of great wealth, he constructed pavilions, collected ancient calligraphy, paintings, and bronzes, and kept up close associations with the literati of his day. In the beginning of the Chih-cheng reign period, at the age of fifty, he is said to have divided his property among his friends and relatives and journeyed freely about, finally returning home in his last years to die. Ni Tsan studied the landscape style of Tung Yüan and Chü-jan, and works do survive that may be taken to show that influence. His real abilities, however, lay with "level distance" landscapes of a still and soothing tone. This style, described as a melancholy serenity resulting from "a complete change from traditional techniques late in life," expresses within a simple surface composition the exalted feelings within one's breast, and is the concrete expression of a creative attitude that "strives to paint in a simple and unaffected manner."

This work was done in 1355 (Chih-cheng 15), on the occasion of the artist's visit with friends to the fishing village of Wang-yün-p'u. Ni Tsan was then fifty-five, and in those years in the grip of a dilemma that caused him much worry and anger. In this painting one feels that resentment sublimated into a burning creative energy. The trees are forlorn, and the surface of the painting is largely taken up by open space; yet it is not without substance, and exudes a high degree of tension.

45. *Wang Meng. "Reading in Spring Mountains." Yüan dynasty. Light color on paper. 132.4 × 55.4 cm. Shanghai Museum.*

Wang Meng (ca. 1308-85) took the alias "Woodcutter of Golden Oriole Mountain" probably in 1351, the first year of the Chih-cheng reign period. As this painting is signed, "Painting, poetry, and calligraphy by Wang Meng,

the old woodcutter beneath Golden Oriole Peak," it can be judged a post-Chih-cheng work. Compared technically with the "Hermitage at Pien-shan" (Pls. 46, 47), there is greater use of moss spotting, which becomes here the chief expressive technique on the mountains and slopes, and the composition is more simple and flat. The two seven-word regulated poems that appear in the upper left-hand corner are Wang Meng's own compositions.

46, 47. *Wang Meng. "Hermitage at Pien-shan." Yüan dynasty. Ink on silk. 141.0 × 42.2 cm. Shanghai Museum.*

Wang Meng was a native of Hu-chou in Chekiang Province. He was styled Shu-ming, and went by the alias the "Woodcutter of Golden Oriole Mountain." He was the maternal grandson of Chao Meng-fu and the paternal cousin of T'ao Tsung-yi. In late Yüan he was appointed to a legal office, but taking refuge from military rebellion he went into seclusion at Huang-ho-shan and assumed there the "Woodcutter of Golden Oriole Mountain" alias. In 1368 (Hung-wu 1) he emerged to take office under the Ming dynasty and was made prefect of T'ai-an in Shantung Province, but he later became involved in Hu Wei-yung's plot against the throne and died in prison. The dates of his birth and death are not entirely clear, but judging from the signature "the fifteenth day of the ninth month of the sixth year of the Chih-cheng reign period, at seventy-five years of age," which appears on a Wang Meng painting recorded in the *Keng-tzu hsiao-hsia chi*, the artist would have been 114 years old at the time of his death in prison in 1385 (Hung-wu 18). This date, however, is not entirely reliable.

Wang Meng felt strongly the influence of his grandfather Chao Meng-fu. He also studied Wang Wei and Tung Yüan, and finally established his own unique style. His free and shifting technique may be considered outside the range of Chao Meng-fu's style. In his drawing he fleshed out the natural scene with accretions of "spread fiber" contour shading, and his composition favored height and distance with many imposing mountain peaks, revealing his study of Northern Sung landscape paintings.

This painting carries the artist's signature, "Hermitage at Ch'ing-pien, painted by Wang Shu-ming of Golden Oriole Mountain, in the fourth month of the twenty-sixth year of the Chih-cheng reign period," marking it a work of 1366 near the end of Wang's period of seclusion. The painting depicts an early summer scene at Pien-shan, a famous scenic area in the artist's native district of Wu-hsing. Hills rise in waves like leaping dragons toward the central peak, filling the work with a sense of motion making the most effective use of the vertical hanging scroll. The mountain tops are done in the rounded *fan-t'ou* style of Chü-jan, while the slopes make much use of the "spread fiber" shading, accented by heavy black moss spots. The surface is well filled, yet the painting gives an effect of neat elegance. The mounting paper above the scroll bears the large characters of Tung Ch'i-ch'ang reading, "Painted by Wang Shu-ming, first under Heaven." It is one of Wang Meng's masterpieces and is often mentioned in the critical writings of the Ming and Ch'ing periods. It passed through the hands of famous collectors in late Ming and early Ch'ing, and finally came into the Ch'ing imperial collection. At the collapse of the Ch'ing dynasty, it passed again into private hands.

There appears as well to have been a smaller version of this painting, called the "*Ching-pien yin-chü t'u hsiao-fu.*"

48. *Wang Meng. "Mount T'ai-pai" (detail). Yüan dynasty. Light color on paper. Full size: 27.0 × 238.0 cm. Liaoning Provincial Museum.*

The painting presented here is a section from the end of the Mount T'ai-pai scroll. There is no signature, but it does bear a seal showing the characters "Wang Meng." In the skillful distribution of mountains and the feeling of depth that they produce, and the large expression of space that spreads out from top to bottom at the end of the scroll, the work seems to draw upon the Northern Sung landscape style. The technique applied to the buildings here recalls the architectural style, and with the cleverness in the depiction of human figures and the structural shading of mountains and rocks, is entirely consistent with the account of Wang Meng's style carried in the histories of painting. As one of Wang Meng's most famous works, this scroll is listed in the catalogues of many collections. It finally came into the Inner Treasury of the Ch'ing court, and is listed in the *Shih-ch'ü pao-chi*, but in this imperial catalogue no mention is made of the Ch'ien-lung inscription seen on this painting. Perhaps it was omitted by the editors during the collation of 1782.

49. *Li Sheng. "A Landscape Scroll." Yüan dynasty. Light color on paper. 22.7 × 69.0 cm. Shanghai Museum.*

Li Sheng (fourteenth century), styled Tzu-yün with the alias Tzu-yün-sheng, was a native of Hao-liang in Anhui Province. He excelled at ink bamboo, hollowed rocks, and "level distance" landscapes on a small scale.

This scroll was painted on the occasion of the artist's parting with Ts'ai Hsia-wai, who was to go to Nan-ch'ang as head of the Taoist Ch'ung-chen temple there. It probably depicts the the scenery around Tien-shan Lake in Kiangsu, where Li Sheng spent his last years. Inscriptions by Ts'ai Hsia-wai and other famous literati were probably removed by someone, judging by the artist's own colophon, which states "Inscribed again in *ping-hsü*, the sixth year of the Chih-cheng reign period," and by the reference to a poem he had himself composed to send off Ts'ai Hsia-wai, and by the colophon of Chu Yi-tsun (1629–1709) that appears at the end of the scroll.

The drawing in this scroll draws upon the Li Ch'eng-Kuo Hsi school, but the shading and dotting technique are of a special character, the ink tone being especially superb. The awkwardness of the trees, however, suggests that Li Sheng was not a professional painter.

The first colophon by Chu Yi-tsun differs somewhat from the text printed in the *P'u-shu-t'ing shu-hua pa* (Mei-shu ts'ung-shu edition), or else there were possibly two landscape scrolls by Li Sheng in existence. There are at present, however, no materials to examine this problem further.

50. *Mural in the San-ch'ing Hall of the Yung-lo Palace. "A Group of Divines" (detail). Yüan dynasty.*

51. *Mural in the Ch'un-yang Hall of the Yung-lo Palace. "Chung Li-ch'üan and Lü Tung-pin" (detail). Yüan dynasty.*

The Yung-lo Palace is located in Yung-lo-chen, a town in the southeast of Yung-lo District in Shanhsi Province. The town is said to have been the residence of the Taoist immortal Lü Tung-pin, and in T'ang times his dwelling there was known as "the sacrificial hall of Lord Lü." In Sung and Chin times, however, the character 祠 (tz'u) was

changed to 観 (kuan), a special usage denoting a Taoist temple. In 1262 the temple was destroyed by fire, but was later rebuilt and enlarged and given the name "the great Ch'un-yang Palace of Immortality."

In the Yüan dynasty the palace was again greatly enlarged, and a small part of it remains standing today. Of the two gates (Shan-men and Wu-chi-men) and three halls (San-ch'ing-tien, Ch'un-yang-tien, Ch'ung-yang-tien), all besides Shan-men are structures dating from the Yüan period. These all contain murals, which although somewhat retouched, are also works of the Yüan period. On the wall of the San-ch'ing Hall, dated the sixth month of the second year of the T'ai-ting reign period (1325), is the signature of painter-in-attendance Ma Ch'i, eldest son of Ma Chün-hsiang; and in the Ch'un-yang Hall are inscribed the names of Li Hung-yi, Wang Shih-yen, Wang Ch'un, Chang Shih, Wei Te, Chang Tsun-li, T'ien Te-hsin, and Ts'ao Te-min, all disciples of Chu Hao-ku of Ch'in-ch'ang, and dated 1358 (Chih-cheng 13). The mural must thus be the work of the early or mid-fourteenth century, though the identity of the artist is not known.

These works are related in style to the religious temple murals that flourished in the Northern Sung period. The tradition of large religious paintings that was continued in the Chin state after the collapse of Northern Sung is preserved in many murals of the Yüan period in Shanhsi Province, including those in the Yung-lo Palace. The composition, in which large figures are crowded into a surface without empty space, and the landscape background are especially characteristic of the Northern Sung style. Plate 51 shown here appears on the northern wall of the Ch'un-yang Hall, and is called "Chung Li-ch'üan and Lü Tung-pin Discussing the Tao." Around the four walls of the hall is depicted the life of Lü Tung-pin in fifty-two sections. The section presented here shows the novice Lü Tung-pin (on the left) receiving instruction from the immortal Chung Li-ch'üan. It is a grand figure painting that captures even a psychological state.

Plate 50 is a section of the mural in the San-ch'ing Hall. Around its four walls are 280 figures grouped around the central portraits of the Eight Chief Divines. These gods take on the form of emperors and empresses, and around them are grouped immortal earls (仙伯), true adepts (眞人), divine kings (神王), warriors (力士), golden boys (金童), and jade maidens (玉女), all in a variety of precisely expressed male and female, young and old, civil and martial forms.

The Yung-lo Palace stood forgotten for a long time, but after the Liberation it was suddenly rediscovered with much fanfare.

52. *Anonymous. "Kuang-han Palace." Yüan dynasty. Ink on paper. 75.6 × 62.1 cm. Shanghai Museum.*

The palaces depicted here are identified by an inscription over the main gate as Kuang-han-kung, or the Palace of the City of the Moon, where dwelled the fabled Ch'ang O, goddess of the moon in Chinese mythology. This architectural style, in which fine ruled lines were used to draw buildings, boats, and carriages, flourished since the Northern Sung period, and was developed by many famous artists such as Kuo Chung-shu. Yüan masterpieces in this style are the Ta-ming Palace and Ta-an Hall paintings by Wang Chen-p'eng. The scroll entitled "Ascending the River at the *Ch'ing-ming* Season" by Chang Tse-tuan in-

troduced in this volume (Pls. 4, 35) is the most outstanding example of this style to survive from the Sung period, and this painting of the Kuang-han Palace is perhaps the best of the post-Sung period. Although this work does not approach the overwhelming power of the earlier "Ascending the River" scroll, it is nonetheless superior in its precision of line and elegance of tone. It is a representative work that shows the standard of architectural painting in the Yüan period. The signature in the lower left corner, 臣賢, is a later addition, and probably an attempt to falsely ascribe the painting to Wei Hsien, a famous architectural painter of the Southern T'ang state.

53. Chao Yüan. "Grass Pavilion at Ho-hsi." Ming dynasty. Light color on paper. 84.3 × 40.8 cm. Shanghai Museum.

Chao Yüan (latter half of the fourteenth century) was styled Shan-ch'ang, with the alias Tan-lin. His native place is sometimes said to have been Su-chou, but judging from the praise of his contemporary literatus Wang Feng, who referred to him as "Chao Yüan of Ch'i-tung who visited in Wu-hsia," and the signature "Chao Yüan of Ying-ch'eng" that appears on this painting, he must have been originally from Shantung Province and taken up residence in Su-chou. Taking Tung Yüan and Chü-jan as his masters, he excelled at landscape painting and was held to rival Wang Meng. During the Hung-wu reign period in early Ming he became a court art historian, but was executed for disobeying the will of the Emperor T'ai-tsu.

The colophon on this work reads "The Grass Pavilion at Ho-hsi, painted by Chao Yüan of Ying-ch'eng for the master of Jade Mountain." It was done for Ku Ah-ying (alias Chin-su Tao-jen) and depicts his country villa at Ho-hsi. Ku Ah-ying's was one of the leading families of K'un-shan, and he was a great patron of literary and artistic figures of late Yüan. Chang Shih-ch'eng, known in late Yüan as Prince of Wu, appointed Ku prefect of K'uai-chi, but he refused the office and fleeing further harassment went to live in seclusion at Ho-hsi in Chia-hsing, Chekiang Province.

This painting is thought to show the Grass Pavilion and the scene that surrounds it. In composition and technique it makes no attempt at eccentricity, and as described in Ku Ah-ying's inscription, it captures fully the characteristics of a broad expanse of water. It was done in 1363 (Chih-cheng 33), and is a superb piece well qualified to represent literati painting in late Yüan.

54, 55. Wang Fu. "Study at Hu-shan" (detail). Ming dynasty. Color on paper. Full size: 28.0 × 821.0 cm. Liaoning Provincial Museum.

According to the colophon by Wang Fu at the end of this scroll, the work was painted in 1410 (Yung-lo 8) for a friend named Chung Yung. Wang long before had been requested to do this painting of his Hu-shan study, but kept postponing it until a gift of fine paper from Chung Yung pressed him to complete the work and send it off. The mountains and slopes are plainly built up with a "spread fiber" shading technique (known as the Wang Meng style), and a waterside community is unfolded along the length of the scroll. In both composition and brushwork the piece avoids novelty to faithfully pursue the natural scene, and in the poetic effect and elegance that pervade it, shows fully Wang Fu's style as a literati painter. The seals on the scroll show it to have been in the possession of Hsiang

Yüan-pien, An Yi, and the Inner Treasury of the Ch'ing court. Seals of appraisal set by Wen Cheng-ming and his son Wen P'eng are also to be seen, and a colophon by Wen Cheng-ming appears at the scroll's end.

56. Wang Fu. "Bamboo and Rocks." Ming dynasty. Ink on paper. 68.7 × 23.5 cm. Shanghai Museum.

Wang Fu (1362–1416) was styled Meng-tuan, and took the aliases Yü-shih, Chiu-lung Shan-jen, and Ch'ing-ch'eng Shan-jen. He was a native of Wu-hsi in Kiangsu Province. The Wang family had for generations lived in seclusion without seeking office, but at the end of the Yüan period Wang Fu became a "district scholar." He was subsequently dismissed from office, however, and went into seclusion at Chiu-lung-shan. In 1378 (Hung-wu 11), early in the Ming dynasty, he again took office, but soon became further involved and was dispatched to Shanhsi Province as a soldier. At this he again fled into seclusion, only to emerge in the tenth year of the Yung-lo reign as a Grand Secretary in the Imperial Secretariat, on the basis of his ability as a calligrapher. His was a life of many strange turns indeed.

Wang Fu was also well read in Buddhism and Taoism, and a collection of his poetry in five chapters, called Yu-ku hsien-sheng shih-chi, survives. His best talent, however, lay with painting, and even in landscapes derived from the styles of the Four Great Masters of Late Yüan he left works rich in individual character. His most famous genre, however, was his dead tree, bamboo and rock paintings. The best received of these were his ink bamboos, which were said to possess the manner of Wen T'ung of Northern Sung. Fundamentally the ink bamboo is supposed to be the concrete expression of the artist's character, and it may be said that in Wang Fu's ink bamboo are best expressed the transcendent, exalted ideals of his life and character.

This painting Wang Fu did for Kuo Yi (styled T'ing-chang, alias T'ing-sung Lao-jen, a painter of landscapes, pines and bamboo). At the lower right of the painting is inscribed his own seven-word, four-line poem. Beneath the shadow of an overhanging bank grow young bamboo, their green freshness suggested in ink monochrome. The work avoids the clichés of the theme and shows a fine observation of nature in the drawing of the partially opened leaves. At the lower edge is placed a single orchid, probably to complete the so-called "three friends" (san-yu) or "three purities" (san-ch'ing) design with bamboo, rock, and orchid.

57. Hsü-Pi. "Grass Pavilion in an Autumn Forest." Ming dynasty. Ink on paper. 100.3 × 26.7 cm. Shanghai Museum.

Hsü Pi, a native of Ch'ang-chou in Kiangsu Province, was styled Yu-wen with the alias Pei-kuo-sheng. The dates of his birth and death are not clear. Ch'ien Ch'ien-yi estimates the time of his death to have been the eleventh or twelfth year of the Hung-wu reign period (1378 or 1379), while extant paintings carry a later date suggesting he may have died in prison early in the Yung-lo reign period (1403–24). In late Yüan times he formed a group called the "Ten Friends of Pei-kuo" with Kao Ch'i, Chang Yü, Yang Chi, and others who lived around him, exchanging poems and passing the literary life. He was later summoned by Chang Shih-ch'eng to office, but refused and retired to Shu-shan in Hu-chou, where he built a residence. In 1374 (Hung-wu 7) he did finally accept appointment,

passing through offices in the Censorate and Board of Punishments to become imperial commissioner for civil and financial affairs in Honan.

Hsü Pi excelled alike at poetry, prose, calligraphy, and painting. He is especially renowned for his poetry, which is collected in his *Pei-kuo-chi*. He is said in his landscape painting to have studied Tung Yüan, but judging from extant works, the influence of Wu Chen, one of the Four Great Masters of Yüan, seems strong. In the shape of the mountains and the "spread fiber" shading technique the influence of Wu Chen can be seen, but there is none of the strong ink and brushwork or free careless-ness characteristic of Wu Chen, and practiced as well by Hsü Pi throughout his career as a painter. The com-position here is a common one, featuring a secluded pavi-lion in the foreground and a distant landscape set out on the far side of a body of water. The scene is fashioned by carefully building up strokes with a soft, gentle brush. At the top of the painting is inscribed a seven-character four-line poem by the artist, and another poem by Ch'en Hsün, a scholar of the Yung-lo reign period.

58. *Wang Mien. "Ink Plums." Ming dynasty. Ink on paper. 68.0 × 26.0 cm. Shanghai Museum.*

Wang Mien was a native of Chu-chi in Chekiang Province. He was styled Yüan-chang, and had also the aliases Chu-shih Shan-nung and K'uai-chi Wai-shih. Born to a farm-ing family, he became by diligent study a disciple of the outstanding Neo-Confucian scholar Han Hsing, and after Han's death, became tutor to his children. Wang Mien was successful in his district examinations, but acquired a reputation as a nonconformist when he failed to take the *chin-shih* degree and abandoned thoughts of an official ca-reer. Later as his eccentricities multiplied, he became known as "K'uang-sheng," the "mad scholar." Like other hermits at the end of Yüan, he foresaw the impending disorder and retired to Chiu-li-shan, where he cultivated plums and built a residence called "The Plum Blossom Study." Among his writings is a collection of poetry, the *Chu-chai shih-chi.*

Wang Mien also painted bamboo and rocks, but he excelled most at plums done in ink, and was held not inferior to the Sung plum painter Yang Pu-chih. He was one of the molders of the characteristic ink plum style that flourished in late Yüan and early Ming times.

Among the many ink plum paintings by Wang Mien, there are none so packed with plum blossoms in full bloom as this one. Little empty space is left, and even that is filled with the artist's own poems. One of these bears the date *yi-wei*, marking the painting a work of the fifteenth year of the Chih-cheng reign period (1355). There are two theories on the dates of Wang Mien's life. One sets his birth in 1337 (Chih-yüan 3) and his death in 1407 (Yung-lo 5), while the other fixes his birth at 1277 (Chih-yüan 14). If the former date is accepted, this painting would have been done at the age of twenty-one. But this is not confirmed by the mature style of calligraphy, nor is it consistent with the line in his poem, "My temples have all turned white." Further, it would have been impossible for Sung Lien, who died in 1381, to speak in his biographical sketch of Wang Mien's death. Thus the latter date, as given by Wu Jung-kuang in his *Li-tai ming-jen nien-p'u,* is the more probable.

59. *Ma Wan. "Poetic Conception of Evening Clouds." Ming dynasty. Color on silk. 96.0 × 56.0 cm. Shanghai Museum.*

Ma Wan (mid-fourteenth century) was a native of Chiang-ning (some say Sung-chiang or Hua-t'ing) in Kiangsu Province. He was styled Wen-pi, and had the aliases Lu-tun-sheng, Chu-yüan Kuan-che, and Kuan-yüan. In 1370 (Hung-wu 3) he became governor of Fu-chou-fu, and was generally known as "Governor Ma." He had early followed Yang Wei-chen (styled T'ieh-yai) in the study of the *Spring and Autumn Annals,* and was further famous as a poet, leaving over five hundred pieces in a collection entitled *Kuan-yüan-chi.* Ma was highly praised as a "master of the three arts of painting, poetry, and calligraphy"; his calligraphy was of high quality, and he followed Tung Yüan and Mi Fu in landscape painting. These were highly praised as presenting a rich scene in a broad, "level-dis-tance" perspective, with a unique method of handling the subject.

This painting is an example of the Mi style landscape fla-vored with a touch of Tung Yüan, in which Ma Wan most excelled, and is thought to be a work of 1359 (Chih-cheng 19), during his most mature, creative period. The mountains are brushed in a medium light wash and over-spotted with the "fallen eggplant" dotting technique to show shadowed portions and create a harmony of ink tones. Empty white spaces are left in the mountain slopes to suggest mists; the rounded mountain peaks stand in isola-tion, yet are spatially related to each other in a successful projection of depth. The manner in which the subtle colors of the scene are captured in a waning light shows an uncom-mon technique. In contrast to the formalized Mi style since Ming times, which ignored the creativity necessary to Mi mountains, this painting employs elements of the Mi style in a manner most appropriate to landscape expression.

In the upper right of the painting appears Ma Wan's signature, and in the upper left a five-syllable regulated poem by a monk named Wu-yüan, about whom nothing is known.

60. *Hsia Ch'ang. "Ink Bamboo." Ming dynasty. Ink on paper. 151.2 × 54.3 cm. Shanghai Museum.*

Hsia Ch'ang (1388–1470) was originally named Chu Ch'ang, but changed his name to Hsia Ch'ang upon the urging of the Hung-wu emperor. A native of K'un-shan in Kiangsu Province, he was styled Chung-chao, and used the aliases Tzu-tsai Chü-shih, Yü-feng, and K'un-shan-jen. Passing through a succession of offices after taking his *chin-shih* degree, he was finally appointed president of the Court of Imperial Sacrifices at the beginning of the T'ien-shun reign period (1457–64). He died shortly after retirement at the age of eighty-three. Hsia was an excellent calligrapher and had once serve the inner court as Grand Secretary in the Imperial Secretariat. He was also a fine poet. In painting, though said to have tried his hand at landscape, his best work was in ink bamboo and rocks. His rain-beaten, mist-shrouded bamboo were of particularly high quality, and he was always mentioned together with his teacher, Wang Fu. Hsia's style added new creative ideas to the ink bamboo form that was brought to completion in late Yüan. His paintings were valued at a thousand pieces of gold a sheet, which gave rise to the popular jingle, "one bamboo by President Hsia is worth ten ingots of gold from Hsi-liang."

This painting was presented to someone named Shu-chao. Differing from those who painted but a single stalk of bamboo, Hsia arranged two stalks, one light and one heavy, to give depth to the surface of the painting. Using a

rich ink to create harmonious tones, he produced fresh, young bamboo leaves and branches.

61. *Tai Chin. "Spring Mountains Turning Green." Ming dynasty. Ink on paper. 141.3 × 53.4 cm. Shanghai Museum.*

Tai Chin (late fourteenth-fifteenth centuries) was styled Wen-chin, with the aliases Ching-an and Yü-ch'üan Shan-jen. He was a native of Ch'ien-t'ang in Chekiang Province. His studies carried him broadly from Ma Yüan, Hsia Kuei, and the Southern Sung academy forms to the Li Ch'eng-Kuo Hsi style, and he excelled equally at landscape, figure, and flower-and-bird painting. A member of the Hsüan-te painting academy established by Emperor Hsüan-tsung (1426–35), he left his mark on the whole of the later court style, and as a result of his influence upon contemporary non-academy painters and on later times, was regarded as the founder of the Che school and considered the leading artist of the Ming dynasty as well. Though a professional painter, Tai's literati associations were comparatively more numerous than was the case with other Che school painters, and he was rather highly evaluated by later literati critics.

This painting depicts a noble scholar walking with a stick through spring mountains, followed by a servant boy carrying a lute. It was done in 1449 (Cheng-t'ung 14). Features of the Che style can be seen in the strong, heavily inked lines and numerous coarse strokes that compose the trees and slopes. Although the formal composition is based upon the Southern Sung academy style, the work perhaps shows aspects of Tai's landscape style, which is apt to be confused with the later Shen Chou. The motif of the scholar with cane and boy with lute, as well as the structure of the mountains, are common to Tai Chin's other paintings. Nothing is known of the man named Wen Hsü mentioned in the artist's colophon, to whom the work appears to have been presented.

62. *Li Tsai. "Ch'in Kao Astride a Carp." Ming dynasty. Light color on silk. 164.3 × 45.8 cm. Shanghai Museum.*

Li Tsai, styled Yi-cheng, was born at Fu-t'ien in Fuchien province, but later took up residence in Yünnan. It was he who gained fame as the artist under whom Sesshū studied when he traveled to Ming China. The dates of his birth and death are not known, but with Tai Chin and others he held appointment in the painting academy during the Hsüan-te reign period (1426–35). Li Tsai excelled at landscape painting, in which he was said to have studied both Kuo Hsi of the Northern Sung academy and Ma Yüan of the Southern Sung academy. His basic landscape form, however, owes more to the Chekiang style of late Yüan, and he appears to have been much influenced by Tai Chin, founder of the Che school.

This painting depicts the Taoist immortal Ch'in Kao ascending heaven on the back of a carp. In contrast to other Ch'in Kao paintings, which show no more than water and mounted carp, however, this one presents the event within a fully sketched natural scene and skillfully captures the dramatic moment of the ascent with several applauding persons placed on the bank. The pulsating ink surfaces characteristic of the Che school are conspicuous here in the foreground bank and distant mountains and in the method of placing trees upon them. It is understandable why some contemporary literati judged him eccentric, though his

drawing of distant trees shows study of the Kuo Hsi landscape tradition in late Yüan. This is perhaps the best among surviving Li Tsai works.

63. *Wang Ch'ien. "The Most Beautiful Blossoms." Ming dynasty. Light color on silk. 206.4 × 117.6 cm. Shanghai Museum.*

Wang Ch'ien (first half of the fifteenth century) was a native of Ch'ien-t'ang in Chekiang Province. He was styled Mu-chih and known by the alias Ping-hu Tao-jen. Wang was noted for his ink plums, and held to rival Ch'en Hsien-chang. Stylistically, his plums are more ornate than those of Wang Mien; they illustrate the more formalized Ming manner and smell rather strongly of professionalism.

This painting is dated the *ping-yin* year of the Cheng-t'ung reign period (1446). Though the name has been effaced, the painting was presented to someone who was in charge of instruction in the local schools of the capital. In the upper portion is inscribed a poem by Hsiao Tzu (?–1446), a *chin-shih* of the Hsuan-te reign period (1426–35) who became a Han-lin scholar, tutor to the heir apparent, and president of the board of revenue.

64. *Chang Lu. "Figures" (detail). Ming dynasty. Light color on silk. Full size: 26.0 × 154.0 cm. Tientsin Museum.*

Chang Lu lived during the first half of the sixteenth century, and died at the age of seventy-four. He was styled T'ien-ch'ih and had the alias P'ing-shan, though it is said that he went commonly under his style name. He was a bright child, and is said to have entered the painting profession by copying the landscape and figure paintings of Wu Tao-tzu and Tai Chin. Chang followed Ku Chin in painting gods, demons, and Buddhist images, and further studied the style of Wu Wei. Considered a painter within the Che school tradition, he received a mixed evaluation after the end of Ming.

Chang Lu had once been a student in the imperial academy and perhaps hoped to take the official examinations; he seems, however, to have given this up in favor of a life free of responsibility. Famous men of letters and scholars were said to have sought his company, and poetry attesting to this survives.

It is not wholly clear that Chang Lu took Wu Wei as his master, though he was indeed considered first in line after Wu Wei's death. His style does resemble that of Wu Wei in places, and his brushwork shows the same careless freedom. It was for this reason that he was counted one of the "mad school" by later literati critics.

Neither the signature nor seal of Chang Lu appear on this long scroll; but the sharp, strong lines radiating lineally from a central point, as seen in the folds of the clothing of the figures, and the rapid, sharp-angled brushwork are consistent with his style, as is the liberal use of ink in drawing trees and slopes. This is one of Chang Lu's best works, which earned him an equal reputation with Chang Chi-shan, but it gives somewhat the feeling of preoccupation with ink and brush technique.

65. *Chiang Sung. "A Drifting Boat by a Reedy Bank." Ming dynasty. Light color on silk. 189.2 × 104.0 cm. Tientsin Museum.*

Chiang Sung, who lived in the first half of the sixteenth century, was known by the alias San-sung and was a native of Chin-ling (Nanking). Concrete information

about his period of activity is lacking, but as he met censure with Wang Chao and Chang Lu from Ho Liang-chün, who referred to them as contemporaries, it must have been during the Cheng-te and Chia-ching reign periods. Chiang took Wu Wei as his master, but his superior professionalism and coarse use of the heavy "scorched ink" drawing technique earned him the harsh criticism of the dominant Nan-tsung painters of the time.

The theme treated in this painting was apparently a favorite of the artist, since there are two more similar works, which differ only in the number of fishing boats and wild geese, or in the position of the trees in the central ground. This work is rather lacking in depth perspective, but the glistening effect of the richly applied ink, which shows no trace of shading or structural modeling, reveals fully the superior technique of the Che school painters. As praised in one catalogue, "The painting gathers in the beauties of the Chin-ling [Nan-chin] landscape." Chiang Sung's works skillfully capture scenes of wet rivers and mountains.

66. *Chou Wen-ching. "Winter Crows on an Old Tree."* Ming dynasty. Ink on paper. 151.1 × 71.7 cm. Shanghai Museum.

Chou Wen-ching (middle of the fifteenth century) was a native of Fu-t'ien in Fuchien Province. During the Hsüan-te reign period (1426–35) he served in Jen-chih Palace as instructor in the arts of yin and yang (陰陽訓術); he later passed from a position as secretary of accounts in Ta-yü District, Anhui, to become an usher in the Court of State Ceremonial. There exists another painting dated 1463 (T'ien-shun 7) that bears the signature "director of the Jen-chih Palace," so that his appointment as district secretary must have come after 1463. As detailed records are not available, it remains in doubt whether or not Chou Wen-ching was a painter in the court academy. He did figure, flower, and bamboo and rock paintings, but excelled most at landscape, in which he followed the style of Hsia Kuei and Wu Chen. Among his surviving works are many that show the Hsia Kuei form, others in which the influence of the Yüan court style is strong, and even some that exhibit features of the Che school, or perhaps a local Fuchien variant called Min-hsi, all testifying to the breadth of his painting style.

This painting depicts crows at rest on an old tree in deep winter. It is novel in both its handling of theme and composition, and shows a professional facility in the drawing of the bamboo, rocks, and old tree.

67. *Yao Shou. "Fishing in Solitude on an Autumn River."* Ming Dynasty. Light color on paper. 162.2 × 59.0 cm. Shanghai Museum.

The life of Yao Shou is discussed in the note to Plate 11. According to the artist's colophon, this painting was done in 1476 (Ch'eng-hua 12) in response to an essay entitled "An Appreciation of the Ch'ing-yün-shan estate" by Chang Pi (1425–87). It is probably in imitation of a painting of the same title by Chao Meng-fu, which is mentioned in the colophon, but the influence of Wu-chen is strongest in it. Above the painting on separate paper is an appraisal by Tung Ch'i-ch'ang.

68. *Chou Ch'en. "Guests Arrive at a Mountain Study."* Ming dynasty. Color on silk. 136.2 × 72.2 cm. Shanghai Museum.

Chou Ch'en was a native of Wu District in Chekiang Province. He was styled Shun-hsiang and had the alias Tung-ts'un. As he lived near Ch'en Hsien (styled Chi-chao), he became Ch'en's disciple and mastered his style. Chou Ch'en had origionally studied the painting of Sheng Mao of the Yüan period, and was said to have rivaled Tai Chin. According to one story, when Tai Chin fell into disfavor with the painting academy, it was Chou Ch'en who interceded on his behalf with Hsüan-tsung. But judging from his signed surviving works, his relations with Ku Lin, and the notation in the *Ming-shan-tsang* that he was a contemporary of Wen Cheng-ming, his active period seems to have been much later, after the death of Tai Chin. Chou Ch'en was said to have studied the Northern Sung styles of Li Ch'eng and Kuo Hsi, and the Southern Sung academy style of Ma Yüan and Hsia Kuei. Surviving works do bear this out, though not so simply: there are also paintings resembling Sheng Mao, and others under the influence of the Ming Nan-tsung school. The sharply angled mountain peaks, the modeling of slopes in the "ax-cut" technique, and the drawing of the trees perhaps show Chou Ch'en copying the Sung landscape style in this painting, and its superior brushwork substantiates his reputation as "the best hand working in the academy style."

69. *T'ang Yin. "Companions in Spring Mountains."* Ming dynasty. Light color on paper. 81.8 × 43.7 cm. Shanghai Museum.

T'ang Yin (1470–1523) was styled Po-hu and Tzu-wei, with the alias Liu-ju Chü-shih, and was a native of Wu District in Kiangsu. His talent was early recognized, and his literary cultivation was high enough to earn him praise as the "first romantic genius in Chiangnan." But he imbibed heavily with the likes of Chang Ling and Chu Yün-ming, and remained reckless of conduct throughout his life. In 1498 (Hung-chih 11) he took first place in his local examinations; but in the following year, at the comprehensive examinations in which he was expected to lead the field, he became involved in a cribbing incident and lost a promising future on the spot. Cursed with a rash and imprudent character, he became worse as time went on and ended his life in poverty.

T'ang Yin first studied the painting of Chou Ch'en, then advanced through the northern and southern traditions of the Sung period and the Four Great Masters of late Yüan. Through these he developed finally a style of his own, and standing on a par with Ch'ou Ying, split the academy school into two parts.

This painting depicts the delight of a literati excursion into the early spring mountains, seeking flowers and tippling wine. A single dot of light red color adorns the clothing of the figure on the right. An "ax-cut" modeling of the slope in the Li T'ang manner is only partially visible around the stream's mouth. The work shows the intermediate character of the academy school, and was done late in the artist's life.

70. *T'ang Yin. "Silk Fan in the Autumn Wind."* Ming dynasty. Ink on paper. 77.1 × 39.3 cm. Shanghai Museum.

T'ang Yin excelled equally at landscape, figure, architectural, and flower-and-bird painting. His paintings of beautiful ladies seem to fall into two types: the classical genre style employing a lovely, elegant line, and as shown in this painting, the drawing of beauties with a sharper, stronger stroke.

This work captures a sorrowful lady, just past summer at the start of the autumn winds, concealing her disappointment at unrequited love behind a no longer useful silk fan. It is a representative figure painting by T'ang Yin.

71. *Ch'ou Ying. "Recluse Fishing at Lien-hsi." Ming Dynasty. Color on silk. 127.7 × 66.3 cm. The Palace Museum.*

Though Ch'ou Ying was no more than a craftsman painter, his art was understood and highly evaluated by the literati painters of the Wu school in his time, such as Wen Cheng-ming and the group surrounding him. It was perhaps by common drawing technique and creative conception that he exerted such a great influence upon the formation of Wu literati style.

This work presents a waterside village scene with the dust settled and the sky beginning to clear after rain, while fog continues to envelop the distant mountains. The refreshing effect of a river village about to greet early summer is achieved with a firm technique, and the work shows none of the cleverness that is often openly displayed in the work of professional painters.

73, 74. *Shen Chou. "Three Cypress Trees" (details). Ming dynasty. Ink on paper. 46.1 × 100.4 cm.; 46.1 × 121.5 cm. Nanking Museum.*

Shen Chou (1427-1509) was styled Ch'i-nan, with the alias Shih-t'ien. He was generally called Shih-t'ien, though late in life he took a further pseudonym, Pai-shih-weng. Native to Hsiang-ch'eng-li in Ch'ang-chou, Kiangsu Province, his family had been noted Confucians since his grandfather Shen Ch'eng. Shen Chou was the eldest son of Shen Ch'eng's second son Heng, and his paternal uncle was Shen Chen. Shen Chou studied prose and poetry from Ch'en Meng-hsien in his youth, but as he grew older, his interests shifted to painting.

Grandfather Shen Ch'eng had once been summoned to office, but relinquished his position because of widespread corruption. The men of the family had since remained scholars in retirement. Many in the family were skilled in literary composition, calligraphy, and painting, and they formed their own family tradition in these arts. As a noted family in the Hsiang-ch'eng-li area, they further possessed a rich collection of valuable calligraphy, paintings, and bronze and stone inscriptions, the classical paintings of which were probably influential in Shen Chou's development as an artist. Though his prose, poetry, and calligraphy were also ranked high in his day, it was commonly held that his painting overshadowed his literary efforts.

Shen Chou is said to have studied the styles of Tung Yüan, Chü-jan, and Li Ch'eng through the works of the Four Great Masters of late Yüan, and he appears to have been most strongly influenced by Wu Chen and Wang Meng. He painted nothing but small-scale works before the age of forty, but the large paintings done in the latter half of his life do employ the brushwork of Wu Chen, and through Wu Chen seek an understanding of Tung Yüan and Chü-jan. He was, however, never able to really assimilate the tranquil calm of Ni Tsan's style.

There are a great many paintings attributed to Shen Chou still extant, and the appraisal of these works toward a definition of his genuine work is a very difficult task. Together with the formation of the Wu school of literati painters, it is a problem that must be taken up in the future.

Neither the seal nor signature of Shen Chou appear on this painting, but it has been attributed to him nonetheless. There are many entries concerning paintings of this title in painting catalogues. It appears as "The Cypresses of Yü-shan" in the *T'ien-shui ping-shan lu*, a list of the confiscated properties of Yen Sung; it is recorded as "Painting the Three Cypresses of Chao-ming by the Chih-tao Temple at Yü-shan" in the catalogue to Wang Yen-chou's Erh-ya-lou collection; as "The Three Cypresses of Yü-shan" in the *Shu-hua t'i-pa chi* by Yu Feng-ch'ing; and is referred to as the "Three Cypress Trees" of Chen Chou by Li Jih Hua and Ch'en Ch'i Ju of the late Ming dynasty. All these refer probably to the same work. The "Three Cypresses of Yü-shan" were originally called "The Cypresses of the Seven Stars." They marked the spot where Chao-ming, heir apparent to the throne of Liang, prepared his lessons, and it was famous for its wierdly shaped trees, which resembled seven dragons in wild dance. At the time, only three of the original trees remained, the rest having been replanted.

The leaves in this work are expressed with "black pepper dots" in light, medium, and heavy ink, and the trunks are forcefully and rapidly executed to skillfully capture the likeness of old cypresses. The brushwork here has much in common with the Shen Chou landscape style, and is somewhat different from the boneless ink wash flower and fur paintings at which he also excelled.

75. *Shen Chou. "After a Landscape by Ta-ch'ih." Ming dynasty. Light color on paper. 211.4 × 110.0 cm. Shanghai Museum.*

This painting carries a colophon by the artist explaining that the work is after the style of Huang Kung-wang (styled Tzu-chiu, alias Ta-ch'ih). It is dated 1494 (Hung-chih 7), and was done in Shen Chou's sixty-seventh year. The phrase 大癡道人 implies only that the artist is attempting to capture the aesthetic feeling of Huang Kung-wang's work, not to adopt his brush and ink technique. Features resembling Huang Kung-wang's are in fact few in this painting, and it rather exhibits the unique traits that Shen Chou formed under the influence of the style of Wu Chen. The composition sharply separates the foreground and background with soaring central mountains, while in the expression of detail various techniques are elaborately and sensitively attempted. The work contrasts strongly with many other so-called Shen Chou paintings, which show a monotonous line and have a lifeless air.

77. *Wen Po-jen. "Fishing in Seclusion by a Flowery Stream." Light color on paper. 25.6 × 33.5 cm. Shanghai Museum.*

Wen Po-jen was a native of Wu District in Kiangsu Province. A nephew of Wen Cheng-ming (being the oldest son of Wen K'uei, an elder brother of Wen Cheng-ming), he was styled Te-ch'eng and used the aliases Wu-feng, Pao-sheng and She-shan Lao-nung. It is said that he once fell out badly with Wen Cheng-ming, but seems to have later restored intimate relations with his children. Though his poetry is not mentioned in the anthologies of the period, he did participate in many poetry parties, and was probably a skilled poet like others in the Wen family.

The family of Wen Cheng-ming is famous for the number of literati painters that emerged from it, and it may be said that this family, and the literati who surrounded Wen Cheng-ming, constitute the basis of the Wu school of

literati painters. Wen Po-jen was of course one of the leaders in this. He, too, did landscapes colored in heavy blue and green, but excelled most at landscapes done in ink wash and pale red. Simple composition, soft brushwork, and a subtle harmony of tones between light color and ink are common features of the landscapes of the Wen group. In the case of Wen Po-jen, however, the scene is rather more fully drawn, and it is for this reason that his technique is held not at all beneath that of Wen Cheng-ming.

This painting is a work of 1569 (Lung-ch'ing 3), when the artist was sixty-eight. It does not much admit the influence of Wang Meng as asserted by the painting histories, and is rather more Wen Po-jen's own style. The composition is based on the stream flowing down the center, and the viewer's eye is drawn naturally upwards by the arrangement of the protruding slopes and trees. The work shows an artless skill in evoking a sense of depth on a vertical plane in this hanging scroll.

78. *Ch'en Ch'un. "Camellia and Narcissus." Ming dynasty. Ink on paper. 136.1 × 32.6 cm. Shanghai Museum.*

Ch'en Ch'un (1483–1544) was a native of Ch'ang-chou in Kiangsu Province. He was originally styled Tao-fu, but as he came to be commonly known by this name, he took another, Fu-fu, and was also known by the alias Pai-yang Shan-jen. He became a follower of the famed Wen Cheng-ming, who was a friend of his father, and studied the classics, poetry, calligraphy, and painting under him. He later passed provincial examinations, but unattracted by the prospect of an official career, passed the rest of his life as an unemployed scholar. The fact that the Ch'en family was one of the most wealthy in the Wu area contributed to the number of famous scholars around him, and Lu Ts'an became his father-in-law. Ch'en Ch'un became one of Wen Cheng-ming's favorites, and he often joined in the poetry and wine fests that centered around him, in the company of such scholars as Wang Ch'ung and Ts'ai Yü. Another of his companions was Chang Huan, who composed Ch'en's tomb inscription and had a deep understanding of his character, poetry, and painting. Ch'en Ch'un, in short, must not be overlooked in the formative period of the Wu school of literati painting.

The dean of late Ming literati, Wang Shih-chen, once compared Ch'en Ch'un's painting to the calligraphy of Chu Yün-ming, and he was of course one of the stronger individualists of the Wu school. In landscape painting he had passed through the Four Great Masters of late Yüan to assimilate the styles of Mi Fu, Mi Yu-jen, and Kao K'o-kung, and the influence of Wen Cheng-ming was of course strong. Nonetheless, his best talent was for ink wash floral painting. As seen in this work, apart from the flowers, no outline is used on the branches and leaves. These forms are suggested with blotches of thick ink to evoke a subtle range of natural colors with the tones of ink monochrome. The narcissus that lies beneath the camellia is outlined in rapid strokes, and is possibly in imitation of the ink orchids of the Sung artist Chao Tzu-ku, in whose surviving paintings this drawing technique appears. The ink wash flower paintings of Ch'en Ch'un, like those of Hsü Wei, exerted a great influence on later ages as an accepted type of floral painting for literati artists.

79. *Ch'ien Ku. "Ladling Water by a Mountain Home." Ming dynasty. Color on paper. 85.1 × 30.4 cm. Shanghai Museum.*

Ch'ien Ku (1508–?) was a native of Wu District in Kiangsu Province. He was styled Shu-pao, and as his teacher Wen Cheng-ming had once inscribed the characters 懸磬室 ("Room of the Hanging Chimes") in his home, he later adopted the alias Ch'ing-shih. He lost his parents at an early age and his family was poor, but he later studied literary composition, calligraphy, painting and even epigraphy under Wen Cheng-ming, and established himself as a poet and calligrapher in his own right. Many of his writings survive. As a painter he may be said to have joined other outstanding talents in the circle of Wen Cheng-ming, such as Lu Chih and Chü Chieh, in handing on features of that master's style. Ch'ien Ku's extant paintings testify well to the breadth of his technical means, which can be seen in his divergent use of the "red pepper" dotting technique transmitted by Shen Chou and Wen Cheng-ming, the soft shading and subtle ink tones common to the whole Wen group, as well as an ink wash technique, which might be taken for shading of the "ax-cut" type.

This painting was done in 1573 (Wan-li 1) for a person named Huang Fu-liu, and is one of few works revealing the style of Ch'ien Ku's late years. The drawing is principally shading and dotting, to which light colors are added. Though it recalls the Wen family style, it has already gone beyond the influence of Wen Cheng-ming to express the artist's own individual style.

The date of Ch'ien Ku's death is set at 1572 (Lung-ch'ing 6) at sixty-five years of age by Wu Jung-kuang in his 歷代名人年譜 (*Chronologies of Famous Men Throughout the Ages*), though no substantiating evidence is given. But since the date 1578 (Wan-li 6) appears on some paintings extant and recorded, the date of his death must still be regarded as uncertain.

80. *Hsü Wei. "Peony, Banana Palm, and Rock." Ming dynasty. Ink on paper. 120.6 × 58.4 cm. Shanghai Museum.*

Hsü Wei (1525–93) was a native of Shan-yin District in Chekiang Province. He was first styled Wen-ch'ing, but later changed it to Wen-ch'ang. He used the aliases T'ien-ch'ih, Ch'ing-t'eng, and (breaking up the character 渭 [*wei*]) T'ien-shui-yüeh. In 1540 (Chia-ching 19) he obtained his district *hsiu-ts'ai* degree, but became ineligible for office when he subsequently failed the provincial examination. His literary reputation, however, was high in his home area, and he was acknowledged by famous literati. Middle age brought eccentric behavior: he inscribed his own epitaph and attempted suicide. In 1566 (Chia-ching 45) he suffered a fit, killed his second wife, and was thrown into prison. He was fifty-three when released, already an old man, and in 1593 (Wan-li 21) his unlucky life came to an end.

Hsü Wei was a genius who even left works of drama behind him, and he exerted a great influence on later times in several respects. He said of himself that his calligraphy was first in value, his poetry second, his prose third, and his painting fourth. His calligraphy favored the style of Su Shih (alias Tung-p'o) and Mi Fu, and he may be regarded, with Chu Yün-ming, as one of the most strongly individualistic artists of the middle Ming period. In his poetry, too, there are many fine verses that pour out his inner feelings.

Hsü Wei is said to have received instruction in painting from Ch'en Ho, and was probably also influenced by his friends Hsieh Shih-ch'en and Shen Shih. His surviving

works, however, show a unique style that seems to admit the influence of none of these artists. He did occasional landscape and figure paintings, but his principle themes were flowers, plant and insect paintings, fish and shells, and dead tree, bamboo, and rock paintings, done with a free, careless technique in which the ink was spilled on the paper and spread around or applied with a broad, flat brush. Despite this careless approach, he captured superbly the character of his subjects, and created an outstanding beauty of harmonious ink tones.

This painting takes its theme from Wang Wei's "Plantains in the Snow" with the addition of peonies, though the form of the peonies is already ignored. The artist's profligate character shows clearly in this work, and it is representative of the Hsü Wei style, which had much influence on art from Pa-ta Shan-jen to the Eight Eccentrics of Yang-chou, and even to Chao Chih-ch'ien in the modern age.

81–84. *Hsü Wei. "Miscellaneous Flowers" (details). Ming dynasty. Ink on paper. 81. 30.0 × 123.0 cm.; 82. 30.0 × 113.0 cm.; 83. 30.0 × 147.0 cm.; 84. 30.0 × 110.0 cm. Nanking Museum.*

Imitations of Hsü Wei's "Miscellaneous Flower" scrolls are by no means few, and there are many works that attempt a common theme and technique. Within the rythmic movement of the brush, the inherent nature of the subject is well grasped, and the richly mixed ink achieves an even more subtle effect of color than would the application of color itself.

85. *T'ao Ch'eng. "Leave-Taking for Yün-chung." Ming dynasty. Ink on paper. 25.1 × 155.0 cm. The Palace Museum.*

T'ao Ch'eng (late fifteenth to mid-sixteenth centuries) was a native of Pao-ying (Yang-chou-fu) in Kiangsu Province. He was styled Meng-hsüeh (sometimes written Mao-hsüeh), and used the alias Yün-hu Hsien-jen. He obtained his provincial *chü-jen* degree in 1471 (Ch'eng-hua 7; some say during the Cheng-te reign period). He was adept at poetry, calligraphy, and painting, and one of his poems is collected in both the *Ming-shih-tsung* and *Ming-shih chi-shih* anthologies. As writings about him imply, he was rather a strange character, but in spite of that he found patrons in such famous contemporaries as Wu K'uan, Ch'eng Min-cheng, and Li Meng-yang.

T'ao Ch'eng could handle a variety of themes in his painting, but excelled most in portraits, flower-and-bird paintings in the "hook" outline style, and landscapes in blue and green. His best features, it is held, appear in his small-scale works.

This scroll was done on the occasion of parting from Ko K'ao (styled Mien-hsüeh), who was to take office as department director for Shanhsi in the Bureau of Finance. The formally attired figure in the upper right is probably Ko K'ao. To his right are drawn mountains obscured in white clouds. The line of this range moves off to the left and is soon lost in the clouds, suggesting that the deep, precipitous mountains through which he must pass to his appointment continue on from that point. The face and clothing of Ko K'ao are sketched only with abbreviated strokes, but his character is yet well caught. The drawing of the trees and mountains, too, possess a freedom undiluted by formal cliches.

86. *Chou T'ien-ch'iu. "Narcissus and Bamboo" (detail).*

Color on paper. 32.0 × 386.0 cm. Liaoning Provincial Museum.

Chou T'ien-ch'iu (1514–95) was a native of Ta-ts'ang in Kiangsu, but changed his residence to the Wu District. He was styled Kung-hsia, and used the alias Huan-hai. A learned and versatile literatus, he was an associate of Wen Cheng-ming, painted floral works and ink wash orchids, and gained attention as an excellent calligrapher in the seal (篆), clerical (隷), running (行), and formal (楷) styles. His ink orchids were variously said to have been modeled on Chao Meng-fu or Cheng Ssu-hsiao, both Yüan artists, and there were perhaps no better orchid painters in Ming than he. The outline technique in this painting of bamboo and rock arranged among narcissuses is in an archaic style. It is perhaps based on the work of Chao Meng-chien, an artist from the Sung imperial family who was known as a painter of orchid, bamboo, and narcissus in late Sung and early Yüan times. It is a powerful work of superior execution.

87. *Ch'en Hung-shou. "Lotus and Rock." Ming dynasty. Ink on paper. 151.9 × 62.0 cm. Shanghai Museum.*

Ch'en Hung-shou (1599–1652), a native of Chu-chi, Chekiang, was styled Chang-hou. He first used the alias Hsi-lien, but after the collapse of the Ming dynasty in 1644 he became a monk and changed it to Hui-ch'ih. He became a district scholar with the title *chu-sheng*, but soon gave up pursuit of an official career and returned to his native district, where he lived an unfettered life and became known as a "mad scholar." He excelled, however, in literary composition, calligraphy, and painting, and associated with famous literati of his day, such as Ni Yüan-lu, Huang Tao-chou, and Chou Liang-kung. Ch'en first studied the painting of Lan Ying, but later fashioned his own style from the strong points of Su T'an-wei (Six Dynasties), Wu Tao-tzu (T'ang), Li Kung-lin (Sung), and Chao Meng-fu (Yüan). In both figure painting and the depiction of landscapes, trees, and rocks, he was satisfied with neither a commonsense technique nor the mothods of the Northern and Southern schools. He turned his attention to pre-Sung archaic styles and gave them new life in modern form. His figure paintings were particularly unusual; they made extensive use of continuous straight lines, and the figures were somewhat strangely proportioned, exhibiting a richly individualistic expression. His name was linked with that of Ts'ui Tzu-chung in the popular phrase, "Ch'en of the south and Ts'ui of the north."

This painting depicts a large and small rock standing in a pond and several lotus flowers. The drawing of the lotus flowers differs from the common "hook" outlining method. Particularly in the lotus leaves afloat on the water can be seen the rich decorative expression of the artist. According to the colophon, the work may be dated before 1644, during the unrest of battle at the change of dynasty.

88. *Ch'en Chia-yen. "Winter Birds on Plum and Bamboo." Ming dynasty. Ink on paper. 212.5 × 81.5 cm. Tientsin Museum.*

Ch'en Chia-yen, styled K'ung-chang, was a native of Chia-hsing in Chekiang Province. Flower-and-bird painting seems to have been his best work. Details of his life are lacking, but one source sets his birth at 1539 (Chia-ching 18), and his death sometime within the T'ien-ch'i reign period (1621–27), suggesting his active period to have been during the Wan-li reign period (1573–1619).

This painting employs a heavily inked stroke on the plum branches, and only a thin outline on the bamboo, bringing out the full sense of each. The addition of three birds to this composition distinguishes it from simple ink wash plum and bamboo themes and evokes the more gorgeous atmosphere of a flower-and-bird painting. This work is somewhat lacking in refinement, but is yet individualistic and powerful. The cyclical signs *ting-wei* that appear in the colophon correspond to the year 1607 (Wan-li 35).

89. *Tseng Ching and Chang Ch'ung. "Hou Tung-tseng." Ming dynasty. Color on silk. 121.3 × 62.1 cm. Shanghai Museum.*

The subject of this painting is Hou Tung-tseng, who took his life after the failure of a local defense against Ch'ing troops during the reign of the Ming prince Fu-wang at the end of the dynasty. Styled Yü-chan, he was a *chin-shih* of the T'ien-ch'i reign period and served as education advisor in Kianghsi. He is pictured here sitting on a couch in a corner of his garden. The division of labor in this cooperative painting is not precisely known, but Tseng Ching probably did the portrait of Hou Tung-tseng, and Chang Ch'ung the servant, trees, and rocks.

Tseng Ching (1568-1650), styled Po-ch'en, was a native of Fu-t'ien in Fuchien Province, though he later changed his residence to Nanking. His portraits were highly admired by contemporaries as "mirror images caught on paper and silk, startling in their likeness." Judging from his paintings, this was no exaggeration. As stated by Chang Keng, "he would first line out the bone structure in ink, then color in the countenance old or young; but the spirit would be already present in the ink bones." The basis of his technique thus lay ultimately in line, which was traditional enough; but his method of "overlaying his colors dozens of times," and his careful shadowing technique are obvious influences of Western art, which as a professional painter he was comparatively free to adopt.

In contrast to the realism of facial features, however, is the black ink outline used in the drawing of dress. This is an old convention in Chinese portraiture, and its presence here shows the limitations of an age that sought to uphold tradition. The date 1637 (the *ting-ch'ou* year of the Ch'ung-chen reign period) appears in the colophon of Chang Ch'ung imposed on the tree trunk at the right. Tseng Ching was thus seventy years old at the execution of this painting.

Chang Ch'ung was styled Tzu-yü, and took the alias T'u-nan. He was a native of Chiang-ning (by another source, Chiang-tu) in Kiangsu Province. He excelled at figure painting (especially beautiful ladies), and achieved a fresh effect as well in landscape and flower and plant paintings.

This meticulous portrait of a famous contemporary must be regarded as an important example of the style of Tseng Ching and Chang Ch'ung, for very few of their works survive.

91. *Chang Hung. "Landscape" (detail). Ming dynasty. Color on paper. 32.0 × 84.0 cm. Tientsin Museum.*

Chang Hung was born in 1580, and though the date of his death is unknown, he was still alive in 1660. A native of Wu District in Kiangsu, he was styled Chün-tu, and took the alias Ho-chien. In addition to landscapes, he did religious, figure, and floral paintings. His style was described as "archaic and awkward of line, applying wet, dilute ink surfaces, and achieving a dignity based on ancient standards." It was further said that he "modeled his work on that of Shih-t'ien-weng (Shen Chou), but was unable to transcend his master's style." His ties with the Shen Chou style lay in his use of a worn, tufted brush, and while unable to surpass Shen Chou in this respect himself, he possessed good qualities not present in the work of Shen Chou. This painting, though done with traditional technique, is yet infused with the fresh effect of a modern scenic painting, and is an example of the individualist styles that bloomed in the late Ming period.

92. *Yang Wen-ts'ung. "Village of the Immortals." Ming dynasty. Ink on paper. 131.9 × 51.5 cm. The Palace Museum.*

Yang Wen-ts'ung (1597-1645), styled Lung-yu, was a native of Kuei-yang, Kueichou. At the end of the Wan-li reign period he received the provincial *hsiao-lien* degree. During the Ch'ing-chen era he was appointed magistrate of Chiang-ning District, and was later impeached for corruption. When the late Ming prince Fu-wang established himself in Nanking, Yang was again employed as a censor and military inspector; and upon the succession of T'ang-wang he was charged with the administration and defense of Ch'u-chou (Kiangsu). After its fall he was captured at P'u-cheng, where he committed suicide. In painting he was said "to stand somewhere between Chü-jan and Hui Ch'ung, able to combine the best features of Huang Kung-wang and Ni Tsan." When he became district education officer in Hua-t'ing, however, he was overwhelmed by Tung Ch'i-ch'ang and much influenced by him.

This painting was done in 1642. In composition it combines both high and middle distance perspective; the contour shading is carefully worked, and the effect completed with heavy ink.

93. *Li Liu-fang. "Landscape." Ming dynasty. Ink on paper. 147.7 × 30.3 cm. Tientsin Museum.*

Li Liu-fang (1575-1629) was styled Mao-tsai and Ch'ang-heng, and used the aliases Hsiang-hai and P'ao-an. Since his study was named T'an-yüan, he was also called T'an-yüan Hsien-sheng. Li was a native of Chia-ting in Kiangsu Province. In 1606 (Wan-li 34) he received the provincial *hsiao-lien* degree, but failed the metropolitan examinations and had to abandon hopes for an official career. He was a learned man and a skilled poet and writer, and with other contemporaries such as T'ang Shu-ta and Ch'eng Meng-yang, was among the "Four Gentlemen of Chia-ting." He modeled his calligraphy on the style of Su Shih and excelled at seal carving, being ranked with Ho Chen. His book, *T'an-yüan-chi*, is also renowned.

Wu Wei-yeh of the early Ch'ing period composed a "Song to the Nine Friends in Painting" in praise of nine literati painters, and both Li Liu-fang and Ch'eng Meng-yang were included. Li seems as well to have had a close association with Ch'ien Ch'ien-yi. He did flower, bamboo, and rock paintings, and beautiful works in ink wash survive. Li excelled most, however, at landscape painting, in which he studied Wu Chen. He was not, however, by his own account, simply an imitator of Sung and Yüan works. He sought rather to penetrate and reveal the aesthetic meaning behind them, and his many extant works reveal him one of the few richly individualistic artists among literati painters in late Ming. He had spent the better part of a year around

Lake Hsi, and the love of nature that that scenic area inspired must have given form to many fine mountains in his paintings.

This work was done in 1618 as the artist was drifting in a boat along the Wu-sung river. It is not, of course, a literal description of the scene, but a commitment to paper of imaginary mountains gathered from several natural views. The forms of the trees and mountains, the forceful dotting in rich ink, the spirited contour shading, and the composition of the painting are all common to the work of the period. This one, however, is of especially superior execution.

94. *Shen Shih-ch'ung. "Mountain Residence." Ming dynasty. Color on paper. 168.7 × 43.8 cm. Tientsin Museum.*

Shen Shih-ch'ung, styled Tzu-chü, lived in the first half of the seventeenth century and was a native of Hua-t'ing in Kiangsu Province. He studied under Sung Mao-chin and Chao Tso, but rather than restricting himself to the Shen Chou, Sung Hsü, and Sung Mao-chin style, he seems to have accepted the influence of Tung Ch'i-ch'ang. His extant works often closely resemble those of Chao Tso or Tung Ch'i-ch'ang, and it is probably for this reason that critics describe him unkindly, along with Chao Tso, as a notorious counterfeiter of Tung Ch'i-ch'ang paintings. It was also asserted, to the contrary, that though all great masters of the time farmed their work out to disciples, Shen Shih-ch'ung alone never ghosted for anyone. It was in this period, as the Wu school became more formalized, that literati painters began to turn toward professionalism. Thus the Yün-chien school that Shen founded included many professionalized painters, of which Shen was one. Shen Shih-ch'ung did his best work on horizontal scrolls, and was not so skillfull with vertical paintings.

This work bears neither signature nor seal, but in 1787 (Ch'ien-lung 52) P'an Kung-shou (1741-94) acknowledged it the work of Shen Shih-ch'ung, done in the spirit of an earlier "Mountain Residence" by Huang Kung-wang. The work is divided into three horizontal sections on which are arranged foreground, center, and background scenes. Between them are placed water and clouds in the manner of the most ordinary vertical scroll composition. The ink and brushwork show no trace of the Huang Kung-wang technique, and the work is entirely typical of the Wu school of literati painting in late Ming.

95. *Shen Hao. "Landscape" (album leaf). Ming dynasty. Color on paper. 28.8 × 24.0 cm. Tientsin Museum.*

Shen Hao, born in 1586 and still living in 1661, was a native of Wu District in Kiangsu Province. He was styled Lang-ch'ien and used the alias Shih-t'ien. Bold and forthright of character, he was a skilled poet and writer, painter and calligrapher. His landscape style was close to that of Shen Chou. He was also well versed in painting theory, and wrote a tract entitled Hua Chu. This work is an impromptu piece, and according to the colophon is in imitation of Li T'ang of Sung. Leaving aside matters of form, there perhaps is a similarity of effect.

96. *Fu Shan. "Landscape" (album leaf). Ch'ing dynasty. Color on silk. 25.3 × 25.8 cm. Tientsin Museum.*

Fu Shan (1605-84) was a native of Shanhsi Province, from either Yang-ch'ü or T'ai-yüan. He was first named Ting-ch'en and styled Ch'ing-chu (青竹), which he later changed to Ch'ing-chu (青主), and used the aliases Se-lu, Chu-yi Tao-jen, Kung-chih-t'a, and Shih Tao-jen at various points in his life. After the fall of the Ming dynasty he donned vermillion clothing, lived in a cave, and cared for his mother; even after peace was restored he continued to dress as a rustic and live in retirement. During the K'ang-hsi reign period (1662-1722), however, he was designated a "Scholar of Wide Learning" and appointed a Grand Secretary, but he never did assume the responsibilities of office. Fu Shan was an outstanding calligrapher and painter, and excelled as well at poetry, prose, and seal engraving. His landscapes were careless and free of execution, and his mountain peaks were roughly sketched without detailed modeling. The effect is novel, however, and exhibits a surprising sense of internal structure. His ink bamboos were further praised as full of rhythmic vitality.

This painting, as suggested by the criticism above, is a "bone" landscape, emphasizing the values of basic structure. Its effect is quite different from the Nan-tsung painting of the Chiangnan area, which centered in the Wu school. Its particular quality lies in its artless suggestion of distance, and its rich expression of the literati style of painting.

97. *Fu Mei. "Landscape" (album leaf). Ch'ing dynasty. Color on silk. 22.2 × 24.4 cm. Tientsin Museum.*

Fu Mei (1628-82) was the son of Fu Shan. He was styled Shou-mao and Hsü-nan, and used the aliases Chu-ling and Mi Tao-jen. Like his father, he excelled at poetry, painting, calligraphy, and seal engraving, being particularly adept at landscape painting. While his father excelled at the expression of "bone" or structure, Fu Mei was noted for evocation of mood. This painting is individualistic in both composition and drawing technique, and compared with his father's landscapes, offers a more charming effect.

98. *Kung Hsien. "Leaves in Red and Yellow." Ch'ing dynasty. Ink on paper. 99.7 × 65.0 cm. Shanghai Museum.*

Kung Hsien (?-1689) was styled Pan-ch'ien and Yeh-yi, and used the aliases Pan-mou, Tzu-chang-jen, and Ch'i-hsien. He was born in K'un-shan, Kiangsu Province, and after some moving about settled in Chin-ling (Nanking), where he managed a small garden of one-half *mou* (hence his alias, Pan-mou), at the foot of Ch'ing-liang Mountain. He took his pleasure in the delights of poetry, calligraphy, and painting, and is counted among the Eight Masters of Chin-ling.

At the beginning of the Ch'ing dynasty many Ming refugees emerged as individualistic painters. Kung Hsien was one of them, and himself acknowledged the creative originality of his landscape paintings. The painting here is characteristic of his landscapes without human figures, expressing a mood with special meaning that harks back to Ni Tsan. In his detail technique, the globular quality of the rocks is caught entirely by ink tones, a method probably influenced by Western shadow techniques. The cyclical signs, yi-ch'ou, that appear in his colophon mark the painting a late work of 1685 (K'ang-hsi 24). Beneath the artist's colophon are lines of praise dated 1698 (K'ang-hsi 37), by Kao Shih-ch'i (1645-1704).

99. *Fa Jo-chen. "Landscape." Ch'ing dynasty. Light color on paper. 88.0 × 81.0 cm. Liaoning Provincial Museum.*

Fa Jo-chen (1613-96), a native of Chiao-chou in Shantung

Province, was styled Han-ju, and took the aliases Huang-shan and Huang-shih. He obtained his *chin-shih* degree in 1646 (Shun-chih 3), and after appointment to the Han-lin Academy, became a reader-in-waiting in its Pi-shu-yüan, a drafting bureau concerned with ceremonial and diplomatic documents. He was later designated a Doctor of the Five Classics, and became finally a lieutenant-governor of the Fuchien-Anhui region. He was a skilled poet, painter, and calligrapher, showing his best talent in landscape painting. Stylistically he belonged to the Wu school of literati painting, but his fine, meticulous brushwork gave his work a unique surface vitality and movement.

That this painting is in imitation of the Chü-jan style is borne out by comparison with the "Wind in the Pines of a Myriad Valleys" (Pl. 33). According to the colophon, the work was done in 1689, in the artist's seventy-seventh year.

100. *Ta Ch'ung-kuang. "A Solitary Boat in Autumn Rain." Ch'ing dynasty. Ink on paper. 58.0 × 72.0 cm. Liaoning Provincial Museum.*

Ta Ch'ung-kuang (1623–92) was a native of Tan-t'u in Kiangsu Province. He was styled Tsai-hsin, and used the aliases Chiang-shang Wai-shih and Yü-kang Sao-yeh Tao-jen. He obtained his *chin-shih* degree in 1652 (Shun-chih 9), and held office as provincial censor and governor of Kianghsi Province, but after difficulties stemming from his impeachment of the powerful Ming Chu, he resigned his office and divorced himself from politics. He was an excellent poet and painter, and authored works on calligraphy and painting such as the *Shu-fa* and *Hua-ch'üan*. As seen in this work, his landscape technique is terse and rough, and recalls the Yüan style of painting. He was said to have captured the atmosphere of the rivers and mountains of Nan-hsü-chou (Tan-t'u), held to be rich in imperial spirit, but this was no more than an expression of his own pure, hard character. This effect was described by Wang Shih-ku and Yün Shou-p'ing as "rich without vulgarity, moist and unparched." The colophon carries the date 1710 (K'ang-hsi, keng-yin year), but as this was well after the artist's death, the cyclical signs must be in error. They should probably read *keng-wu* (1690) or *ping-yin* (1686).

101. *Hsiang Sheng-mo. "Listening to the Sounds of Winter" (detail). Ch'ing dynasty. Ink on paper. 29.5 × 406.0 cm. Tientsin Museum.*

Hsiang Sheng-mo (1597–1658) was a native of Chiahsing in Chekiang Province, and the grandson of the great Ming collector Hsiang Yüan-pien. He was styled K'ung-chang, and used the aliases Yi-an and Hsü-ch'iao. He first studied the landscapes of Wen Cheng-ming, but later went back to Sung and Yüan painting. Skilled at flower, bamboo, tree, and rock painting, his pines were especially valued.

The style of this painting belongs to the Wu school of literati painting, but in composition and motif it shows the influence of the Yüan dynasty Li-Kuo school, which contributes to its gravity of expression. The painting depicts one scholar on the riverbank observing nature in the still of winter, and another on the way to visit him. It is a rather narrative scene, yet it expresses fully the artist's unaffected inspiration.

102. *Ch'eng Cheng-k'uei. "Landscape" (album leaf). Ch'ing dynasty. Color on paper. 22.6 × 44.4 cm. Nanking Museum.*

Ch'eng Cheng-k'uei (latter half of the seventeenth century) was a native of Hsiao-kan in Hupei Province. The character *k'uei* in his name had originally been written 葵, but in the Shun-chih reign period was changed to 揆. He was styled Tuan-po, and had the aliases Chü-ling and Ch'ing-hsi Tao-jen. He obtained his *chin-shih* degree in 1631 (Ming, Ch'ung-chen 4) and rose to vice-presidency of the Board of Works, and after the fall of the Ming dynasty took up residence in Chiang-ming, Kiangsu Province. He studied the painting of Tung Ch'i-ch'ang, and opened new realms of expression with his favored "worn brush" technique. His ink wash tree and rock paintings were especially highly valued.

This painting, a leaf from a landscape album, illustrates well his debt to Tung Ch'i-ch'ang, but tends toward a fuller description of scene and greater intimacy. In the upper left is a seal bearing the single character 揆 (*k'uei*).

103. *Tsou Che. "Monks Conversing in a Pine Forest." Ch'ing dynasty. Color on paper. 80.0 × 43.5 cm. Shanghai Museum.*

Tsou Che, styled Fang-lu, was born in 1636 and was still alive in 1708, though the time of his death is unknown. He was a native of Nanking (Chin-ling), as his father had journeyed from Wu to Chin-ling and decided to take up residence there. Tsou Che was counted one of the Eight Masters of Chin-ling. He was skilled at landscape, pines, and flowering plants, the latter said to show the style of Wang Yüan (styled Jo-shui) of the Yüan period. His landscape paintings were modeled on those of his father, and within an atmosphere of soothing tranquillity, give a rich, traditional effect.

This painting bears the cyclical signs *ting-hai* (1707, K'ang-hsi 46), and reveals what is perhaps the artist's latest style. It shows somewhat the influence of Kung Hsien, though there are obvious differences in effect. The brushwork is quite forceful, but novelty of composition is avoided in favor of more realistic depiction. The artist himself is perhaps one of those conversing in the mountain monastery. Tsou's work was influenced by the orthodox Wu literati school, but shows mostly his own individual style. Compared with Wang Kai, Liu Yü, and other Chin-ling painters, the influence of Kung Hsien is less.

104. *K'un-Ts'an. "Thatched Hut in Green Mountains." Ch'ing dynasty. Color on silk. 89.8 × 35.0 cm. Shanghai Museum.*

K'un-ts'an (middle to late seventeenth century) was a native of Wu-ling in Hunan Province, but resided at Niu-t'ou-shan in Chiang-ning, Kiangsu. His surname was originally Liu, and after becoming a monk he took the style Shih-hsi and the aliases Pai-t'u, Ts'an Tao-jen, and Shih Tao-jen. He was stern and silent of character, having little to do with people. He traveled widely, though prone to illness. His painting was based on the Nan-tsung style, but he remained unfettered by its formalisms and attained his own realm of expression. Technically, his strength lay in his contour shading, an effect achieved by using very little ink on his brush, and in his unique use of heavy black "burnt ink."

K'un-ts'an, known with Shih-t'ao and Pa-ta Shan-jen (Chu Ta) as one of the "three monks of early Ch'ing," possessed an unconventional style, though he was more

restrained than the wild Chu Ta and more traditional than Shih-t'ao. He is perhaps best described as one who worked through established forms without becoming mired in them, for he was said to have "achieved the scenic beauty of Yüan painters."

This painting is dated by its colophon to 1663 (K'ang-hsi 2). As more of K'un-ts'an's paintings were done in this year than any other, it must have been his most mature period as an artist.

105. *Hung-jen. "Pines and Rocks in the Clouds of Huang-shan." Ch'ing dynasty. Light color on paper. 198.1 × 81.0 cm. Shanghai Museum.*

Hung-jen (1610–63) was originally named Chiang T'ao and styled Liu-ch'i (by another source, however, his given name was Fang, and his style Ou-meng). After becoming a monk he took the aliases Chien-chiang and Mei-hua Ku-na. He was born in Hsi District, Anhui Province. In the year following the collapse of Ming (1645) he shaved his head, took monastic orders, and by cutting himself off from the society of the new dynasty exhibited an anti-Ch'ing posture. His associations were limited to a few anonymous mountain monks, hermits and commoners, in which respect he differed from Shih-t'ao, whose experience his own otherwise resembled.

In his painting Hung-jen stood much in admiration of Ni Tsan, whose spirit he deeply absorbed in fashioning a distinct style of his own. This work attempts to capture the atmosphere of the sea of clouds surrounding Huang-shan, which was the place of his longest residence and the frequent subject of his paintings. The three peaks at the lower right are perhaps meant to depict "the three islands of P'eng-lai," a place of eternal youth in Chinese legend. While the composition seems at first sight quite novel, the painting is a realistic scene in which the pines and mountains are depicted without the slightest exaggeration. The outline is done in the "parched brush" manner, and though fine, hard, and sharp, is yet devoid of coldness. Shih-t'ao and Mei Ch'ing both did paintings of Huang-shan, but its clean, refreshing air was an aspect mastered by Hung-jen alone. Hung-jen sings with pure feeling of his beloved, familiar Huang-shan in this powerful work. It is a product of his later years, dated 1660 (Shun-chih 17) by the cyclical signs *keng-tzu* at the lower left.

106. *Mei Ch'ing. "Lien Tan T'ai at Huang-shan." Ch'ing dynasty. Ink on paper. 34.0 × 22.0 cm. Shanghai Museum.*

Mei Ch'ing (1623–97) was styled Yüan-kung and used the alias Ch'ü-shan. He came from the famous Mei clan of Hsüan-ch'eng in Anhui Province. In 1654 (Shun-chih 11) he obtained the provincial *chü-jen* degree, and associating with such literati artists as Wang Shih-ku, became well known as a calligrapher and poet. Wang Shih-chen rated his landscapes outstanding and his pines the most outstanding. Mei Ch'ing was a contemporary of Shih-t'ao; both loved Huang-shan and made it the subject of many paintings. This painting is one of the many surviving works on that theme, and is of particularly superior execution.

Huang-shan was a famous mountain in the northwest of Hsi District, Anhui Province. According to the *Hsin-an chih* by Lo Yüan (a *chin-shih* of the Ch'ien-tao reign period in Sung), "it was originally named Yi-shan. . . . The Yellow Emperor once made an imperial journey there with Jung Ch'eng-tzu and Fu Ch'iu-kung, where they fashioned

the pill of immortality. In 747 [T'ang, T'ien-pao 6] its name was decreed changed to Huang-shan." This painting is based on that story.

107, 108. *Chu Ta. "Landscape and Flowers Album." Ch'ing dynasty. Ink on paper. 38.1 × 31.6 cm. Shanghai Museum.*

Chu Ta was born in 1626 and last known alive in 1705. His given name is sometimes given as Yu-jui; he was styled Hsüeh-ko, and took the aliases Pa-ta Shan-jen, Ho-yüan, Jen-wu, and Ko-shan. Chu Ta was a native of Nan-ch'ang in Kianghsi Province. Like Shih-t'ao, he came from the Ming imperial family, and as a refugee from the Ming court he felt a violent antagonism toward Manchu rule. As a literati painter, he committed his frustration and remorse to his work. After the fall of Ming he retired from the world to become a monk, and was a skilled poet, painter, calligrapher, and seal engraver. There are many anecdotes concerning his eccentricties. His paintings were nearly all done in a state of intoxication. His unconventional style eschewed traditional methods, and he poured out his heart as dictated by his mood and feeling, in what was perhaps the culmination of the meaning of literati painting. Like his character, the quality of his painting is uneven, but in his best works his antagonistic spirit is purified and his frustrations transcended to attain a realm of absolute composure.

This album, like the "Peaceful Last Years" album in possession of the Sumitomo family, one of the noted collectors in Japan, contains landscape and floral paintings done mostly in the year 1694 (K'ang-Hsi 33). Both are masterpieces done in similar style, and form twin jewels among surviving Chu Ta paintings.

The "Lotus" painting presented here belongs to the flower category. It intends, however, to express symbolically an absolute realm within the artist's mind, by evoking within the structure of contrasting values of brush and ink, line and surface, a feeling of infinite composure that recalls the "equanimity of heaven." It is a superior work, which matches his "Lotus" in possession of the Sumitomo family. The "Landscape" painting presented here is also outstanding among his landscapes, and its execution is on an equal par with the Sumitomo work. Chu-ta's landscapes, however, compared with his floral and miscellaneous paintings, seem rather eccentric and a bit inferior in creative imagination, and for that reason are perhaps more stable and consistent in quality. In this painting careful attention is given to depth perspective and the transformation of trees, slopes, and spotted moss, showing no carelessness of execution. In terms of stylistic affinity, the lotus painting perhaps attempts to outdo Hsu Wei, and the landscape to surpass Tung Ch'i-ch'ang.

109. *Ch'eng Sui. "Landscape" (album leaf). Ch'ing Dynasty. Ink on paper. 27.4 × 22.5 cm. Shanghai Museum.*

Ch'eng Sui (1605–91) was a native of Hsi District in Anhui Province, and resided in Chiang-tu (Yang-chou) in Kiangsu Province. He was styled Mu-ch'ing, and took the aliases Ch'ing-hsi, Kou Tao-jen, and Chiang-tung Pu-yi. A district *chu-sheng* degree holder from late Ming times, he was one of the "refugee" artists who refused to serve the Ch'ing court. A skilled poet, writer, seal engraver, and landscape painter, he was in the latter fond of using the "parched brush" technique. He was said to have modeled his painting on the Northern Sung artist Chü-jan, but had his own special style, which in its artless expression of

elegance resembled Huang Kung-wang of the Yüan dynasty. The subtle expressiveness of his brushwork, "in wetness, drawing in spring marshes, in dryness, rending the autumn winds," was held to rival the famous T'ang artist Chang Tsao. The end of the colophon reads "Ch'eng Sui at the age of eighty-four," dating this painting 1689 (K'ang Hsi 28), a mature work of the artist's old age. There is in Japan a painting similar in design to this, which is a copy based on this work.

110. *Kao Ch'i-p'ei. "Noble Scholar" (album leaf). Ch'ing dynasty. Ink on paper. 32.4 × 26.4 cm. Shanghai Museum.*

Kao Ch'i-p'ei (?–1734) was a native of Liao-yang in Liaoning Province. He was styled Wei-chih, with the alias Ch'ieh-yüan, and had been registered under the White Banner division of the Chinese Banner Troops. In his official career he rose to the vice-presidency of the Board of Punishments.

Kao Ch'i-p'ei began the study of painting from the age of eight. Still unable after ten years to establish a school of his own, he followed the suggestion of a dream to achieve new realms of truth in finger painting. He treated a variety of themes, including human figures, landscapes, flowers and trees, fish and dragons, birds and animals. His work was uneven, and had further a rough and bold spirit, recalling somewhat the manner of Wu Wei (styled Hsiao-hsien) of Ming, which made it hard to approach intimately. As seen in his "Landscape Album" in Amsterdam, however, he occasionally produced masterpieces that may be aptly termed eccentric. The album leaf shown here is a finger painting, differing hardly at all in effect from the abbreviated free outline technique with brush. Passing back through Wu Wei, the work approaches the realm of late Sung and early Yüan ink wash artists such as Liang K'ai, and rivaling Hsü Wei of Ming, it forges a link to the later unconventional attitudes of the Eight Eccentrics of Yang-chou, especially Li Shan. A laudatory inscription by Ch'ien Tu (1763–1844), a literati painter of the late Ch'ing who was known for his elegance of style, is dated 1842 (Tao-kuang, *jen-yin* year), roughly a century after Kao Ch'i-p'ei, and in it he places this album as a product of the artist's middle age.

111. *Wang Shih-shen. "After the Figure Painting of Tao-ch'i." Ch'ing dynasty. Ink on paper. 53.5 × 119.8 cm. Kuangtung Museum.*

Wang Shih-shen (1686–1759) was a native of either Hsiu-ning or Hsi District in Anhui Province. He took the aliases Ch'ao-lin and Chin-jen, and late in life after losing his sight, the name Tso-mang-sheng. Taking up residence in Yang-chou, he became one of the Eight Eccentrics gathered there. He excelled at floral landscapes, within which his ink plums were said to resemble immortals.

This painting is in imitation of Shih-t'ao (styled Tao-chi), and a copy of his figure painting. The colophon, in a familiar Ch'an (Zen) aphorism, describes transient phenomena as "reflections in a mirror, the moon in the water," and evokes the absolute realm of no-self, no-mind with the words, "clouds pass the mountain tops, the lion emerges from his den." The flavor of the Shih-t'ao original is seen also in the posture of the humoresque figure. But in place of the solemn feeling of loneliness and searching emotion that one expects to find in Shih-t'ao, whose paintings were often an extension of his own ego, there is here a feeling of peace in this posture

of non-conformity, and a self-contentment in its boldness.

112. *Huang Shen. "Flowers" (album leaf). Ch'ing dynasty. Ink on paper. 23.5 × 29.1 cm. Nanking Museum.*

Huang Shen was born in 1687, and was last recorded alive in 1768. He was a native of Min District in Fuchien Province (other sources give the districts of either Ch'ang-ting or Ning-hua), was styled Kung-mao, and used the alias Ying-p'iao. In 1731 (Yung-cheng 9) he moved to Yang-chou. Designated a master of the three arts of poetry, painting, and calligraphy, he was, as a painter, counted among the Eight Eccentrics of Yang-chou. His calligraphy was modeled on the Six Dynasties father and son masters Wang Hsi-chih and Wang Hsien-chih, and also Huai-su of T'ang, giving an effect of archaic resilience.

Huang Shen sought first to found his painting on the Yüan artists Huang Kung-wang and Ni Tsan, with elements of Wu Chen, but almost none of these Nan-tsung style landscapes survive. Those we have are mostly scenes of small size and charming mood, which exhibit the admirable nature of his artistic temperament. Besides landscapes, he excelled as well at human figures, Taoist immortals and Buddhist monks, and also floral paintings. He is said to have studied figure painting with Shang-kuan Chou, an artist from his own native area. They were often rough and coarse of line, and gave a strong, harsh effect in what was known as the "Min smell." This was probably not only the result of his having been raised in the Min region, but also due to the influence of his teacher. His best work lay in the small-scale scenic pictures and floral paintings mentioned above, rather than those odorous figure paintings. The "Lily" presented here is a leaf from an album of flower paintings. It seems at first glance close to the style of Li Shan, but possesses a crisper beauty than that. Therein lies its alleged eccentricity.

113. *Kao Hsiang. "Landscape." Ch'ing dynasty. Album leaf. Ink on paper. 28.6 × 38.5 cm. Shanghai Museum.*

Kao Hsiang (eighteenth century) was a native of Chiang-tu (Yang-chou) in Kiangsu Province. He was styled Feng-kang and used the alias Hsi-t'ang. He excelled at ink plums and landscapes, and was a talented poet and seal engraver. One of the Eight Eccentrics of Yang-chou, his landscape style was calm, simple, and rich with the air of a man of letters. The major sources of his style are said to lie in Hung-jen, with elements from Shih-t'ao. Few of Kao Hsiang's works have survived, and there are none in Japan. This landscape album is indeed a work of great calm and simplicity, standing somewhere between Hung-jen and Shih-t'ao in its effect. At first glance abstract in conception, it yet contains much poetic emotion based on natural scenic description. Perhaps for this reason it is described as eccentric. The Japanese artist Uragami Gyokudō, painting in a similar style, is perhaps the superior artist.

114. *Kao Ts'en. "Mountain Pavilion in Clear Autumn" (detail). Ch'ing dynasty. Color on silk. 27.0 × 354.0 cm. Liaoning Provincial Museum.*

Kao Ts'en lived during the K'ang-hsi reign period (1662–1722). Originally a native of Hang District in Chekiang Province, he resided in Chin-ling (Nanking). The younger brother of Kao Fu (styled K'ang-sheng), who was known as a painter of narcissuses, Kao Ts'en was styled Wei-

sheng, and also Shan-ch'ang (though some sources consider these two different persons). As a youth he studied painting under Priest Chi Chu, a descendent of the Ming royal house, and later established his own school. Counted among the Eight Masters of Chin-ling, his landscapes and ink wash flowers were described as "entering the divine in their impressionism." Among the Eight Masters of Chin-ling, only the leader Kung Hsien is well known in Japan, and many of his works survive there. But the others are nearly unknown, and Kao Ts'en is very rarely found. Judging from this painting, the style of Kao Ts'en appears to evolve more from that of Chao Ta-nien than the Four Great Masters of late Yüan. Its style is rather archaic, slow-moving, and bland, showing the artist's natural effect to be one of gentle, elegant tranquillity.

115. *Chao Chih-ch'ien. "The Chi-shu Cliffs." Ch'ing dynasty. Color on paper. 69.1 × 35.5 cm. Shanghai Museum.*

Chao Chih-ch'ien (1829–84), a native of Shao-hsing, Chekiang, was styled Yi-fu and Wei-shu, and took the aliases Leng-chün Pei-an and Wu-men. He obtained the provincial *chü-jen* degree, and at the age of fifty was appointed magistrate of P'o-yang District in Chiang-hsi. Well versed in poetry, painting, calligraphy, and seal engraving, he was a skilled painter of flowers, trees, and rocks, and was held to have "drawn upon Ch'en Ch'un (Ming) and Li Shan (Ch'ing), creating a style of great excellence." His painting belongs to the Yang-chou tradition, but rose above the mediocrity of that school and showed an individual and highly elegant style. He was perhaps the last great literati painter.

The location of Chi-shu-yen ("Piled-book Cliffs") is not clear, but it must have been a place of surpassing scenic beauty. According to the colophon, this painting was done at the request of P'an Tsu-yin (alias Cheng-an), who later became president of the Ministry of Works and was known as a collector of epigraphy.

116. *Jen Hsün. "Red Leaves and Autumn Cicadas." Modern. Color on paper. 30.5 × 27.8 cm.*

Jen Hsün (1835–93), styled Fu-ch'ang, was the younger brother of Jen Hsiung, and excelled at flower-and-bird painting. Long a resident of Shanghai, he is known to have once been an art dealer. With his brother Jen Hsiung, his influence on painting circles was great. His drawing was precise, his composition unique, and his best works of small size. This painting is in imitation of the style of Ch'ien Yü. It shows a fine sharpness in the drawing of detail, and the vermillion of the red leaves is most effectively applied. The painting is dated *chi mao*, which corresponds to 1879, in the artist's forty-fourth year.

117. *Kao Lun. "Starlings and Persimmon." Modern. Color on paper. 140.0 × 45.5 cm. Association of Chinese Artists.*

Kao Lun (1879–1951), styled Chien-fu, was a native of Fan-yu in Kuangtung Province. A leading artist of the Ling-nan school, he was well known for his flowers and birds. He studied Western painting in Japan, and after his return became famous for promoting the "New Academy School of Painting" and the "New Literati Painting." Kao Lun was essentially a synthesizer of Chinese and Western styles, but upon closer examination, the Japanese Shijō school, a Kyoto group led by Matsumura Goshun,

seems to loom large in the result. This painting of starlings (*pai t'ou weng*, or "white-headed old man") and persimmon skillfully penetrates its subject with rough rhythmical strokes, achieving a unique effect.

118. *Jen Yü. "A Clear View of P'eng-hu." Modern. Color on paper. 133.2 × 64.6 cm. Kiangsu Provincial Museum.*

Jen Hsiung (1820–56) and his brother Jen Hsün were artists equal in reputation to Chao Chih-ch'ien, who exerted a great influence on later times. The family was native to Hsiao-shan, Kiangsu Province.

Jen Yü, styled Li-fan, was the son of Jen Hsiung. Raised in a family of artists and nurtured by his environment, he had excellent training and sensitivity, and exhibited a powerful style in landscape, figure, and bird and animal painting. He was known particularly for the vast, still effect of his landscapes.

This painting depicts in subdued tones a view of P'eng-hu on a clear day. Different in effect from the work of Jen Hsiung and Jen Hsün, it suggests a softer, more distant world. The elegant brushwork, which subdues the movement of the trees and distant mountains, and the tone of the vast sky and broad waters evoke the stillness of nature within which a single fisherman is placed to establish an intimacy of mood. Within late Ch'ing painting circles Jen Yü is a figure well worth attention.

119. *Wu Ch'ang-shih. "Grapes and Gourds." Contemporary. Color on paper. 175.0 × 47.3 cm. The Palace Museum.*

Wu Chün-ch'ing (1844–1927) was a central figure in painting circles of the late Ch'ing and early Republican period. A native of An-chi, Chekiang Province, he was styled Ch'ang-shih and took the aliases Fou-lu and K'u-t'ieh. By the end of the Ch'ing dynasty he had become magistrate of An-tung District. Though he did not take up painting until past the age of fifty, he excelled at paintings of flowering plants, and in addition was also a skillful poet and writer, calligrapher, and seal engraver. While taking the Eight Eccentrics of Yang-chou, plus Shih-t'ao and Pa-ta Shan-jen, as his masters, he developed further the style of Chao Chih-ch'ien, and created an individual style of great interest.

His themes were all things close to the daily lives of common people, such as grapes and gourds, and peony, wisteria, lotus, hibiscus, and chrysanthemum flowers. With bright, fresh colors and bold strokes he gave these sublime expression in works of imposing style. His touch was held to be like the sudden fall of rain—taking up his brush, he would set down his design in a single breath, filling it with a pent-up spirit of rebellion. This painting treats one of his most successful themes, and in its feeling of vitality, its coloring, and its bold, lively strokes, reveals the true character of the artist.

120. *Ch'en Heng-k'o. "Autumn Flowers." Modern. Color on paper. 177.9 × 90.0 cm. The Palace Museum.*

Ch'en Heng-k'o, who was well known in Peking during the early Republican period, was styled Shih-tseng, and used the aliases Huai-t'ang and Hsiu-tao-jen. A native of Hsiu-shui, Kianghsi Province, he was one of those original artists who had received an education in Western painting and sought to fuse it with Chinese styles. This attempt at a unification of the two traditions is frequently encountered

from this period on. Ch'en Heng-k'o excelled at landscape and floral painting, and his small-size works in particular exude a purity of feeling, expressing deep meaning with abbreviated strokes. Satirical genre painting was also characteristic of his work. This painting is a skillful synthesis of Western and Chinese styles, with its simple, concise brushwork and pleasant coloring, and it has a cool, refreshing effect. Even within this simplified execution, there is present a keen observation. Especially in the strength and tensity of its line, the work reveals a flavor different from Japanese artists.

121. Ch'i Pai-shih. "Flowers and Doves." Contemporary. Color on paper.

Ch'i Pai-shih (1863–1957) was named Huan, and styled Wei-ch'ing. His pseudonym Pai-shih was taken from the name of his native village, located in Hu-t'an, Hunan Province. Working laboriously in his youth, he became a cabinetmaker and showed great skill as a wood-carver. He spent the first forty years of his life in his village, then traveled all over China, and returned again to Pai-shih-ts'un. At the age of fifty he moved to Peking because of rampant banditry in Hunan. He was self-taught and had no specific teacher, but was close to Wu Ch'ang-shih, for whom he had great respect and affection. The course of modern Chinese painting, which passed from Chin Tung-hsin, Cheng Pan-ch'iao, and Chao Chih-ch'ien to Wu Ch'ang-shih, flowed into Ch'i Pai-shih, in whom it received a spirited style enriched by a wholesome feeling for life and full of humor and irony. There are good works, too, among his paintings of ladies, but his most successful themes were flowers-and-birds, and plants and insects. Anything that came into his hand—dragonfly, chick, tadpole, cherry, or bee—stirred with life in his simple strokes, giving a fresh, vivid impression. Especially striking is his superb touch—bold, yet tempered and sincere. After the birth of the Chinese People's Republic, his presence became all the more illustrious, and he left many fine works from his latest period. This painting, representative of his late years, shows an open, magnanimous style in its beauty of color and strength of line. The blooming flowers and doves are perhaps meant to be singing of peace.

122. Hsü Pei-hung. "A Pair of Horses." Contemporary. Color on paper. 110.0 × 102.0 cm.

There stands in Peking a Hsü Pei-hung Memorial Hall in which are arranged works central to the artist's life. Looking at them, one gathers the image of an idealist, skilled in both oil painting and Chinese ink styles, who labored to open socialist trends in their synthesis. Hsü Pei-hung (1895–1953) was a native of Yi-hsing, Kiangsu. He first studied painting in Shanghai, but in 1918 went to Paris to take up oil painting. Almost all Chinese artists, whether oil painters or not, work in the traditional Chinese manner too, and Hsü Pei-hung was typical in this respect. Working to harmonize both styles, he served in Chungking during the war, attempting to raise the morale of the people through artistic activity. Horses were one of his favorite themes, and he did many in running form. This painting is a good example of the kind in which a Western *dessin* is assimilated into a Chinese rough sketch technique. The artist has perhaps lodged the vitality of the people in the energy of these galloping horses. The painting is dated

kuei chi, which corresponds to 1953, near the end of the artist's life.

123. Fu Pao-shih. "Chung-shan Tomb." Contemporary. Traditional style. 79.5 × 28.0 cm.

The large work entitled "How Beautiful the Rivers and Mountains" that hangs in the People's Assembly Hall in Peking is familiar to many, and was painted by Fu Pao-shih and Kuan Shan-yüeh.

Fu Pao-shih (1903—), a native of Hsin-yü, Kianghsi, traveled to Japan at an early age to study at the Tokyo School of Fine Arts (Tōkyō Bijutsu Gakkō). He was strong in landscape and figure painting, and was also well versed in Chinese art history and aesthetic theory. After the Liberation, he traveled about painting from life as he found it, and gradually evolved a unique style of his own. In all his paintings, he sought to infuse a feeling of love into the nature and spirit that Chinese things possessed. This painting depicts the famous Chung-shan Ling, the tomb of Sun Yat-sen, in Kuangtung. The roof of the beautiful tomb is visible in the midst of the humid, mountain greenery. The drawing of the pines in the foreground with their strong, sinuous strokes is characteristic of a Chinese artist. This is a fine work representative of contemporary Chinese painting. The artist is now a vice-chairman of the Association of Contemporary Chinese Artists, and as head of the Chiangsu Chinese Painting Academy is an important figure in contemporary art circles.

124. Li K'o-jan. "Green Rocks and Silken Falls." Contemporary. Traditional style. 69.8 × 46.9 cm.

Li K'o-jan (1907—) is a native of Hsü-chou, Kiangsu, and studied ink and oil painting at the Shanghai Professional School of Art and the Hangchou National Art Academy. During the war he engaged in anti-Japanese propaganda work, doing chiefly propaganda paintings. After the war, while teaching at the National Professional School of Art, he received the guidance of Ch'i Pai-shih and Huang Pin-hung. He shows special excellence in ink wash landscapes, achieving a unique style that adds new sensitivity and techniques to traditional forms of painting. His is perhaps one of the most interesting styles being developed in modern Chinese painting circles. After the Liberation, he became a professor in the Central Art Academy, and is regarded as a powerful central figure in the art world.

This painting is basically ink wash with a simple coloring skillfully added, and depicts a magnificent view of a waterfall at Lake Ting in the Ling-nan area. The figures in the pavilion resemble not the noble scholars of antiquity, but the people of modern China. The scene of green cliffs interspersed with trees, however, and the view of the waterfall sending up flying spray evoke solemnly the timeless and immense power latent in the Chinese landscape. This painting was done in 1953.

125. Chiang Chao-ho. "A Village Girl Reading Chairman Mao." Contemporary. Traditional style. 103.7 × 76.5 cm.

With the advance of national socialist construction, contemporary Chinese painting often draws its themes from the circumstances of that construction, and many works attempt to fulfill the role of encouraging popular morale. This painting depicts a stalwart farm girl at work for modern

China, sitting in the shade of a willow tree during a pause from her labor, and reading a page in the *Selected Works of Mao Tse-tung.* There is no gaudy coloring; in the peach-colored shirt, blue overalls, and yellow-green color of the willow swaying in an eastern breeze, this is a refreshing world of light spring tones. Chiang Chao-ho is a native of Lu District in Szechwan who went to work in Shanghai after the early loss of his parents. Recognized for his work "A Family of Rickshaw Pullers," which he painted in 1929, he was employed as a teacher in the Shanghai Professional School of Art. Since the war, he has been in Peking developing a new style of genre painting, using a writing brush and a powerful and effective sketching technique.

126. *Wu Tso-jen. "A Portrait of the Artist Ch'i Pai-shih." Contemporary. Oil. 116.0 × 89.0 cm.*

Wu Tso-jen (1908—) is also a pivotal figure in the modern Chinese art world. He is now head of the Central Art Academy and vice-chairman of the Art Association of China. Before the Liberation he taught in the fine arts department of Central University and at the Peking Professional School, showing practiced ability in oil, portraiture, and ink wash painting. The thick, viscous brushwork characteristic of Chinese painters seems to be fully exhibited in both his oil and ink work. This painting, a representative portrait, shows Ch'i Pai-shih in 1954 at the age of ninety-one. The dignified figure of Ch'i Pai-shih wearing a white beard is depicted with careful sincerity, achieving a forceful, grave picture. The artist seems to have been emotionally overwhelmed by this grand master of Chinese painting leaning on a fur-covered sofa. The deep gaze from under slightly-knit white brows is firmly captured. In China there are many examples in which both Western and Chinese painting styles have taken root in a single artist, a fact that serves to distinguish modern Chinese painting from that of Japan.

127. *Yeh Ch'ien-yü. "The Great Alliance of Races in China." Contemporary. Commemorative painting. 73.0 × 48.5 cm.*

Works of this type are called *nien hua,* done to commemorate special events and occasions. Commonly produced at New Year's time or at the beginning of spring, this one features Chairman Mao in the center, with representatives of the several minority racial groups, each in their native dress, surrounding a table and offering congratulatory toasts.

Yeh Ch'ien-yü (1907—) is a native of T'ung-lu, Chekiang. A cartoonist from youth, he was the author of "Mr. Wang and Little Ch'en," a comic series which enjoyed great popularity. Later he began to do paintings in the traditional style, and distinguished himself with beautifully drawn human figures. Recently he has gained attention for his lively paintings of customs and events in the new China, and has applied his abilities to the illustration of literary works. He is influential as a vice-chairman of the Association of Contemporary Chinese Artists and chairman of the department of Chinese painting in the Central Art Academy. Even in this commemorative group portrait with Chairman Mao, a colorful caricature style is visible.

128. *Huang Pin-hung. "Mountain Residence at Ch'i-hsia." Contemporary. Traditional style. 87.5 × 47.3 cm.*

Huang Pin-hung (1863–1954), like Ch'i Pai-shih, was an artist whose long life spanned the late Ch'ing and modern

periods. A native of Yi District in Anhui Province, his given name was Chih, his style Pin-hung, and his alias Yü-hsiang. Widely known for his landscape painting, he was a member of the Hui school, but was never fettered by its stylistic traditions. Always evoking a clear, fresh, and expansive mood, his best features are seen in this 1953 work of his late period. Long involved in art education, he taught in the Hangchou Professional School of Art, and as he was also an art scholar, exerted much influence on later times.

129. *P'an T'ien-shou. "Red Lotus." Contemporary. Traditional style. 139.0 × 70.0 cm.*

The unique style of this painting, with tones applied in ink wash and light color, and the red hue of the lotus pleasantly effected, shows itself evolved under the influence of Shih-t'ao, Pa-ta Shan-jen, and Wu Ch'ang-shih. P'an T'ien-shou (1897—) was born in Chekiang, and has served as professor and president of the Shanghai Professional School of Art and the National Professional School of Art. He has written a *History of Chinese Painting,* and is influential at present as a vice-chairman of the Association of Chinese Artists and head of the Chekiang Art Academy. This work was done in 1961.

130. *Kuan Shan-yüeh. "A Newly Opened Road." Contemporary. Traditional style. 95.0 × 198.0 cm.*

Kuan Shan-yüeh (1912—) has an established reputation as a landscape painter, and has already produced many powerful works. Born in Yang-chiang District, Kuangtung Province, he refined his technique through long painting excursions over the country, and produced a strong, fresh style of scenic painting in the Chinese style. The development of the new China has been striking, and the modern view is one of new roads pushing through famous mountains and valleys. His work promises to revive features of the heavy style of the Ling-nan school. He is a director of the Association of Chinese Artists, and vice-president of the Kuang-chou Art Academy.

131. *Hu P'ei-heng. "Shao-shan, the Place where Chairman Mao Studied as a Youth." Traditional style.*

Hu P'ei-heng (1892–1962) came from a Mongolian family. Showing an early talent for painting, he taught himself in the Chinese ink style. The basis of his own style lay in the traditions of his race, and he used particularly strong contrasts, favoring heavy black ink and strong colors. Overwhelmed by Chairman Mao, he became a faithful supporter of modern China. In this painting he depicts an elegant view of the childhood home of Chairman Mao enclosed in a bamboo forest.

132. *Hu P'ei-heng, Ch'in Chung-wen, Kuan Sung-fang, Wu Ching-ting, Chou Yüan-liang, Chou Huai-min, Kuo Ch'uan-chang, Yin Po-heng, Liu Li-shang, and Yen Ti. "Sunrise at Tai-tsung." Contemporary. Traditional style.*

Tai-tsung refers to T'ai-shan, a famous mountain in Shantung Province. In ancient times the Son of Heaven often gathered the feudal lords here to carry out the ceremonies of feudal investment and imperial succession. This painting depicts sunrise on this famous mountain, incorporating a festive air in a grand scenic view characteristic of great China. Cooperative effort is common in the new China,

and in this case ten artists, headed by Hu P'ei-heng, have collaborated to produce this great work. The colophon at the upper right states that the work was presented to the government and party in commemoration of the fortieth anniversary of the socialist revolution.

133. *Ch'ien Sung-yen. "On Lake Fu-jung." Contemporary. Traditional style. 108.0 × 65.0 cm.*

Ch'ien Sung-yen (1898—), a native of Wu-ssu in Kiangsu Province, began to study painting at the age of nine. Using traditional techniques, he painted scenes from actual life, resulting finally in a skillful rendering of new conditions after the Liberation. Wu-ssu is both an industrial site and a scenic area, and the view of Lake Fu-jung is a lively and beautiful one that combines both aspects. In the foreground, boats are busily moving freight, while smoke pours from a row of chimneys in the industrial area behind the island at mid-lake. In a characteristically Chinese scene, the smoke disappears within the mists around the foot of the mountains. The work is a frank depiction of the new China, filled with life and energy. The artist is assistant head of the Kiangsu Academy of Chinese Painting, a member of the Wu-ssu Municipal People's Committee, and a vice-chairman of the Literary Union in that city. This work was done in 1958.

134. *Li Ping-hung. "The Revolutionary Uprising at Nan-ch'ang." Contemporary. Oil. 201.0 × 262.0 cm.*

Chinese oil painting depicts with firm realism historical events and living activities associated with the development of socialism. Many works strive to stimulate the viewer's energies, arouse his will to struggle, and sing out the joys of socialist construction. This painting depicts faithfully in enthusiastic colors the Communist army at the time of the battle for righteousness and justice at Nan-ch'ang. A dramatic, colorful effect is achieved with red-necktied soldiers and red flags surrounding the figure at center, who resembles Chou En-lai.

135. *Wang Te-wei. "Heroic Sisters." Contemporary. Oil.*

In the war of liberation, women, too, often made great contributions through their heroic deeds. This painting captures such a moment within a dynamic composition, portraying firm strength and enthusiasm with powerful, intense drawing. There must have been many such stories of heroic girls pushing their way through wild country. In this depiction, one carries a wounded comrade, another, holding a rifle, looks anxiously ahead. Her eye is piercing and all about hangs an air of tension. The form is not at all new, but this is a powerful work that expresses frankly the artist's intention.

136. *Li Ch'ün. "A Portrait of Lu Hsün." Modern. Woodblock. 12.0 × 10.0 cm.*

In modern Chinese art, woodblock prints have played a most vital role, showing uninterrupted growth since the earliest post-Liberation art. It is well known that its source lay in Lu Hsün, who taught that "In revolutionary situations woodcuts have the widest use; even in the busiest times, one can engage in woodcarving during a leisure moment." The so-called woodblock movement was promoted as a people's art, and it spread widely with concrete achievements among the masses. Its leading artists were active in Yen-an in the north, and include Ma Ta, Li Ch'ün, Hu Yi-ch'uan, Wo Cha, Ku Yüan, Kuo Tiao, Chiao Hsin-ho, Chang Wang, Yen Han, Hsia Feng, and others. This piece is a portrait of Lu Hsün by Li Ch'ün. With a clean, powerful expression it depicts Lu Hsün, writer and father of woodblock printing in China. Simple and artless in style, it has a fresh, resolute air. It was cut in 1936.

137. *Ch'en Yen-ch'iao. "Resistance." Modern. Woodblock. 12.0 × 20.0 cm.*

Ch'en Yen-ch'iao was a central artist in the Lu Hsün woodcut tradition active in the south, who played a large role in the war of resistance against Japan. Also working in the southern tradition were Wang Jen-feng, Mai Kan, Li Hua, Li Chih-keng, Wang Shu-yi, Lai Hsiao-ch'i, Ting Cheng-hsien, and many others. This print apparently shows the people's militia, their guns at the ready, engaged in a night battle. It is very simply done, and its expression is vivid and straightforward. The pitch-black mountain range and the shining, white plain in front of it give a graphic impression. The work was cut in 1935.

138. *Wo Cha. "Seize Back our Cattle and Sheep!" Modern. Woodblock. 18.5 × 29.0 cm.*

This scene depicts the people rising up to recover the cattle and sheep seized from them. At the far side an explosion occurs; in the front a herd of cattle and sheep mill about. Though not at all skillfully executed, the work is powerfully expressed and is full of raw feeling and exaltation of spirit. It is perhaps just these qualities that make woodblock prints so appealing. This work was done in 1944.

139. *Yen Han. "Ambush." Modern. Woodblock. 22.3 × 18.5 cm.*

Waiting in hiding for the enemy was the battle style of the Chinese people during the war. This work by Yen Han of the northern school shows the style of the period. The bravery of these people, supporting a shooting soldier with arms and shoulders, is here carved with simple directness. The smoke of gunfire and the form of a mere boy lending a hand are graphically presented. The artist himself perhaps lived through such a scene. This piece was done in 1944.

140. *Shih Lu. "Overthrow Feudalism!" Contemporary. Woodblock. 31.5 × 21.9 cm.*

The enemy of the people was not only foreign armies, but also feudalism within the government. This print by Shih Lu presents the masses storming the gates of a great wall in their efforts to overthrow feudalism. The high wall done in such minute detail and the picture of the troops climbing the wall right in front of our eyes gives the impression of a movie scene.

141. *Ku Yüan. "The Struggle to Lower Rents." Modern. Woodblock. 13.5 × 19.6 cm.*

The people carried out a determined struggle against cruel exactions. The figure whom the people are bearing down on here is either a landlord or an official. Those thrusting forward abacus and ledger, the man whose outstretched arm points in contention, and the woman holding a child are all the images of people in pursuit of a new society. Ku Yüan, born in Kuangtung and a graduate of the Lu Hsün

Art Academy of Yen-an, sought in his work a realistic depiction filled with love. This work was cut in 1942.

142. *Li Hua. "Arise!"—from the "Angry Tide" series. Contemporary. Woodblock. 19.4 × 27.2 cm.*

The people charging forward in attack is the subject of this bold, impassioned work. Some are carrying rifles, but others are grasping only spears and waving sickles. All charge over the hill with their hair flying out behind them. This mass uprising does indeed resemble the rush of an angry tide. Li Hua was an artist of the northern school, and this print is one of a series. It was done during the period of postwar civil insurrection in 1947.

143. *Chang Yang-hsi. "Carrying Food to the Fields." Contemporary. Woodblock. 21.0 × 55.0 cm.*

The modern woodblock prints that penetrated and developed within the people's liberation struggle turned after the Liberation to an expression of the joy and energy of reconstruction. In this print women and children have prepared food and are taking it to the men working in the fields. Perhaps it is a scene from a rural commune. The cheerful appearance of the girls, the children romping about in play, and the sparrows fluttering peacefully about give the print a richly caricatured effect in which the melody of a Chinese song can nearly be heard.

144. *Hsiao Lin. "At the Construction Site of T'ien-an-men." Contemporary. Woodblock. 29.0 × 58.8 cm.*

In the new China there is striking construction underway in many areas. The ornate and imposing T'ien-an-men ("Gate of Heavenly Peace"), which constitutes a grand stage in the middle of People's Square, is a superb example of this, the mighty air of which is probably stunning to visitors. This print painstakingly depicts T'ien-an-men under construction, exhibiting the vital energy of the rising new China. Of course no trace of this scene remains, and it is now only a matter of historical record.

145. *Shen Jou-chien. "In the Midst of Another Great Leap Forward." Contemporary. Woodblock. 46.0 × 31.0 cm.*

The "Great Leap Forward" was an impressive slogan heralding the work of construction, and under it ships, bridges, and factories were built, railroads laid, and industry developed. This print seeks that atmosphere in the ship building industry, expressed in a tight, clear composition and simple coloring. A red flag stands atop the ship, while in the distance billowing smokestacks accentuate the rhythms of construction. This piece is perhaps typical of contemporary Chinese woodblock prints.

146–53. *Paper Cutouts.*

Within the sphere of "painting" (繪画) in the new China, seven types are commonly recognized—traditional ink painting (國画), commemorative painting (年画), "chain" painting in series (連環画), oil painting (油画), water color (水彩), woodblock prints (版画), and free sketch (素描). In addition to these, however, cartoons, propaganda paintings, and paper cutouts (剪紙) also appear in exhibitions. Paper cutouts are close to woodblocks in effect, but have their own special flavor. Cutouts of operatic masks are one well-known example, simply done in a variety of colors, but flowers, birds, the symbolic animals associated with the twelve horary characters, and other types bound up with popular customs are common.

In paper cutting, it is necessary that all parts of the design be continuously connected. This condition itself is productive of great interest, and gives rise to very decorative designs. In complex pieces the technique can produce very grand designs, and for exhibitions artists do ambitious works that are not inferior to ink or oil paintings. Presented here are typical examples in flower-and-bird, insect and fish, and scenic designs, which show a strength, viscosity, and degree of precision that are perhaps different from Japanese styles of ornamentation. In them may be seen the continuing life of popular traditions at the base of Chinese art.

CHRONOLOGICAL TABLE

Chronological Table

Date	Dynasty	Emperor	Reign period		General information
947	Nan-T'ang	Chung-chu	Pao-ta	5	
960	Sung	T'ai-tsu	Chien-lung	1	Founding of the Sung state.
962				3	
965			Ch'ien-te	3	Annexation of Later Shu state by Sung.
967				5	
970			K'ai-pao	3	
975				8	Surrender of Li Yü and fall of the Nan-T'ang state.
1038		Jen-tsung	Pao-yüan	1	Establishment of the Hsi-hsia state by the Tangut Li Yüan-hao.
1067		Ying-tsung	Chih-p'ing	4	Compilation of the 資治通鑑 (*Comprehensive Mirror for the Aid of Government*) by Ssu-ma Kuang.
1069		Shen-tsung	Hsi-ning	2	Initiation of the New Policies by Wang An-shih.
1072				5	Death of Ou-yang Hsiu (1007–72).
1074				7	
1079			Yüan-feng	2	
1082				5	
1088		Che-tsung	Yüan-yu	3	
1094			Shao-sheng	1	Death of Shen K'uo (1030–94).
1098		Yüan-fu		1	
1104		Hui-tsung	Ch'ung-ning	3	
1107			Ta-kuan	1	Death of Ch'eng Yi (1033–1107).
1119			Hsüan-ho	1	
1125				7	Conquest of the Liao state by Chin.

Date	Art	Court and Academy (Official school)	Literati, Buddhist monks, Taoist priests (Independent schools)
947	Tung Yüan, Chou Wen-chü and Hsü Ch'ung-ssu commisioned to collaborate on the "Enjoying the Snow" on New Year's Eve.	Huang Ch'üan style of flower-and-bird painting.	Hsü Hsi style of flower-and-bird painting.
960		Coexistence of local styles of realism in landscape.	
962	Death of Tung Yüan.		
965	Huang Ch'üan, Huang Chü-ts'ai, and others follow the ruler of Shu (Szech-wan) to the Sung capital Pien-ching, and enter the Sung painting academy. Shih K'o declines invitation to the painting academy and returns to Szech-wan.	Establishment of the Academy style of painting; intellectualized composition in search of "organizing principle."	*Yi-p'in* "untrammelled" style of ink wash practiced by Shih-k'o.
967	Death of Li Ch'eng (919–67).		Li Ch'eng school and Fan K'uan school flourish in North China.
970	Death of Han Hsi-tsai (902–70).		
975	Arrival of Chü-jan and Hsü Hsi at Pien-ching.		Tung Yüan and Chü-jan school flourish in South China.
1067	Death of Ts'ai Hsiang (1012–67).		
1069		Reform of the Academy style; poetic, lyrical expression led by the spirit of southern (Chiangnan) painting; the revival of mid-T'ang styles, and fusion of Huang and Hsü flower-and-bird styles.	
1072			Literati ink painting.
1074		Kuo Jo-hsü's 図画見聞誌 (*Experiences in Painting*).	
1079	Death of Wen T'ung (1018–79).		Wen "Hu-chou" school of ink bamboo.
1082	Su Shih tours Red Cliff.		
1088	Wang Shen: "Misty Rivers and Folded Peaks."		
1098	Li Kung-lin taken ill, retires to estate at Lung-mien Mountain.	"Outline sketch" style again recognized.	Landscape style of Mi Fu and Mi Yu-jen.
1104	Mi Fu made a "Doctor of Painting."		
1107	Kuo Hsi: "Elation over Woods and Springs."	The Kuo Hsi school.	
1119	Chang Tse-tuan: "Ascending the River at the *Ch'ing-ming* Season."	"Level-distance" landscape perspective brought to final form.	

Date	Dynasty	Emperor	Reign period		General information
1127		Kao-tsung	Chien-yen	1	Fall of Northern Sung and establishment of Southern Sung.
1130				4	
1135			Shao-hsing	5	
1165		Hsiao-tsung	Ch'ien-tao	1	
1190		Kuang-tsung	Shao-hsi	1	
1195		Ning-tsung	Ch'ing-yüan	1	
1200				6	Death of Chu Hsi (1130–1200).
1201			Chia-t'ai	1	
1206			K'ai-hsi	2	Unification of the Mongols by Jenghis Khan.
1219			Chia-ting	12	Expedition of the Mongol Army into Central Asia.
1234		Li-tsung	Tuan-p'ing	1	Conquest of the Chin state by the Mongols.
1253			Pao-yu	1	
1275		Kung-tsung	Te-yu	1	Visit of Marco Polo to Kublai Khan. Death of Chia Ssu-tao.
1279		Wei-wang	Hsiang-hsing	2	Fall of the Southern Sung state.
1286	Yüan	Shih-tsu	Chih-yüan	23	
1289				26	
1295		Ch'eng-tsung	Yüan-chen	1	
1310		Wu-tsung	Chih-ta	3	
1325		T'ai-ting-ti	T'ai-ting	2	
1327				4	
1328		Wen-tsung	T'ien-li	1	
1329				2	
1344		Shun-ti	Chih-cheng	4	
1345				5	
1346				6	
1352				12	
1353				13	Occupation of Kiangsu by Chang Shih-ch'eng, assumption of title Ch'eng-wang.
1354				14	
1355				15	

Date	Art	Court and Academy (Official school)	Literati, Buddhist monks, Taoist priests (Independent schools)
1127		High period of Academy landscape painting; mastery of the "deep distance" landscape perspective.	
1130	Death of Li T'ang.		
1135	Death of the Emperor Hui-tsung (1032–1135).		
1165	Death of Mi Yu-jen (1086–1165).		
1190	Ma Yüan made painter-in-attendance in Academy.		
1195	Hsia Kuei made painter-in-attendance in Academy.		
1201	Liang K'ai made painter-in-attendance in Academy.		
1206		Formalism and mannerism; the "one-corner" method of composition, including the "mountain section, expansive water" style.	
1219			
1234			"Ink play" enters the Ch'an Buddhist exercises of monk painters.
1253	Fan An-jen made painter-in-attendance in Academy.		
1275			The golden age of ink wash painting. The Liu-t'ung-ssu school of Mu Ch'i and Lo-ch'uan.
1286	Chao Meng-fu arrives at capital in response to invitation.		
1289	Birth of Chao Yung (1289–1361?).	Restoration movement: revival of styles prior to Southern Sung; emphasis on line drawing; reproduction of the Li-Kuo, Tung-Chü, and Mi landscape schools, and Huang style flower-and-bird painting.	
1295	Death of Chao Meng-chien (1199–1295).		
1310	Death of Kao K'o-kung (1248–1310).		
1325	Ma Ch'i: mural in the San-Ch'ing Hall of the Yung-lo Palace.		
1327	Death of Jen Jen-fa (1254–1327).		
1328	Death of Li Shih-hsing (1282–1328).		
1329	K'o Chiu-ssu made "Doctor in Appraisal of Painting and Calligraphy."		
1344	Wang Yüan: "Bamboo, Rock, and a Flock of Birds."		
1345	Death of K'ang Li-k'uei (1295–1345).		
1346	Li Sheng: "Landscape" further inscribed.		
1352	T'ang Li: "Fishing in a Snowy Cove."		
1354	Death of Wu Chen (1280–1354). Death of Huang Kung-wang (1269–1354).		
1355	Wang Mien: "Ink Plums." Ni Tsan: "Autum Sky in a Fishing Village."		Flourishing of the Nan-tsung tradition: the Tung-Chü school, "inspirationism," the mainstream of Ming and Ch'ing painting.

Date	Dynasty	Emperor	Reign period		General information
1358				18	
1359				19	
1363				23	Summons of Chang Shih-ch'eng rejected by Ku Ah-ying.
1364				24	
1365				25	
1366				26	
1367				27	
1368	Ming	T'ai-tsu	Hung-wu	1	Fall of Yüan and establishment of the Ming dynasty.
1370				3	
1372				5	
1374				7	
1378				11	Dispatch of the monk Tsung-lo to the Western Regions.
1380				13	The attempted rebellion of Hu Wei-yung.
1385				18	
1392				25	Fall of Koryo, establishment of the Choson state by the Yi clan.
1403		Ch'eng-tsu	Yung-lo	1	
1404				2	
1407				5	
1412				10	
1426		Hsüan-tsung	Hsüan-te	1	
1431				6	Compilation of 四書大全 and 五經大全, compendia of Neo-Confucian commentary on the Four Books and the Five Classics.
1438		Ying-tsung	Cheng-t'ung	3	
1446				11	
1448				13	Rebellion of Teng Mao-ch'i.
1449				14	
1462		Ying-tsung (Ch'ung-tso)	T'ien-shun	6	
1465		Hsien-tsung	Ch'eng-hua	1	
1470				6	
1474				10	
1476				12	
1477				13	
1486				22	
1487				23	
1488		Hsiao-tsung	Hung-chih	1	Demand of the Tatars for tribute.
1494				7	

Date	Art	Court and Academy (Official school)	Literati, Buddhist monks, Taoist priests (Independent schools)
1358	Li Hung-hsüan, Wang Shih-yen: mural in the Ch'un-yang Hall of the Yung-lo Palace.		The Four Great Masters of Late Yüan, exponents of Tung-Chu school.
1359	Ma Wan: "Poetic Conception of Evening Clouds."		
1363	Chao Yüan: "Ho-ch'i Grass Pavilion."		
1364	Death of T'ang Li (1296–1364).		
1365	Death of Chu Te-jun.		
	Death of K'o Chiu-ssu (1312–65).		
1366	Wang Meng: "Hermitage at Ch'ing-pien Mountain."		
1367	Death of Shang Mao (?).		
	Death of Chang Wo (?).		
1370	Death of Yang Wei-chen (1296–1370).		
1372	Death of Wei Su (1295–1372).		
	Chao Yüan executed for disobeying imperial edict.	Renascence of Academy.	
1374	Hsü Pi enters court.		
	Death of Ni Tsan (1304–74).		
1385	Death of Wang Meng (1308?–85).		
1392	Fang Tsung-yi: "Deep in Cloudy Mountains."		
1403	Death of Hsü Pi.		
	Pien Wen-chin made painter-in-attendance at Wu-ying Hall.	Huang style flower-and-bird painting.	
1407	Death of Wang Mien (1335–1407).		
1412	Wang Fu: "Study by Lake and Mountain."		
	Death of Wang Fu (1362–1412).		
1426	Admission of Li Tsai, Shih Tui, Chou Wen-ching to the Academy.	High period of Academy, featuring Li-Kuo and Ma-Hsia schools.	Period of decline in the Nan-tsung school.
1431	Death of Li Tsai (?).		
1438	Birth of Hsü Tuan-pen (1438–1517).		
1446	Wang Ch'ien: "The Most Beautiful Blossoms."		
1449	Tai Chin: "Spring Mountains Turning Green."	The Che school (Tai Chin). Bold and forceful brush and ink work.	
1462	Death of Tai Chin (1388–1462).		
1465	Tu Chin fails official examination.		
1470	Death of Hsia Ch'ang (1388–1470).		
1474	Death of Tu Ch'iung (1396–1474).		
1476	Yao Shou: "Fishing in Seclusion by an Autumn River."		
1477	Birth of Lü Chi.		
1486	T'ao Ch'eng: "Departure into the Clouds."		
1487	Death of Chang Pi (1425–87).		
1488	Admission of Sun Lung to the Academy.		
1494	Shen Chou: "After a Landscape by Ta-ch'ih."	The maturation and flourishing of the Che school style; Wu Wei and Chang Lu.	

Date	Dynasty	Emperor	Reign period		General information
1495				8	
1496				9	
1498				11	
1501				14	
1508		Wu-tsung	Cheng-te	3	
1509				4	
1517				12	
1523		Shih-tsung	Chia-ching	2	
1525				4	
1526				5	
1529				8	Death of Wang Yang-ming (1472–1529).
1538				17	
1539				18	
1544				23	
1552				31	
1557				36	Occupation of Macao by Portuguese.
1559				38	
1562				41	
1567		Mu-tsung	Lung-ch'ing	1	
1569				3	
1573		Shen-tsung	Wan-li	1	
1575				3	
1576				4	
1582				10	Start of Jesuit missionary activity.
1583				11	Invasion of Liao-tung by Manchu chief Nurhachi.
1585				13	
1586				14	
1587				15	Arrival of Mateo Ricci at Nanking.
1590				18	Death of Wang Shih-chen (1526–90).
1592				21	
1595				23	
1598				26	Dismissal of Ku Hsien-ch'eng and the beginning of the Tung-lin party struggles.
1607				35	
1618				46	

Date	Art	Court and Academy (Official school)	Literati, Buddhist monks, Taoist priests (Independent schools)
1495	Death of Yao Shou (1423–95).	Criticism of eccentricity and heterodoxy by literati.	
1496	Lin Liang, Lü Chi return to Jen-chih Hall, appointed directors of the Brocade Guard. Death of Ch'en Hsien (1405–96).	Huang-style painting.	Paintings of "The Four Gentlemen"; ink wash flower painting.
1498	T'ang Yin takes first place in the local examinations.	Academy school: Chou Ch'en, T'ang Yin, and Ch'ou Ying.	
1501	Wen Cheng-ming writes in praise of Chang Ling's "Noble Scholar in Autumn Forests."		The Wu school and the renascence of the Nan-tsung tradition: Shen Chou; the Tung-Chü and Mi styles.
1508	Birth of Ch'ien Ku (1508–78). Death of Wu Wei (1459–1508).		
1509	Death of Shen Chou (1427–1509).		
1517	Wen Cheng-ming: "Madame Hsiang and Lady Hsiang."		
1523	Death of T'ang Yin (1470–1523).		
1525	Wen Cheng-ming appointed painter-in-attendance in the Han-lin Academy.		Stylistic maturation of the Nan-tsung tradition (Wen Cheng-ming).
1526	Death of Chu Yün-ming (1460–1526).		
1529	Death of Tu Mu (1459–1529).		
1538	Death of Chang Lu (1464–1538).		
1539	Birth of Ch'en Chia-yen (1539–1627?).		Hsü Hsi style (Ch'en Ch'un).
1544	Death of Ch'en Ch'un (1483–1544).		Huang Ch'üan style (Lu Chih).
1552	Lu Chih: "Clouded Peaks and Wooded Valleys."		
1557	Death of Ch'ou Ying (1506?–57).		
1559	Death of Wen Cheng-ming (1470–1559).		
1562	Yen Sung imprisoned.		
1567	Hsieh Shih-ch'en (b. 1488) reached 81st year.		
1569	Wen Po-jen: "Fishing in Seclusion by a Flowery Stream."		
1573	Ch'ien Ku: "Ladling Water by a Mountain Home." Death of Wen P'eng (1498–1573). Revision of the 藝苑巵言 by Wang Shih-chen.		
1575	Death of Wang Po-jen (1502–75).		
1576	Death of Lu Chih (1496–1576).		
1583	Death of Wen Chia (1501–83).		
1585	Birth of Lan Ying (1585–1664).		
1586	Birth of Shen Hao (1586–1661).		
1587		Importation of Western painting techniques.	
1590	Death of Hsiang Yüan-pien (1525–90).		Individualistic styles (Hsü Wei).
1592	Death of Hsü Wei (1521–92).		
1595	Death of Chou T'ien-ch'iu (1514–95).		Tradition upheld by disparaging North and honoring South.
1598		End of the Che school and its fusion with literati painting.	Division of the Wu school: Sung-chiang school (Tung Ch'i-ch'ang); Su Sung school (Chao Tso); Hua-t'ing school (Ku Cheng-yi); Yün-chien school (Shen Shih-ch'ung); Ku-shu school (Hsiao Yün-ts'ung).
1607	Ch'en Chia-yen: "Plum, Bamboo, and Winter Birds."		
1618	Li Liu-fang: "Landscape."		

Date	Dynasty	Emperor	Reign period		General information
1624		Hsi-tsung	T'ien-ch'i	4	Occupation of Taiwan by the Dutch.
1626				6	
1629		Yi-tsung	Ch'ung-chen	2	
1635				8	
1636				9	
1639				12	
1642				15	
1643				16	
1644				17	Fall of Ming.
1645	Ch'ing	Shih-tsu	Shun-chih	2	Prohibition against cutting the hair by the Manchu government.
1646				3	Resumption of the official examinations.
1650				7	
1652				9	
1658				15	
1660				17	
1663		Sheng-tsu	K'ang-hsi	2	China's first literary inquisition.
1664				3	Death of Ch'ien Ch'ien-yi (1581–1664).
1673				12	Rebellion of the three border territories held by Wu San-kuei, **Ti Ching-chung, and Shang K'o-hsi.**
1677				14	
1675				16	
1678				17	
1679				18	
1680				19	
1682				21	Death of Ku Yen-wu (1613–82)
1683				22	
1684				24	
1685				23	
1687				26	Signing of the Treaty of Nerchinsk.
1689				28	

Date	Art	Court and Academy (Official school)	Literati, Buddhist monks, Taoist priests (Independent schools)
1626	Birth of Chu Ta (1626–1705).		
1629	Death of Li Liu-fang (1575–1629).		
1635	Death of Li Jih-hua (1565–1635).		
1636	Birth of Tsou Che (1636–1708). Death of Tung Ch'i-ch'ang (1555–1636).		
1639	Death of Ch'en Chi-ju (1578?–1636).		
1642	Yang Wen-ts'ung: "Village of the Immortals."		
1643	Death of Chang Ch'ou (1577–1643).		
1644	Death of Ni Yüan-lu (1549–1644). Death of Chang Jui-t'u.		
1645	Death of Yang Wen-ts'ung (1597–1645).		Flourishing of individualistic styles; "refugee" painters highly active.
1646	Death of Huang Tao-chou (1585–1646). Death of Ko Cheng-ch'i.		
1650	Death of Tseng Ching (1568–1650).		Assimilation of some Western painting techniques.
1652	Lan Ying: "Mount Hua at the Height of Autumn." Death of Ch'en Hung-shou (1599–1652). Death of Wang To (1592–1652).		
1658	Death of Hsiang Sheng-mo (1597–1658).		
1660	Death of Chang Hung (1580–1660). Hung-jen: "Pines and Rocks in the Clouds of Huang-shan."		
1663	Death of Hung-jen (1610–63). K'un-ts'an: "Thatched Hut in Green Mountains."		
1664	Lan Ying reaches 80th year.		
1673	Death of Hsiao Yün-ts'ung (1596–1673).		
1675	Yün Shou-p'ing: "Fallen Flowers and Swimming Fish."	Revival of Hsü style by Yün Shou-p'ing.	
1677	Death of Wang Chien (1598–1677).	Ch'ang-chou school.	
1678	Fu Shan refuses office despite designation as Hung-po scholar.		
1679	Kao Ts'en last recorded alive.	Standard style of "Official" school.	
1680	Death of Wang Shih-min (1592–1680). Wang Kai produced first compilation of 芥子園画傳初集 (Mustard Seed Garden Painting Manual).	Activity of the orthodox line of the Wu school: the "four Wangs, Wu, and Yün."	
1682	Conversion of Wu Li to Christianity. Birth of Hua Yen.	Influence of Western painting styles.	
1683	Death of Fu Mei (1628–83).		
1684	Death of Fu Shan (1607–84).		
1685	Kung Hsien: "Leaves in Red and Yellow."		
1687	Shih-t'ao: "Dragon Pines in Light Rain." Birth of Huang Shen (1687–1768).		
1689	Death of Kung Hsien. Fa Jo-chen: "Pavilion at Sung-ch'üan Mountain." Ch'eng Sui: "Landscape." Shih-t'ao again welcomes the K'ang-hsi emperor.		

Date	Dynasty	Emperor	Reign period		General information
1690			29		
1692			31		
1694			33		
1696			35		
1697			36		
1698			37		
1704			43		
1705			44		
1707			46		
1708			47		
1709			48		Death of Chu Yi-tsun (1629-1709).
1711			50		Death of Wang Shih-chen (1634-1711). Compilation of the 佩文韻府, encylopedia of rhymes and their literary sources.
1715			54		
1718			57		
1720			59		
1722			61		
1723	Shih-tsung	Yung-cheng	1		Suppression of Christianity and transfer of missionaries to Macao.
1732			10		
1734			12		
1740	Kao-tsung	Ch'ien-lung	5		Compilation of the 大清一統志, comprehensive gazeteer of provinces and border countries.
1777			42		Death of Tai Chen (1723-77)
1782			47		Compilation of the 四庫全書, comprehensive bibliographical collection.
1793			58		British Macartney mission seeks trade.
1794			59		
1799	Jen-tsung	Chia-ch'ing	4		
1805			10		Death of Chi Yün (1724-1805).
1815			20		Death of Tuan Yü-ts'ai (1735-1815).
1818			23		Death of Weng Fang-kang (1733-1818).

Date	Art	Court and Academy (Official school)	Literati, Buddhist monks, Taoist priests (Independent schools)
1690	Death of Yün Shou-p'ing (1633–90).	Yü-shan school (Wang Hui).	
1692	Death of Ta Chung-kuang (1623–92).		
1694	Chu Ta: "Landscape and Flowers Album."	Lou-tung school (Wang Yüan-ch'i).	
1696	Death of Fa Jo-chen (1613–96).		
1697	Death of Mei Ch'ing (1623–97).		
1698	Death of Ch'a Shih-piao (1615–98).		
1704	Death of Kao Shih-ch'i (1645–1704).		
1705	Wang Yüan-ch'i made director of the "P'ei-wen-chai Catalogue of Calligraphy and Painting" bureau.	Adoption of the Wu school Nan-tsung style by the painting academy.	
1707	Tsou Che: "Monks Conversing in a Pine Forest."		
1708	Completion of the 佩文書齋書画譜 (P'ei-wen-chai Catalogue of Calligraphy and Painting).		
1715	Death of Wang Yüan-ch'i (1642–1715). Giuseppe Castiglione in attendance at Inner Palace in Peking.		
1718	Death of Wu Li (1632–1718).		
1720	Death of Wang Hui (1632–1720).		
1722	Death of Ma Yüan-yü (1669–1722).		
1723	Yüan Chiang in attendance at the Inner Palace.		
1732	Death of Chiang T'ing-hsi (1669–1732).		
1734	Death of Kao Ch'i-p'ei (1672–1734).		Huang style (Shen Nan-p'ing).
1740	Death of Kao Hsiang (1640?–1740).		
1744	Compilation of the 石渠寶渠, catalogue of Ch'ing imperial collection.		
1748	Death of Kao Feng-han (1683–1748).		Formation of the Yang-chou painting circle.
1754	Li Shan: "Spring Scene at Ch'eng-nan." Li Fang-yung (b. 1695) reaches 61st year.		The "Eight Eccentrics" and unconventional styles.
1755	Yüan Chiang: "Wu-t'ung and Hibiscus."	The Yüan school: Yuan Chiang and Yü Chih-ting.	
1759	Death of Wang Shih-shen (1686–1759).		
1761	Chin Nung: "Butterfly Orchid."		
1762	Death of Li Shan (?). Death of Hua Yen (age 81).		
1763	Death of Chin Nung (1687–1763).		
1764	Death of Cheng Hsieh (1693–1764).		
1765	Death of Giuseppe Castiglione (1689–1765).		
1768	Death of Huang Shen (age 82).		
1797	Lo P'ing: "Plank Road over Chien Mountain."		
1799	Death of Lo P'ing (1733–99).		
1805			Decline of the Yang-chou painting circle.

Date	Dynasty	Emperor	Reign period		General information
1829		Hsüan-tsung	Tao-kuang	9	
1840				20	Opium War (1840–42).
1845				25	
1846				26	
1850				30	T'ai-p'ing Rebellion (1850–64).
1860		Wen-tsung	Hsien-feng	10	
1872		Mu-tsung	T'ung-chih	11	Death of Tseng Kuo-fan (1811–72).
1884		Te-tsung	Kuang-hsü	10	
1892				18	Organization of the Hsing-chung-hui by Sun Yat-sen.
1894				20	Sino-Japanese War (1894–95).
1896				22	
1898				24	Death of T'an Ssu-t'ung (1865–98).
1900				26	Boxer Rebellion.
1912	Chinese Republic			1	Establishment of the Republic of China.
1919				8	Outbreak of the May Fourth Movement.
1927				16	Death of K'ang Yu-wei (1858–1927). Death of Wang Kuo-wei (1877–1927).
1937				26	Beginning of second Sino-Japanese War.
1949	People's Republic of China				Establishment of the People's Republic of China.
1950					Korean War (1950–53).
1955					First Afro-Asian Conference.
1957					

Date	Art	Court and Academy (Official school)	Literati, Buddhist monks, Taoist priests (Independent schools)
1829	Death of Kai Ch'i (1774–1829).		
1845	Death of Ch'ien Tu (1763–1845).		
1846	Publication of Chang Hsiang-ho's 四銅鼓齋論画 (Ssu-t'ung-ku chai Treatise on Painting).	Decline of Nan-tsung tradition of literati painting. Advance of literati painters into professionalism.	
1850	Death of Fei Tan-hsü (1801–50).		
1860	Death of Tai Hsi (1801–60).		
1884	Death of Chao Chih-ch'ien (1829–84).		
1892	Death of Jen Yi (1840–92).		
1896	Death of Hsü-ku (1824–96).		
1901	Death of Jen Yü (1853–1901).		
1906	Exploration of Tun-huang by Aurel Stein from 1906–9. Exploration of Tun-huang by Paul Pelliot from 1906–8.		
1907	Inspection of historical remains in North China by Edouard Chavannes.		
1919	Hsü Pei-hung studies in France from 1919–27.	Influence of Western Impressionism.	
1927	Death of Wu Ch'ang-shih (1844–1927).		Yang-chou tradition made model for "national" style.
1951	Death of Kao Lun (1879–1951).		
1953	Death of Hsü Pei-hung (1895–1953).		
1955	Death of Huang Pin-hung (1864–1955).		
1957	Death of Ch'i Pai-shih (1863–1957).	Chinese painting transformed by socialist realism.	

Map of China

(continued on p. 232)

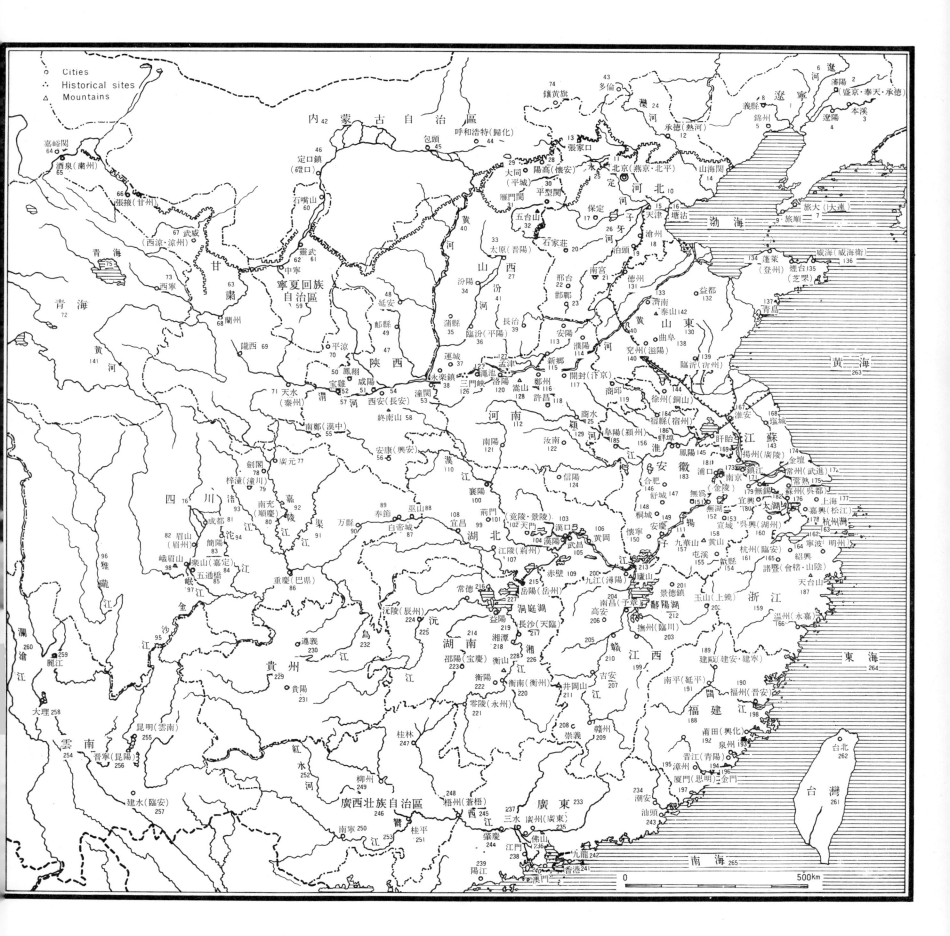

Cities
Historical sites
Mountains

内　蒙　古　自　治　區　42
呼和浩特(歸化)
包頭 45
定口鎮 46
(磧口)
石嘴山 60
靈武 62
中寧 61
寧夏回族 59
自治區
嘉峪関 64
酒泉(肅州) 65
張掖(甘州) 66
武威 67
(西涼・涼州)
青海 75
西寧 73
甘肅 63
蘭州 68
隴西 69
青海 72
黄河 141

鎮黄旗 74
多倫 43
灤河 24
承德(熱河) 12
大同 29
(平城)
陽高(懷安) 28
張家口 25
雁門関 30
平型関 31
五台山 32
太原(晋陽) 33
石家莊 20
定 21
河北 10
北京(燕京・北平) 27
山海関 14
保定 17
天津 26
滄州 18
泊頭 19
邢台 22
邯鄲 23
南宮 131
德州
黄河 40

遼河 6
瀋陽 2
遼寧
(盛京・奉天・承德)
義縣 8
錦州 5
遼陽 4
本溪 3
旅大(大連) 7
旅順 1
渤海 9
威海(威海衛) 136
蓬萊 134
(登州)
煙台 135
(芝罘)
山東
黄河 40
濟南 133
泰山 142
曲阜 138
臨沂(沂州) 139
益都 132
兗州(滋陽) 140
青島 137
黄海 263

山西 27
汾陽 34
汾河 41
蒲縣 35
臨汾(平陽) 36
運城 37
長治 39
安陽 113
濮陽 114
新鄉 115
開封(汴京) 117
鄭州 116
洛陽 120
嵩山 128
許昌 118
商邱 119
商水 125
潁河 129
汝南 122
信陽 124
河南 112
南陽 121

延安 48
鄜縣 49
平涼 70
鳳翔 50
寶雞 51
咸陽 54
天水 71
(秦州)
渭河 57
西安(長安) 53
終南山 58
潼関 52
三門峽 38
永樂鎮 38
澠池 120
孟津 122
盟津
陝西
南鄭(漢中) 55
安康(興安) 56
漢江 110
襄陽

劍閣 78
廣元 77
梓潼(潼川) 79
南充 92
(順慶) 80
嘉陵江
成都 81
四川 76
眉山 82
(眉山) 94
沱江 83
簡陽
岷江
峨眉山 98
五通橋 84
嘉定
重慶(巴県) 97
雅礱江 96
金沙江 95
奉節 90
白帝城 87
萬縣 86
巫山 88
集
宜昌 99
荊門 101
天門 102
竟陵・景陵 103
漢口 106
漢陽 104
武昌 105
黄岡
江陵(荊州) 107
湖北
赤壁 109
九江(潯陽) 200
廬山
岳陽(岳州) 227
洞庭湖
常德 216
益陽
沅陵(辰州) 224
沅 225
江
遵義 230
烏江 232
貴州 229
貴陽 231
湖南
邵陽(寶慶) 223
湘潭 218
湘江
衡陽 222
衡南(衡州) 220
零陵(永州) 221
長沙(天臨) 217
岳州

合肥 146
舒城 147
安徽
桐城 149
懷寧 150
安慶 148
蕪湖 152
黄山 157
屯溪 155
九華山 151
江蘇
盱眙 145
鳳陽
浦口
南京 146
(金陵)
鎮江 169
揚州(廣陵)
金壇
常州(武進) 174
無錫 179
蘇州(吳都) 177
嘉興(松江) 176
吳興(湖州) 160
杭州(臨安) 161
杭州灣 163
紹興 154
諸暨(會稽・山陰) 187
天台山
寧波(明州) 162
浙江 159
溫州(永嘉) 166
東海 264

淮安
鹽城
徐州(銅山)
宿縣(宿州)
阜陽(潁州) 186
蚌埠
宿城
淮
江
上海
太湖
宜興

江西
景德鎮 201
玉山(上饒) 210
鄱陽湖
南昌(子章) 204
撫州(臨安) 203
高安 206
宜春
建甌(建安・建寧) 189
南平(延平) 191
贛江
吉安 207
井岡山 211
崇義 208
贛州 209
福建
福州(晋安) 198
莆田(興化)
晋江(青) 195
漳州(潭) 194
廈門(思明) 196
金門
汕頭 243
潮安 234
廣東 233
三水
廣州(廣東) 235
佛山 238
肇慶 244
江門
陽江 239
澳門 240
九龍 242
香港 241
台北 262
台灣 261
南海 265

雲南 254
昆明(雲南) 255
晋寧(昆陽) 256
建水(臨安) 257
大理 258
麗江 259
瀾滄江 260
紅水河 252
柳州
廣西壯族自治區 246
梧州(蒼梧) 248
西江 245
桂林 247
南寧 250
鬱江 253
桂平 251
潯江

0　　　　　　　　500km

231

56. An-k'ang (Hsing-an)
57. Wei River
58. Chung-nan-shan
59. Ning-hsia Mohammedan Autonomous Region
60. Shih-tsui-shan
61. Ling-wu
62. Chung-ning
63. Kansu
64. Chia-yü-kuan
65. Chiu-ch'üan (Su-chou)
66. Chang-i (Kan-chou)
67. Wu-i (Hsi-liang; Liang-chou)
68. Lan-chou
69. Lung-hsi
70. P'ing-liang
71. T'ien-shui (Ch'in-chou)
72. Ch'ing-hai
73. Hsi-ning
74. Hsiang-huang-ch'i
75. Ch'ing-hai Lake
76. Szechwan
77. Kuang-yüan
78. Chien-ko
79. Tzu-t'ung (T'ung-ch'uan)
80. Nan-ch'ung (Shun-ch'ing)
81. Ch'eng-tu
82. Mei-shan (Mei-chou)
83. Chien-yang
84. Lo-shan (Chia-ting)
85. Wu-t'ung-chiao
86. Chungking (Pa-hsien)
87. Pe-ti-ch'eng
88. Wu-shan
89. Feng-chieh
90. Wan-hsien
91. Ch'u-chiang
92. Chia-ling River
93. Fu River
94. T'o River
95. Chin-sha River
96. Ya-lung River
97. Min River
98. Ngo-mei-shan
99. Hupei
100. Hsiang-yang
101. Ching-men
102. T'ien-men (Ching-ling; Ching-ling)
103. Han-kou
104. Han-yang
105. Wu- h'ang
106. Huang-ling
107. Chiang-ling (Ching-chou)
108. I-ch'ang
109. Ch'ih-pi
110. Han River
111. Yangtse River
112. Honan
113. An-yang
114. P'u-yang
115. Hsin-hsiang
116. Chen-chou
117. K'ai-feng (Pien-ching)
118. Hsü-ch'ang
119. Shang-ch'iu
120. Lo-yang
121. Nan-yang
122. Ju-nan (Ts'ai-chou)
123. Kuei-ch'ih
124. Hsin-yang
125. Shang-shui
126. San-men-hsia
127. Meng-chin
128. Sung-shan
129. Ying River
130. Shantung
131. Te-chou
132. I-tu
133. Chi-nan
134. Feng-lai (Teng-chou)
135. Yen-t'ai (Chih-fou)
136. Wei-hai (Wei-hai-wei)
137. Ch'ing-tao
138. Chü-fu
139. Ling-yi (Yi-chou)
140. Yen-chou (Tzu-yang)
141. Huang River
142. T'ai-shan
143. Kiangsu
144. Hsü-chou
145. Feng-yang
146. Ho-fei
147. Shu-ch'eng
148. T'ung-ch'eng
149. An-ch'ing
150. Huai-ning
151. Wu-wei
152. Wu-wei
153. Yi-ch'eng
154. Hsi-ch'ien
155. T'un-ch'i
156. Huai River
157. Chiu-hua-shan
158. Huang-shan
159. Chekiang
160. Wu-hsing (Hu-chou)

List of Artists